African-American Ar

Oxford History of Art

Sharon F. Patton joined the faculty at the University of Michigan, Ann Arbor in 1991 with a joint appointment in the History of Art Department and the Center for Afroamerican and African Studies. In July 1996, she was appointed director of the Center. Currently she is working on contemporary African-American art. Her research interests are in African-American and West African art. In 1980 she earned her doctorate degree in African art history at Northwestern University, Evanston, Illinois. Prior to her appointment at the University of Michigan, she was chief curator at the Studio Museum in Harlem where she organized the major retrospective on Romare Bearden, titled 'Memory and Metaphor, the Art of Romare Bearden'

in 1991. A book of the same title was published by Oxford University Press that same year. She has been the curator for several exhibitions on African-American and African art; her last show was in 1992, 'African Art from the Museum Collection: A Celebration', for the University of Michigan, Museum of Art. Recently she completed an article on three contemporary African-American women artists in David C. Driskell, *African American Visual Aesthetics: A Postmodernist View*, for the Smithsonian Press in 1995. She has written articles on folk artists, Minnie Evans, nineteenth-century African-American cabinetmakers, Asante (Ghana) regalia, as well as on contemporary African-American artists.

Oxford History of Art

African-American Art

Sharon F. Patton

Oxford New York

OXFORD UNIVERSITY PRESS

1998

Oxford University Press, Great Clarendon Street, Oxford OX2 6DP

Oxford New York

Athens Auckland Bangkok Bogota Bombay
Buenos Aires Calcutta Cape Town Dar es Salaam
Delhi Florence Hong Kong Istanbul Karachi
Kuala Lumpur Madras Madrid Melbourne
Mexico City Nairobi Paris Singapore
Taipei Tokyo Toronto

and associated companies in Berlin Ibadan

Oxford is a trade mark of Oxford University Press

© Sharon F. Patton 1998

First published 1998 by Oxford University Press

British Library Cataloguing in Publication Data
Data available

Library of Congress Cataloging in Publication Data
Data available
0–19–284213–7 Pbk
0–19–284254–4 Hb

10 9 8 7 6 5 4 3 2 1

Picture Research by Elisabeth Agate with Lisa Luedtke
Designed by Esterson Lackersteen
Printed in Hong Kong
on acid-free paper by
C&C Offset Printing Co., Ltd

In Memory of
My Mother, Audrey Overton Patton (née Hill)
and My Father, Joseph Chauncey Patton

Contents

Introduction

As I was preparing this manuscript, I recalled my first teaching appointment at Minnesota, when an African-American artist, a ceramicist named William Artis, suggested I teach an African-American art history course. I was perplexed; as far as I knew, there were only a few black artists, most of whom were contemporaries. Why was this? My art history course had made no mention of black artists, and I considered naïvely that I was pretty well familiar with American art, especially modern American art. All of us young black art historians at mainstream universities were studying everything except black (including African) art. Students take their lead from their professors, and I was no exception. Artis, somewhat incredulous, advised me to read James Porter, *Modern Negro Art* (1943). Fortunately, it was reprinted in 1969, just as I began to investigate this black art history, and when black cultural awareness was developing nationally. Only after I had become a bit better informed did I realize that Artis (1914–77) had been a student of Augusta Savage (1892–1962) at the Harlem Community Art Center, and had exhibited in the renowned Harmon Foundation shows in the 1930s.

The author of *Modern Negro Art* was an art historian and professor at Howard University (Washington, DC) whose book became the first basic text on the subject. Writing about biography, career, styles and influences, he followed the classic format of American art history, which until *c.* 1975 was strongly documentary. This monograph approach, typical of American art scholarship, had little to do with iconography, patronage and art criticism. Not until 1973, when Elsa Honig Fine published *The Afro-American Artist*, was there any similarly useful reference for periods after 1940. Her method of introducing each period with a summary of white American artists and movements and their European counterparts or antecedents implied standards of quality and connoisseurship and a pedigree to which we could compare African-American art. Such comparisons were not actually made, although artistic influences (usually, and not unexpectedly for American artists, European) were cited if they were acknowledged by the artists under discussion. There had been earlier publications, such as Alain Locke's *The Negro in Art* (1940) and Cedric Dover's

Modern Negro Art (1960), but these were essays, commenting on art or on the depiction of the black image in Western art. After 1973, Samella Lewis, with *Art: African-American* (1978), reissued as *African-American Art and Artists* (1990), and David C. Driskell, with *Two Centuries of Black American Art* (1976), have begun to fill the gaps and to include art criticism and patronage.

In the course of my inquiries I soon discovered that there is an alternative academy, a network of researchers in the black community. Research on African-American art has been ongoing, virtually unnoticed by scholars in academia. These part-time researchers have provided me with information about contemporary art, often from a more centred African-American viewpoint, and have confirmed that art always represents the culture and society from which it emerges. Furthermore, these 'invisible' art historians do not respect the conventional distinction between high and low art, with its implied qualitative significance. In other words, they see quilts, ceramics, folk art, as no less worthy enterprises than marble statuary, Palladian architecture or oil painting. To them, my thanks. Some of the information that I have learned from them is included in this text, which begins in the mid-seventeenth century and ends in the opening years of this decade.

In the 1970s the conjunction of postmodernism with the discipline of art history had its effect on the study of African-American, as it did too on American art in general. The recent development of literary and critical theories has made historians of modern American art look at all types of artistic production, and how art represents history, culture and society—a revisiting of Arnold Hauser's *Social History of Art* (1957–8) and Erwin Panofsky's *Iconography and Iconology* (1939). They have taken a more cosmopolitan and nuanced interpretation than before, focusing especially on critical and popular reception, and the participation of non-white and women artists. Coincidentally, many more African-American women have had access to training and new technologies, embarking upon successful art careers. That this text evidences more women artists after 1980 is not happenstance.

My book, then, has been written in the context of these circumstances. It does not follow the traditional histories of American art by John Wilmerding, Barbara Rose or Wayne Craven. There are chronological gaps; the history about African-American art is as yet incomplete. As to my approach, I decided to avoid a litany of art genres and artists' biographies and styles and focus instead on themes, attempting to synthesize detailed interpretations of individual works with concerns for social and cultural analysis, i.e. make what postmodernists call a close textual reading. Yet at the same time I organized the material within broad chronologies. Biography and art styles have been thoroughly covered in exhibition catalogues, monographs and the current art history texts on black American art. The theme approach became a

useful way to organize material, especially with the period after 1913, when the proliferation of practitioners and of documentation would have made it impossible to cover every individual artist. Because of this abundance, already familiar artists and regions, e.g. Texas, have been excluded from discussion. My objective was to make particular 'points' in the most efficient manner, highlighting trends and notable exceptions, even into the late modern period (i.e. after 1975) while foregrounding the work of art. Unfortunately my coverage of architecture and my noble intentions to discuss photography, ceramics, glass, and textiles in the twentieth century have fallen prey to editorial considerations. My apologies to those artists and architects, several of whom are friends. To them I say, 'Next time …'.

The most threadbare section is still the history of the eighteenth and early nineteenth centuries. Slavery is the main reason for the paucity of information about art and artefacts of these years. For the 'voice' of the black artisan or artist is heard mostly in the narratives and records of slave-owners, who, for all practical purposes, observed nothing extraordinary or anything remotely indicative of cultural production. None the less, evidence, beginning with Porter's, has been produced to show the presence of artisans and artists among African-American slaves. Approximately 30 years later, Driskell added considerably to this art history of slavery, particularly to the history of architecture. Around the same time African-American studies in the field of historical archaeology followed the lead of historians, who, within the past 25 years have started to direct their attention to slaves' lives. The participation of free African Americans, though, has been neglected and their contribution needs study. What we have learned so far about black slaves and free blacks should be credited largely to those political activists of the 1970s who demanded that we look at the records, written and archaeological, to revise our assumptions that there were no black artisans or artists. However, the volume of the scholarly literature of the eighteenth and early nineteenth centuries far exceeds actual documented objects.

In looking at these early periods I have included a range of artistic genres in order to show the breadth of recent scholarship on eighteenth- and early nineteenth-century African-American art. Around 1980 newer evidence expanded our knowledge of slaves and free blacks as artists and artisans. The decorative arts, metalworking and furniture-making cited in household inventories and newspaper and city directory advertisements had for long been our only records, but within the past ten years or so actual signed pieces have started to come to light. Derrick Beard, founder of the Center for African-American Decorative Arts, has found furniture by Thomas Day (c. 1823–60) and Dutreuil Barjon (c. 1799–after 1854).

What has also become clear from these finds, from my own research

on cabinet-makers in New Orleans, and from recently published articles, is the central role of immigrants who came from Saint-Domingue (Haiti) to Charleston (South Carolina), New Orleans (Louisiana), and, in smaller numbers, to New York City. Their contribution warrants further research.

A younger generation of scholars, well equipped with postmodernist theories, is making significant contributions to the history of African-American fine artists of the nineteenth century. Their investigation of issues of race, class, gender and sexuality has expanded upon the earlier information on biography and style to provide a rich text about the possible meanings of African-American art and the relationship between culture, society and production. It is in this context that this book has been written, and the work is organized as follows.

Chapters 1 and 2 show firstly that slavery and racism did not prevent African Americans from making art, and secondly that there were two concurrent productions by the mid-nineteenth century: folk and fine art. For example, at the same time as black slaves were making decorative ironwork in Texas, Louisiana, and South Carolina, 'Dave' (see p. 64) was making large storage jars inscribed with couplets, and anonymous slaves were making face vessels, Patrick H. Reason (1817–98) was engraving abolitionist portraits, and Robert S. Duncanson (1821–72) was establishing national and international fame as a landscape painter. I wanted to correct the current suggestion in texts on black art in America that crafts and decorative arts *preceded* fine art-making. In Chapters 1 and 2, I devote attention to architecture, especially that of Louisiana. By exploring, for example, the building of New Orleans from the early to mid-nineteenth century, I wish to show that there is an architectural history that reflects class and different types and histories of black culture.

One theme was followed through into Chapters 3 and 4: the contribution of folk artists. Although only one or two are represented, I felt that they should be included to keep the reader aware of parallel artistic productions: of folk and fine art. For example, the making of quilts remained quite vigorous. In the 1990s the work of Horace Pippin (1888–1946), Thorton Dial (b. 1928), Bill Traylor (1854–1947), Bessie Harvey (1929–94), Joseph Yoakum (1886–1972), Elijah Pierce (1892–1984), and countless other folk artists has been featured in solo exhibitions and individual monographs as part of the renewed popularity of American folk art in the United States. The idea that folk art represents the community and fine art does not is contradicted by artists' collectives like AfriCobra (see p. 215), by the presence of James Hampton (1909–64) or Minnie Evans (1892–1987), whose idiosyncratic nature does not necessarily make them 'folk'. That fine art is characterized by illusionism, finished surfaces, valuable materials and acknowledgment of previous art, and folk art is not, is contradicted by the

confluence of folk art quilters and fine artists Alvin Loving (b. 1935) or Faith Ringgold (b. 1934), or the use of folk culture and techniques by fine artists Alison Saar (b. 1956) and Willie Birch (b. 1942). Contemporary scholarship accepts what post-World War II African-American artists have been doing for some time: ignoring academic distinctions under the rubric of art.

I shall avoid the polemics about what constitutes art, but suffice it to say that we should not consider one artistic enterprise or genre of less value than another. Different kinds of art are examined in Chapters 1 and 2, at least to get the reader thinking about where art can be found. In Chapters 3 and 4 I rely on traditional categories: painting, graphic arts, and sculpture. Also in these two chapters, whenever possible, I include comments by the artists. They reveal the artist's intent and their response to art criticism, as well as providing for the reader an opportunity to formulate personal ideas about modernism and late modernism and African-American culture.

The book shows that African-American artists may sometimes reflect mainstream American art but at other times veer from it. In that divergence we see styles, aesthetics, and meaning that are characteristically African (and sometimes North American Indian). Particular individual works have been illustrated to demonstrate such similarities and dissimilarities. The reader is cautioned, however, not to construe these representative works as necessarily the best or only style of art in an artist's career.

My exposition is indebted to postmodernist, feminist, and Afrocentrist interpretations, acknowledging that the appreciation of art is both an aesthetic and an intellectual experience. Theories and new analytical methods from disciplines other than art history have helped indicate how artists might have been understood in their own time; and how our present understanding of a work's social and cultural significance can be expanded beyond the interpretation that was available to its creator. This is particularly the case for art made during the antebellum period and shortly thereafter (see Chapter 2). Throughout I have attempted to strike a balance between discussions of theory, practice, and style.

One final brief note. Readers will notice different terms are used to denote African descendants in North America. Each represents a particular historical moment, and indicates how black Americans were viewed and how they viewed themselves. In the eighteenth century the term 'African' indicated a racial nationalism which disappeared when the wish for repatriation to Africa shifted into a desire to be accepted as an American citizen. By the mid-nineteenth century, the terms 'coloured people' and 'Negro' were preferred; and by the late nineteenth century, 'Negro'. Heated debates ensued about what term appropriately showed allegiances to black nationalism and the civil

rights movements of the 1960s: 'Negro', 'Black', 'Afro-American'? What you called yourself reflected your political views and sympathies. The term 'Negro' was used disparagingly. In the context of the cultural avant-garde, the chosen term was 'Afro-American', which quickly became 'African American' and 'Black American'. Then, as now, this usage provided a way of recognizing the African along with the European heritage.

Lastly, I hope that readers will not only learn about black people as artists, but also the ways in which art manifests the cultural diversity that is part of belonging to the African diaspora. I should like the book to give you an experience of someone looking through a keyhole, catching a glimpse that stimulates you to open the door and enter into the world of African-American art.

Colonial America and the Young Republic 1700–1820

1

Introduction

When John Hawkins returned to England in 1562 with several hundred slaves captured in a buccaneering raid on the Spanish Main, Queen Elizabeth pronounced the deed 'detestable' and predicted that it would 'call down vengeance from heaven upon the undertakers of it'. But when the profits which such ventures would bring were pointed out, she demurred in further opposition. Nonetheless, the English were of no significance in the Atlantic slave trade until almost a century later.[1]

Slavery was crucial to the formation not only of African-American identity, but of American identity, shaping the lives of white as well as black Americans, and providing the context in which the nation's economy, politics and society developed. The pattern of slavery in North America depended on a variety of factors: cultivation of particular crops, the size of the slave-holding unit, the local density of black and white populations, and the laws of the colony and, later, of the state.

In British North American mainland colonies, slaves were chattels whose status after 1660 was in perpetuity and hereditary. Within 40 years, African slave labour became more available and less expensive due to increased English involvement in the African slave trade. From the mid-seventeenth to the end of the eighteenth century, slavery expanded westward from the Chesapeake tidewater regions of Virginia and Maryland, and coastal South Carolina and North Carolina to the Piedmont (North Carolina and inland Virginia), and southward towards the low country of South Carolina, and across the lower South (Georgia, Alabama, Mississippi).

The transatlantic trade in African slaves had originated in European overseas expansion in the period 1400–1700, when voyages to Africa, Asia, and the Americas were revealing lucrative new re-

sources of land and materials. The Europeans were first attracted to Africa by the presence of gold, a material essential for the new developments in European currencies and trade. As early as the 1480s they had also discovered the highly profitable trade in African slaves, who were either bought or captured to provide cheap labour to support European expansion into the Americas. Over a period of 400 years approximately 12 million Africans were shipped from the African coast to the 'New World' of the Americas, a route known as the Middle Passage, with the heaviest trade taking place from *c*. 1650 to 1850. The earliest record of slaves being brought into the British mainland colonies is in 1619. In August of that year, John Rolfe, a tobacco planter, noted in a letter to Sir Edwin Sandys, treasurer of the Virginia Company of London, which intended 'to plant an English nation', that a Dutch man-of-war had arrived at the English settlement at Point Comfort, Virginia, and 'brought not any thing but 20 and odd Negroes, which the Governor and Cape marchant bought for victualles'.

Europe set its stakes on the profitability of North American raw materials and goods produced by cheap labour. European chartered trading companies, such as the Royal African Company (England), the Dutch West India Company, and the Company of the West (France) actively engaged in slave trading, and the English also brought existing African slaves from the Caribbean into the major slave port of Charleston, South Carolina, and the wharves along Chesapeake Bay, and later to the northeastern ports, such as Boston, Rhode Island, and Philadelphia. Every colony had slaves, but slavery's principal foothold remained in the southern staple-producing colonies.

The largest number of African-born slaves arrived in the mid-eighteenth century at the same time that native-born African Americans were reproducing an African-American culture. By the time of the American Revolution, slavery was firmly rooted in British North America, where half a million blacks were living amongst a population of two and a half million British colonialists.

There were also free blacks living in the colonies, but very few, comprising roughly four per cent of the black population. From around 1660 they began to earn money, and accumulate property. Most free blacks were mulattos (i.e. of mixed parentage and fair-skinned); very

few were full-blooded blacks (African or African-Caribbean).

The fight for independence 1775–83

British North America's thirteen mainland colonies: Massachusetts, New Hampshire, Rhode Island, Connecticut, New York, New Jersey, Pennsylvania, Delaware, Maryland, Virginia, North Carolina, South Carolina and Georgia, joined together with the aim of becoming independent from Great Britain. An estimated 5000 Africans and African Americans fought alongside whites in the War of Independence (1775–83).

The young Republic (1776–1820), founded on the principles of liberty, relied upon the prosperity of slavery, and so, protected by the 1787 Constitution, slavery continued. Once the Revolutionary War was over the importation of slaves was revived, with South Carolina and Georgia in particular making enormous purchases before the trade was abolished by law on 1 January 1808. Even then an illegal trade continued, and about 40,000 more Africans were brought to the United States between 1808 and 1861.

In the Federal period (1780–1830), too, slavery began to decline in the Northeast, with individual state manumission laws allowing for gradual emancipation. Anti-slavery proponents, mostly Quakers (the Society of Friends), argued that slavery contradicted the basic tenets of republican ideology and enlightenment, i.e. the rights of man, and—most important—violated the law of God. The developing industries, factories, and farms in the Northeast did not require the great number of slaves that were needed in the South for crop production and harvesting.

After the Revolution there were more free blacks, comprising approximately nine per cent of the black population. The newly emancipated blacks, many of them dark-skinned, were referred to as freed blacks. They acquired their freedom either through escape, manumission by will or, later, state decree or self-purchase. Some had immigrated from Europe or the Caribbean. A special group from Haiti and Cuba, called the 'free people of colour', usually mulattos, had immigrated to New Orleans and Charleston because of the revolutionary struggles in the 1790s in Saint-Domingue (Haiti). They established an élite class in both these mercantile southern cities and were often successful tradesmen or artisans. Some entered into the planter class. Because of the relative anonymity of urban life, which provided a certain measure of liberty, free blacks mostly gravitated towards cities and towns. In the Northeast free blacks outnumbered slaves, whereas in the South the opposite was overwhelmingly the case. Consequently slavery began to be regional, so that by the beginning of the nineteenth century there were 'free' states (in the North) and 'slave' states (in the South).

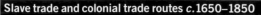

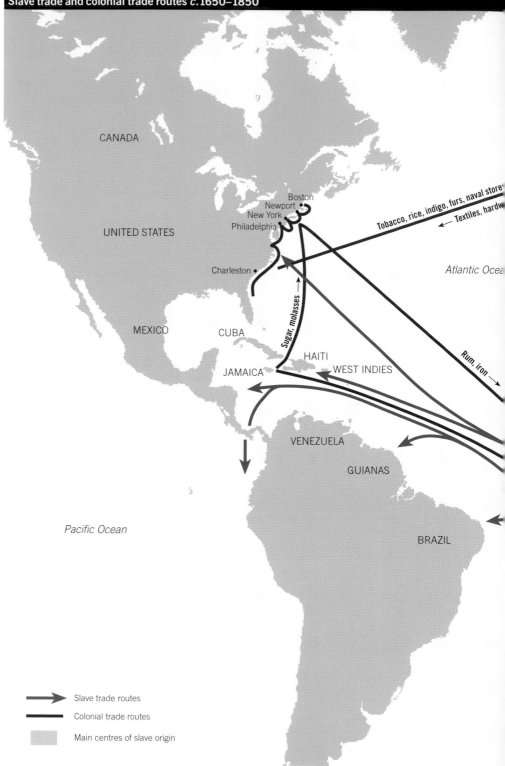

CANADA

UNITED STATES

Boston
Newport
New York
Philadelphia

Charleston

MEXICO

CUBA

HAITI

JAMAICA

WEST INDIES

VENEZUELA

GUIANAS

BRAZIL

Pacific Ocean

Atlantic Ocea

Tobacco, rice, indigo, furs, naval store ← Textiles, hardw

Sugar, molasses

Rum, iron →

→ Slave trade routes

— Colonial trade routes

Main centres of slave origin

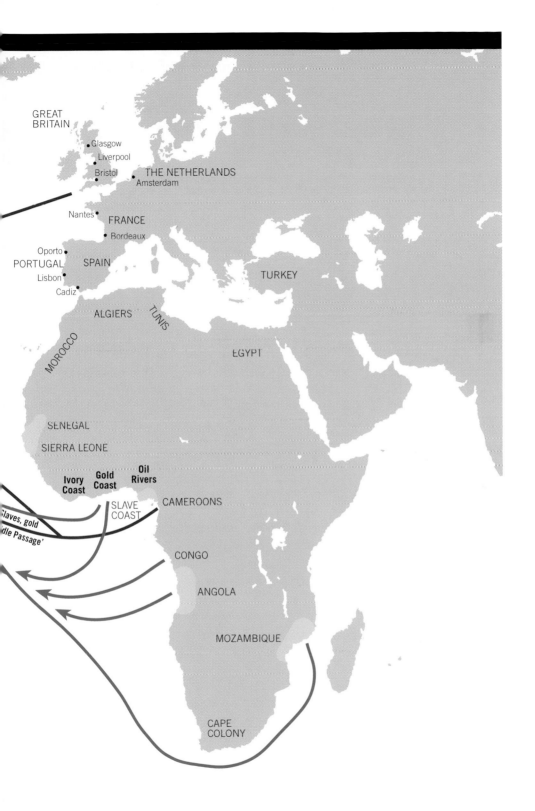

GREAT
BRITAIN
• Glasgow
• Liverpool
• Bristol
THE NETHERLANDS
• Amsterdam
Nantes •
FRANCE
• Bordeaux
Oporto •
PORTUGAL
SPAIN
Lisbon •
• Cadiz
ALGIERS
TUNIS
MOROCCO
TURKEY
EGYPT
SENEGAL
SIERRA LEONE
Ivory
Coast
Gold
Coast
Oil
Rivers
SLAVE
COAST
CAMEROONS
Slaves, gold
dle Passage'
CONGO
ANGOLA
MOZAMBIQUE
CAPE
COLONY

Increasing conflict between the thirteen colonies and Great Britain, primarily over Britain's attempts to regulate colonial commerce, led to the American Revolution (1775–83) and the Declaration of Independence (1776) in which the colonies declared themselves a Republic (1776–85). The United States as a nation was created with the Treaty of Paris (1783), and governed under the articles of the Confederation until, during the Federal period (1780–1830), a stronger national government was instituted in the Constitution (1787). The Constitution, while it declared the inalienable rights of its citizens, recognized and protected slavery. Federal acts, called Fugitive Laws, provided return between states of escaped black slaves. In 1800, the United States was a young federation; each state was a single political unit and society and equal to every other state.

Beginning in colonial times, there was a series of conflicts between white settlers and North American Indians, called Indian Wars. After 1815, the United States government began removing Indians to reservations west of the Mississippi River. The relationship between Africans and African Americans, slave and free, and North American Indians varied: sometimes it was one of animosity, sometimes of friendship and alliance against whites, with inter-marriage and borrowing from one another's culture.

Africa, North America and African-American culture

Twentieth-century diffusionist theories about continuity of African culture and the process of cultural change among Africans and their descendants dispersed in the Americas (a dispersal called the African diaspora) aimed to establish a legitimate basis of African culture and to explain its role in the evolution of African-American customs and beliefs (Africanism). For many decades it was presumed that slavery had erased all memories of African culture, and that slaves looked to their masters for ideas and models of material culture. In the last 30 years scholars have reconsidered these views, including one held by cultural anthropologist Melville Herskovits who, despite having invented the term 'Africanism' in *The Myth of the Negro Past* (1943), felt there was little, if any, evidence of African culture in the visual arts.

Africanism, with regard to type and degree, is a matter of syncretism (traditions merged but still discernible) and acculturation (gradual but complete cultural transformation). It involves not only recognizing preserved traits or the design and shape of objects—as, for example, the Kongo (Central Africa) symbol impressed on the bottoms of African-American/Indian earthenware (see pp. 38-40)—but also recognizing cultural and social practices within everyday experience. For example, the slave earthen houses at the eighteenth-century Kingsmill plantation in Virginia, which were discovered and excavated by the archaeologist William H. Kelso, appear very similar to those of early European settlers. They were, in fact, altered to suit the specific way of life and social view of Africans, having, for instance, smaller interior spaces, and a different use of landscape space. Today the term syncretism, which refers to the merging of *two* cultures, has been re-

placed by creolization: the merging of *two or more* cultures—English, Spanish, French, African, American Indian.

Plantations

The majority of Africans and African Americans were slaves labouring on plantations in the South. Slaves' value as labour underpinned mercantilism in the American colonies, offsetting the negative effects of the English commercial system, which generally led to colonial debt and bankruptcy. Slavery was instrumental in the development of southern colonies and greatly facilitated the Republic's self-sufficiency after the War of Independence.

Most planters had modest-sized houses, especially in the early colonial period, *c.* 1620–70, when their homes were not much larger than those of their overseers and slaves, and were often of the same design and materials.

By the late seventeenth century a small group of well-off planters was able to assemble large land holdings. Their exceptional scale and spatial layout made them so impressive that, by the middle of the eighteenth century, the definition of 'plantation' referred to these and not to the earlier and typically smaller plantation. Yet only about 27 per cent of the planters had holdings comprising thousands of acres and owned over 200 slaves. Among them was George Washington, who, in 1786, shortly before his election as President of the United States, owned 8000 acres and 216 slaves on the Mount Vernon plantation in Virginia.

As slavery increased, so did the status difference between white and

Plantations

A plantation refers to an agricultural, labour-intensive enterprise in which a number of workers (whites and slaves) work together to produce a crop for someone else, who will sell it on the (usually international) market. Plantations resembled and functioned as self-sufficient industrial villages. Specific colonies and plantations specialized in particular crops: tobacco in the tidewater areas of Virginia and Maryland; rice in the subtropical lowlands, called the low country, of South Carolina and Georgia, indigo and sugar in French (later Spanish) Louisiana colony. Cotton eventually became the main crop in the South: South Carolina, Georgia, Alabama, Mississippi River Valley and Texas became known as the 'cotton belt'.

1 Mansion
2 Slave huts

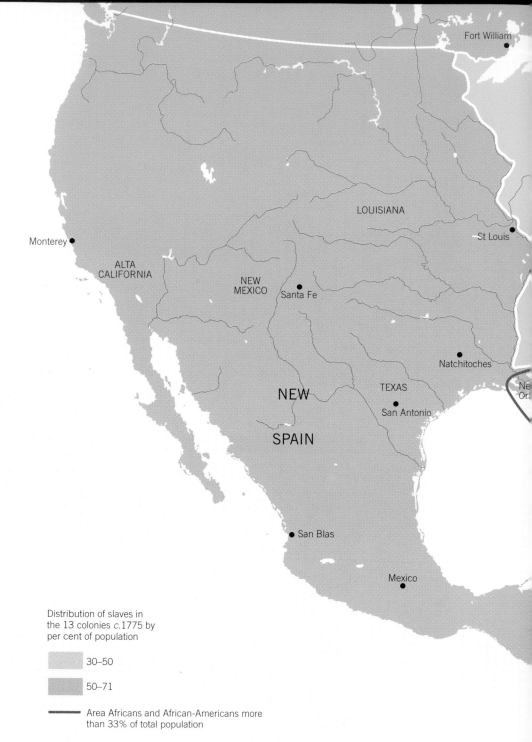

Fort William

LOUISIANA

Monterey

St Louis

ALTA
CALIFORNIA

NEW
MEXICO

Santa Fe

Natchitoches

NEW

TEXAS

New
Or.

San Antonio

SPAIN

San Blas

Mexico

Distribution of slaves in
the 13 colonies *c.*1775 by
per cent of population

30–50

50–71

Area Africans and African-Americans more
than 33% of total population

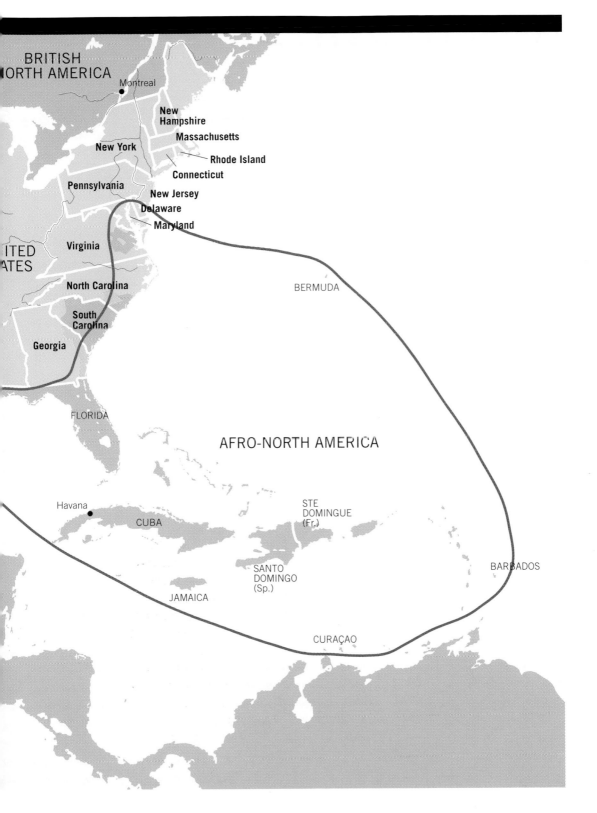

BRITISH
NORTH AMERICA

Montreal

New
Hampshire

Massachusetts

New York

Rhode Island

Connecticut

Pennsylvania

New Jersey

Delaware

Maryland

UNITED
STATES

Virginia

North Carolina

South
Carolina

Georgia

BERMUDA

FLORIDA

AFRO-NORTH AMERICA

Havana

CUBA

STE
DOMINGUE
(Fr.)

BARBADOS

SANTO
DOMINGO
(Sp.)

JAMAICA

CURAÇAO

black, house and field slave, between master and labourer. By 1770 class and racial differences were more clearly defined through architectural design and scale. The largest estates in the eighteenth century were mostly concentrated in three areas of the United States: the coastal region from Chesapeake Bay to northern Florida; the cotton lands from the mid-portions of South Carolina, Georgia and Alabama to eastern Mississippi and the lower Mississippi Valley; and from just north of Memphis to south of New Orleans.

Architecture and the plantation layout
Plantation architectural plans and their representation of social status varied according to size and location, but there was little difference in the general plantation landscape and architectural model. Typically, the main house was centrally located and the slave quarter was peripheral, the houses either clustered or in a linear scheme. This dramatic hierarchical symbolism was most evident in large plantation estates. The arrangement, rather than scale, of building types provided the key indication of social status. Eventually the main country house became a larger, more architecturally elaborate structure. The grand plantation estates in the tidewater and low country regions exuded Georgian taste and deliberately mirrored the aristocratic estates of England; typically, the planter was considered a prominent gentleman. The slave-owners' and plantation managers' descriptions have dominated and shaped our perceptions of slaves' lives for decades. We must now rely upon archaeology. By examining architecture and artefacts we can see how slaves sustained their cultural affinities with Africa while developing African-American culture within a rigidly structured environment— in other words, how cultural subversion and resistance were achieved.

Slave houses
Slaves arrived equipped with the conceptual and technological skills required to build their own houses. In the colonial period, there is evidence of African continuities in the exterior, in the construction and types of materials, and in what is deemed appropriate space. Gradually the process of syncretism altered the exterior appearance, but not the preference for small spaces and how space was used. Slaves built their own individual houses from materials provided by the plantation or scavenged from the natural settings. Relying on accounts by ex-slaves and slave-owners, a few American paintings and drawings, and archaeological excavations which have occurred most intensely on the coastal areas of the Southeast, architectural and cultural historians have reconstructed the appearance of early slave houses. Those built between c. 1650 and 1700 resembled houses in West and Central Africa. They had floors of beaten dirt called *pisé*, thatched reed or palmetto leaf roofs, wattle-and-daub, tabby, or clay-wall construction.

Slaves, either captured or purchased, were brought primarily from West and Central Africa by the British, French, Dutch, Spanish and Portuguese. They could obtain freedom by escaping, by self-purchase, or by testamentary manumission. A loosely organized system for helping fugitive slaves escape to Canada or areas of safety in free states, called the Underground Railroad, was active in the nineteenth century.

Just after 1619, free blacks migrated from Europe to North America for the same reasons as whites, and some arrived as indentured servants and obtained their freedom by means of contractual agreement, or were freed by their owners. Between 1791 and 1804, the slave revolts in Saint-Domingue (now Haiti), and later migrations from Santiago de Cuba in 1809, as a consequence of France's occupation of Spain, caused whites and mulattos, referred to as 'gens de couleur libre' (free people of colour) to migrate primarily to Louisiana and South Carolina. They comprised a separate social and economic class among the freed blacks (usually Africans or first generation African Americans) in the lower South. Another term for people of African descent, creole, is found mostly in Louisiana, which had a large emigré group from Haiti. Creole, especially used after 1860, also denotes French or Spanish born in America.

Beginning with the efforts of The Society of Friends (Quakers) in 1688, there was growing agitation for abolishing slavery in the Northeast. Several states passed laws abolishing slavery, for example, Vermont in 1777, or permitted gradual emancipation, such as Pennsylvania in 1780 or New York in 1799. Free blacks established mutual benefit societies in the North, such as the African Union Society (1780, Newport, Rhode Island) or the African Society (1796, Boston) for the purpose of strengthening the black community and advocating the abolishment of slavery.

Individual houses were approximately 10 or 12 feet (3–4 m) square, which made them appear not unlike peasant cottages in the British Isles. Consequently, newly arrived planters saw nothing unusual, and African-style slave houses were to stand for at least a generation.

Gradually variations in style developed through the adoption and adaptation of European features. Hewn logs, timber frames, brick and mortar began to be used, chimneys were introduced, plans such as the 'dogtrot cabin' (two basic square rooms with a breezeway between them) and two-storey elevations made an appearance later in the republican period. Planters wanted to impose their cultural values, which could be most easily achieved in architecture, and which represented slave-holders' visible authority over slaves. However, the architectural landscape of slaves covertly subverted this authority. Slaves on plantations and farms lived in relative isolation from European-American society, as in South Carolina where one European noted at mid-century:

They are as 'twere a Nation within a Nation, in all Country Settlements, they live in Contiguous houses, and often 2, 3, and 4 families of them in one house. Slightly partitioned into so many apartments, they labour together and converse almost wholly among themselves.[2]

What remained was an African and African-American preference for small square rooms, which should be seen as a subtle, but important, means of cultural preservation.

The revival of African culture on the plantations

The coastal strip from Charleston, South Carolina, to the St Johns River in northern Florida is often considered by historians as the northernmost extension of the West Indies (see map, p.26–7). The first permanent English settlers came from Barbados in 1670, bringing with them their slaves and expecting to build a plantation colony in South Carolina. Planters soon turned to rice, which African slaves knew how to grow and harvest. By 1708 blacks made up 50 per cent of the population; and by 1730, there were an estimated 30,000 settlers of whom 20,000 were blacks. A Swiss newcomer named Samuel Dyssle remarked in 1737 that Carolina 'looks more like a negro country than a country settled by white people'. South Carolina's black culture, initially West Indian and, later, after 1730, mostly from Angola (Central Africa) was more African than that of any other colony in British North America. Furthermore, the illegal trade in slaves continued the infusion of African culture into the low country.

Life on the plantations

African culture gradually re-emerged in South Carolina, for instance on the Curriboo plantation, which was established in 1740 by French Huguenots on the Santee River, approximately 70 miles (112 km) north of Charleston, South Carolina. In 1983, two archaeologists, Thomas R. Wharton and Patrick H. Garrow, discovered slave houses dating from the mid-1700s which were narrow, rectangular, single- and double-unit buildings without chimneys. First, they were built by digging trenches into the ground to hold the foundations, then courses of clay reinforced with upright posts were laid in the bottom of the trenches and built up to the desired wall height. This form of construction was called cob-walling. Alternatively, they may have been constructed of upright posts woven with sticks or wattles and packed with clay, called wattle-and-daub. The narrowly spaced walls are presumed to have

Diagram (reconstruction) of slave house at Curriboo plantation.

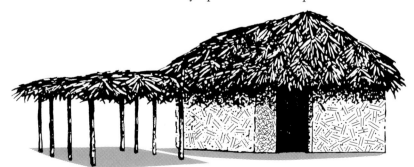

supported steep roofs with either gabled or hipped ends, covered by bark, splint planks or, probably, thatching. Palmetto fronds were still being used for roof thatching in this region well into the twentieth century. Cob-walling and wattle-and-daub construction, materials and plans seen at Curriboo have been found in slave houses in Jamaica, Haiti, and Barbados, and in the rainforest and savannah regions of West and Central Africa.

At the Curriboo plantation, hearths and fireplaces were outside houses, as they are in many West and Central African compounds or living quarters, with activities, including cooking, taking place outside. The small spaces of slaves' houses excavated here and on other seventeenth- and eighteenth-century southern plantations measure, on average, around 12 feet (3.6 m) square or 12 × 14 feet (3.6 × 4.26 m), duplicating African domestic architectural plans and showing a preference for small, dark, enclosed spaces.

It may have seemed to the slave-master that his logical, spatially ordered world of domesticity and entrepreneurship was an ideal representation of race and class, with the slaves' servitude and lowly status as property duly recognized. Unwittingly, however, the slave-master was, in fact, reinforcing a cultural landscape that was familiar to his slaves.

Planters bought more Africans than did town and city dwellers. Small or large and isolated community settlements allowed slaves to recreate the African past and produce a dominant African culture, as seen in South Carolina. During the late seventeenth and the eighteenth century, African and African-Caribbean slaves created a distinctive subculture in America, an African-American way of life in the shadow of the slave-master. This social and cultural world went unnoticed by slave-masters: a black world that whites rarely penetrated. From dusk to dawn, on holidays and the Sabbath, there was no work and slaves were on their own. Slaves also had relative autonomy in and around their cabins, and in their gardens. It did not go unnoticed. As one rice planter in the Carolinas asserted in 1828: 'We lose sight of them till next day. Their morals and manners are in their own keeping.' And another planter in Mississippi reported, with a discernible measure of dismay, that his slaves took pride in crops and livestock produced on his estate as *theirs*. The countryside as well as the slave house formed a relative shelter for the slaves' daily cultural landscape. Slave life contained the key elements of the African cultural past: cooking and eating one-pot meals, speech, oral traditions and folklore, dances and ceremonies (practised secretly in the woods), and making art.

As one former slave, Ben Sullivan, living on St Simon's Island (off Georgia), remembered:

Now, old man Dembo, he used to beat the drum to the funeral, but Mr [James] Couper, he said stop that. He said he don't want drums beating round

the dead. But I watch them have a funeral. I get behind the bush and hide and watch and see what they does. They go in a long procession to the burying ground and they beat the drums 'long the way and they submit the body to the ground. They dance round in a ring and they motion with the hands.[3]

New European-American influences

From around the time of the Revolutionary War, there remains evidence of slow and selective acculturation. The effects of European-American building practices on slave houses were evidenced in the two indigo plantations in Berkeley County, South Carolina: Curriboo (1740–1800) and its sister Yaughan (1740–1820). European-American artefacts made from durable materials (clay, glass, metal) outnumbered African and African-American artefacts, usually made of perishable materials (plant fibre and animal hide, wood). European post-constructed frame houses appeared, and excavations have revealed iron nails and small amounts of window glass (*c.* 1775). Significantly, hearths were moved indoors, and eventually replaced by stick and clay chimneys.

The demography of the Carolinas and of all the colonies, whether rural or urban, gradually changed. Slaves had more contact with Europeans and European Americans because of the increasing immigration of whites, mostly from Great Britain, some from France and the Caribbean. In smaller slave communities, particularly those near urban centres like Williamsburg, Virginia, the process of acculturation happened more rapidly than in the outlying rural areas, because the ratio of the white population increased to that of blacks.

Slave-holders insisted on housing slaves in English-, and, later (*c.* 1720–70), American-style structures because they accorded with their estate plans, and because slaves were their moral responsibility. A civilizing principle was operating here: European-American forms were equated with culture and civilization. The opportunity for the slave to articulate in three-dimensional form any reference to African antecedents was short-lived and generally thwarted. For no expressive form marks power and presence in a landscape more than architecture.

A planter's house in Louisiana

Marie Thérèse (1742–1816), a slave whose parents were born in Africa, established Yucca plantation (later renamed Melrose plantation by new owners in the 1870s) along the Cane River. Scholars have now confirmed the legend that her lover, Claude Thomas Pierre Metoyer, a Frenchman, in 1778 granted her 70 acres of land, on which Marie Thérèse soon established a tobacco and indigo plantation. By 1832, through Spanish land grants and subsequent purchases, the creole Metoyer family held over 10,000 acres of land and had the largest number of slaves owned by free blacks in the United States.

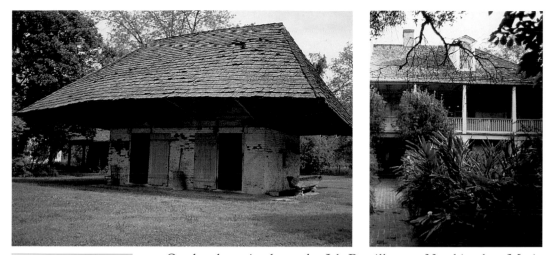

African house *c*.1798–1800
and Metoyer Mansion *c*.1830

The dramatic overhanging roof
design of the African house,
similar to those found in West
Africa, makes this a singularly
distinctive African-American
structure. Recently the roof
design has been considered
an amalgam of African and
rural French architectural
influences.

On the plantation located at Isle Breville, near Natchitoches, Marie
Thérèse built in *c*. 1798 one of the most distinctive architectural designs
in America: African House ⌊1⌋. It was a storehouse, in plan strongly re-
sembling a West African (savannah region) one-room plan granary
with steep roof, seen even today. How such a distinctive African-de-
signed structure came to exist in Louisiana is conjectural. Possibly
Marie Thérèse's parents, who, according to local legend, held on to
African customs, described such buildings. The rural region, and less
racially restrictive French–Spanish legal codes at least provided an op-
portunity for an 'experimental' structure to be built.

Slaves probably built African House using local materials: cypress
and palmetto from the yucca tree, found on the banks of the Cane
River. The type of construction was that used in early Louisiana
French creole homes, built by slaves for white planters in the area: at
ground level the construction is of whitewashed soft bricks, supported
on which is a loft made with timbers filled in with moss, mud, and deer
hair. The French call this *bousillage entre poteaux* (mud-walling be-
tween posts). At the half-storey (loft) large cypress beams abut the wall
and support an exceedingly large overhanging hipped roof. So far, no
other similar structure has been documented in Louisiana or the
South.

On the same plantation, two additional structures—homes—were
built, one during Marie Thérèse's lifetime. Yucca House, dating from
c. 1796–1800, is in the style of a rural colonial Louisiana home: one-
storey, mud-post construction, a chimney at each end, a rear gallery,
and a large hipped roof. Another larger house was built on the site in
c. 1830. This house style was that of a French creole planter's mansion,
common in the area, based upon a West Indian (French/African) in-
spired design, which could accommodate the hot, humid climate.
These one-and-a-half-storey mansions, which were in use until the
last quarter of the nineteenth century, have a wide, steep-pitched

(often dormer) roof, rooms opening on to the gallery with no interior hallway, a deep verandah, brick columns and a raised main floor (meaning the basement is at ground level with brick pillars). Seraphin Llorens (active 1830s and 1840s), a free man of colour and a carpenter–joiner from New Orleans, who settled at the Isle and married into the family, built the house for Louis Metoyer (1770–1832), the son of Marie Thérèse. Metoyer, who studied architecture in France, designed it.

The Metoyers' main house and plantation favourably impressed travellers. Historian and landscape architect Frederick Law Olmsted (1822–1903) recalled such comments as those of a steamboat captain: 'The plantations appeared no way different from the generality of those of white Creoles; and on some of them were large, handsome, and comfortable houses;'[4] and Olmsted acknowledged that the plantation house of a 'nearly full-blooded Negro' family (probably the Metoyers) in Louisiana was one of the best he had seen. African-American vernacular architecture was thus a product of various influences, an interactive sharing of diverse cultures which effectively met the demands of a particular environment and climate.

Plantation slave artists and craftsmen

TWENTY POUNDS REWARD
RAN away from the subscriber, on the 31st of May last, a very dark mulatto fellow names JAMES about five feet six or seven inches high, twenty-nine years old, square and strong made, sensible and well spoken, is as good a joiner as any in Virginia, at Coach, Phaeton or Chair work, is a good house joiner, carver, wheelwright and painter, and is a tolerable negro fiddler. Whoever delivers the said fellow to me, near Boyd's Hole, King George County, if taken out of this State, shall receive the above reward, but if taken in this State, shall be entitled to 12:1. (William Fitzhugh, *Virginia Gazette* 26 June 1784)

The history of black American artists and craftsmen (or artisans) in colonial times is brief and incomplete. Facts can be gleaned from written accounts, succession and judicial records, 'runaway' ads in regional newspapers, letters, and late eighteenth-century travellers' descriptions. Until recently African Americans wanted to 'shut out' the past because it was considered ignominious history. But new ways of thinking about art as cultural production have encouraged recognition of artefacts and crafts as art.

In general, evidence shows that there were slave artisans; and that they were of greater value than untrained slaves. They were much sought after and competed with free white labour, especially in towns and cities. Slaves brought with them from Africa knowledge and technology of metalwork, woodcarving, pottery and weaving. Some were identified as artisans on the slave ship manifest, indicating that they were very valuable on the market. Others were trained by white arti-

sans who lived in cities; or who, as itinerants, visited plantations. Sometimes skills were handed down in the family. An example is John Hemings (b. 1775), the son of Thomas Jefferson's slave, Elizabeth Hemings, and a white English carpenter, John Nelson. John Jr learnt his carpentry skills from his father, and became master carpenter and furniture-maker for the Jefferson household. Artisan slaves' lives were presumably less harsh than those of field slaves because slave-holders considered them an important investment. Some planters owned so many slave artisans that special workshops and outbuildings were erected for the establishment of mini-markets.

Among the highly valued slaves were male carpenters and carpenter–joiners and blacksmiths. They built the vast majority of plantation structures, especially the service buildings, often the main house, including the architectural ornamentation: fireplace mantel, window-frame mouldings and newel-posts. They provided decorative ironwork and puttywork classical motifs, plants or flower garlands, to adorn the fireplace mantels and ceiling borders.

2

Pieced quilt, late 18th century.

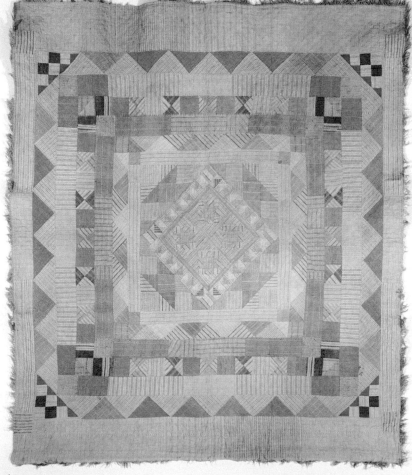

Textiles and patchwork quilts

RUN-AWAY from the Subscriber, at Ponpon, in the night of Tuesday the 24th of March last, a short, thick, likely, mustee wench, named ROSE, about 25 years of age, she has always been brought up to the house, and is a very good seamstress; she carried away with her several different suits of cloaths …
(Thomas Smith, *Charleston South-Carolina Gazette and Country Journal*, 9 June 1772)

Notices like the one above confirm that African and African-American women produced fabric and clothes, and that black women sometimes rebelled against their condition and fled, especially seamstresses and weavers whose skills provided them with a means to earn a livelihood after escape.

Nearly every plantation had a weaving room or shed where slaves were trained in spinning and weaving, lace-making, intricate needle-work and embroidery. Textiles were woven from silk (rarely), home-spun flax, wool and cotton, called 'Negro cloth', and osnaberg. Colours were obtained from local materials (trees, plants, flowers) and from dyes imported from South America, the West and East Indies, Mexico, and England. The product of female slave labour assured an income for the slave-holder that could offset the fluctuating income from cash crops. In some instances, the textiles were so highly regarded that slave-holders established successful weaving enterprises.

Not only did slave women weave and make clothes for their own and the planter's family, they also made bed coverlets and quilts for themselves and for slave-mistresses, who sometimes participated in the work.

Bed quilts were among the most valued household objects, but unfortunately most of the quilts made before 1775 have been lost. Those surviving are associated with wealthy slave-owning plantations. Fabric was very expensive before the Industrial Revolution (in the United States this occurred *c.* 1850) so every scrap was salvaged and recycled into patchwork, also called pieced, quilts.

The earliest dated slave-made quilt, a pieced quilt [2], from Beaver Dam plantation in Hanover County, Virginia, has a most unusual feature: bits of woven fabrics, instead of expensive imported printed textiles usually found on surviving late eighteenth-century patchwork quilts. Striped ticking, checks, plaids, and solids contrast with the block-printed textiles, creating a mosaic pattern of blue (the indigo blue colour now faded) and white colours. The quilt's design patterns, such as the eight-pointed stars in the diamond-shaped centre, display a skilled manipulation of triangle and square patches to create ingenious shapes. Black women adopted and adapted a popular European and European-American technique, transforming it into a remarkable folk idiom.

Folk art

Slave artisans also made well-crafted objects for their own use. The earliest dated artefacts of black folk culture were found on Virginia plantations. Two remarkable examples, a wrought-iron statue of a human figure, and a wooden drum, show a continuance of African cultural practices. Although one can only surmise the contextual use and meaning of these objects, they show incontestably that skilled slaves were brought to America and that the slave world retained a vestige of African culture.

The slave drum [3], acquired in 1645 from colonial Virginia by Sir Hans Sloane of London, is a replica of an Akan (West Africa) chief's drum, which would traditionally be displayed in a pair. It is an important instrument for dance, ritual and playing speech texts. This decorative object denotes the hand of a woodcarving specialist, who presumably had as high social status in the American slave community as he would have had in West Africa. Because the drum imitates the tones of African speech, white colonialists were wary of its potential to help stir up revolt among the slaves. Thus in many instances drums were prohibited. However, that drums were important culturally explains why slaves continued to use them in their new environments (see p. 31), making this drum highly significant as both artefact and art form.

In the savannah regions of West Africa blacksmiths made ritual objects of iron, in local village communities in Mali, in the Senegambian region, and northern regions of Burkino Faso (formerly Upper Volta), Côte d'Ivoire, and Ghana. There the blacksmith held the highest po-

3

Slave drum, *c.*1645.

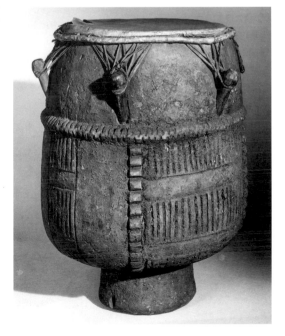

4

Wrought-iron figure, late 18th century.

Where this statuette was found—buried in the earthen floor at the site of a blacksmith shop and slave quarters in Alexandria, Virginia—suggests it may have had some ritual significance.

litical and spiritual authority. Slave records from ship cargo lists, auctions and runaway notices show that approximately 20 per cent of the Africans brought to America between 1650 and 1740 were Mande and Wolof peoples (Senegal–Gambia). Some of these slaves would have been blacksmiths, as evidenced, for example, by a wrought-iron figure [4], which was found buried in the earthen floor at the site of a blacksmith shop and slave quarters in Alexandria, Virginia. This location and the figure's formal similarities—simple, slightly undulating form—with ritual figurative iron statuettes among the Bamana (a member of the Mande peoples) in Mali, strongly suggest some similar spiritual significance for the American figure. Its actual meaning and purpose, however, remain a mystery.

Pottery

In the 1930s, archaeologists found undecorated fragments of unglazed, low-fired earthenware at slave sites at Colonial Williamsburg and nearby plantations in Virginia. Not until excavations at Kingsmill plantation, near Williamsburg in 1978 was there proof that such earthenware was made at plantations and by slaves. Some of the fragments were found by accident, such as the colonoware jug [5] retrieved from the Combahee River in front of Bluff plantation, South Carolina. The earliest pieces date from the 1670s, but most are from the early to mid- 1700s.

In 1978 Leland Ferguson proposed the currently accepted term 'colonoware', which acknowledged the mergence of two cultural traditions, North American Indian and African-American. Indians sold their coarse earthenware to whites, who, as well as using the wares, apportioned them to slaves. Possibly blacks also bought pieces. Definitely contact occurred between the blacks and Indians. As demand increased, slaves made pottery as they had in West and Central Africa, hand-building the pieces and stacking and firing them outdoors at low temperatures.

On some plantations, the earthenware was distinctly African: West African pottery forms with plain, curve-bottomed shallow bowls, and large and small globe-shaped jugs. Besides the form, another indication of African culture is given in the incised marks of crosses, sometimes enclosed in a circle or rectangle, on bowls found in river bottoms and slave-quarter sites in South Carolina. Quite possibly these marks —a circle or square inscribed with two criss-cross lines—are Kongo (Central Africa) symbols of the cosmos. These vessels may be ritual, used to propitiate water or ancestral spirits.

Although we have little knowledge of manufacture or distribution, we do know that the shape and duration of colonoware was affected by the type of slave society and the degree of contact with Europeans. On the urban Virginia site of Kingsmill plantation, where the second

Colonoware jug

Although most colonoware is undecorated, there are examples of incised or impressed linear decorations, as in this example, that create a weave-like texture to the rich brown coloured surface.

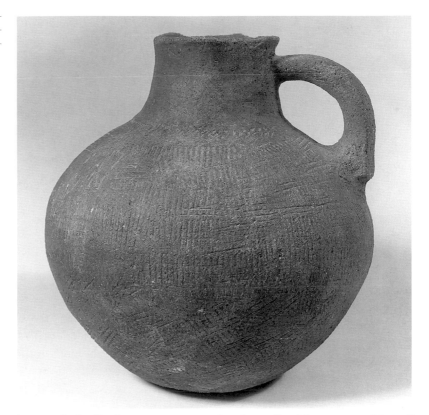

largest find of colonoware was made, slaves lived in communities of modest size and had extensive contact with European Americans. Soon European pottery forms and shapes were adopted: there are vessels with tripod legs, flat-bottomed bowls, plates, and chamber pots. The largest quantities of excavated colonoware have been produced in the South Carolina low country region. The isolated rural Yaughan and Curriboo plantations in South Carolina, where there were sizeable slave communities, have so far yielded the most colonoware in the state. Here slaves had minimal contact with whites. They had contact with Indians, but here a syncretic form emerged, African-Indian colonoware. So while slaves at Curriboo and Yaughan plantations adopted European-style houses (not necessarily out of choice), they held on to African pottery techniques and forms, which were very similar to those of the North American Indian.

By the mid- to late 1800s production of colonoware ceased. One reason for the popularity of colonoware in the colonial period, and its disappearance afterwards, is that initially the scarcity of European ceramics forced whites, including the planter class, and blacks to use local earthenware in which to prepare and—in the case of blacks—cook and serve their food. But when glazed and cheaper ceramics were imported from Great Britain, the need for locally produced African-Indian earthenware declined.

The pre-1978 term 'colono-Indian ware' reflected a mid-twentieth-century concept of a strictly segregated colonial experience: Indians made pottery and sold or traded it to white planters for their slaves. The more recent concept of colonoware accommodates the more complex process of colonial creolization, recognizing that demography and culture varied from place to place; that some Indians worked as slaves on plantations and some blacks lived in Indian villages, making for an active exchange of technology and aesthetics; and that this folk pottery used European, traditional Indian and African forms and designs.

Urban slave artists and craftsmen

White master artisans established their businesses in cities or towns. If they owned slaves they trained some or all of them in various profitable artisan skills: fine metal-working and cabinet-making. In urban, compared with rural areas, there were fewer slaves per owner. Some of the urban slave artisans belonged to planters who hired them out to work on a particular project or for a specific master artisan. In such an arrangement, slave-owners used slaves to earn income or to pay off the slave-holder's debt.

Slaves were important for the growth of urban industries which catered to local and increasingly diverse markets. For example, Philadelphia was famous throughout the eighteenth century for its red-bodied pottery called 'Philadelphia Earthenware'. From 1721 to 1774 some successful European-American potters, such as Richard Stanley (1730–1807), who had five slaves working at his business, exported their wares to colonies in New England and to the South.

As indicated by advertisements for runaway slaves, dating from 1698 to 1774, urban slave artisans were more likely than rural slaves to become masters in their trade. They could then earn money and purchase their freedom, or live independently either as a manumitted or as a fugitive slave. One slave in New Orleans, for example, named Jacoba—probably Jacob Bunel, goldsmith (active 1763–82)—was the slave of Jean-Baptiste Dominique Bunel, and was considered a 'master goldsmith'. He was called in for an appraisal for a succession inventory in the eighteenth century and was freed after his master's death in 1764 to continue his profession as a goldsmith.

Skilled slaves working in the city had an advantage over unskilled slaves. The competitive market for their wares, and the anonymity which a city provides, enabled a fugitive to exist and to blend with the free black population. John Frances, a goldsmith, is an example. He was the subject of an $8 reward for his capture, posted in the *Pennsylvania Packet* of 1 May 1784. Commonly called Jack, aged 40 and slave to Benjamin Halsted of New York City, he had been in the charge of and working for John Letelier, a white goldsmith in Pennsylvania, when he made his escape.

Although their numbers were modest, free African Americans also worked as artisans in cities, occasionally alongside slaves in artisan shops. At the end of the colonial period and afterwards, there was an increasing demand for skilled craftsmen and artisans who could make objects that represented the newly acquired tastes for European-designed furniture, and metalwork.

With only a few whites working as artisans, African and African-American slaves and free black artisans dominated the artisan professions. Economic growth at the turn of the century provided for free blacks professional opportunities and the development of a black middle class. Training was acquired either during the time of their enslavement or within the family. One family apprentice, for example, was Celestin Glapion (1784–1826), a carpenter–joiner, active between 1805 and 1823 in New Orleans, whose family continued the profession into the twentieth century. Not until after 1825 was black hegemony in artisanship in the United States, especially in the South, challenged by recent European immigrant and native-born white artisans.

Furniture

During the colonial period and in the early years of the American Republic, furniture was generally large-scale to accommodate the grand plantation mansion, which typically had rooms 25 feet (7.6 m) long and ceilings 14 to 18 feet (4.3 to 5.5 m) high, with some pieces made at a more modest scale for smaller mansions and urban town houses. Standard furniture pieces included easy chairs, wardrobe cabinets, four-poster beds, day beds, and chests. In the hierarchy of skilled furniture-makers, it was the cabinet-maker who had master status and was the most rigorously trained artisan. Next in rank came the carpenter–joiner, who had journeyman status and made quality furniture and interior architectural woodwork, and lastly came the carpenter. Very few African Americans have been identified as being active in the eighteenth and nineteenth centuries.

Thomas Gross, Jr (d. 1839, active 1805–39) was a cabinet-maker in Philadelphia, a centre of furniture production in the Northeast. He learned the trade from his father, Thomas Gross, who was active in the late 1700s. A chest on chest [6] by Thomas Gross Jr is the earliest signed furniture piece by an African American. This type of domestic furnishing, that remained popular in the nineteenth century, is his only identified work. Unlike the ornate, high chests of the pre-revolutionary period, the simpler silhouette, low bracket feet and refined details, like simple handles and fine bead moulding, display a newer American taste for elegant classicism.

Silversmiths

Only one silversmith, Peter Bentzon (c. 1783–1850, active at the end of

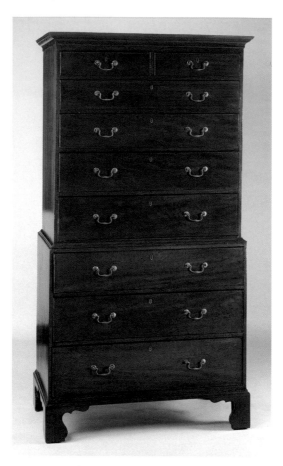

the century), has been identified (by two marks on an existing piece). Bentzon was apprenticed to a silversmith in 1791, and opened his own shop a few years later in Philadelphia, where he remained except for two periods when he lived and worked in St Croix (1806–16, and 1829–48). Nine pieces are known to have been made by him. One particularly fine silverware piece is a footed cup [**7**]. The simple vase-like shape of the cup is characteristic of the unadorned forms favoured during the early years of the classical revival in decorative arts during the Federal period.

Fine artists

You can hardly open the door of a best room anywhere without suprizing [*sic*], or being surprized by, a picture of somebody plastered to the wall and staring at you with both eyes and a bunch of flowers. (John Neal, early 19th century)[5]

After the War of Independence there was accelerated urbanization and wealth. In major American cities the number of American fine artists increased twofold. The arrival of itinerant trained European portrait painters was balanced by the increasing number of white American-

7 Peter Bentzon

Footed cup, c. 1820.

Although inscribed with the date 1841, the cup may have been made during the 1820s, when Bentzon lived in Philadelphia. It was presented to Reverend Luckock at St John's Church Sunday School in Christiansted, on St Croix.

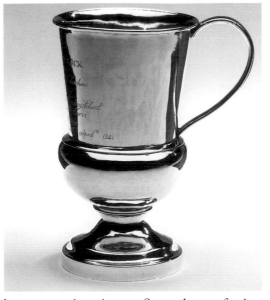

born portrait painters. Soon the profession of painter became respectable and lucrative. Earlier colonial American 'limners' were often trained craftsmen who had worked as house painters or as sign painters. Consequently as portrait painters they were usually self-taught and worked in a naïve style. Limners were active until the early nineteenth century. After the mid-eighteenth century, portraiture, which retained its popularity, became more elegant, but portraits were not ostentatious. Most had a straightforwardness and self-confidence reflective of an optimistic society. The centrepiece of humanist values was individualism, a quality prized by the burgeoning white middle class, who typically represented the puritanical values of hard work and economic competitiveness. They imitated the older and wealthier aristocracy of the pre-revolutionary era by commissioning paintings which reflected cosmopolitan tastes and the individualism and entrepreneurial spirit of the American Republic. What better way to display this new American identity than in the portrait? Leading portraitists used the technique and compositions of the European Old Masters, acquired through study abroad, which appealed to wealthy merchants and their families of Philadelphia, Washington DC, Boston, and Baltimore.

In general, there were obvious economic and social disadvantages for African Americans, slave and free, which discouraged their becoming fine artists. Only scant evidence, in the form of advertisements in city and commercial directories, can be found from the late eighteenth and early nineteenth century. However, a few slaves and free blacks became graphic artists, draughtsmen, and commercial portrait painters.

At Mr M'Lean's, Watch-Maker near the Town-House, is a Negro Man

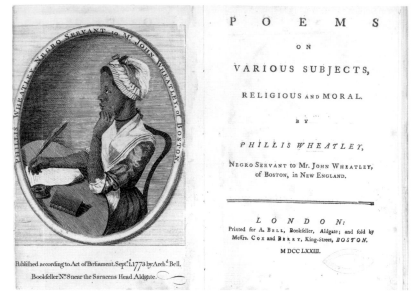

whose extraordinary Genius has been assisted by one of the best Masters on *London*; he takes Faces at the lowest Rates. Specimens of his Performances may be seen at said place. (*Boston Newsletter*, 7 January 1773).

The first documented African-American poet in the United States is Phillis Wheatley (1754–84), a slave born in Gambia, West Africa, who called herself '*Afric's* muse'. When denied in Boston, she had her book of poetry published in London (financed by Selina Hastings, the Countess of Huntingdon). Wheatley was required to have her portrait engraved on the frontispiece, ostensibly to verify the author's race. She remembered that the Reverend John Moorhead of Boston, where she had spent her youth, owned a slave named Scipio Moorhead, who was a poet and an artist. Scipio Moorhead had learned the craft from the Reverend's wife, Sarah, who was a drawing instructor and painter. Wheatley requested that Scipio Moorhead render her portrait. The ink drawing that Moorhead did of Ms Wheatley (untraced) was engraved in London, *Portrait of Phillis Wheatley* [8]. The engraving shows a skill of line and renders the poetess in profile in a contemplative pose typical of colonial period portraiture. Phillis Wheatley composed a poem in tribute to Scipio Moorhead which mentioned two of his paintings, *Aurora* and *Damon and Pythias*. It was included in her publication, and entitled: 'To S. M., A Young African Painter, on Seeing His Works':

> To show the lab'ring bosom's deep intent,
> And thought in living characters to paint,
> When first thy pencil did those beauties give,
> And breathing figures learnt from thee to live,

How did those prespects [sic] *give my soul delight,*
A new creation rushing on my sight?
Still, wond'rous youth! each noble path pursue,
On deathless glories fix thine ardent view:
Still may the painter's and the poet's fire
To aid thy pencil, and thy verse conspire!

Joshua Johnston (also spelled Johnson, *c.* 1765–1830), a free black artist, was active during the late eighteenth and the first quarter of the nineteenth century in Baltimore, Maryland, a city that had over 25,000 free blacks (compared to 3000 slaves) in the early 1800s. He is the earliest documented African-American professional painter. Johnston, about whose early life little is known, was born a slave but had been freed by 1796, when he first advertised his talents as a portrait painter in the city directory, and in the *Baltimore Intelligencer*, as someone who 'experienced many insuperable obstacles in the pursuit of his studies'. Unlike typical American portrait painters, who were itinerant, Johnston spent his career in the vicinity of his home city. Itinerancy among black artisans and artists was ill-advised because slave-traders were active, and patrols and slave auctions routine. The Fugitive Slave Act of 1793 rendered all African Americans potential escapees.

Despite such difficulties, Johnston continued his work, painting those who prospered as mercantilists and their families. Today there are 80 paintings which are either signed by or attributed to him, the most familiar dating from between 1803 and 1814. His style and choice of subject link early colonial portraiture to indigenous folk tradition. It was a very conservative painting style, which would have been considered provincial. The straightforward painting technique, closely modelled forms, sharp value contrasts of light and dark colours, and stilted poses are very similar to the portraits of an earlier, more familiar American painter, Charles Peale Polk (1767–1822), who lived in Baltimore in the 1790s.

Indeed, scholars have discovered that some of the sitters portrayed in his paintings also sat for Charles Peale Polk, which previously encouraged the belief that Johnston may have been a slave of the Peale family, a family of collectors and painters. Recent evidence shows, however, that he was freed by his white 'father' at the age of 19. Had he been in the Peale family's employ, he could have been familiar from adolescence with Polk's paintings. Regardless, he would have seen paintings in a similar style as he taught himself how to paint.

No Baltimore artist of this period painted more portraits of children than did Johnston. Typically, figures gaze forward, with details of dress and face crisply delineated. Sometimes the subjects are shown in front of an open casement window with landscape views, as in his painting, *Westwood Children* [9]. This is an unusually varied composition for Johnston: the figures are placed asymmetrically and shallow space jux-

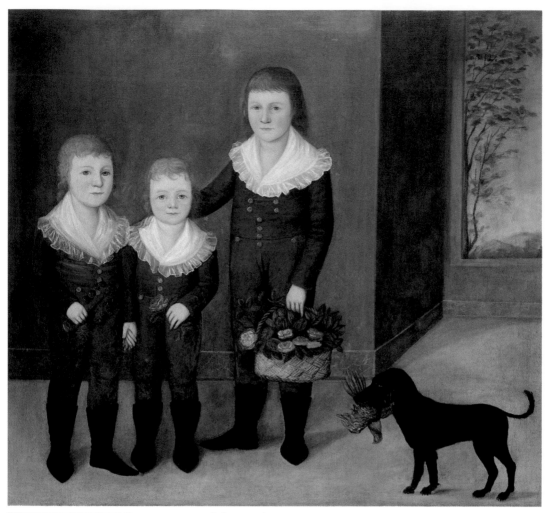

9 Joshua Johnston

Westwood Children, c.1807.

taposes spatial recession.

Among Johnston's portraits only two have been identified as African Americans, both clerics. *Portrait of a Gentleman* [**10**], is probably of Daniel Coker (1780–1846). Coker, who had been ordained by Bishop Ashbury, founder of the Methodist church in America and a sitter to Charles Peale Polk, was living in Baltimore in 1800 and again in 1816. He helped establish the African Methodist Episcopal (AME) Church (which broke away from the white Methodist Church in 1816) and was among the new black élite who publicly pointed to the conflict between the ideals of the Declaration of Independence and the principles of Christian egalitarianism on the one hand and the maintenance of slavery on the other. In 1810 he published a pamphlet—*A Dialogue between a Virginian and an African Minister*—demanding universal emancipation. Coker eventually left America for Africa, sponsored by the American Colonization Society (founded 1817), a white American anti-slavery organization which sought to resettle freeborn and

emancipated slaves to West Africa between 1821 and 1867.

The fact that he painted portraits of black clerics indicates that Johnston was one of those free blacks belonging to the élitist mulatto class who, according to historian Ira Berlin, 'worked to pull free Negroes and slaves together to create a united black caste' in the fight for abolition and civil rights, instead of segregating themselves from slaves or integrating into white society. The AME Church, with its subsidiary schools, fraternal organizations and benevolent societies, was one of the institutions where free blacks and slaves might gather to improve and protect themselves.

Judging from the subjects of his portraits, it is evident that Johnston also associated with affluent whites, some of whom were sympathizers of abolitionism.

The world of the slave in the rural and urban areas gives us a contrast of artistic genres, styles and aesthetics. The patron and consumer was the planter. Wealthy planters who emulated European tastes were dependent on the skills of their slaves and the availability for hire of itinerant European, European-American and free African-American skilled artisans. There is a variation in quality, but not necessarily in the designs and styles, of furniture, architecture, and quilts. Slaves built the planter's house according to the planter's or a hired architect's plans. There are some indications that, if skills were sufficient, planters would rely upon slaves for design as well as construction.

Social and economic differences and population patterns affected the type and degree to which Africans and African Americans adopted the European aesthetic, style and technique. Acculturation occurred more rapidly in cities, where a more sophisticated clientele demanded European forms while they simultaneously searched for an 'American' style in fine and decorative arts. In Northern colonies, and later states, African Americans were numerically in the minority, working and living close to whites. For free African Americans who ostensibly had creative autonomy, survival and recognition depended on patronage. They had to meet the taste criteria of the upper and middle classes, typically European and European-American. Consequently, artists and artisans made forms that conformed to current fashion.

Although there were few black patrons, they had a considerable impact on the careers of free black artists. The two paintings by Joshua Johnston, a drawing by Scipio Moorhead, and the inscribed metalwork by Peter Bentzon, hint at their presence. Their patronage warrants further investigation. Warranting further study, also, is the relationship between the free black and slave artisans.

Acculturation occurred more slowly and in more diverse ways in the South, generally because of the large slave communities. In the early colonial period African and American Indian cultures infiltrated the

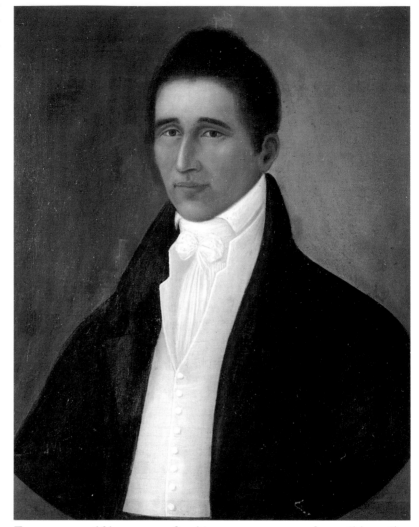

10 Joshua Johnston

Portrait of a Gentleman, 1805–10.

Basing their decision on the study of identified images, scholars have concluded this is a portrait of the Revd Daniel Coker, one of the founders of the African Methodist Episcopal Church.

European world by means of architecture, pottery and, possibly, quilts. Conversely, Africans also adopted and adapted designs and techniques, as evidenced in quilts and architecture. This was either a result of economic necessity, as in the case of earthenware, or prescribed by the slave-owner, as in the design of slave quarters. There is evidence, however scant—a drum, and a figure—that a group of Africans or African-American slaves sometimes commissioned works. Both objects, with their obvious African style and meaning, are extraordinary, and therefore suggest some kind of patronage within the slave community. Slaves were also consumers, as shown by the earthenware. It is very probable that they needed other objects as well. Slaves' resistance to the condition of slavery is manifest in the retention of African cultural practices and forms, such as the religious markings of colonoware and the sporadic appearance of African-designed houses and spatial arrangements. There was in general a shift between European-derived

forms and styles and African ones. Extant eighteenth-century quilts show that African Americans adopted European techniques and copied European designs, but from the evidence provided by later nineteenth-century quilts, they also very likely devised their own African-based quilt designs and patterns. As one would expect, objects intimately associated with rites and ceremonies were African in shape and form, as for example the drum and the wrought-iron figure [3, 4].

We can only speculate about folk art production among free African Americans because no evidence remains. Perhaps these works displayed Africanisms, especially if a skilled slave was recently freed. A carpenter–joiner could carve a walking stick. Or a seamstress could stitch a 'special' quilt for her family. The worlds of the free black and the slave in the eighteenth century are only just beginning to be revealed by new research.

There are thus many variable factors to be considered in summarizing African and African-American culture from *c.* 1650 to *c.* 1815: the size of communities; cosmopolitan society or rural isolation; extensive or minimal contact with European-American culture; economic independence or dependence as a slave-labourer; the constant immigration of Africans; and different types of colonial governments, British or French–Spanish. The continuous expansion of slavery brought with it a vigorous anti-slavery movement and an equally aggressive political and ideological defence of it by slave-holders, a conflict which created a fundamental crisis in American society from the late eighteenth into the nineteenth century. Despite the odds, Africans and their descendants survived and developed as artists and artisans, contributing to the development of a vibrant African-American culture into the antebellum period.

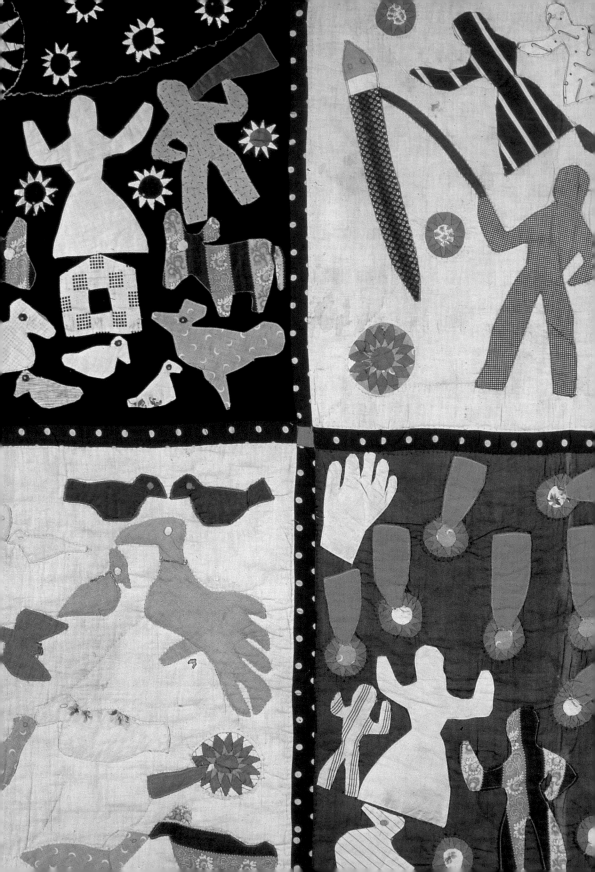

Nineteenth-Century America, the Civil War and Reconstruction

2

Introduction

The period leading up to the American Civil War, known as the ante-bellum era, was, for whites, a time of optimism, territorial expansion and political self-determination spurred by the war of 1812 (with Britain). 'Manifest Destiny' was popular. The phrase stood for an expansionist doctrine that promoted the United States' duty and right to expand its territory and influence throughout North America. It reflected a growing spirit of confidence in an age of population increase, greater urbanization and westward movement, the latter aided by technological progress in transportation and communications. Unclaimed territories, with their vast natural resources, were seen as a place for exploration and exploitation by industries and land barons. Settlement of the frontier added new states to the Union, and the Louisiana Purchase in 1803 secured a vast new territory in the West. The seventh president, Andrew Jackson, sometimes considered the incarnation of frontier democracy, was elected in 1828. Under his administration the United States annexed Texas (1845), which precipitated the Mexican War and, after Mexico's defeat, led to the acquisition of California and most of the Southwest. Westward expansion continued; the Pacific Northwest was added in 1846 by a peaceful settlement with Britain. The theme of Manifest Destiny captured the imagination of individuals who, as Albert Boime aptly noted, expressed 'the privileged national ideal, the ruling-class aspirations for American society'. Americans were cosmopolitan, still looking to Europe for standards in art and culture while at the same time developing a unique national identity.

There were now more free African Americans because of the large immigration of blacks from Haiti and Cuba, fleeing the revolutionary struggles in Saint-Domingue, and the efforts of abolitionist societies. From around the 1780s in most states, including those of the upper

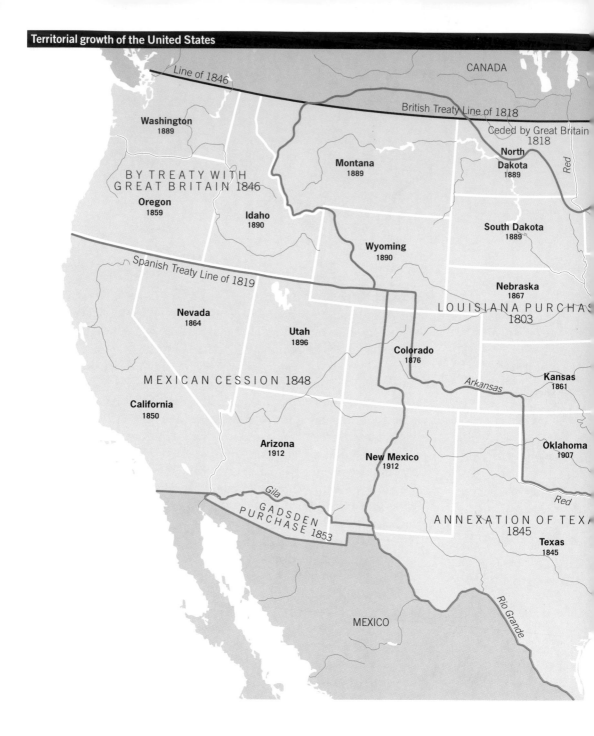

Line of 1846

CANADA

British Treaty Line of 1818

Ceded by Great Britain 1818

Washington
1889

North
Dakota
1889

Montana
1889

Red

BY TREATY WITH
GREAT BRITAIN 1846

Oregon
1859

Idaho
1890

South Dakota
1889

Wyoming
1890

Nebraska
1867

LOUISIANA PURCHAS
1803

Spanish Treaty Line of 1819

Nevada
1864

Utah
1896

Colorado
1876

Kansas
1861

MEXICAN CESSION 1848

Arkansas

California
1850

Arizona
1912

New Mexico
1912

Oklahoma
1907

Gila

GADSDEN
PURCHASE 1853

Red

ANNEXATION OF TEXA
1845

Texas
1845

MEXICO

Rio Grande

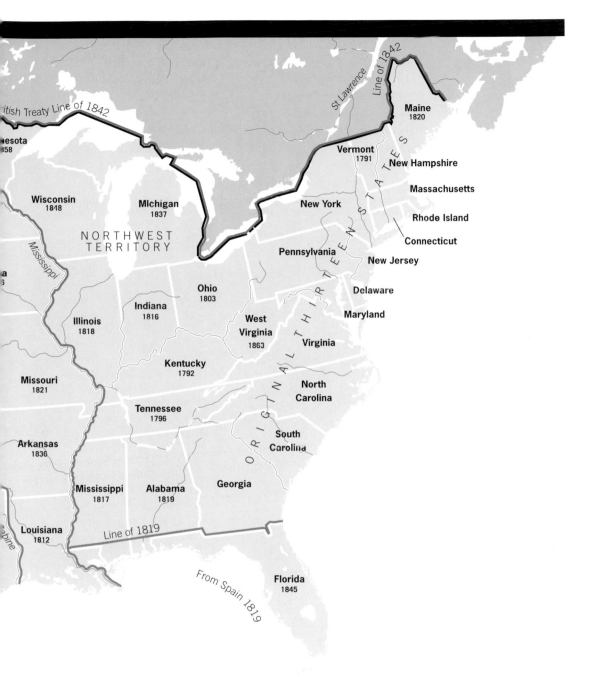

British Treaty Line of 1842

St Lawrence

Line of 1842

Maine
1820

esota
858

Vermont
1791

New Hampshire

Wisconsin
1848

Michigan
1837

New York

Massachusetts

Rhode Island

Connecticut

NORTHWEST
TERRITORY

Pennsylvania

New Jersey

Delaware

Mississippi

Ohio
1803

Indiana
1816

West
Virginia
1863

Maryland

Illinois
1818

Virginia

a
5

Kentucky
1792

Missouri
1821

North
Carolina

Tennessee
1796

South
Carolina

Arkansas
1836

Mississippi
1817

Alabama
1819

Georgia

ORIGINAL THIRTEEN STATES

Louisiana
1812

Line of 1819

bine

From Spain 1819

Florida
1845

South, these societies petitioned legislatures, prosecuted freedom suits, and helped protect free blacks from re-enslavement. Free blacks continued to settle in cities such as Boston, Philadelphia, Charleston, and New Orleans. Slaves in the South remained on plantations, but greater numbers were moved to the cities between 1820 and 1840 in response to the increasing demand for semi-skilled and skilled labourers in industries and factories. The mixed population of free and enslaved blacks in the cities was regarded warily by whites, some of whom returned their slaves to the countryside after several dramatic slave rebellions, such as the one led by Denmark Vesey in 1822 in South Carolina.

Abolitionism and the antebellum period

Over 5000 free and enslaved blacks fought in the War of Independence. This experience encouraged blacks to seek their own freedom. At the same time abolitionist societies, which regarded slavery as a sin, advocated compulsory emancipation of black slaves. These societies, particularly active from 1830 to 1860, normally looked for non-violent solutions. The American Anti-Slavery Society (estab. 1833) was founded by William Lloyd Garrison, who advocated moral persuasion. However, by the mid-1840s other organizations were calling for more aggressive political action. Frederick Douglass (1818–95), an escaped slave who became a spokesperson for abolitionist causes and won renown for his oratorical skills, advocated more aggressive strategies and international coalition. There were also black and interracial female societies in the Northeast. Representative of the white abolitionist outlook was Harriet Beecher Stowe's *Uncle Tom's Cabin*, which became an effective piece of propaganda.

The Dred Scott decision in 1857 declared that African Americans were not United States citizens. Anti-slavery organizations immediately flooded the slave states with literature, lobbied the nation's capital, and promoted their cause in the *Liberator*, the *National Anti-Slavery Standard*, *Freedman's Journal*, and the *North Star*. Regional animosities were heightened. Among the most dramatic abolitionist action was the raid led by John Brown (1850–59) on the United States arsenal at Harpers Ferry, West Virginia, in 1859.

The Civil War (1861–5) was precipitated, among other things, by the North's nullification of fugitive slave laws. As the war dragged on, the Emancipation Proclamation on 1 January 1863 abolished slavery in the Confederacy. The aim was twofold: to deplete manpower reserves in the South and enhance the Union cause abroad, especially in Great Britain.

Eventually the North (the Union) defeated the South (the Confederacy) and the Reconstruction period (1865–77) began. The social and economic order of the South had been devastated, and the United States used several strategies to prevent the old planter aristocracy regaining their former power. During Reconstruction, many of the former slaves became sharecroppers, in a farm tenancy system which was intended to give them independence, but which in effect sustained a type of economic bondage for the black American. The Thirteenth Amendment (1865) of the Constitution guaranteed freedom to black Americans. Yet this guarantee was made meaningless in individual states by laws known as Black Codes, which limited the civil rights of blacks and enforced segregation from the community.

Segregation received federal sanction in the Supreme Court decision in Plessy v. Ferguson, 1896.

Whites believed that free blacks might form alliances and incite the slaves to rebel against their masters, or to escape. In the 1840s and 1850s greater numbers of southern slaves fled, and free blacks migrated for better job opportunities. Slaves 'disappeared' into free African-American communities in the North or escaped to Canada via the Underground Railroad, swelling the black population in the North. Free blacks also left the South because of economic and social restrictions that gradually diminished their professional opportunities in the artisan trades as, increasingly, white artisans and tradesmen protested at blacks' employment in the same profession. Even at this date, the African-American population remained predominantly enslaved; at the end of the 1850s, just before the Civil War, four million blacks were slaves, half a million were free.

The anti-slavery movement

During the first half of the eighteenth century, the South, with its doctrine of states' individual legal rights, and especially on issues involving slavery, was becoming estranged from the North. After the election of Abraham Lincoln to the presidency in 1860 the seven states of the South seceded from the Union and formed the Confederacy, precipitating the Civil War (1861–5). Some Christians (especially Quakers and Methodists) continued to see slavery as irreconcilable with Christian faith, a violation of the law of God, and a contradiction of the rights of man. Around 1830, southern and (especially) northern abolitionist organizations like the American Anti-Slavery Society, black American mutual aid and benevolent societies, and black churches like the African Methodist Episcopal Church (founded 1796), argued for the abolition of slavery on moral and political grounds. They embarked on a sustained political campaign, which involved publishing slave interviews and images in abolitionist periodicals, and slave narratives. Black abolitionists carried the added burden of disproving the claims of black inferiority espoused by politicians and southern pro-slavery interests.

Increasingly, abolitionists, especially black abolitionists, argued for more aggressive tactics. The famous African-American abolitionist, Frederick Douglass, stated in 1857 that:

If there is no struggle, there is no progress. Those who profess to favor freedom and yet deprecate agitation are men who want crops without plowing up the ground, they want rain without thunder and lightning, they want the ocean without the awful roar of its many waters. This struggle may be a moral one, or it may be a physical one, and it may be both moral and physical, but it must be a struggle. Power concedes nothing without a demand. It never did, and it never will.

Free black and slave artisans

Slaves were responsible for much of the artistic production of the ante-

bellum period. Even though their anonymity has made it very difficult to identify the work of specific black craftsmen, their importance as part of the artisan trades, especially in the South, is unquestionable. After 1820 not only whites but also many free blacks, mostly artisans, possessed slaves. Master artisans, white or black, held or accepted slaves as indentured contracts. The reasons for the development of this slave artisan class in the antebellum period were: diversification of goods, scarcity of labour, and the high cost of manufactured goods. The economic advantages were obvious. Trained slaves helped augment the slave-holder's income, and slaves—unlike indentured apprentices—did not have to be released upon reaching journeyman stage. The master artisan was thus relieved of having to start all over again every few years with untrained apprentices. Moreover, the slave might reach master status as far as skill was concerned, but once he was purchased, his pay would remain at the original unskilled level, making him a very cost-effective worker. Artisanal skills also benefited the slave: he or she could buy freedom, or at the very least provide a more comfortable life for his or her family by purchasing clothes, liquor and additional household goods. Some slaves were sent to England to learn cabinet-making. The slave-owner, whether planter or artisan, ultimately profited from the work of slave artisans.

The emancipation of 1863 had one major drawback for the slave artisan: the economic protectionism of slavery ended, forcing him to compete in the open market. Black slaves were at a considerable disadvantage, for whites and former free blacks had an existing clientele, and the benefits of experience and knowledge of the market. Inevitably, hundreds of slave artisans failed to compete, and for the remaining decades of the century produced art works only for their own immediate community, effectively becoming folk artists.

By responding to the needs of a rapidly growing wealthy antebellum class, young black men seized the opportunity for economic advancement and social recognition, but had to compete not only against whites but also slave artisans, who were cheaper and sometimes equally competent, for artisan business. During the first three decades of the nineteenth century the urban slave and free black artisans dominated the markets, bested only by those master European artisans who worked for extended periods in the United States. Black artisans catered to white and black customers. Free black master artisans increasingly took on more apprentice-indenture contracts with African Americans (some slaves) than did whites; it gave them additional income and the opportunity to mentor the future generations of black artisans. Free black artisans were also able to provide manumission for their slave artisans, some of whom were relatives, and, in their additional role as money lenders, to supply important financial resources for the African-American community.

By the 1840s, however, white artisans from the northeastern United

States and Europe (particularly Germany and Ireland), who were becoming aware of how entrenched African Americans were in the craft trades, particularly in the South, argued for some legal assistance. In response to this some northern and southern states passed legislation that made it unlawful for a master to hire out his slave in the trades. Other legislation limited the number of businesses owned by free blacks, and in some states in the South required specific numerical ratios of white to black workers in a business. Free blacks who could own property, like lithographers Grafton Tyler Brown (see p.85), and cabinet-makers Dutreuil Barjon and Thomas Day (see p.61), established their business in keenly competitive districts, and succeeded. Some black artisans expanded their businesses through partnerships with other blacks to boost their competitive edge and increase retail inventory to include imported items from Europe and other areas of the United States. However, laws that prohibited manumission and interstate travel by free African Americans (they had to have a passport or identity badge) increased their handicap and exacerbated conflicts around issues of race and economics. These problems, combined with increasing industrialization in the North, contributed to the demise of hundreds of African-American artisans after 1850.

Fine artists

The development of the African-American fine artist resulted from a variety of social and economic conditions before and after the Civil War: the ending of the slave trade; the expansion of free black communities and a growing middle- and wealthy class of Americans. Many of the free fine artists were mulatto, whose colour and education—often in Europe, sponsored by a parent or an abolitionist society—and access to a higher standard of training provided in the cities privileged them over darker-skinned blacks. This social class distinction, in addition to their skill and the patronage they could attract, determined whether they became fine artists.

For the African-American artist this was singularly challenging. Many were very active in the decorative arts or artisan trades, as it was a

The art world

Iconography means the study and interpretation of figural representations and their symbolic meanings.
Iconology refers to less obvious meanings and multiple meanings taken from different disciplines.
Folk art is made by those without formal training, often inspired by spiritual visions. It represents the maker's own culture and society, using any kind of material that is convenient.
Fine art usually denotes graphic arts, painting, sculpture, and sometimes also architecture. It makes use of expensive materials (oil paints, marble, etc.) and special tools, and is created by individuals who have undergone formal art training or an apprenticeship which has given them certain skills and a specialist outlook on their chosen discipline.

major means of livelihood. Consequently many professional fine artists started out as artisans: as sign and banner painters—Robert Douglass, Jr (1809–87); as house painters—Robert Duncanson; or as draughtsmen—Grafton Tyler Brown.

Whenever possible, African Americans followed the same career path as whites. They had professional art training, the European Grand Tour, patrons, critical acceptance and public visibility by means of local or regional art exhibitions and viewing. Patronage was essential for the livelihood of these artists. During the antebellum period most of their patrons were European-American abolitionists. Black abolitionists and, after the Civil War, black community leaders also became patrons. By the late nineteenth century some African Americans remained in Europe as expatriate artists after their Grand Tour of London, Rome and Paris.

Architecture, the decorative arts, and folk art
Urban and rural architecture

Vernacular architecture involved both slaves and free African Americans who worked as builders and builder–designers. Of these, few had been trained formally, but most had trained as apprentices for European or European-American architect–builders. The Faubourg Marigny, at that time a 'creole of colour' suburb of New Orleans, Louisiana, provides a good example of an area where free blacks like Louis Nelson Fouché (active 1830–55), Laurent Ursain Guesnon (active 1820s), William Kincaide (active 1820s to 1840s), and Jean-Louis Dolliole (1779–1861), designed and built modest town homes. Here there are two building types: the French creole cottage and the African-Caribbean structure called the shotgun house.

A type most predominant in the early development of Marigny, dating mostly from 1810 to 1830, is the creole cottage. Very few remain today. Jean-Louis Dolliole, who with his father, Louis, and uncle, Jean-François Dolliole, were builder–designers, emigrated from France (Provence) in the late eighteenth century. He designed and built in 1820 what is considered a masterpiece creole cottage on Pauger Street [11]. Typically creole cottages were set on large plots, which enhanced their rural character. The plastered brick cottage follows the proportions of late eighteenth-century Spanish colonial period design: double pitched hip-roof, low profile, and elevation (around 10 feet, or 3 m), and shutters with iron strap hinges. The roof projects approximately 5 feet (1.5 m), allowing roofwater to drain on to the street. The materials used by Dolliole distinguish his from other cottages, for, by 1800, flat-tile roofs were out of fashion. Jean-Louis Dolliole kept the house until 1858.

The main African-American contribution to American vernacular architecture design is the shotgun house. Roughly 12 × 20 feet (3.6 ×

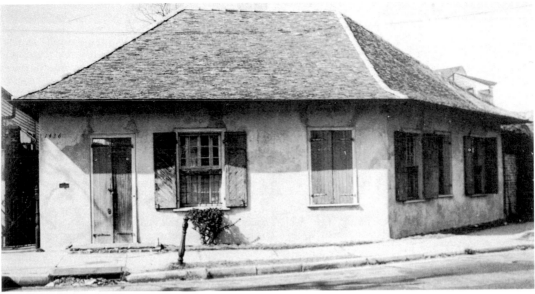

11 Jean-Louis Dolliole
Creole cottage, Pauger Street, New Orleans, 1820

6 m), shotgun houses are still prevalent in the South because of their efficient use of land, modest cost, and suitability to the climate. The distinctive form of such houses, which date from 1810 onwards, represents formal links with African and Caribbean architecture. It is attributed to French creoles and free black creoles from Saint-Domingue and Cuba, who migrated to New Orleans and Charleston, South Carolina, after 1784 and from 1800 to 1810. They brought the architectural plan for shotgun houses from Haiti and established the style as an urban alternative to the creole cottage. The Haitian shotgun is an amalgamation of Yoruba (Nigeria, West Africa) and Arawak Indian plans and elevation. The building technique, however—of open-bay framing and half-timbering—is French. A typical plan is one room wide and three to four rectangular rooms deep, with an adjoining open hallway. A hipped roof with the primary entrance located on the narrow gable end, faces the street. Later in the century there were variations, for example houses with a half-storey, called 'camelback' shotguns. After *c.* 1860, English Victorian embellishments were used to decorate the brackets, eaves of the roof and gables [**12**]. Scholars disagree about where the design first and later appeared in the United States, but they all agree that the shotgun first appeared in the urban and later in the rural South, where eventually it came to be associated with poor working-class communities.

Some planters also allowed slaves to design and build their own houses, though others were hostile to any such overt expression of African culture. According to Ben Sullivan, an ex-slave from St Simon's Island, there was a slave called Okra from the Kongo region in Central Africa, who, in recreating his house on Hopeton plantation, reinforced memories of his birthplace:

Façades and cross-section of
shotgun houses, New Orleans,
mid-19th century.

One could fire a gunshot and
the bullet would travel clear
through to the back of the
house, hence its name.

Ole man Okra he say he want a place like he have in Africa so he built him a
hut. I 'member it well. It was about twelve by fourteen feet and it have dirt
floor and he built the side like basket weave with clay plaster on it. It have a flat
roof what he make from bush and palmetto and it have one door and no win-
dows. But Massa make him pull it down. He say he ain't want no African hut
on he place.[1]

By the mid-nineteenth century, African-type houses—cob-walls,
wattle-and-daub, and wood fibre—were very rare, which makes the
next example extraordinary. Still standing in 1907, in Edgefield, South
Carolina, it was built by Tahro, whose slave name was Romeo. He was
one of 409 slaves from the Congo and Angola basin (Central Africa)
brought over on *The Wanderer*, the last slave ship to North America,
which ran aground on Jekyll Island off the coast of Georgia on 28
November 1858, while evading British anti-slavery ships. Tahro's slave
house [13] had a timber frame with lathe walls held in place by twine
netting. Inside, bundles of straw were hung vertically. The roof was
covered with straw thatches. The carefully woven single-room struc-
ture (approximately 7×10 feet/2.13×3 m), with a door at the gabled
end and no windows, was, according to Tahro, like the one he built for
himself in Africa.

Furniture

Fine furniture was made and sold in speciality shops in the cities, or on
plantations in cabinet shops producing European-style furniture.
Successful planters and mercantilists, businessmen and their families,
some recently migrated from France, Spain, Germany and England,
wanted finely made, solid furniture which denoted social status. Local
woods (walnut, pine, cypress) were apt to be used on plantations and
were less expensive than the imported woods mahogany and rose-
wood. The most popular pieces were marble-topped washstands,
sleigh beds, four-poster beds (called in the South tester beds), chests of
drawers, armoires, secretaries, whatnots, chairs, sofas, and desks. An
excellent example of a slave having the skills of a master cabinet-maker

is provided by the beautiful and sophisticated cellarette [**14**] attributed to Peter Lee, a slave of John Collins in Alabama. Lee's highly skilled work not only reflected upon the slave-owner's social status but was likely to have earned Lee respect and status in the slave community, in which people probably retained the high regard for artisans that they had in Africa.

Thomas Day (1801–61/66), a free black, was active as a cabinet-maker until 1860. He opened shop in Milton, North Carolina in 1823, and by 1850, Day was the fifth wealthiest man in Caswell County, employing artisans, mostly slaves in his shop. The output of the Day factory at the old Yellow Brick Tavern was considerable. Many wealthy homes in Virginia, the Carolinas and Georgia were furnished with his works. Taking his book of designs, Day would sometimes travel several hundred miles to patrons' homes, to visualize each piece in its proper setting. Known for his mahogany pieces, Day developed standard Empire or Greek Revival designs. His distinctive signature, a pairing of facing s-scroll motifs, bring bold design elements to a secretary [**15**].

There were more free black artisans and entrepreneurs in New Orleans between 1810 and 1840 than in any other city in the United States. The Crescent City was renowned for its cabinet-makers, including those from France, like François Seignouret (b. 1768). Among the ever-growing number of cabinet-makers were free men of colour, several of whom had been born in Saint-Domingue or Cuba. One of the earliest known cabinet-makers was Celestin Glapion (1784–1826), to whom an armoire (Louisiana State Museum) is attributed, dating c. 1810–15. At the turn of the century, free blacks trained under white cabinet-makers but by 1819 the majority of free blacks were training under free black cabinet-makers. One was Jean Rousseau (active

13 Tahro
Slave house, c. 1890.

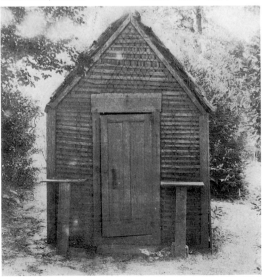 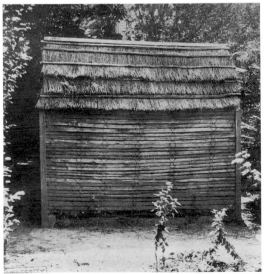

between 1813 and 1833), who trained Dutreuil Barjon (c. 1799–after 1854). By the 1830s Barjon was considered a master cabinet-maker. Today his name is mentioned alongside those of notable whites: Frenchmen François Seibrecht (1786–after 1857) and Seignouret, and Prudent Mallard (1809–79).

Barjon established a very successful shop in 1822 on the premier furniture-making street, Royal Street in the French Quarter, and soon established a furniture warehouse, Barjon & Co., in 1834, which sold his own designed and imported furniture from Hamburg and Berlin. He helped introduce the austere Biedermeier (1815–50s) style to New Orleans, a city dominated by French furniture designs. The sleigh bed [**16**], signed by Barjon, reflects a taste for the fashionable American Empire style (1810–40), based on early nineteenth-century French Empire style (1804–15), and neoclassical British Regency style (1800–40): massive bold furniture with rounded corners and curvilinear elements including s-curve supports and mahogany wood. Classical furniture designs like this were popular in Louisiana in the 1830s, showing the decline of the ornate French rococo designs. Although Barjon was, and still is, recognized as an important cabinet-maker of his day, very little is known about his career and life. Encountering financial difficulties by mid-century, Barjon handed over his business to his son, Dutreuil Barjon Jr (after 1821–70), who made Biedermeier-style furniture. Barjon Sr escaped his creditors by fleeing, with his mistress, to France around 1854. Barjon & Co. closed in 1867.

After the late 1840s the number of black cabinet-makers and carpenter-joiners declined by almost 50 per cent, paralleling the situation in

16 Dutreuil Barjon
Sleigh bed, c.1835.

17 Anonymous
Clockwork figure, c.1833.
This cast lead piece was made
by slaves of Valzin Bozonier
Marmillon (1794–1862) at
Mathilda plantation in St John
Parish, Louisiana. The figure
stood on top of a cypress clock
case and was mechanized to
strike the hours.

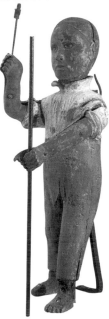

other decorative arts and skilled trades throughout the South, and to some extent in the North. In the 1850s, as North–South tensions flared, economic growth slowed considerably in the southern cities. This, combined with mechanized mass production and the fashion for up-holstered furniture after the 1870s, undoubtedly had an adverse affect on the livelihood of both black and white artisans. Some diversified into undertaking, or tobacco shops. Businesses failed, artisans filed for bankruptcy and some, like Dutreuil Barjon, fled the country. The fate of many professional artisans is unknown. In the lower South, some probably migrated to the Midwest and Northeast after the 1840s. A few stayed and managed to succeed.

Metalwork and woodcarving

Figurative sculptures, walking-sticks, pottery and quilts all provide glimpses of slave artistic traditions. Some, such as the cast lead clock-work figure [17] from Louisiana, represent the skills of both black-smiths and woodcarvers. The decorative wood walking-stick [18] was carved by Henry Gudgell (c.1826–95), a slave blacksmith, wheelwright, copper- and silversmith in Livingston County, Missouri. The staff is decorated with carved reliefs of a lizard, a tortoise and a snake, which are considered by several scholars to evidence a retention of design ele-ments found on many West African ritual staffs. The tradition of using elaborately carved staffs as insignia among men, or in dance, is a fea-ture of African and African-American culture. This walking stick, however, was made for John Bryan, a friend of Gudgell's master, Spence Gudgell.

18 Henry Gudgell

Walking-stick, c.1863.
The rendering of two
viewpoints for the human
figure and animals in a single
composition is typical of naïve
folk art style.

Pottery

The best-known pottery of the antebellum period is the alkaline-glazed (wood ash- or lime-based) stoneware, found only in certain re-gions of the United States: the western Carolinas, Georgia, upper Florida, Alabama, eastern Texas and to a lesser extent in Arkansas and Mississippi. Edgefield District in western South Carolina has the ear-liest dated wares, c. 1815, and the most prolific production site in the re-gion. Production continued until 1880, peaking between 1830 and 1860.

African-American slaves, who outnumbered whites four to one, mostly worked in pottery mills or shops owned and operated by white 'pioneer potters', who were well-to-do farmers or planters. Notable were the Reverend John Landrum, his brother Abner Landrum, founder of Pottersville Stoneware Manufactory, and John's son-in-law, Lewis J. Miles of Miles Mill Factory (c. 1850–79). Miles Mill was the leading manufacturer of alkaline-glazed earthenware in the nineteenth century. Typical vessels would not be marked, but would be slip-deco-rated in a light grey-green or yellow-green (earlier), or later, in a darker olive-green and brown colour. The green-brown glazes were typical of the Miles Factory. Some slaves were skilled potters called 'turners', who specialized in certain forms, such as storage jars.

One slave, known simply as Dave (c. 1780–1863), 'threw pots' for 29 years. So far, over 50 of his pots have been discovered. Large storage jars, used for storage of salted meat and rendered lard, were his most distinctive forms. His signature was a jar with a wide mouth and thick rolled rims, often 24 inches (60 cm) tall. There are approximately twenty enormous 25-gallon (95-litre) jars signed by Dave still in exist-ence bearing a completion date, and a rhymed couplet incised between the crescent-shaped lug handles on the high broad shoulders. One of his largest (40-gallon/151-litre), a storage jar [19], has the following in-scription: *Great and Noble jar/Hold sheep, goat, or bear* and on the opposite side: *Lm* [initials of Lewis Miles] *May 13, 1859/Dave & Baddler*. Baddler was another black 'turner' at Miles Mill.

How Dave became literate is conjectural, but he may have devel-oped his poetic skills while assisting (as a typesetter?) Abner Landrum, who owned a local newspaper, *Edgefield Hive*, until 1831. On 12 July 1834, by which time he was an apprentice and slave of John Landrum, Dave completed his earliest known couplet jar. By 1840 Dave was a slave of Lewis J. Miles. One vessel documents the new ownership: *Dave belongs to Mr Miles/wher*[e] *the oven bakes & the pot biles*, and is dated on the other side: *31 July 1840*.

Some couplets record how meats were preserved: *A very large jar which has four handles/pack it full of fresh meats—then light candles* (1858). Others express sentiments about slavery (1857), pride (1857), and spiritual redemption (1862). The last signed pot with an incised couplet is dated May 31 1862. Dave's genius is evident in his ability to assert his identity within the anonymity of slavery by composing witty verse, signing his name and the date of the finished work, and alluding to his physical strength by the distinctively large jars. Dave's pots are cultural and personal commemoratives as well as works of art.

Unique in glazed stoneware are face vessels attributed to slave potters also living in Edgefield District. They made what is considered one of the more inventive stoneware forms in the South. Dating between 1860 and 1880, and ranging in height from 4 to 9 inches (10 to 23 cm), these 'grotesque jars', and 'voodoo jugs', as they were popularly called, were renamed in 1969 'Afro-Georgian' and 'Afro-Carolinian' by art historian Robert Farris Thompson to denote both the artisan's African heritage and the area of manufacture. We do not know what the slaves called them. Many were discovered in the vicinity of Colonel Thomas Davies's Palmetto Firebrick Works in Bath, South Carolina.

Davies, who opened his factory in 1862 and closed it three years later, informed ceramic historian Edwin A. Barber in 1893 that his slaves were allowed time on their own to make face vessels in 1862: 'They were accustomed to employ in making homely designs in coarse pottery. Among these were some weird-looking water jugs, roughly modelled in the front in the form of a grotesque human face evidently intended to portray the African features.'[2] Barber, in turn, considered the facial forms similar to African art.

19 Dave the Potter

'Great and Noble jar', 13 May, 1859.

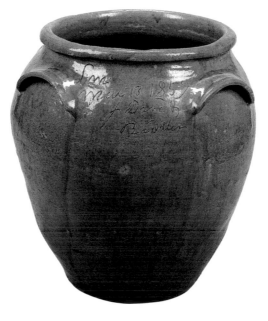

Edgefield face vessels display a human face on one side of the body, sculpted in relief. As shown in one Afro-Carolinian face vessel [20], the contrast of the white porcelain bulbous eyes and teeth next to the clay lips and the brown glaze of the body create a visually dramatic and animated image. The use of two different clays, the open-mouth expression, and the white eyes contrasting against the darker coloured form appear similar to Kongo 'power' statuary, according to African scholars. The knowledge that Kongo slaves worked at the Davies Factory makes the hypothesis that the style and technique is African-derived more plausible. Making human-face earthenwares is considered to be an African translation of the British Toby, which could have been imported into North America. Alternatively, as has been recently documented, it could have been a continuance of pottery forms seen in northern Kongo region, where, by the early nineteenth century, the people had transformed the Toby into a more African form and magical object.

The meaning and function of these vessels is conjectural. Some were kept in families for generations; others were found in the vicinity of the Underground Railroad. This, and the care with which they were modelled and fired, and their small size (suggesting that they were not utilitarian objects) hint at some special, possibly spiritual, significance. Some of these pots have holes. Pottery damaged in this way has been found on burial grounds in South Carolina and Georgia. One writer in Columbia, South Carolina, observed in 1881:

When a negro dies, some article or utensil, or more than one, is thrown upon his grave; moreover it is broken. Nearly every grave has a most curious collec-

20 Anonymous

Afro-Carolinian face vessel, c.1860.

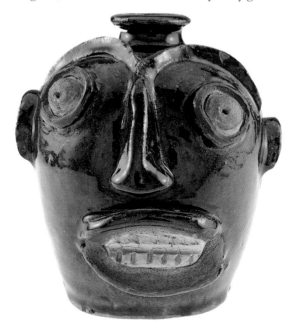

tion of broken crockery. On the large graves are laid broken pitchers, sirup [*sic*] jugs, plaster images. Chief of all these, however, are large water pitchers; very few graves lack them. What the significance of so many cracked pitchers and jugs may be I do not know. Surely the negro of Columbia does not regard this particular form of earthenware with special admiration or affection.[3]

Another writer observed the same practice in 1891 in the same place, and noted that graves were decorated with a variety of objects, including fragments of crockery, and cited an engraving depicting the grave of a Kongo chief 'that would do very well for the picture of one in the Potters' Field, Columbia, South Carolina'.[4] On the grave all articles were cracked or perforated with holes. As mortuary items, face vessels may have been protective spiritual devices and prestige objects reflecting African spiritual concepts and practices.

Afro-Carolinian and Afro-Georgian face vessels mark the confluence of cultures in North America. They display an amalgamation of African pottery technique: two clays with different firing temperatures; and of European pottery forms and technique: using the potter's wheel (not traditionally used in West and Central Africa); and a late eighteenth-century form of face vessel: the British Toby. Furthermore, the vessels suggest the continuity of African beliefs.

Quilts

Female slaves continued to dominate textile production in the antebellum period, and after the Civil War women quilters dominated folk art genres. Numerous surviving quilts from the antebellum period are attributed to slaves. On plantations, slave women made quilts on their own or under the supervision of the slave-mistress. Learning from family members or the slave-mistress, black women excelled in making pieced, commonly called patchwork, appliqué, and embroidered quilts and coverlets. Upon seeing their work it is easy to understand how they earned incomes to purchase their freedom. One fine example of dexterity, and a masterpiece of design, using a pattern called 'Touching Stars', is a silk quilt [**21**] made by two slaves, Aunt Ellen and Aunt Margaret, who belonged to the Marmaduke Beckwith family at the Knob plantation in Kentucky.

Quilting bees or quilting parties were very much a part of plantation society in the nineteenth century. They were elaborate affairs, either sponsored by the slave-master or arranged impromptu by the slaves. Quilting parties provided opportunities for socialization and reinforced slave community ties, thereby making them significant social events that contradict the common belief that slave life disrupted African-American cultural traditions. During the antebellum period quilts were hung outdoors as signs: those with the colour black in them indicated a place of refuge (a safe house) on the path of the Underground Railroad. 'Jacob's Ladder' and 'North Star' patterns were

21 Aunt Ellen and Aunt Margaret

Silk quilt, 1837–50.

This quilt is made in the Touching Stars pattern. The two slaves who made the quilt for the Marmaduke Beckwith Morton family remained with them after Emancipation.

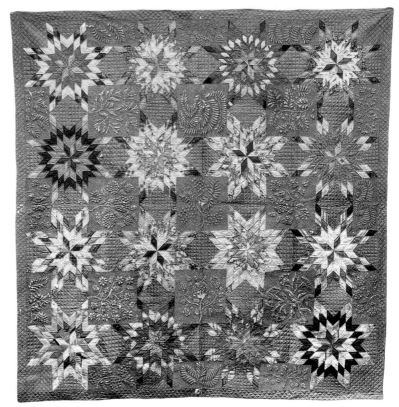

symbols for the Underground Railroad. In the Northeast free black and white women in abolitionist organizations such as the Female Anti-Slavery Society (established in 1834) made quilts at Ladies' Fairs or Ladies' Bazaars to raise money for abolitionist causes.

Two appliqué quilts by Harriet Powers (1837–1911), a former slave, create powerful narratives about Christian faith, oral traditions in the African-American community and autobiography. Narrative quilts are a distinctly American, and particularly African-American art form. The earliest Bible quilt [**22**] caught the attention of white American Jennie Smith, who saw it exhibited in the agricultural section at the Cotton Fair in Athens, Georgia, in 1886. Eleven panels illustrate Old and New Testament stories memorized from church sermons: Adam and Eve, Cain and Abel, Jacob, the Birth of Christ, Betrayal by Judas, the Last Supper, and the Crucifixion. Together they tell the story of fall and redemption. Powers eventually sold the quilt to Jennie Smith in 1891 because of extreme financial hardship, but only on the condition that she be allowed to visit 'the offspring of my brain'. Giving Smith a full description of each scene, Powers, who was illiterate, ensured that her testimony of God's word prevailed.

The second Bible quilt [**23**] of *c.* 1898 was commissioned from Powers by the wives of Atlanta University professors, who had probably seen the first Bible quilt, exhibited in 1895 in the Negro Building at

the Cotton States and International Exposition in Atlanta. Focusing on the sixth panel, 'Jonah cast overboard of the ship and swallowed by a whale', scholars have claimed evidence of Africanisms, because the simple flat shapes are like those found on Fon (West Africa) commemorative appliqué cloths. It is more likely, however, that materials, technique, and a wish for visual clarity were responsible for the style, rather than cultural memories of African appliqué textiles. Ten of the fifteen scenes illustrate the Old Testament (including Moses, Noah, Jonah, and Job) and there are scenes from the New Testament (including Christ's baptism and crucifixion). Scripture is more here than a story about salvation and redemption; it becomes a metaphor for freedom. Commonly, among black preachers and in the black spirituals, Joshua, Jonah, Moses and Noah were seen as children of the Hebrews, those who were delivered from their persecutors in this world and not in the afterlife. They were seen in the larger context of uniting one's present condition with the ritual and mythical past, and linking it also to the possibility of rebirth in the future. When seen as a post-Emancipation period narrative, Powers's quilts confirm the realization of a change from slave to free person, a personal experience of deliverance.

22 Harriet Powers
Bible quilt, 1886.
This quilt has faded considerably: the light tan background was originally deep pink, and the brown sashing between squares was green.

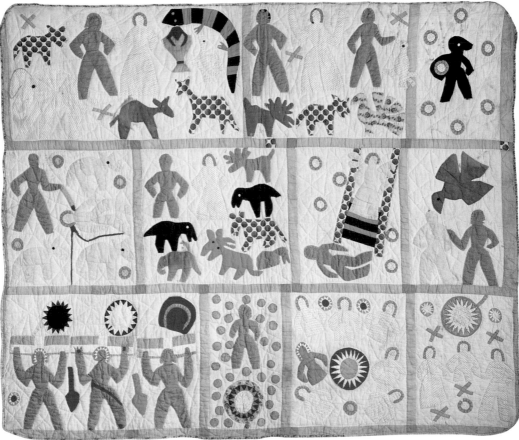

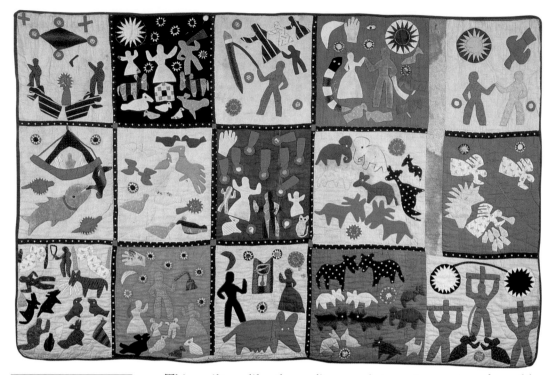

This quilt, unlike the earlier one, interprets events and parables culled from the oral traditions of the community between the religious scenes. Thus in panel 13:

Rich people who were taught nothing of God. Bob Johnson and Kate Bell of Virginia. They told their parents to stop the clock at one and tomorrow it would strike one and so it did. This was the signal that they had entered everlasting punishment. The independent hog which ran 500 miles from Georgia to Virginia her name was Betts.

There are natural disasters as representations of divine warning, as in panel 8:

The falling of the stars on November 13, 1833. The people were frightened and thought that the end of time had come. God's hand staid the stars. The varmints rushed out of their beds.

Both quilts are mnemonic texts for Powers. For by viewing them she would see represented her black southern culture and genealogy in the folktales, biblical stories and oral histories. Harriet Powers's Bible quilts remind us of the narratives of those ex-slave women who, in dictating their story, overcame illiteracy to celebrate freedom and to deny anonymity.

In African-American decorative and folk art, we see evidence of acculturation—Dolliole's creole cottage, Day, Barjon and Lee's furniture; Dave's pots, the quilt of Aunts Ellen and Margaret; and

syncretism—Afro-Carolinian face vessels; Harriet Powers's Bible quilt, and the shotgun house. Only in rare instances is there strong retention of African culture, as seen in Gudgell's walking-stick or in Tahro's Kongo-designed and -constructed home in South Carolina. It seems, then, that in the nineteenth as in the previous century, white consumers and urban environments determined the degree of artistic acculturation during the antebellum period. Likewise, the few extant examples of folk art and architecture from the late eighteenth century which show African forms and/or African-derived content, such as Tahro's house, face vessels, and Powers's quilts, indicate that one would be most likely to find artistic Africanisms in large black communities in the rural South.

Fine arts: Painting, sculpture, and graphic arts

Struggling against the European view that Americans lacked any significant achievement in the arts, young Americans choosing careers in the arts were eagerly greeted as patriots and heroes whose careers proved that the new nation was rising above merely material and commercial endeavours. The American republic demanded American subjects in art and that Americans support the arts. Art was a means of social legitimization among all Americans, a way of transcending lower middle-class origins, and, for blacks, race. The goal of the African-American artist was, when seen in a broader cultural context, the same as that of any American artist. Hence African-American intellectual Edward M. Thomas's comments in 1862: 'Where the Fine Arts are not reflected, there exists some great fault in construction of a nation, and … the individual.' By mid-century, members of the free African-American middle-class community were also encouraging and promoting the African-American fine artists, who were considered a 'credit to the race'. Their works were praised in their own time as the very flower of Negro culture. Between 1852 and 1887 the black press and several publications by African-American authors, including Martin R. Delaney, William Wells Brown, and William J. Simmons, all extolled the achievements of African-American painters, printers, and sculptors as those of exemplary citizens. The free blacks hoped that education and the political, economic and cultural achievements of individuals would 'uplift' the race. These 'race men' and 'race women', with their exemplary public presence, would expose misconceptions about race and gender stereotypes and the injustices of slavery.

Exhibitions and the viewing public

To understand the cultural significance of African-American art works, we must also consider their audience and the circumstances under which these works were viewed. What assumptions did viewers hold about the art and what expectations did the viewers have in antic-

ipation of seeing the work? Artists earned money and gained critical fame by exhibiting their works publicly. There were four main venues for exhibiting: private galleries, public exhibition spaces, entrepreneurial exhibits, where an artist or agent charged admission for viewing a single work of art, and massive fairs or expositions, where art objects were viewed alongside machinery or agricultural products. In addition there was an entirely private venue: the home of a patron–collector.

By the 1850s the newly wealthy Americans had also become interested in collecting art, and displaying decorative arts and fine arts in the same room. In such a context, artworks in private homes functioned as both spectacle and possession. As a status symbol, art was cultural capital. Consequently the collector laid claim to and also defined taste or culture.

Before the rise of municipal museums in the 1870s and 1880s, only a few art institutions existed, such as the New York Academy of Art (est. 1803), the Boston Athenaeum (est. 1807) and the Pennsylvania Academy of Fine Arts (est. 1805), where very few African-American artists exhibited. Robert Douglass Jr and Henry Ossawa Tanner exhibited at the Pennsylvania Academy of Fine Arts; Edward Bannister at the Providence Art Club. African Americans looked mainly to public exhibition spaces, where the upper middle-class and wealthy could view quality art, hung row upon row on the walls. One such place, a

viewing studio–gallery, was owned and operated by an African American: James Presley Ball (1825–1905), a photographer active from the mid-1840s to the 1860s in Cincinnati, Ohio. Ball's Great Daguerrean Gallery of the West (at that time Ohio was considered 'West', whereas today it is considered Midwest) opened in 1847, becoming the largest such gallery in the region. A description published in *Gleason's Pictorial* [24], a pictorial weekly of the mid-century, reveals the popularity and scale of Ball's business and studio:

It occupies four rooms and one ante-chamber on the third, fourth, and fifth stories. Mr Ball takes [daguerreotypes] with an accuracy and a softness of expression unsurpassed by any establishment in the Union. The fourth room is the great Gallery: it is twenty feet wide by forty long. The east wall is ornamented with one hundred eighty-seven of Mr Ball's finest pictures. Babies and children, young men and maidens, mothers and sires look you in the face. [There are] five or six splendid views of Niagara Falls. No wonder then that there is daily such a rush for this gallery![5]

Among the photographs were landscape paintings by Robert S. Duncanson (see pp.81–5). Americans who could not afford to buy a painted American landscape could buy a photograph of one.

The alternative to public museums or galleries was the public exhibition. Such exhibitions were staged by individual entrepreneurs, either the artist or the agent, in rented rooms in cities. A single or several works would be displayed and admission charged to view them. Press previews of new exhibits ensured that hundreds of viewers attended. As a result exhibitions became popular media events.

One type of highly successful exhibition and art genre was the panorama, which toured American cities. *Ball's Splendid Mammoth Pictorial Tour of the United States* (1855), a hand-painted photographic panorama 600 yards (549 m) long, on which Robert S. Duncanson and other African-American painters worked, was accompanied by a pamphlet in which Ball expressed his anti-slavery sentiments by showing not only Africa and the slave trade but also landscape as representing nature used for capital gain. Advertised in the *Liberator*, the *Pictorial Tour* was assured attendance when it travelled around the country. Large audiences for such exhibitions raised the public stature of the artists, as well as defraying expenses and, if things went well, providing an income for the owners, or artists, or both.

Henry Ossawa Tanner's paintings were exhibited at the Cotton States and International Exposition, Atlanta of 1895, where, coincidentally, Harriet Powers displayed her Bible quilt. Robert C. Ogden, a white American businessman from Philadelphia, was responsible for exhibiting Tanner's work in the Negro Building. He felt that Tanner's paintings 'would have lost their distinct race influence and character if placed in a general art exhibition', and his purpose was 'to get the

influence of Mr Tanner's genius on the side of the race he represents'. One of the more important nineteenth-century American public exhibitions was the Philadelphia Centennial Exposition of 1876, at which the works of two African-American artists, Edward M. Bannister and Edmonia M. Lewis, were exhibited among hundreds of works by European and white American artists. These vast exhibitions garnered a lot of attention for the artists, and some newspaper reviews and articles, but not necessarily patronage.

Abolitionist patronage

Many African-American artists benefited from abolitionist patronage. Organizations, families and individuals, from the United States and England, mostly American commercial businessmen and landholders, played an important role, enabling artists to achieve professional status by commissioning portraits and sponsoring trips abroad. Their activities occurred in major northern cities, including Philadelphia, Boston, Cincinnati, and New York. Many were wealthy, middle-class citizens who also wanted to express their cultural sensibilities and aspirations by acquiring art and promoting American artists. They felt that aggrandizement of wealth and patriotism were not incompatible with anti-slavery sentiments. Abolitionist newspapers, such as the *Liberator*, the *National Anti-Slavery Standard*, and *A. M. E. Christian Reader*, published reviews and reports on artists' works. The content of these essays was usually a discussion of subject-matter, and the artist's biography, which specified race. Artists promoted by white and black abolitionists effectively and visibly represented an alternative image of the black man and woman for two different but not necessarily exclusive agendas: upholding Christian morality, and exposing the folly of racial prejudice by demonstrating the humanity of blacks.

25 Robert S. Duncanson

Uncle Tom and Little Eva, 1853.

Harriet Beecher Stowe's novel, *Uncle Tom's Cabin* (1852) became very popular among anti-slavery groups in Great Britain and the United States. Duncanson copied this scene from an engraving that illustrated the original edition, depicting Tom and Eva gazing at the heavens by the edge of Lake Pochantrain, Louisiana.

Another reason for the close association between black artists and abolitionists was the latter's belief that images were very effective tools to proselytize their cause. Abolitionists insisted that these images were a truthful depiction of actual events or individuals. Production of images was prolific in order to appeal to the public's imagination. They appeared in broadsides, newspapers, books, and periodicals. The black person was humanized and not intimidating. Portrayal as victim was very common. The goal was to appeal to the viewer's emotions. Supporters of slavery often characterized these images as 'incendiary'. In 1835, for example, President Andrew Jackson (1829–37) urged Congress to pass a law prohibiting, 'under severe penalty', their circulation in the South.

Abolitionists were inclined to commission works specifically about an African-American subject. Harriet Beecher Stowe's novel, *Uncle Tom's Cabin* (1852), was first serialized over a year in the abolitionist newspaper *National Era*, beginning in 1851. It was circulated fervently in anti-slavery circles in the United States and Great Britain, to kindle support for abolition. Readers were untroubled that the plot, while enlisting their sympathy, had derisive connotations for blacks. The novel inspired many commissions by white patrons. The Duchess of Sutherland, who was a friend of Stowe, in 1856 commissioned Eugene Warburg to carve several sculptural reliefs (untraced) on the subject.

Another abolitionist, James Francis Conover, who had just moved from Cincinnati to Detroit, commissioned a painting from Robert S. Duncanson, who responded with *Uncle Tom and Little Eva* (1853) [25]. The painting drips with romantic sentimentalism. This aesthetic softening—the daintiness of the foliage, rosy-pink skies, and pious gesture—may be construed as a feminization of art. Critical language about nature and art, with descriptions such as 'refined beauty' and 'delicate feeling of colour', evoke comparisons with sentimental literature of women abolitionist authors, such as Stowe. The painting has been interpreted as a contemplative moment that reflects a central theme of *Uncle Tom*: salvation through spiritual love and sacrifice, and a belief in salvation from the evil of slavery. Critics focused on the subject; one in the *Detroit Free Press* called the work 'Uncle Tomitude'. Even Duncanson ridiculed it, suggesting his discomfort with the subject. Another, more cynical, note resounds in a comparison of the painted scene with the subject's portrayal in popular theatre. There was around the same time a most influential theatrical version, *Uncle Tom's Cabin*, by George Aiken (1830–76), a writer of musical plays. In Aiken's interpretation there is a shifting of attention away from Tom and his family to the relationship between Tom and the young white child whose life he saved. In doing this, Aiken conveyed the notion, attractive to antebellum whites, that the slaves' love for their masters could exceed that for their own families.

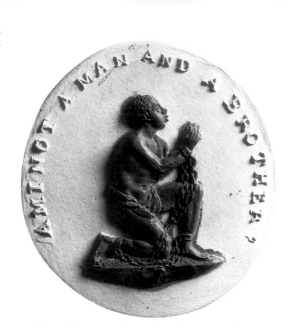

Portraiture continued to be a popular genre for African-American artists. The majority of paintings were portraits depicting popular abolitionist personalities, like Abraham Lincoln; prominent abolitionists, like William Lloyd Garrison and Charles Sumner; folk heroes like John Brown and Colonel Robert Gould Shaw; black abolitionists like Frederick Douglass, Dr John V. DeGrasse; Bishops Jermain W. Loguen and Daniel A. Payne of the African Methodist Episcopal Church. Furthermore, prints and drawings of ex-slaves' portraits were popular, often being used as illustrations for published autobiographies sponsored by white abolitionists.

Abolitionists also distributed slave emblems. Printed on letterheads, coins, crockery, needlework, tokens and medallions, was their most famous image: the half-nude black kneeling to convey Christian pathos. A member of the English Committee to Abolish the Slave Trade, the potter Josiah Wedgwood (1730–95) employed his chief modeller, William Hackwood, to design a cameo entitled *Am I Not a Man and a Brother?* [**26**]. A package of these was sent to American statesman, scientist and writer Benjamin Franklin (1706–90), who was president of the Pennsylvania Abolition Society. Franklin wrote the following to the English society: 'I have seen in their [viewers'] countenances such Mark of being affected by contemplating the Figure of the Supplicant that I am persuaded it may have an Effect equal to that of the best written pamphlet, in procuring favour to those oppressed People.' Presses in Boston, Philadelphia and New York made the kneeling slave a popular media image.

As African-American abolitionist Angelina E. Grimké expressed it: 'Until the pictures of the slave's sufferings were drawn and held up to public gaze, no Northerner had any idea of the cruelty of the system …

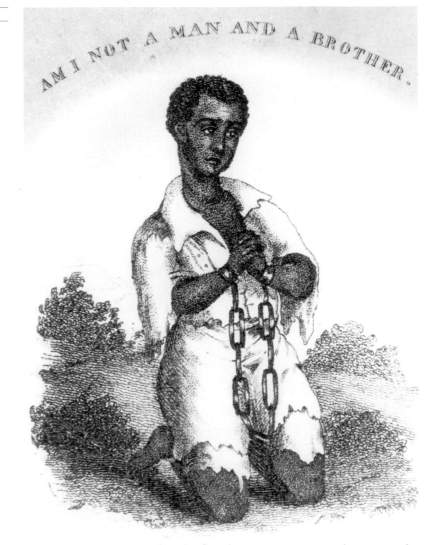

and those who had lived at the South ... wept in secret places over the sins of oppression. Prints are powerful appeals.'[6]

Graphic arts

Patrick H. Reason (1816–98), a printmaker active between *c.*1835 and 1850 in New York, produced engravings, mostly for male and female, white and black anti-slavery societies, one of which, the New York Anti-Slavery Society, sponsored him to study the technique in London. In 1839, Reason copied Wedgwood's image in a copper engraving of the same title [**27**] for an African-American benevolent organization called the Philadelphia Vigilant Committee. Reason, however, altered Wedgwood's composition—a pious figure kneeling with hands clasped in prayer and head turned upward—by depicting the man turning towards the viewer, gazing piteously slightly down-

ward and wearing the tattered European clothing of an American slave. The rural, presumably southern, landscape shows the figure in a real, not abstract world, and this, combined with the figure's appearance and gaze, produces an image which plays both to sentimentalism and to African-Americans' view of themselves as intelligent people, not bondsmen. It counters the stereotype of Wedgwood's Christian image of blacks as docile.

The engraving of the portrait of *Henry Bibb* [**28**] illustrated the former slave's autobiography, *Narrative of the Life and Adventures of Henry Bibb, an American Slave* (1850). It is representative of African-American portraits, which always presented a dignified posture, with contemplative or serious demeanour, in this instance used to amplify the intellectual and moral character of the sitter. The popularity of slave narratives provided an opportunity for African-American artists to promote both themselves and abolitionism among the upper and middle classes.

Jules Lion (*c.* 1809–66, active 1836–66) had immigrated from France to New Orleans in 1827. Although virtually nothing is known about his training, Lion acquired sufficient skills to be awarded an honourable mention for his lithograph, *Affût aux Canards* (The Duck Blind/Hide) in the Paris Exposition in 1833. After twelve years in New Orleans, he returned briefly to France in 1839, where he learned the daguerreotype process. On his return to New Orleans in the same year he advertised his daguerrean views of the city landmarks in the city directories and local newspapers. Lion was among the first American artists to open a daguerreotype studio in the United States, and the first to exhibit

28 Patrick H. Reason
Portrait of Henry Bibb, 1848.

daguerreotypes in New Orleans. As a means of promoting this new photographic process, he held an exhibition in 1840, selling lottery tickets for a prize of a daguerreotype. He also attained popular and critical eminence in lithography, especially his portraits of prominent Louisianans, after 1840. Lithography (invented 1798 in Munich) became popular around the middle of the century in America and provided an inexpensive alternative to photography, and widely accessible reproductions of city- and landscapes. The influence of photography is apparent in Lion's lithograph *View of Chartres Street, New Orleans* [**29**], a light-filled scene, with realistic rendering of spatial perspective, value contrasts of light and dark, precision of detail and superb draughtsmanship; and a stillness of mood and design. For the next 25 years, until 1865, Lion operated a lithography and daguerreotype studio first in the French Quarter, and later in Faubourg Marigny.

Landscape painting
Landscape painting, which in the previous century was secondary to portraiture, dominated the American art world from around 1830 until the end of the century. Between 1820 and 1870 landscape was a very popular painting subject, and used as a vehicle for moral imperatives, spiritual inspiration, and didactic messages. It embodied the romantic ideals of Ralph Waldo Emerson (1803–82) and also those of the Jacksonian era by representing an American subject in art. Wilderness pride, new political order, the regenerative powers of the 'New World' and futurity were all encoded in the arts. Artists simultaneously presented the public with the native character of American geography, its revelation of God's presence, and a political ideology of 'Manifest Destiny'. Realism frequently merged with sentimentalism and the sublime, undercutting the political realities and establishing an ideology about culture that functioned as a model of the 'true' American.

By mid-century large landscape paintings displayed broad comprehensive views and deep spatial illusionism. Nature had become a metaphor for America. And what better way to represent individualism, freedom, the land of opportunity and democracy than the landscape of the Ohio River Valley, Hudson River Valley, Pacific Northwest and West?

Robert Scott Duncanson (1821–72) taught himself about art by studying and copying engravings of famous European paintings. By 1842, while travelling between Monroe, Michigan, Cincinnati, and Detroit, he was painting mostly abolitionist portraits and landscapes. Within approximately fifteen years he was proclaimed the 'best landscape painter in the West', earning his reputation during frequent trips abroad to exhibit in Canada, Scotland, England, and Italy, becoming the first black to receive international recognition.

29 Jules Lion

View of Chartres Street, New Orleans, 1842.

His artistic success has been partly credited to the benevolence of American and English abolitionists, including William Berthelet, Bishop James Payne, Harriet Leveson-Gower, the Duchess of Sutherland and her friend Charlotte Cushman, and abolitionist organizations such as the Western Freedman Aid Society and the American Anti-Slavery Society. Duncanson's first substantial commission came from one of the wealthiest entrepreneurs in the country, and one of Cincinnati's most prominent art patrons and abolitionists, Nicholas Longworth, in 1850. The eight murals [**30**], rediscovered in

1930 under layers of wallpaper, depict landscapes of the American West, several in the style of the Hudson River School.

Shortly after 1850 Duncanson was one of a group of painters, including T. Worthington Whittredge (1820–1910) and William Sonntag (1822–1900), who helped define a regional landscape art known as Ohio River Valley style, that was fostered by the exhibition in Cincinnati of paintings by Thomas Cole (1801–48), the founder of the Hudson River School. In 1853, Duncanson travelled with William Sonntag to Italy. Around that time, Duncanson finished his most familiar work, *Blue Hole, Flood Waters, Little Miami River* [**31**]. It displays the conventions of the classic Hudson River style, similarly functioning as a representative national landscape. The emphasis is on wilderness, with little evidence of man's intrusion. By using the popular image of boy-in-nature as a narrative device, Duncanson humanizes the landscape, alluding to innocence. The central opening of space, the shimmering area of water, and triangular framing of the sky by trees, convey a sense of expectancy in what lies over the horizon, reflecting a spirit of optimism that typified Jacksonian America.

The Civil War discouraged outdoor sketching (as studies for finished works), a fact which helps explain the increasing popularity of

31 Robert S. Duncanson

Blue Hole, Flood Waters, Little Miami River, 1851.

Large landscape vistas like this one were not only influenced by the Hudson River artists' philosophy, but were made with the help of daguerreotypes which Hudson River spokesman, Ashur B. Durand, urged artists to use as a 'quick mechanical means to record details and scenic vistas and to provide more time for studio work'. Duncanson had experience with photography. He worked in James P. Ball's studio, and briefly as a photographer. Duncanson also used stereography (1850–90) to make studies for his landscape paintings.

literary paintings in the mid-century. Duncanson was a member of the Cincinnati Sketch Club and in the late 1850s and again in 1861 participated in their discussions about literary subjects taken from the works of Lord Byron, Thomas Moore, and John Milton. He continued to use literary subjects in his works for the rest of his life, particularly scenes taken from the works of Sir Walter Scott, who had become very popular with American readers.

Among Duncanson's literary paintings were large-scale works, usually called salon paintings (after the large-scale history paintings exhibited at the Paris Salon) or 'grand pictures'. These 'touring exhibition' pictures, displayed in public halls such as Pike's Opera House in Cincinnati, catapulted him to fame. The plot-based landscape helped organize the meaning(s) of landscape imagery by imbuing it with literary and religious content. This appealed to viewers, who valued the social associations of the literary work itself: its tone, class assumptions, and reading audience, and the author's success and social status. The robust landscape that represented expansionist democracy gave way to elegance, a feminization of landscape that represented middle-class values, and culture.

On 30 May 1861 Duncanson arranged a public viewing at Pike's Opera House. Hanging opposite *Western Tornado* (purchased by Charlotte Cushman as a gift for the Duchess of Sutherland) was the work that would earn him international fame: *Land of the Lotus Eaters* [**32**]. Based on Tennyson's poem, 'The Lotos-Eaters' (1862), it displays

32 Robert S. Duncanson

Land of the Lotus Eaters,
1861.

a panoramic view of lush, tropical land overgrown with delicately rendered exotic foliage, with serpentine rivers and streams, mountain peaks in the far distance, and an overall golden tonality. Here the scenery, like theatre, is partly constructed, both artificial and real. Duncanson used the painting technique and style of luminism: a lack of one particular viewpoint, clarity of light, lots of clouds and sky, and a long horizontal format to convey a more reflective and sublime image.

Shortly thereafter, Duncanson took the painting to Toronto where it was exhibited in 1861, and then to Montreal in 1863, where he—with other American landscape painters—stimulated a younger generation of artists to establish the first Canadian 'school' of landscape painting. After remaining in Montreal for two years, he decided to travel to Dublin, Glasgow and the Scottish highlands, and London to exhibit the painting. This took him from 1865 to 1867. Critics and audiences in the United States and in England were full of praise, frequently making comparison with Frederick E. Church's *Heart of the Andes* (1859). One notice—in the London *Art Journal* (1866)—read:

America has long maintained supremacy in landscape art, perhaps indeed its landscape artists surpass those of England. Certainly we have no painter who can equal [Frederick] Church ... we are not exaggerating if we affirm that the production under notice may compete with any of the modern British School. Duncanson has established high fame in the United States and Canada.[7]

Land of the Lotus Eaters is an escapist landscape. A crisis of spirit is deceptively rendered in a sentimental vision. The South had seceded from the Republic in 1860, and a political/economic crisis loomed over the immediate horizon. Duncanson's seductive inhabitants are dark skinned, and the men drugged by lotus, languishing in a tropical

The Hudson River School

The **Hudson River School**, a label used from the late 1870s, denotes a loosely organized group of artists based in New York, who specialized in landscape painting. They were active from *c.* 1825 to 1870, the 1850s and '60s being the period of most characteristic production. It was not a school in the strictest sense, i.e. centred on a specific studio or academy. The valley of the River Hudson from New York to the Catskill Mountains was the symbolic and actual centre of activity, but was not the only area depicted.

Thomas Cole (1801–48), whose romantic ideas of the picturesque and the sublime were fostered by Ralph Waldo Emerson, is the school's acknowledged founder and the key to its establishment. Cole's European training lent the imprint of established art to his views of American scenery. Related to Cole's treatment of landscape was the work of writers such as William Cullen Bryant (a friend and admirer of Cole) and James Fenimore Cooper, which celebrated American scenery in prose and poetry.

By the 1840s the Hudson River School included Thomas Moran (1837–1920), T. Worthington Whittredge, Ashur B. Durand (1796–1886), John F. Kensett (1818–72), and Frederick E. Church (1826–1900), a pupil of Cole. They showed regularly at the annual exhibitions held by the National Academy of Design and the American Art Union.

After Cole's death the Hudson River School grew under the leadership of Durand, who became the principal spokesman and theorist. He stressed 1) the actual study of nature, 2) meticulous preparation by sketching, 3) carefully conceived studio paintings. There were two types of composition: expansive vistas and vertical forest interiors. The artists travelled widely, painting and sketching in remote regions of the northern United States, Canada, the Arctic, the American West, and South America. Their focus on the uncivilized and unsettled land evoked a lyrical and mystical view of nature, which after the 1870s was considered old-fashioned.

Luminism is considered by some scholars to be a distinct landscape style; by others to be part of the Hudson River School tradition, primarily in the 1850s and 1860s. As with the Hudson River School, nature was the inspiration and subject. Compositions are meticulously rendered, with sky and clouds consuming large areas of the canvas and with no foreground barrier. The paintings shift from theatrical narratives to scenes of metaphorical significance. Painters like John F. Kensett and T. Worthington Whittredge, and founder Fitz Hugh Lane (1804–65), sought to render the mystical effects of diffused light, giving a dreamily poetic atmosphere. Many of the artists were influenced by photography, as was the Hudson River School.

landscape, represent the African-American slave and the indolence of the South. The iconology of this painting transforms the meaning of Tennyson's poem. Its poignancy is heightened when it is interpreted within the context of American political history and the social history of the artist's own race and culture.

Other landscapes by Duncanson were concerned with black social conditions in antebellum and reconstruction America. Works dated before 1865 hold a double-coded meaning, one for whites, another for blacks, which revises the old formulaic comprehension of the 'magisterial gaze' (as an evolutionary movement from wilderness to civiliza-

tion) to one about slavery and emancipation. The tale of the slave George Washington McQuerry, who escaped in 1849 and eventually settled in a small community in Miami County, Ohio, was well known among blacks in that region. Therefore *Blue Hole, Flood Waters, Little Miami River* could be understood as not just a bucolic fishing scene, but a tribute to black life and freedom. Fleeing the United States during the Civil War (often sponsored by an abolitionist society), Duncanson used fictional protagonists in his literary paintings as the key with which viewers could unlock social comment on freedom and bondage, and moral decline. The very escapism embodied in landscape painting inevitably levelled a critique at the abusive social order that produced the need for such escape. Viewing Duncanson's landscapes as escapist images can reveal a political subtext within his paintings.

American artists ventured into the wilderness like scientists exploring new terrain. Grafton Tyler Brown (1841–1918) spent much of his life and professional career in the Pacific Northwest and San Francisco, California. Migrant blacks, like other Americans, sought a place to achieve wealth and status and to realize the American dream, which had been unattainable in the Northeast. The discovery of silver and gold provided an additional incentive to go west. On the eve of the Civil War Brown joined the pioneers.

Brown represented a particular type of American character, ambitious, an entrepreneur and, most of all, unable to resist wanderlust. In 1861 he worked as a draughtsman and lithographer for Charles C. Kuchel, a German lithographer in San Francisco, where he drew and printed stock certificates, street maps, and views of mining towns which promoted real estate development and westward migration from the eastern United States. In 1866, and for the next twelve years, Brown owned or co-owned a lithography company on Clay Street (known as 'Lithographers' Row'), attracting important clients, including the Wells Fargo Mining Company, Levi Strauss and the Ghirardelli Chocolate Company.

Brown soon sold his business and once again travelled, sketching as he went, to Vancouver, British Columbia, the Northwest Territories, and the Pacific Northwest—Washington, and Portland, Oregon—before eventually settling in St Paul, Minnesota by 1890.

His skills as a topographical draughtsman and lithographer, and his knowledge of photography (stereoscopy) and his travel experiences are readily apparent in one of his later paintings, *Grand Canyon of the Yellowstone from Hayden Point* [33]. Terrain, trees and water shaped by moderately impressionistic brushstrokes of paint characterize his mature painting style. Placing the viewer at a high vantage point, the sweeping, rapidly receding space from foreground to far distance conveys the overwhelming power of nature. At a time when Manifest

Destiny, economic progress, and the civilizing missions of the entre-
preneurial class had been achieved, *Grand Canyon* represents a nostal-
gic view of the past, when landscapes of a specific region of the
continent were popular representations of a national vista. The govern-
ment had already begun setting aside wilderness sites like Yellowstone
(the oldest National Park, established in 1872) for conservation and the
enjoyment by the public.

Most of Brown's known works date from the mid-1880s to the mid-
1890s, when there was increasing racial divisiveness and segregation.
We can therefore read his landscapes as expressing an alternative view
of individual freedom. The dramatic scenes he depicted were of places
where few blacks actually lived, and those few did so virtually free of
racism. While these landscape views reflected whites' ideas of nation-
hood, for African-Americans they were ironic images about freedom
and a process of cultural colonialization.

Edward Mitchell Bannister (1826/7–1901), another major African-
American fine artist, did not have the benefit of a European tour. Self-
taught, he painted subtly luminous and atmospheric landscapes, which
by the time of his death had fallen out of favour. In 1850 he settled in
Boston, Massachusetts, an important abolitionist city, which, with the
third largest free black population in the Northeast, provided eco-
nomic, artistic and social opportunities for a successful career as an
artist and political activist. Assisted by his wife, and with support from
middle-class black abolitionists, including Dr John V. DeGrasse and
William Cooper Nell, Bannister began his career as a portrait, land-
scape and seascape painter.

He proved to be a moderately successful portrait painter of African
Americans, and also, to judge by the advertisements of his skills that he
placed in the *Liberator* in the 1850s and in 1863 and 1866, not only a
painter but a portrait photographer. His experience as a photographer
and his painterly technique are both evident in the dignified portrait,
Newspaper Boy [**34**] which Bannister completed just before moving to
Providence, Rhode Island in October 1869. A middle-class young man
stands mid-point between pose and gesture, with a serious expression.
Bannister has captured the moment with abbreviated, visible strokes
of paint and muted colour tones. *Newspaper Boy* provides a singular
glimpse into the industrious urban life of the African-American
middle-class.

In Providence there was a growing art community, and many
wealthy white art patrons who increasingly supported Bannister's
efforts in the 1870s. Shortly after his arrival there Bannister completed
his most renowned painting, *Under the Oaks* (untraced), which was
first exhibited in 1876 at the Massachusetts Centennial Art Exhibition
at the Boston Art Club and, during the same year, at the United States

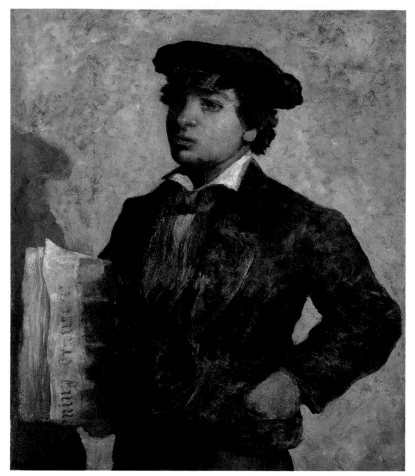

34 Edward Mitchell Bannister
Newspaper Boy, 1869.

Centennial Exposition in Philadelphia, where it won a Certificate of Award and a first-place bronze medal. Bannister, the first African American to win a national award, immediately gained national attention. Bannister recalled his moment of claiming the prize:

I learned from the newspapers that '54' had received a first-prize medal, so I hurried to the Committee Rooms. There was a great crowd there ahead of me. As I jostled among them many resented my presence, some actually commenting within my hearing in a most petulant manner, what is that colored person in here for? I endeavored to gain the attention of the official in charge. He was very insolent. Without raising his eyes, he demanded in the most exasperating tone of voice, 'Well what do you want here anyway? Speak lively.'
 'I want to enquire concerning 54. Is it a prize winner?'
 'What's that to you?' said he. I was not an artist to them, simply an inquisitive colored man; controlling myself, I said deliberately, 'I am interested in the report that *Under the Oaks* has received a prize; I painted the picture. 'An explosion could not have made a more marked impression. Without hesitation he apologized, and soon every one in the room was bowing and scraping to me.[8]

The African-American and American press praised his work, calling it 'the greatest of its kind that we have seen from an American Artist', or an 'example of the power of this race to achieve great results in art'. Subsequent exhibitions enhanced his reputation as a great painter of New England land- and seascapes culminating in a triumphant retrospective exhibition at the Providence Art Club, which he helped found, in 1891.

In a lecture, 'The artist and his critics', given in 1886 at the Rhode Island School of Design, Bannister expressed his admiration for the painters Washington Allston, a leader of the romantic movement in American art, and Jean-François Millet, a French artist associated with the Barbizon School. Allston's view of art capturing the spiritual in nature and Millet's nostalgic yet realistic scenes of peasant life expressing anti-industrialism are evident influences. Bannister also picked up on the intimate views of nature showing dense masses of foliage and emphasizing the seasons and weather.

In *Approaching Storm* [35] a lush stand of trees is seen against heavily atmospheric sunlit skies with blustery nebulous clouds. The horizon line is low and the painterly surface softly textured, showing an intimacy, a new subjectivity not seen in the Hudson River tradition. The drama of a man struggling against an oncoming storm, a familiar theme in American painting, functions as a metaphor about humankind, conveying the uncertainty of life's struggle.

Bannister's landscapes depict the supremacy of nature—a kind of universal spiritual harmony in which humankind is unobtrusive and unimportant. Exploration of formalism always takes precedence over any anecdotal passages. Realism meant not specificity of detail, but of time, seasons, and rituals of daily working life. These traits are evident in *Haygatherers* [36]. Bannister effectively adapted the style tenets of this familiar European theme to suit an American context in which stability was desired during a period of rapid social change.

Approaching Storm and *Haygatherers*, both characteristic of landscape painting in the late nineteenth century, represent rural Arcadia.

Neoclassical sculpture
Idealized figural sculpture was the most popular art form during a revival of classicism in the United States, primarily in the first half of the nineteenth century. There were no American fine art sculptors before 1825, only self-taught artisans. Artists revived the concept that the human body was the ultimate artistic ideal. Marble, life-size figures, usually of a partly clothed or nude female, were generally singular, in the round, but conceived on a frontal axis. Marble provided an abstraction of form that made nudity acceptable for citizens of the Victorian age. Sculptors portrayed allegorical subjects taken from literature, history, mythology and the Bible, and were judged by how well

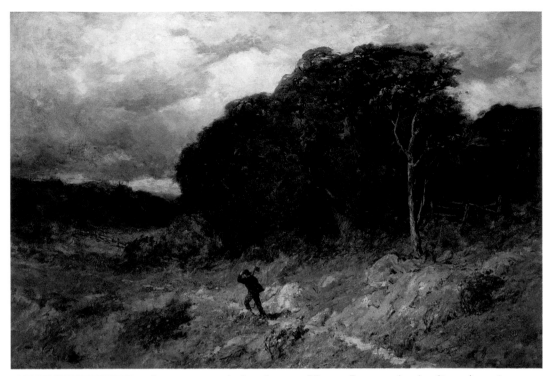

they conveyed the drama. Henry James, the leading American art critic of the mid-century, insisted that 'art is a language. ... Language is but the medium of ideas, the expression of sentiment'.

Neoclassicism represented a kind of romantic 'escapism' partly spurred on by the mid-eighteenth-century archaeological excavations in Pompeii and Herculaneum. Americans followed their European counterparts in their enthusiasm for the antique. Neoclassicism stood for the nobility and grandeur of great civilizations; and America saw itself as a modern re-creation of the civilization of Rome, echoing Rome's military acumen and territorial expansion, town planning and system of law. Art, as during the antique era, represented ennobling ideas and concepts like truth, justice, and reason. During a period of social reform, the idealized body deflected political concerns, especially when infused with sentimentality. Furthermore, for a young nation, neoclassicism gave a sense of history and authenticity.

Neoclassical sculpture reached a peak of popularity in America between 1830 and 1876. Americans who travelled to Florence and Rome as part of their Grand Tour gazed upon antique classical forms and familiarized themselves with European neoclassical sculptures. While abroad, they commented and wrote critiques on European art, and sought out American artists living there, visiting their studios and having their portraits sculpted. They also bought miniature souvenirs of sculptural masterpieces. The old and newly wealthy Americans bought idealized figural sculpture as a token of status and success.

In the period 1850–75, the second generation of American neoclassical sculptors were in Rome rather than Florence, studying the original antique works, and relying on skilled workmen to copy their plaster models in Carrara marble. These younger American sculptors included women; and all of the American sculptors, while recreating classical antique forms, gradually worked realism into an austere idealized style, emphasizing the narrative.

Eugene Warburg (1826–59), born a slave, is typical of those mid-nineteenth-century American sculptors who arrived at sculpture through the artisan tradition. He was a marble-cutter and tomb-sculptor who progressed to portraiture. Our knowledge about his professional career is based upon three documented works—including one ideal figure, *Ganymede* (1850; untraced), exhibited and sold in a raffle at Hall's gilding establishment in New Orleans—and only one known work, a bust of the United States minister to France, *Portrait of Young John Mason* [37]. The bust is executed in the style of idealized naturalism that closely follows Roman classical portraiture. In 1857 Warburg visited Florence and eventually settled in Rome, where he died in January 1859.

Edmonia M. Lewis (1845–?1911) was the first African-American sculptor to achieve national and international critical recognition. Despite this status, financial success eluded her, and her hardships were severe, especially towards the end of her life. An explanation for her lack of commercial success may lie in her chosen subject-matter: African Americans and American Indians. Her heroes and heroines were

The Barbizon School and American romanticism

The **Barbizon School** (*c.* 1830–*c.* 1870) refers to an informal group of artists who, led by Theodore Rousseau (1812–67), painted romantic views of rural landscape in the vicinity of Barbizon, France. Narcisse Diaz de la Peña, Jules Dupré, Charles Daubigny and Jean-François Millet (1814–75), who joined the group in 1848, painted scaled-down intimate landscape views that reflected pastoral, cultivated land. They observed nature, directly, painting out-of-doors, in order to capture the daily habits of life of rural people and the changing light. In their interest in these features they showed the influence of seventeenth-century Dutch landscape painters. Paintings of this school are characterized by earth-tones, softly textured painterly surfaces, and atmospheric scenes of pastoral landscapes, capturing different times of day and varying weather. Closer viewpoints provide an intimacy not seen in the works of the Hudson River School. Realism is tempered with sentimentalism; nature was seen as a shelter for those disillusioned with industrial urban society. Millet's romantic veneration of peasant life was promoted in the New England states by a friend and former neighbour, the American painter William Morris Hunt (1824–79), and the Barbizon School influenced late nineteenth- and early twentieth-century American landscape painters.

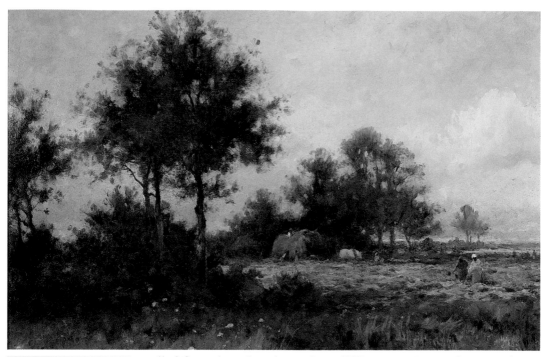

36 Edward Mitchell Bannister
Haygatherers, c.1893.
Willaim Morris Hunt, who
promoted the French style
of landscape painting known
as Barbizon, and the painter
Jean-Françcois Millet had a
studio in the same building
as Bannister during the
mid-1860s.

culled from the cultural margins of Western society and assumed pivotal roles in an alternative narrative about America.

In 1863, with a letter of introduction from abolitionist William Lloyd Garrison, Lewis met and studied under Edmund Brackett (1818–1908), a moderately successful neoclassical portrait sculptor in Boston. In the following year she opened her own studio. In the *Liberator* she announced the sale of two portraits of individuals who were highly regarded by African Americans: *John Brown* (1863), who led the ill-fated anti-slavery rebellion at Harpers Ferry, Virginia; and *Colonel Robert Gould Shaw* (1864), who commanded the heroic Massachusetts 54th Colored Infantry of the Union Army. At an important Bostonian anti-slavery event, the Soldiers' Relief Fund Fair, organized by Bannister's wife, Christiana, in 1864, Lewis sold over 100 plaster replicas of the Shaw portrait busts, the profits of which enabled her to travel initially to Florence and then to Rome. Upon arriving in Rome in 1866, Lewis soon associated with what the writer Henry James described as 'that strange sisterhood of American "lady sculptors" who at one time settled upon the seven hills in a white marmorean flock'. The 'white marmorean flock' included the renowned American woman sculptor, Harriet Hosmer (1830–1908), who greeted Lewis on her arrival, and actress Charlotte S. Cushman (1816–76): women who dared to be independent and professionally ambitious.

Lewis's studio in Rome was frequented by American tourists, who were often art critics as well. Henry T. Tuckerman, a leading American critic at the time, wrote in 1866 that Lewis was 'the most interesting

American artist working in Europe. She has great national genius, originality, earnestness and simple genuine taste.' She remained, except for occasional visits to the United States in the 1870s, an expatriate artist.

Edmonia M. Lewis used the ideal figure to portray heroic themes such as freedom, and to convey an iconology about race and gender. *Forever Free* [**38**], titled after the poignant phrase from the Emancipation Proclamation of 1863, was made in Rome in honour of William Lloyd Garrison. Naturalism enhances the emotional appeal of the subject, while Christian ideas about salvation and redemption heighten the image's sentimentalism. For the first time in African-American sculpture, Lewis had tackled the compositional difficulties in sculpting two figures. A man stands with uplifted arm, broken shackles around his wrist, gazing upward, with his right hand resting protectively on the shoulder of a kneeling woman, who also gazes upward with clasped hands as if in prayer. The composition represents the realization of abolitionism rather than its antebellum aspirations.

Sentimentalism affected people's reaction to the story related visually in *Forever Free*, as is shown in the following report from *The Christian Register* of 1869, on the occasion of the statue's dedication to abolitionist minister Leonard A. Grimes at the Tremont Temple in Boston.

All who were present at Tremont Temple must have been deeply interested. No one, not born subject to the 'Cotton King', could look upon this piece of sculpture without profound emotion. The noble figure of the man, his very muscles seeming to swell with gratitude; the expression of the right now to protect, with which he throws his arm around his kneeling wife; the 'Praise de Lord' hovering on their lips; the broken chain,—all so instinct with life, telling in the very poetry of stone the story of the last ten years.[9]

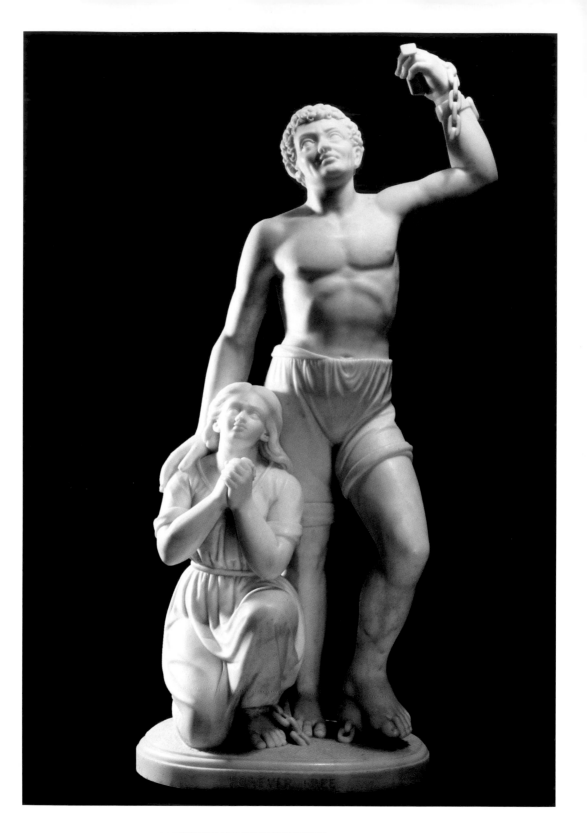

Normally the narrative represented by ideal sculpture appealed to an educated élite, who knew the literary sources and cultural references. Lewis's work, however, had wider appeal, to an uneducated audience, especially an African-American one, who would 'read' the story in the context of their own experiences, as well as to the educated élite who would understand the story in the context of abolitionist and classical literature. Whites and blacks, educated and uneducated, could appreciate this work.

Forever Free is iconographically complex. The kneeling female slave may be taken in Lewis's work to stand not only for nineteenth-century American ideas and attitudes about black slave women, but about women in general. In mid-century women were expected to conform to what has come to be known as the 'cult of true womanhood', meaning to be modest, feminine and domestic. In books, magazines, speeches, and sermons, women were reminded that their place was at home, as guardians of culture and hearth. Images of slave women, especially sculptures, usually depicted the woman naked (except for a discreetly placed cloth), and, if a black slave, conveyed a story about her vulnerability to sexual exploitation, being unprotected by the black man. As the literature and correspondence show, this was a central issue among white women abolitionists, to argue more from a gender perspective about the plight of black people.

Furthermore, the piece echoes sentiments expressed in the mass media about proper gender roles in American society. Black abolitionist newspaper articles called for black women and men to assume the same gender conventions as white Americans. For black men's ability to support and protect their women became synonymous with manhood, and that in turn denoted freedom. Coincidentally, Reverend Grimes was active in reuniting black families who were separated as a result of slavery. On one level, Lewis's female slave conforms to the 'cult of true womanhood' by being clothed and beside her mate.

Next, the female figure copies a very familiar image: the women's abolitionist emblem (also from England, *c.* 1826), which was modelled after Josiah Wedgwood's medallion of the male slave. The *Liberator* used it as a header for the 'Ladies Department' column. Patrick Reason helped popularize the image by selling prints of it in 1835; it was also used as a decorative motif on abolitionist stationery. By 1836 the medallion design became the unofficial emblem of women's anti-slavery groups. Contemporary American feminist scholars have revealed a subtext to this ennobling image. White women used it not only to promote abolitionism but for their own feminist agenda. The female slave, like the white model of 'true womanhood', was viewed as property under the control of men; in other words the black female kneeling slave was for whites a metaphor for their non-liberated condition. At the time, white women were beginning to enter the workplace and to

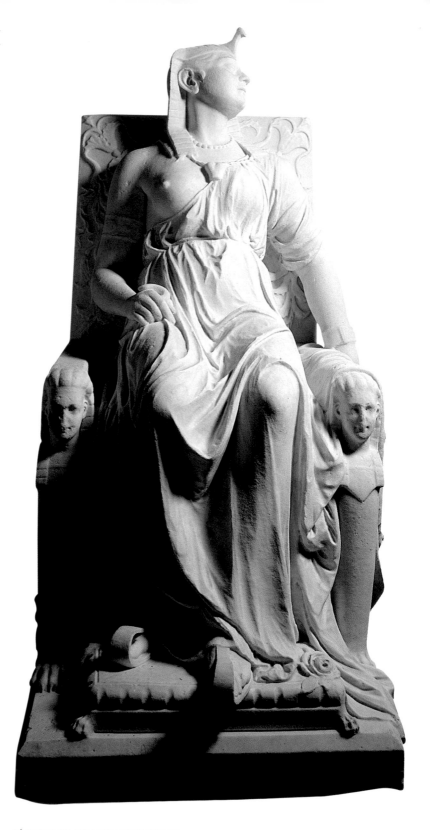

seek economic and social independence; they also reached for political power by demanding the right to vote. This meaning had little if any value for many slave women, who did not need to be freed from the conventions of proper female behaviour. Female slaves, and later freed black women, within the constraints of racism, worked hard and were the family matriarchs who, by the conditions of their lives, were equal to their black men. So on another level of meaning, the kneeling pious slave woman is an ironic image. In *Forever Free* neoclassicism is used to cloak social debates about womanhood, and the role of black women in the black American family.

Several of Edmonia Lewis's sculptures were exhibited in the Women's Pavilion at the Centennial Exposition in Philadelphia in 1876, where over 600 sculptures were exhibited. Among them was the *Death of Cleopatra* [**39**] which caused a sensation among viewers and critics alike. Lewis made a singularly innovative image popular among American sculptors and the public, who were fascinated with death and dying. Paintings, prints, and sculptures typically show the Egyptian ruler just before she commits suicide, either in contemplative thought or swooning with a reverential gaze, holding the asp as a pin about to prick the exposed breast. Instead, Lewis's *Cleopatra* is in a state of disarray, inelegantly slumped upon her throne, with the symbolic cloak of Isis draped about her. Pure classicism yields to realism portrayed in a moment of death.

Cleopatra belonged to a group of feared female subjects—Salome, Delilah, Judith, Clytemnestra, and Cassandra, who were considered women of beauty and demonic power, especially in the 1860s and 1870s. At this time, too, woman as victim was a frequent theme in sentimental literature. Lewis's work followed Harriet Hosmer's sculpture of *Zenobia* (1859). Both were massive sculptural figures combining the images of woman as victim and woman of power. *Cleopatra* does not look at the viewer but gazes away, self-absorbed. The *Death of Cleopatra* conveys two overlapping and sometimes conflicting stories: assertion of female power and evocation of female vulnerability. Viewers interpreted the figure to represent vulnerability, sexual availability, pathos, and, with the suicide, retribution for sensuality and misplaced power in a woman, which is a narrative in the work. Lewis also alludes to the idea that when a woman's ambition is thwarted by society's misconceptions regarding a woman's place in society, she, in her defeat, insists on being in control. She was quoted by African-American abolitionist and author, William Wells Brown, in his publication *The Rising Son* (1874), as saying: 'I have a strong sympathy for all women who have struggled and suffered.' Conceivably, the *Death of Cleopatra* is a representation of Lewis's own life.

The figure alludes to a new era in America—the beginning of the American Renaissance (1876–1917), a tumultuous period socially and

economically. After Reconstruction, the illusion that America represented a new Eden had been eroded by the experience of labour strife, vast accumulations of industrial wealth, greater cosmopolitanism, and increasing European travel. Realism and a more personal expression were increasingly favoured in art. The centennial marked the end of neoclassicism in the United States. Changing tastes and the disappearance of abolitionist patronage probably created a professional crisis for Lewis. The *Death of Cleopatra* was her last known major work.

Genre and biblical painting

The painting of rural and urban scenes of everyday life reached a peak of popularity in America between 1830 and 1863. Genre painting's success depended heavily on the viewer's ability to recognize themselves in the picture, and to understand the painting's narrative. Pictorial images were quickly picked up, and in many instances reinforced by lithographic prints and newspaper drawings, especially in the East Coast states; Currier & Ives (1835–1907), based in New York, was the largest and most successful lithography publisher of the nineteenth century. In the 1870s and 1880s, ethnic humour appeared in American popular literature and art: Irish, Chinese, German and, most frequently, blacks were stereotyped. Currier & Ives' *Darktown* series (1884–97) was one instance of this stereotyping. Images from the series became well known as advertisements for manufactured products. The African-American artist was challenged by the vast numbers of these stereotypical images.

Henry Ossawa Tanner (1859–1937) was a highly successful painter of genre subjects. According to a family friend, W. S. Scarborough, African Americans hoped that the treatment of race subjects by Tanner 'would serve to counterbalance so much that has made the race only a laughing stock subject for those artists who see nothing in it but the most extravagantly absurd and grotesque'.

Tanner spent most of his professional life in France, painting portraits, genre, landscapes, and religious subjects. He received enthusiastic recognition in his own country and was the first African-American artist elected to full membership at the National Academy of Design in 1927.

Following the footsteps of Robert Douglass, Jr, Tanner studied at the Pennsylvania Academy of Fine Arts. He was a student there from 1879 to 1885, during which time he took a drawing class taught by the foremost American portrait painter Thomas Eakins (1849–1916), who required his students to use live nude models, and to study anatomy and photography. Photography was still an interest of Tanner's ten years later, when he spent a brief period at Clark University in Atlanta (1889) and took photographs of rural North Carolina.

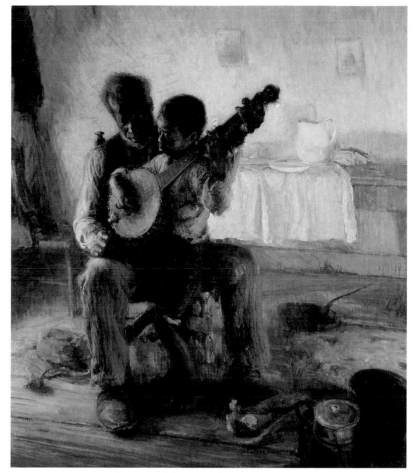

Tanner's first solo exhibition was held in Cincinnati in 1890, sponsored by Joseph Crane Hartzell, a white Methodist Episcopal bishop, and his wife. The same couple financed his travel to Europe the following year. He settled quickly into life in Paris but illness forced him to return to Philadelphia in 1893. In that same year he was invited to speak at the Congress of Africa, at the World's Columbian Exposition in Chicago. Taking the subject of 'The Negro in American Art', Tanner claimed that 'actual achievement [in the arts] proves Negroes possess ability and talent for successful competition with white artists'.

In 1893 Tanner's painting *Banjo Lesson* [**40**] was exhibited at the James S. Earle Gallery in Philadelphia, where the familial intimacy of the image and the technical skill of the treatment won immediate praise from viewers and critics. The rich blue and blue-green colours, the skilful rendering of the figures, and the light emanating from within the painting, create a realistic image and evoke a romantic mood. The black man playing a banjo was a familiar subject in mid-century American genre painting, but Tanner's intimacy provides a subjective interpretation of black life that was unusual. Indeed, the

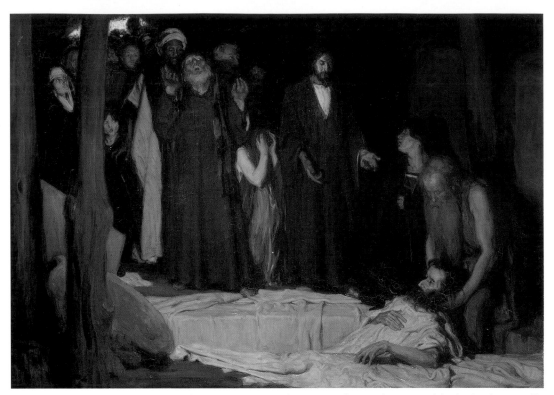

very subject was unusual in 1893, for at this time blacks had virtually disappeared from American genre painting, which was focusing on American urban life.

In 1894 Tanner left again for France, where he exhibited *Banjo Lesson* at that year's Paris Salon. The painting aroused little enthusiasm there, as the Parisians considered it 'peculiarly an American painting'.

Tanner was to remain in France, except for occasional trips, for the rest of his life. He developed an interest in the Middle East. This can be attributed to the popularity of contemporary archaeological excavations in Egypt and the Holy Land, and to his friendship with French artist J. J. Benjamin-Constant, who belonged to a group of artists interested in North Africa and the Middle East. His American patrons, all wealthy businessmen and merchants, including Robert C. Ogden, Atherton Curtis, an art collector, and Rodman Wanamaker, paid for Tanner to visit the Holy Land in 1897. There he saw Jerusalem, the Jordan River, the Dead Sea, and Jericho. When returning via Italy Tanner learned that he had received a medal from the Paris Salon (1897) for the *Resurrection of Lazarus* [**41**], one of his more important religious paintings. Few American artists had been thus honoured. Suddenly Tanner was internationally known.

Thereafter he devoted himself almost exclusively to biblical themes taken from the gospels of the four evangelists, focusing on miracles, the nativity, crucifixion and resurrection. Relying on his impression of

an early Italian Renaissance painting, Fra Angelico's *Annunciation* (1435), Tanner painted a modernist version of the same subject [**42**]. Viewers at the Paris Salon in 1898 were stunned. He had contemporized the pivotal moment in Christianity. Discarding the standard iconography of a courtly scene with its winged figure of Gabriel, haloed kneeling figure of Mary draped in blue cloth, and elaborate architectural portico or chamber, Tanner depicted Mary in the simple striped cotton attire typical for poor Middle-Eastern women. The room is plain except for the suspended textile, carpet and pottery, and on the left a shaft of intense light symbolizes the presence of the Angel Gabriel.

Henry Ossawa Tanner was well versed in Christian dogma and narrative (his father was a bishop in the AME Church), and understood the Old and New Testaments as allegory. There are themes of social injustice in *Daniel in the Lions' Den* (1895), rebirth in the *Resurrection of Lazarus*, ideas of new life and redemption in the *Annunciation*. Tanner wrote about his religious works in 1913 that:

I have no doubt an inheritance of religious feeling, and for this I am glad, but I have also a decided and I hope an intelligent religious faith not due to inheritance but to my own convictions. I have chosen the character of my art because it conveys my message and tells what I want to tell to my own generation and leave to the future.[10]

Tanner's works are like the sermons of African-American preachers who, according to Henry H. Mitchell, 'simply engage in interpretation which unites ancient biblical insights with modern experience to give some firm word about God's will for today'.[11] His religious scenes or landscapes sustained his cultural identity and religious training.

By the 1920s, for some African Americans, Tanner was a disappointment. A leading philosopher named Alain Locke wanted to develop an African-American style and aesthetic, a 'school of Negro art'. Tanner was found wanting. Locke wrote in 1925:

There have been notably successful Negro artists, but no development of a school of Negro art. Our Negro American painter of outstanding success is Henry O. Tanner. His career is a case in point. [He] has never maturely touched the portrayal of the Negro subject. Who can be certain what field the next Negro artists of note will command, or whether he will not be a landscapist or a master of still life or of purely decorative painting? But from the point of view of our artistic talent in bulk—it is a different matter. We ought to and must have a school of Negro art, a local and racially representative tradition. And that we have not, explains why the generation of Negro artists succeeding Mr Tanner had only the inspiration of his greatness to fire their ambitions, but not the guidance of a distinctive tradition to focus and direct their talents.[12]

42 Henry Ossawa Tanner

Annunciation, 1898.

In the late nineteenth century 40 per cent of paintings by American artists were of biblical subjects. This painting displays Tanner's mastery of light, here used as a symbol and a pictorial device for creating space and compositional balance.

Although Locke later softened his criticism of Tanner, his view represented a new age. Fine art in the nineteenth century was seen by African-American artists as a means towards achieving social legitimation and acceptance into mainstream American society. Artists ultimately wanted to transcend race in a media and aesthetic which was to be unconcerned about cultural specificity, other than being 'American'. Each in their own way, with support from whites and blacks, sought to portray an alternative context, free of all stereotypical images, for understanding African-American life as part of American society.

All worked in large cosmopolitan black communities: New Orleans, San Francisco, Cincinnati, Boston, and Philadelphia. Lewis and Tanner became expatriates, often sought out by visiting African Americans. Edmonia M. Lewis singularly transgressed appropriate professional and subject boundaries, daring to be a sculptor (then considered a man's medium) and to depict blacks within the canon of idealism and all that it implied: intellect, morality, and civilization. After mid-century, Lewis and painters such as Robert S. Duncanson, Grafton Tyler Brown, and Edward M. Bannister, subtly manipulated subject-matter to create works whose narratives were based on familiar symbolism but contained allegory which could be interpreted differently according to whether the onlooker took a black or a white viewpoint.

Few African-American artists became internationally known.

Robert Duncanson and Henry Ossawa Tanner achieved this distinction. Patronage played an important part in gaining recognition. Those who had a broad base nationally and internationally or in the African-American as well as the white community were likely to succeed. An artist like Lewis, a non-conformist who depended mainly on abolitionists as patrons and worked in an expensive medium—marble—found life a hard struggle.

Yet even Lewis's art was not overtly racial. She, like all her fellow artists, was motivated by a desire to be among the best American artists, to prove mastery and to achieve universal appeal.

The twentieth century heralded the growth of a black middle class, and a new racial awareness and self-esteem that inspired the search for a new Negro art. The succeeding generation of artists was to reject landscape for the figurative, the rural for the urban. A focus on class, vernacular culture, and Africa was to bring another kind of racial consciousness into art. A different kind of black identity emerged.

NOUS QUATRE À PARIS

Twentieth-Century America and Modern Art 1900–60

3

Introduction

The American Renaissance that had begun in 1876 continued into the twentieth century until the United States' entry into World War I in 1917. It was a period of rapid population growth and great industrial wealth. Cities grew quickly, and the need for efficient transportation resulted in city planning and inventions like the Ford Motor Company's Model T automobile, and Orville and Wilber Wright's first manned motor-driven aeroplane in 1900. Immigrants from eastern and southern Europe continued to arrive, changing the composition of American society. The expansion of the American frontier finally ended with the acquisition of the Hawaiian islands in 1900, and the emergence of the United States with her extensive properties as a new international power. President Theodore (Teddy) Roosevelt's (1901–9) credo 'speak softly, but carry a big stick' proved to be very effective. At the outbreak of World War I in 1914, President Woodrow Wilson (1913–21) wished to keep the United States neutral, but eventually entered on the Allied side in 1917, heralding a period of great upheaval for America. After the war had ended in 1918, the nation settled into an isolationist policy. The Great Depression began in 1929, reaching worldwide proportions, and in America necessitating a federal reform programme. This, known as the New Deal, was launched by President Franklin Delano Roosevelt (1933–45). Twelve years later, the United States entered World War II after Japan attacked Pearl Harbor in 1941.

Civil rights and double-consciousness

Of great and continuing concern for African Americans was the need to obtain full rights of citizenship regardless of race. The African American had to become reconciled to the dilemma of having two racial and ethnic identities, predicated upon the biology of race and

motivated by racism. This was a warring of two souls, one American, the other Negro, to which W. E. B. DuBois, historian, novelist and leading black political radical of the period, and a supporter of pan-Africanism, referred in *The Souls of Black Folk* (1903). In this book he expressed the identity crisis of African Americans as the problem of being

born with a veil, [a] double-consciousness, this sense of always looking at one's self through the eyes of others, of measuring one's soul by the tape of a world that looks on in amused contempt and pity. One ever feels his twoness—an American, a Negro; two souls, two thoughts, two unreconciled strivings, two warring ideals in one dark body, whose dogged strength alone keeps it from being torn asunder. The history of the American Negro is the history of this strife—this longing to attain self-conscious manhood, to merge his double self into a better and truer self.[1]

Double-consciousness was the source of psychological and emotional angst for many who sought ways to mediate two cultural heritages and two environments. This situation was highlighted after World War I, when returning black soldiers had expectations about their right to individual freedom and opportunity after defending these rights in Western Europe. When it became apparent that freedom and equal opportunity were not to be granted, the optimism of the pre-war period gave way to the cynicism of a 'lost generation'.

During the American Renaissance period, Paris became the art centre for sculpture. American sculptors Augustus Saint-Gaudens (1848–1907), and Daniel Chester French (1850–1931) represented the Beaux-Arts tradition, a revival of Renaissance and Baroque styles in architecture, and secondarily in sculpture. Dark bronze with textured surfaces, naturalism in the forms, and showing forms in movement characterized the Parisian style associated with the École des Beaux-Arts. Americans worked in plaster and bronze instead of marble, training at the government art school until 1914. American sculptors returning to the United States formed their own society, the National Sculpture Society, to exhibit their works and to promote sculpture. By 1900 the Beaux-Arts-inspired style was considered academic, and endorsed by the National Sculpture Society and the National Academy of Design (established in 1877).

Meta Warrick Fuller (1877–1968) emerged during the declining years of America's Gilded Age (1876–1905), when more women trained as artists than ever before. Fuller, after completing her formal art studies at the Pennsylvania Museum School of Industrial Art (now the Philadelphia College of Art) in 1899, immediately travelled to Paris, where she studied at the Académie Colarossi (sculpture) and École des Beaux-Arts (drawing) and met Auguste Rodin who, unenthusiastic

43 Meta Warrick Fuller

Ethiopia Awakening, 1914. Because of its enclosed vertical position and expressive restraint, this work is not truly in the Beaux-Arts stylistic tradition. The figure's uplifted hand (not copied in the bronze casting) and turned head effectively convey an 'awakening', and consequently it marks a dramatic change from the popular representation of Africa as a slumbering figure, and as a symbol of slavery.

about her drawings, encouraged her to continue in the sculptural realism that she so favoured. Rodin purportedly declared, 'My child, you are a born sculptor, you have a sense of form!' Fuller also frequented the studio of Augustus Saint-Gaudens. Her reputation grew as a sculptor and her work was exhibited at Samuel Bing's L'Art Nouveau Gallery, Paris. She met W. E. B. DuBois, who at the time was urging black artists to focus on black subject-matter; to make an art that had social and political meaning. DuBois later commissioned a commemorative piece for the fiftieth anniversary of the Emancipation Proclamation (untraced) in 1913.

Returning to Philadelphia in 1902, Fuller continued to exhibit and after a fire in 1910 had destroyed her early work, she made the work which has become her signature piece: *Ethiopia Awakening* [43]. It follows an artistic theme that was popular in the United States: Africa's association with slavery and un-enlightenment. Another eminent American sculptor, Anne Whitney (1821–1915), who had also studied in Philadelphia, made a work of a woman awakening from sleep, entitled *Africa* (1864), which was understood as an awakening from the sleep of slavery. Then Daniel Chester French made a work depicting a lethargic woman reclining on a chair with an Egyptian sphinx nearby, titled *Africa* (1904), which was often referred to at the time as 'Ethiopia Asleep'. This moniker suggests that political overtones connected with colonialism did not go unnoticed by some.

Fuller was aware of what *Ethiopia* denoted both in and outside the African-American community. The 1885 Berlin conference had initiated the partitioning of Africa by European nations; and only Ethiopia had successfully repelled the Italian army in 1896. In 1903 Fuller completed a commemorative plaque in honour of Emperor Menelik II of Abyssinia. She possibly knew about a religious manifestation of pan-Africanism called 'Ethiopianism'. Its adherents were obsessed with the Coptic biblical prophecy that 'Ethiopia shall soon stretch forth her hands unto God' (Psalm 68: 31), and revived Christian teaching by adapting it to indigenous African cultures. Thus black missionary activity in Africa gave rise to 'Ethiopianism', which had a strong political element: it was fervently against colonialism. Furthermore the term 'Ethiopia' was used in popular culture to denote African Americans and Africans. As shown by French's sculpture, it was acceptable to represent Africa as an Egyptian image, which for African Americans meant that their ancestral legacy could be represented as a noble and great civilization.

The development of a modern American art

While some American art audiences and collectors upheld the aesthetic tastes of the late nineteenth century, nostalgically favouring established European styles and subjects, some American artists

Post-Impressionism (1880s–early 1890s), originating in France, it is a label applied posthumously to the work of artists who rejected Impressionism, including Henri Matisse (1869–1954), Paul Cézanne (1839–1906), Paul Gauguin (1848–1903), Vincent van Gogh (1853–90), and Georges Seurat (1859–91). Their achievement laid the groundwork for modern art based largely on concepts and emotions rather than on a more objective appearance of reality.

Cubism (1908–18) originated in France in certain experimental paintings of Georges Braque (1882–1963) and Pablo Picasso (1881–1973). They discarded spatial perspective and conventional techniques of illusionism for a more conceptual approach that regarded painting as a subjective rather than objective response to the world. The style owes much to primitive art, expressionism and the identification of structural relationships in painting.

continued to search for an artistic vernacular that represented modern American experience. The search took place mainly on the East Coast, especially in New York City. What was needed was a more contemporary aesthetic that reflected the rapidly changing society, with its new technology, urbanity and individuality.

The Eight (1900–10) was a group of white American painters, led by Robert Henri (1865–1929), who considered themselves the new moderns (although stylistically they were conservative). They rebelled against the conservative subject-matter in painting and the academicism of the jury system of New York's National Academy of Design. Artists like John Sloan (1871–1951), George Luks (1868–1933), William Glackens (1870–1938), and George Bellows (1882–1925) decided to organize their own art exhibitions at the Macbeth Gallery (NYC) in 1908, which established a precedent in the United States for independently organized art exhibitions. The Eight depicted the gritty urban streets and poor working classes in New York City. Immediately critics, averse to these artists' portrayal of the seamier side of urban life, labelled them the Ash Can School.

A dramatic change in the direction of modernism was apparent elsewhere. White American photographer, Alfred Steiglitz (1864–1942), leader of the Photo-Secession in 1903, criticized those artists whose works 'never lifted above mere literature', that is, works which were exceedingly descriptive in image, style, and narrative content. He, with Edward Steichen (1879–1973), another white photographer, promoted photography as a fine art medium, which they called pictorialism to distinguish it from photojournalism. At the Little Galleries of the Photo-Secession, also known as '291' (291 Fifth Avenue), from c.1905 to 1917, they promoted European avant-garde modernism, showing works by such artists as Henri Matisse (1869–1954), Constantin Brancusi (1876–1957) and Paul Cézanne (1839–1906), some of which were being seen for the first time in the United States. They also exhibited some American modernists: Georgia O'Keefe (1887–1986), Max Weber (1881–1961), and Marsden Hartley

(1877–1943), and African art. There was a connection between some European modernist artists, e.g. Pablo Picasso (1881–1973) and Brancusi, and African art, aspects of which had provided these modernists with a visual inspiration and aesthetic resource.

Three artists, Walt Kuhn, Arthur B. Davies, and Walter Pach, organized the 'International Exhibition of Modern Art' in 1913. It was held at the 69th Regiment Armory in New York City, and quickly became known as the Armory Show. Over 100,000 people attended in New York alone. It travelled to Boston and Chicago, bringing to American audiences and collectors over 1000 works of art by 300 artists, mostly abstract modernist paintings, particularly Post-Impressionist and Cubist works. Audiences and critics either applauded or derided the art. Europeans had by now accepted these art styles but American audiences were shocked, for example, by Cubism, which did not depict nature literally but aimed to convey the essence of reality through simplified form and abstract shapes. French artist Marcel Duchamp's painting, *Nude Descending a Staircase* (1912), acted as the principal lightning rod for public derision. Former president Theodore Roosevelt compared it to a Navajo (American Indian) blanket. Students at the School of the Art Institute of Chicago even burned effigies of two of the exhibitors: Henri Matisse and Constantin Brancusi.

At least the exhibition awakened American artists and audiences to their own provincialism and encouraged them to re-examine their as sumptions about art, aesthetics and meaning. They became more aware of art's expressive capabilities through plasticity and abstraction. Although it had been intended to highlight American art, the Armory Show instead indicated Europe's leadership in modern art.

New Negro ideas

Pan-Africanism in general refers to a movement that seeks to unite and promote the welfare of all people identified with, or claiming membership of, the African or black race. Pan-Africanism is based on the idea of overcoming vast differences in language, ethnicity, religion and geographical origin. It assumes that the political unification of Africa will contribute to the welfare of all black people of African descent, whether or not they actually live in Africa. In the 1920s pan-Africanism included cultural as well as political ideology. W. E. B. DuBois considered his Pan-African Congress, held in Paris in 1919, the first such meeting to explore the concept.

The New Negro movement (1917–35) was a phrase coined by Howard University professor and philosopher Alain Locke and first appeared in a special issue of *Survey Graphic* (March 1925). The movement's zenith was in the 1920s, up until the crash of the stock market in 1929, which curtailed the activity and influence of the African-American middle class and white American avant-garde and intellectuals. Some scholars date the end of the movement to 1933, others to 1935 when numerous race riots erupted in cities.

African-American culture, the New Negro and art in the 1920s

The 1920s was a decade of continuing economic prosperity and rapid industrialization. There was a sense of optimism, a revolt against traditional values, and an exploration of new ideals. However, the burgeoning middle-class prosperity only thinly camouflaged an increasing class stratification, and ethnic and racial tensions caused by population shifts in the cities. The urban ambience and cityscapes of Chicago and New York were transformed by new technology, with skyscrapers, elevated trains, and subways built to accommodate and transport the growing population—swollen by the constant flood of Europeans arriving at Ellis Island, and thousands of African Americans migrating from South to North.

The term 'new Negro', used at the end of the nineteenth century to denote social and economic improvements since slavery, became attached between 1900 and the 1930s to a renewed racial pride, expressed in economic independence, culture and political militancy. Booker T. Washington (1856–1915), a black educator and founder of Tuskegee Institute, emphasized industrial training as a means of self-respect and economic independence. He edited an anthology of historical and sociological essays: *A New Negro for a New Century* (1900), in which a case was put forward that economic self-reliance should precede demands for social equality. W. E. B. DuBois was vehemently opposed to this. DuBois sought political action and racial equality as due to the black people. By the 1920s Washington and DuBois represented two opposing camps on the subject of the 'new Negro'.

The Great Migration

Hundreds of thousands of African Americans migrated from the rural, mostly agricultural South to the urban industrialized North from 1913 to 1946. Historians call this the Great Migration.

Rising expectations and an economic boom created largely as a result of United States involvement in both world wars, combined with the effects of overt racism brought on by Jim Crow laws (segregation sanctioned by law in the South in the 1890s, and practised in the North), encouraged African Americans to leave their traditional agricultural base in the South. Travelling by train, they arrived in the early morning hours in Chicago, Detroit, Cleveland, Philadelphia, New York City, and eventually Los Angeles. African-American newspapers, such as the *Chicago Defender*, urged blacks to leave their places of social and economic repression for those representing economic opportunity and freedom. The social displacement of African Americans mirrored that of all Americans. As cultural historian Eugene Metcalf noted:

In the cultural turmoil following World War I many white middle-class

Americans, especially intellectuals and the young, were cast adrift from the institutional and ideological moorings of American society. Feeling betrayed by the war and the false hopes it had raised and enmeshed in a society undergoing technological and demographic change, they revolted against traditional values and behavior. Some left America entirely; others stayed. But the 1920s were for whites as well as blacks a time of dislocation and adjustment.[2]

The Jazz Age

Europeans' interest in American popular culture, in the form of jazz, movies, and comic books, began in the 1910s and peaked in the 1920s. The period known as the Jazz Age or Roaring Twenties was a time of bootleg gin (US Congress had passed the Eighteenth Amendment which prohibited the sale of alcohol) and 'speakeasies' (establishments in which intoxicating liquor was sold illegally). Life—in America and in Europe—was about urbanism, and in the towns the clubs vibrated to new sounds and rhythms: a music, and dance form, rooted in African-American culture. In Harlem, Chicago, Kansas City and Europe the scene resembled that shown in three renowned paintings of Parisian night life in 1929 by Archibald Motley (1891–1981): *Jockey Club*, *Dans la Rue, Paris* and *Blues*. Jazz, which began in the South and spread its way to the North and West, took its harmonic, melodic and rhythmic elements mainly from African music. The celebration of African-American culture in dance and jazz was an antidote to what was perceived to be the sterility of modern, technology-dominated Western modernist society. As Brendan Gill recalled in a recent essay:

Black writers, artists, composers, and theater performers were thought to be opening the door to a promising future—one that could be shared with a white majority only just beginning to perceive black culture not as a form of failed white culture but as something that had its own complex nature.[3]

Whites made blacks a symbol of personal freedom which embodied modernism. As African-American novelist Langston Hughes wrote in 1926, it was a period 'when the Negro was in vogue'.

'Primitivism', the cultural crucible for modernism, was for European and white American audiences available in American Negro culture, which was regarded as a subculture to mainstream America. Despite the fact that African Americans had lived in North America from the seventeenth century, there was a widespread belief that Africa pervaded Negro culture. As African descendants the American Negro was the modern primitive.

This explains why whites expected African-Americans artists to portray particular subjects. For example, The New Gallery owner and director, George Hellman, urged Archibald Motley to paint the more exotic aspects of Negro life, scenes which should include the 'voo-doo element as well as the cabaret element—but especially the latter' for his

solo show (1928). Several American patrons, including collector and philanthropist Albert C. Barnes (1892–1979), considered African art important for the development of a Negro art idiom. Ironically, so did many African-American cultural critics. The black middle class had accepted an identity refracted through the prism of white American/ European culture and society.

So while they promoted European-derived cultural standards, some of the African-American educated élite saw the opportunity to use the whites' interest in primitivism to promote American Negro arts that reflected the dominant dual heritage of Europe and Africa. While they strove to become part of mainstream American society and culture, there was a desire amongst American Negros and many other Americans to preserve and sustain that exotic 'otherness', the imprint of Africa on American culture, as a palliative for rapid changes in society. Visual artists took advantage of the interest in black culture to broaden the parameters of modern art, its aesthetics and imagery, to accommodate an African-American artistic vernacular.

Expatriates and Paris, the Negro Colony

As in the previous century, artistic training and experience meant travel to Europe, but now Paris, not Rome, was the art capital. American artists, musicians, and writers flocked to the 'city of lights', where they saw the new art at first hand. Paris's reputation for racial tolerance provided an additional motive. By the 1920s there were enough black American artists in Paris to make what artist Hale Woodruff termed a 'Negro Colony'. Artists, sculptors, painters, and printmakers lived a bohemian life on the Left Bank or in the French countryside. They associated with expatriate writers and musicians, creating an informal network for learning about the latest ideas about styles and the leading artists. Artists studied either formally at art schools such as the École des Beaux-Arts or the Académie Julian, or informally by viewing and sketching copies of works in the museums. They were constantly aware of the new art, abstract modernism, which used elements of African art.

The Negro Colony did not go unnoticed. Parisians were fascinated with black arts and culture in Africa, the United States, and the Caribbean. Critics praised their works, including those of Palmer Hayden (see p.120) and Archibald Motley (see p.121). Salons which were considered predictable exhibition venues for French and foreign artists exhibited their productions; French publications reproduced images of their art. American associations sponsored works and exhibitions of African-American art. This period of lively cultural activity was curtailed by the economic depression in Europe and the United States, which made transatlantic travel difficult or impossible.

The New Negro movement

African Americans seized the opportunity during the interwar period to promote political, economic and social agendas that would benefit the black community nationally. Organizations like the National Association for the Advancement of Colored People (NAACP) and the National Urban League were instrumental in promoting the New Negro movement, also called the Negro Renaissance, in their respective journals, *Crisis* (1910), and *Opportunity* (1922). The Negro Renaissance denoted a cultural revitalization in the cities. Its capital was Harlem (uptown Manhattan), which had the largest African-American urban population. The Harlem Renaissance consequently represented most visibly what was also happening in other major American cities. Cultural historian Nathan Huggins noted that 'the Negro Renaissance was a struggle to show an African-American cultural "coming of age" that paralleled the same phenomena [*sic*] in American culture as it moved from under European cultural hegemony, and sought to reinvigorate itself'.

Literature, theatre, visual arts and, later, music were seen as a means

New Negro organizations

The **National Association for the Advancement of Colored People** (NAACP), founded in 1909, grew out of two events: the Niagara Movement, organized by W. E. B. DuBois, William Monroe Trotter and 28 other African Americans in 1905, and the race riot in Springfield, Illinois in 1908. White Americans and a few black Americans were the core members. Their aim was to guarantee the reality of equality in the United States and elsewhere, and they focused on securing legal rights for African Americans and those of the African diaspora. The most prestigious award at the time was the NAACP's Joel E. Spingarn Medal for Entrepreneurial Achievement. Another award, the Amy Spingarn Medal for the Arts, acknowledged the cultural importance of pan-Africanism. DuBois was the editor of *Crisis*, which became the major intellectual publication among African Americans.

The **National Urban League**, founded in New York City in 1911, was created by the merger of several organizations: the Committee for Improving the Industrial Condition of Negroes, the National League for the Protection of Colored Women, and the Committee on Urban Conditions among Negroes. The focus for the new organization was the development of economic opportunities and social welfare for African Americans in American cities. Charles S. Johnson was editor of the League's magazine, *Opportunity*.

The **United Negro Improvement Association** (UNIA) was established by Jamaican activist Marcus Garvey to promote pan-Africanism and economic self-reliance among ordinary African peoples throughout the world. It promoted unification between America and Africa, focusing on economic and political enterprises. It thrived in New York City from 1918 until 1925. Garvey established the Black Star shipping line, and two publications: *The Negro World* and *Black Man*. Garvey felt that African peoples should proudly proclaim Africa as their 'motherland', because a people bereft of cultural and political heritage would always be regarded condescendingly by others.

to define and establish 'membership in the African or black race', and simultaneously to enhance the reputation and self-esteem of African Americans in America. As novelist James Weldon Johnson noted in *The Book of Negro Poetry* (1927), 'no people that has ever produced great literature and art has ever been looked on by the world as distinctly inferior'. Achievement was not to be defined by that cultural production which only imitated European or white America, but by an art which expressed a distinctive African-American cultural identity, most strongly grounded in folk culture.

This expressive and mature African American was the New Negro. The ideology of the concept replaced that of the 'race' men (and women) of the previous century. It was incumbent upon the black middle class, whom W. E. B. DuBois called the 'Talented Tenth' (approximately ten per cent were educated middle class), to lead the way, and consequently prove their worthiness as American citizens, and provide role models for less fortunate African Americans.

Photography
African-American photographers documented the lives of the urban middle class. Skilled photographers felt a responsibility to portray emerging African-American leaders, communities and their lives. Typical was Addison N. Scurlock (1883–1964), who opened his first business in 1911, in Washington DC, and maintained it there until 1964. The city had a sizeable African-American middle-class society, which ensured him a substantial clientele.

James Van Der Zee (1886–1983) was largely self-taught and maintained a studio in Harlem for almost 50 years. By using props in his studio to denote economic prosperity and education, and, like Scurlock, reworking the photograph to emphasize its pictorial effect, Van Der Zee helped create the period, and not merely document it. When he photographed out-of-door scenes in Harlem, Van Der Zee selected images which reflected the New Negro, such as: war veterans, funerals, UNIA parades, Sunday strollers on Lenox Avenue or in the middle-class neighbourhood, Striver's Row on 135th Street as in *Couple with a Cadillac* [44]. He was rediscovered as a documentary photographer and artist in 1968, in the 'Harlem On My Mind' exhibition at the Metropolitan Museum (see p.211).

The New Negro artist
In 1924 during a dinner at the Civic Club, New York, organized by Charles S. Johnson, to promote the emerging black literati, W. E. B. DuBois spoke to white editors and critics about the need for writers and artists to lead as the cultural vanguard of the Negro Renaissance. Upon hearing DuBois, Paul Kellog, the editor of the literary journal

44 James Van Der Zee

Couple with a Cadillac, 1932. This photograph was taken on West 127th Street, Harlem, New York City.

Survey Graphic, proposed and published a special edition entitled *Harlem: Mecca of the New Negro*, which was soon issued as a book, *The New Negro: An Interpretation* (1925). It was a collection of political, sociological and historical essays focusing on Harlem as the stage for a 'dramatic flowering of a new race spirit'. Alain Locke (1885–1954), Professor of Philosophy at Howard University and a Rhodes scholar, was its guest editor. He was the leading strategist of the New Negro movement and called for an identifiable racial art style and aesthetic. He saw the younger generation as capable of establishing the artistic vanguard, not only in terms of style and technique but also subject-matter and evocation of a 'black' sensibility.

In grappling with what constituted this New Negro art, Locke believed African art provided the solution. His essay 'The Legacy of the Ancestral Arts' in the *Survey Graphic* dealt with cultural retrieval from Africa: African-American artists had to learn, along with whites, to appreciate the value of African art and culture. It was not an intuitive endeavour but, as Locke (using illustrations of African art from Albert C. Barnes's collection) wrote,

There is the possibility that the sensitive artistic mind of the American Negro, stimulated by a cultural pride and interest, will receive from African art a profound and galvanizing influence. The legacy is there at least, with prospects of

a rich yield. In the first place, there is the mere knowledge of the skill and unique mastery of the arts of the ancestors, the valuable and stimulating realization that the Negro is not a cultural foundling without his own inheritance.

African art was to replace for the New Negro artist the classical art of ancient Greece and Rome, which was the foundation for Western art and art criticism.

Locke continued:

While we are speaking of the resources of racial art, it is well to take into account that the richest vein of it is not that of portraitistic idiom after all, but its almost limitless wealth of decorative and purely symbolic material. It is for the development of this latter aspect of a racial art that the study and example of African art material is so important. The African spirit is at its best in abstract decorative forms. Design, and to a lesser degree, color, are its original *fortes*. It is this aspect of the folk tradition, this slumbering gift of the folk temperament that most needs re-achievement and re-expression. And if African art is capable of producing the ferment in modern art that it has, surely this is not too much to expect of its influence upon the culturally awakened Negro artist of the present generation.

The motivation was more complex. New Negro artists desired to find their racial tradition in Africa. Admittedly naïve and romantic, this project offered an alternative aesthetic source. As well as this, Locke's emphasis upon African arts as fundamental to the development of modernism was 'in step' with avant-garde American art criticism and exhibitions in New York. Although not dictating one style, Locke saw a vital connection between this new artistic respect for African art and the natural ambition of Negro artists for a racial idiom in art. The fact that European modernists borrowed extensively from African art made the racial art enterprise of the New Negro acceptable and credible within the mainstream American art community, while satisfying a need for cultural links. Locke, however, reduced Africa to a cultural trope for the purpose of promoting racial authenticity. For the next ten years, Locke characterized Africa in simple formalist terms, ignoring the real complexity of its culture.

Graphic art

The Negro Renaissance was primarily a literary movement and African-American authors demanded from their publishers images of African Americans that befitted the new era. Some of the best examples of African-American graphic arts could be found in New York City, which was by now the centre for America's proliferating book, popular magazine, and journal publishing.

Aaron Douglas (1898–1979) regularly read *Crisis*, *Opportunity* and

Survey Graphic while teaching art in Kansas City, so when the opportunity arose for him to travel to Harlem and pursue his art career, encouraged by Charles S. Johnson, he moved without hesitation. Upon his arrival in 1924 he immediately became friends with W. E. B. DuBois and Alain Locke, African-American novelists and poets Countee Cullen and Langston Hughes, and whites such as Albert C. Barnes and Carl Van Vechten, who belonged to the intimate circle of New Negro leaders. Under the tutelage of Bavarian graphic artist Winold Reiss (1886–1953), a close friend of Alain Locke who had illustrated the special 'Harlem' issue of *Survey Graphic*, Douglas discarded realism for a more abstract 'African' style. On the strength of his illus-

46 Aaron Douglas

Crucifixion, 1927.

trations for *The New Negro* Locke called him a 'pioneering africanist'. Ten black-and-white drawings, as in *Rebirth* [45], displayed forms conforming to hard-edge abstract design similar to Art Deco painting of the 1920s and '30s. Human figures are stylized, and complement the schematic patterns, both flat shapes. Commissions soon followed: for the covers of *Crisis*, *Opportunity*, the arts magazine *Fire!!* (published once in 1926), Condé Nast's chic *Vanity Fair* magazine, and various playbills, including that for Carl Van Vechten's play *Emperor Jones*, starring Paul Robeson. Douglas also illustrated thirteen books by leading New Negro authors, Countee Cullen, Langston Hughes, Claude McKay, and James Weldon Johnson. Two assignments garnered Douglas the most attention, French journalist Paul Morand's *Black Magic* (1929), and James Weldon Johnson's *God's Trombones* (1927).

Each illustration for *God's Trombones: Seven Negro Sermons in Verse* is juxtaposed with text so that it functions as a preface to the individual sermon written as verse. The sixth sermon, the *Crucifixion* [**46**], does not show the traditional icon of Jesus on the Cross, but Simon, who carried the Cross when Jesus could carry it no longer. The standard hierarchic composition is inverted to show Simon, not Christ, as the dominant figure. Our attention is directed to the diminutive Christ figure by a diagonal beam of light, the guards' position, and the symbolic halo. African-American Baptist sermons accepted Simon as an African Jew, portraying him, as artist and art historian David C. Driskell noted, as 'a black man who took upon himself the yoke of Jesus' cross in order to relieve him of one last earthly misery'. The *Crucifixion* becomes a metaphor for the African-American experience.

Douglas's signature styles were what he called 'Egyptian form' figures, figures silhouetted in profile with the eye rendered from a frontal viewpoint as in ancient Egyptian tomb reliefs and frescoes, and his use of a single colour, varying in value from light to dark. The gradually enlarged circular shapes of colour create a visual rhythm, evocative of music and spirituality. Historian Nathan Huggins felt that

The Harmon Foundation

The **Harmon Foundation** (1925–67, New York) was set up by William E. Harmon (1862–1928), a real-estate investor from Iowa who wanted to encourage excellence in a variety of professional endeavours through the William E. Harmon Awards for Distinguished Achievement Among Negroes. Harmon hoped that the public recognition of such achievements would encourage others to excel. The Foundation, under the administration of Mary Beattie Brady, is best known for its awards in the visual arts, and for its juried exhibitions (1926–31, 1933) in New York City, under the direction of the Commission on Race Relations of the Federal Council of the Church of Christ in America. As part of its objective to familiarize Americans with Negro art, the Foundation also sponsored travelling exhibitions to major cities and colleges, primarily in the South, sometimes in collaboration with other organizations, such as the College Art Association.

Douglas's attempts to 'interpret what he understood to be the spiritual identity of the Negro people was a kind of soul of self that united all that the black man was in Africa and the New World'.

Painting

Painters heeded Locke's and DuBois' urgings to produce a new racial art. The discovery of African art and the rediscovery of black folk idioms caused dramatic style changes for some artists, Palmer Hayden among them. His painterly seascapes became pseudo-naïve-style genre paintings in the 1930s. So too did the meticulous realism of Archibald Motley's academic portraits change to modernist genre paintings. The mid-1920s was a transitional period for these and others grappling with the challenge of representing the New Negro.

47 Palmer Hayden

Fétiche et Fleurs, 1926. Fang reliquary sculpture and Kuba cloth were popular representations of African art in the USA and Paris. Most African artefacts came from French Colonies (Gabon) or neighbouring areas (Central Africa).

Palmer Hayden (1893–1973) established his reputation first as a painter of land- and seascapes, later of genre. In between these two bodies of work, he painted a still-life, *Fétiche et Fleurs* (Fetish and Flowers) [**47**] which won the Harmon Foundation's Gold Medal for Distinguished Achievement Among Negroes in Fine Arts in 1926. The work reflects

the Negro Renaissance in that Hayden was one of an increasing number of African Americans deciding to make a career in fine arts, and striving to find a racial art idiom. However, it is not obviously 'African' in style, as Hayden avoided predictable abstract designs associated with African art. Instead, by assembling two African art objects— Fang reliquary statue and Kuba cloth (both from Central Africa)— within a traditional still-life, Hayden referred to Locke's New Negro artist (African art as a sign for ancestral legacy of African Americans) and DuBois' Negro Renaissance (the cultured middle class) while retaining his interest in realism. In 1926 Hayden travelled to Paris, where he studied art until 1932.

Ironically, while Locke was stressing decorative art and abstract symbolism as an appropriate style, and downplaying portraiture as desirable subject-matter, there was a portrait artist in the Midwest who became as great a representative of the Negro Renaissance in his region as was Aaron Douglas in New York. Archibald J. Motley Jr (1891–1981) studied at the School of the Art Institute of Chicago (he sat in on a class taught by George Bellows) in a curriculum embracing realism, portraiture, landscape, and genre painting. In 1913 teachers and stu-

49 Archibald J. Motley, Jr
The Octoroon Girl, 1925.

dents at this school had lampooned the artworks in the Armory Show as examples of 'the starved alien minds of modernist painters'.

Motley's many portraits, dating between 1919 and 1931, were mostly of women. Lacking commissions early in his career, he portrayed his family and friends. In *Mending Socks* [**48**], considered to be his finest, he portrayed his paternal grandmother, Emily Motley. Exhibited at the prestigious 'Chicago and Vicinity' show at the Art Institute of Chicago in 1923, it earned him the reputation of an up-and-coming portrait painter. This closely modelled study is at once a portrait and a genre scene of African-American middle-class life.

Motley painted professionally while still a student, and during that time won the Harmon Foundation Gold Medal for *The Octoroon Girl* [**49**], which he later considered, other than *Mending Socks*, the best portrait he ever painted. It is one of several of his 'scientific' paintings of mulatto women. They document a part of America's history of misce-

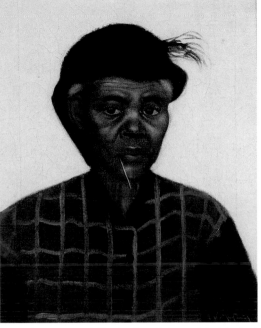

genation, especially in Louisiana, his birthplace, and obsession with the biology of race. The preoccupation with skin colour, linked inevitably to issues of class and slavery, was never far from Motley's work. He was not alone. For instance, Aaron Douglas illustrated a cover for *Opportunity* (October 1925), entitled 'The Mulatto', and another for *Crisis* (January 1930) which juxtaposed a light-coloured woman with a darker one. The image in *Crisis* was similar to one titled *Mother and Daughter* (1925) by African-American portrait painter, Laura Wheeler Waring (1887–1948).

Aside from the politics of race, these images by Motley of fair-skinned women in middle-class settings denoting affluence, education and cosmopolitanism, were a visual rebuttal to the popular media images of the 'mammy' or the 'jezebel' of black American women which continued to hold a place in the minds of the majority of Americans.

Motley on occasion depicted rural, southern working-class African Americans, as in *The Old Snuff Dipper* [**50**]. Here, as before, painterly technique creates a softly modelled form but now the figure is positioned before a plain backdrop, which makes for a shallow picture space, drawing the viewer's attention to the realistic face. Comparisons with his middle-class portraits reveal the same care in painting the face, and the frontal position and direct gaze of the sitter which command our attention and convey dignity.

Motley's interest in portraiture as a way of exploring issues of class and race was able to develop freely because he lived in Chicago, beyond the scrutiny of Northeastern art critics, such as Locke, and far from the avant-garde centre of New York City. Motley and another Mid-

westerner, William E. Scott (1884–1969), painted more portraits than any other American artist of their time. A great many of these were images of the educated middle class, who had commissioned them, clear evidence that the 'Talented Tenth' were conservative, still preferring portraiture, as in the nineteenth century. Locke would have been pleased with Motley's paintings of the 1930s (see p.60). However, understandably DuBois, whose notion of culture was class-oriented, praised Motley in *Crisis* (1926) as a credit to the race.

Conversely, Motley criticized African-American artists for their lack of vision:

What a pity so many of our artists going for pretty landscapes and pictures which have no bearing whatsoever on our group. The Negro poet portrays our group in poems, the Negro musician portrays our group in jazz, the Negro actor portrays our group. All of these aforementioned portrayals are serious, original interpretations of the Negro. There is nothing borrowed, nothing copied, just an unraveling of the Negro soul. So why should the Negro painter, the Negro sculptor mimic that which the white man is doing, when he has such an enormous colossal field practically all his own; portraying his people, historically, dramatically, hilariously, but honestly. And who know the Negro Race, the Negro Soul, the Negro Heart, better than himself?[4]

One painter surpassed the first generation of New Negro painters in being adept in exploiting abstract art to convey an image and aesthetic derived from black culture: Hale Aspacio Woodruff (1900–80). He was one of the foremost representatives of African-American modernist art in the twentieth century. During his youth, he too met DuBois, Charles S. Johnson and Countee Cullen, and like several African-American artists of his generation, began his career as an editorial cartoonist and graphic artist for *Crisis* magazine. In 1927 he travelled to Paris where he studied art for four years, and met Henry Ossawa Tanner and members of the 'Negro Colony'.

In the 1920s abstraction for many American artists meant imitating early Cubism and the post-Impressionist style of Cézanne. Form and space were converted into areas of colour that emphasized the two-dimensional surface of the painting, as in Woodruff's *The Card Players* [51]. The elongated figures echo African sculpture which he had studied earlier in art books and observed during his forays with Alain Locke in the Parisian ethnographic markets. Woodruff later recalled:

On seeing the work of Paul Cézanne I got the connection. Then I saw the work of Picasso and I saw how Cézanne, Picasso, and the African had a terrific sense of form. The master I chiefly admired at that time was Paul Cézanne; then Picasso, who was certainly bolder and more courageous in his cubist work. Then when I saw his painting called *Les Demoiselles d'Avignon*—cubist-like girls with black masks on—the whole thing was clarified for me.[5]

The Card Players acknowledged in style an indebtedness to Cézanne, Picasso, and African art, and paid homage to his time in Paris, where he spent many evenings playing cards with his friends, among them poet Countee Cullen and artist Palmer Hayden.

We younger Negro artists who create now intend to express our individual dark-skinned selves without fear or shame. If white people are pleased we are glad. If they are not, it doesn't matter. We build our temples for tomorrow, strong as we know how, and we stand on top of the mountain, free within ourselves. (Langston Hughes, 'The Negro Artist and the Racial Mountain', *Nation* (June 1926), 694.)

The patronage of the New Negro artist

African-American artists continued to benefit from the support of African-American and European-American individuals, philanthropic organizations and artists' groups. White Americans were important patrons, among them Paul Kellog, Albert C. Barnes, Carl Van Vechten, and Charlotte Osgood Mason, who encouraged African-American artists to develop a Negro art, and an aesthetic. Although well intended, they were segregating New Negro art from the artistic mainstream. African Americans—among them W. E. B. DuBois, Alain Locke, and Charles S. Johnson—lobbied support for African-American artists to study abroad and for purchase of their works, especially by African Americans. Often their respective organizations' periodicals, NAACP's *Crisis* and less frequently the Urban League's *Opportunity*, featured artwork, and also carried a feature story or an article on the arts. Under the editorship of DuBois, *Crisis* continued its efforts into the 1930s. UNIA publications also reviewed exhibitions, and African-American newspapers reported regularly on art activity.

Among African-American individuals, Locke was singularly important in promoting the first and second generation of New Negro artists. He enlisted white art patron Albert C. Barnes, who as a collector considered himself an authority on African and modern European art, to help secure support among key American art collectors and gallery directors. Barnes, like Locke, felt that the African-American artists needed to develop an art which did not imitate the works of white artists, and that they could succeed if they nurtured their 'primitivist' inclinations by studying African art. Locke consistently forged alliances with whites, as an advocate for Negro artists, as he did for example with Zonia Baber for the exhibition 'Negro in Art Week' in Chicago (1928).

From the turn of the century African-American exhibitions were held in local 'colored' branches of the Young Men's Christian Association (YMCA), local branches of the city library, white American organizations like the Art Students' Club in New York City (1923 and 1924), the Chicago Women's Club (1876), or African-American organizations like Chicago's Arts and Letters Society (1917), and the Chicago Art League (1923) at the Wabash Avenue YMCA; and the Tanner Art Students' League (1919) in Washington, DC. There were state and city exhibitions, like the Tercentennial Exposition, Jamestown, VA (1907) and New York State Centennial Fair (1922).

Wealthy African Americans held events in their houses where artists and writers and cultural dilettantes gathered for discussions about the arts. One notable was A'lelia Walker (daughter of multimillionaire Madam C. J. Walker), whose Dark Tower Salon (Harlem) in 1927 emulated early twentieth-century salons in Paris. Upper middle-class and wealthy Northeasterners met socially in Walker's home for tea to discuss cultural events. On these occasions the walls were hung with work that showed the importance of visual arts and literature as representative of the Negro Renaissance—the art work of Aaron Douglas and the poems of Langston Hughes and Countee Cullen.

State funding and the rise of African-American art
The Federal Arts Project

The Federal Arts Project (FAP) was part of President Franklin Delano Roosevelt's domestic reform programme known as the New Deal. Artists were paid for producing a minimum number of works, which were eventually displayed in public, usually in government-owned buildings. Art acted as a morale booster to the public, for the Federal Arts Project, by fostering patriotism, also provided employment. This propagandist function consequently emphasized representational images (popular with the public) as opposed to abstract art (considered

foreign). The FAP supported American art by Americans for Americans. Images of agricultural labourers, industrial workers, and poor people became popular. Reflecting on the period, cultural historian Jonathan Harris comments that art represented the ideals of American culture and community which had retreated to a mythical view of itself as predominantly rural, more agricultural than industrial, and the home of the honest labourer. Holger Cahill (1887–1960), director of the FAP, a part of the Works Progress Administration, asserted that 'American art is declaring a moratorium on its debts to Europe and returning to cultivate its own garden'. Both the emphasis on American subjects and abhorrence of anything European reflected the United States' isolationism between the two world wars.

The legacy of the New Negro movement

The New Negro movement, as far as art was concerned, was indebted to the ideas of Alain Locke, and his ideas were given a platform until after World War II by the Harmon Foundation, which financed juried nationally travelling exhibitions of a 'racially conscious' art. Locke remained closely associated with the Foundation director, Mary B.

Political support for art

Federal programmes
The first phase of President Franklin Delano Roosevelt's domestic reform programme (1933–4), instituted to provide relief and to spur recovery from the Depression, included the **Public Works of Art Project** (1933–4), directed by Edward Bruce. During its five-month existence, the PWAP encouraged the activity of 4000 artists, who produced over 15,000 works.

This enormously successful effort was followed by the **Works Progress Administration** (WPA; after 1939 the abbreviation stood for **Works Project Administration**), which ran the **Federal Arts Project** (FAP) from 1935 to 1943, under the direction of Holger Cahill (1935–41). Approximately 10,000 artists were paid on average about $20 per week and their work became public property. A staggering amount of art was produced, including 108,000 paintings, 18,000 sculptures, 2500 murals and thousands of prints, photographs and posters. The murals were commissioned for public places, such as bus and train stations, banks, schools, post offices and other government buildings. Thus the public at large benefited from the scheme.

The mandate was not only to employ artists but to encourage art education and to document the cultural heritage of the United States, especially that of the rural South, where a long-established way of life was fast disappearing.

American Artists' Congress
Endorsement of the WPA and the FAP came from an unexpected quarter: the **American Artists' Congress** (1936–43) was established in response to the call of the Popular Front and the American Communist Party for the formation of groups of artists and writers to combat the spread of fascism. Stuart Davis (1894–1964) was one of the more active members, and edited the organization's newspaper, *Art Front*, until 1939. The Congress aimed to relieve economic distress resulting from the Depression and to guard against art censorship and the use of art as war propaganda.

Brady, undoubtedly advising her about black art. They often met at the Boykin School of Art in Greenwich Village, which was an important meeting place for black artists and intellectuals in the early 1930s.

Locke's two important essays, 'The African Legacy and the Negro Artist' (1931), and 'The Negro Takes His Place in American Art' (1933) for each Harmon Foundation exhibition catalogue, established him as the Foundation's spokesperson for modern African-American art. In both essays he continued his arguments of the 1920s. He reiterated the importance of African art as conceptually modernist when he considered its 'intellectually significant form, abstractly balanced design, formal simplicity, restrained dignity and unsentimental emotion [sic] appeal'. Capturing a 'true' African-American culture not only meant familiarizing oneself with African art but now also returning to the tradition of a folk vernacular, of say, the rural South. Likewise, many novelists of the Negro Renaissance used southern folksy vernacular language and subjects that inferred a more 'authentic' African-American voice. Ironically, most of such artists and writers lived in cities and were well educated. He wrote that 'the Negro theme and subject [was] a vital phase of the artistic expression of American life', and that one should expect 'from the Negro artist a vigorous and intimate document of Negro life itself'. Locke's insistence on 'artistic expression of American life' encouraged a conventional art, in line with much of American art at the time.

Négritude and figurative sculpture

Central to the impetus of the New Negro movement and carrying its ideas into the 1940s, were the sculptors William E. Artis (1914–77), Nancy E. Prophet (1890–1960), Augusta Savage, Sargent Johnson, and Richmond Barthé. Their works, especially those of Barthé, embodied Négritude—an emphasis on mythic traits of the African personality as sensual and emotionally sensitive. This is what is embodied in the phrase 'Negro soul'. Alain Locke, returning from a visit to Paulette Nardal, an intimate member of the black cultural vanguard in Paris, was surely reinvigorated in his efforts to create a racial art genre.

Négritude

In the 1930s pan-African cultural nationalism was initiated by French-speaking West African and Caribbean black intellectuals, most notably René Maran, Léopold S. Senghor and Aimé Césaire who were based in Paris. Called Négritude, it developed in the climate of modernism: jazz, African primitivism, and surrealism, and was about the values manifested in black African culture, mostly influential in Europe, particularly Paris and in the French Antilles, and the United States. Négritude emphasized mythic traits of the African personality as sensual and emotionally sensitive: a Negro 'soul'. The term first appeared in print in a poem 'Return to my native land' by Martiniquan Aimé Césaire in 1939.

Augusta Savage (1892–1962) began to study art in 1921 in New York City, where she soon established her reputation as a portraitist of Negro Renaissance leaders. However, her most familiar work, *Gamin* [**52**], a plaster model (1929)of her nephew Ellis Ford, earned her a fellowship from the Rosenwald Foundation, on which she travelled to Paris. During the two years she was there she met Henry Ossawa Tanner and Hale A. Woodruff, continued her art studies and exhibited her sculptures. Upon her return to the States (1934), she became the first African American elected to the National Association of Women Painters and Sculptors.

Savage achieved another professional distinction, as the only African-American artist to receive a commission from the New York World Fair's Board of Design in 1937. The theme was 'The American Negro's Contribution to Music, Especially to Song', and Savage's response to this was a monumental work in plaster (never cast) inspired by James Weldon Johnson's poem 'Lift Every Voice and Sing' (the American Negro anthem). Originally entitled *The Harp*, the sculpture [**53**] soon came to be known by the poem's title, which is inscribed on the plaque held by the kneeling figure.

Savage's reputation grew as an arts administrator and mentor for

53 Augusta Savage
The Harp, 1939.
The plaster monumental
sculpture, 16 feet (5m) high
was painted black,
presumably to imitate metal,
although the symbolism of
colour cannot be ignored.
Metal miniatures were sold
as souvenirs.

young art students. In 1932 she opened the Savage Studio of Arts and Craft in Harlem and shortly thereafter, under the auspices of the Works Progress Administration (WPA), was appointed the first director of the Harlem Community Art Center (see p.144). For a brief time during 1939 she opened a gallery in Harlem: the Salon of Contemporary Negro Art. Savage struggled to provide art training and to pass on her experiences and knowledge of modern art to less fortunate students, and her main contribution to art became her encouragement of the next generation of African-American artists.

Richmond Barthé (1901–89) sculpted African, Caribbean and African-American subjects, free-standing and portrait busts. After studying at the School of the Art Institute of Chicago, he made his first trip in 1929, with the assistance of a Rosenwald Fellowship, to New York City, where he attracted the attention of sculptor and art collector, Gertrude Vanderbilt Whitney. He exhibited in the Whitney Museum of

54 Richmond Barthé
Fera Benga, 1935.

American Art Annual in 1933 (and subsequently in 1935 and 1939), and impressed Juliana Force, director of the museum. Three of his works were purchased for the museum's permanent collection, making Barthé the first African-American sculptor whose works became part of a major American museum collection.

Barthé's interest in dance is readily apparent in *Fera Benga* [**54**], one of a series of African theme sculptures. It portrays, with a sensuality unprecedented in African-American art, an acclaimed Senegalese dancer and artist's model from Paris. Subtle breaks in the bronze surface reflect light, enhancing the realism of the figure, and recalling the influence of Auguste Rodin on earlier African-American sculptors. Barthé continued to sculpt figures and busts in plaster, some of which were cast in bronze, and in 1937–8 produced a series of monumental reliefs for the WPA at the Harlem River Housing Project.

Sargent Claude Johnson (1887–1967), often the only artist from the West Coast (Bay Area, California) to exhibit in Harmon Foundation shows, was one of the three artists (Richmond Barthé and Malvin G. Johnson being the others) in the Foundation's last exhibition at the Delphic Studio (New York City) in 1935. His interest in sculpture was perhaps encouraged by his aunt, the African-American sculptor May Howard Jackson (1877–1931). Johnson used an earlier drawing, *Defiant* (1933), which had earned him a Harmon Foundation award, as a model for his *Forever Free* [**55**].

Johnson's experience in art deco ceramic ware is apparent in his simplification of the highly stylized figures into a column, with low reliefs delineating the contours of the children and a highly stylized physiognomy. The overall crispness of form and design is also typical of art deco style. The main figure's face alluded to African masks, representing what Johnson considered to be essential African-American facial features: a racial archetype. In a newspaper interview in 1935, Johnson said:

I am producing strictly a Negro Art. It is the pure American Negro I am concerned with, aiming to show the natural beauty and dignity in that characteristic lip, and that characteristic hair, bearing and manner; and I wish to show that beauty not so much to the white man as to the Negro himself. Too many Negro artists go to Europe and come back imitators of Cézanne, Matisse, or Picasso; and this attitude is not only a weakness of the artists, but of their racial public. All their theories do not help me any, and I have but one technical hobby to ride: I am interested in applying color to sculpture as the Egyptian, Greek, and other ancient people did. I am concerned with color, not solely as a technical problem, but also as a means of heightening the racial character of my work.[6]

His work continued to focus on black racial prototypes: usually dark-coloured, they alluded to southern folk culture.

Folk art

In the 1930s folk art was increasingly touted as America's 'primitive' art—an art that was innocently expressive. It stood nostalgically for the era of the common man, a simpler time. Thus it had moral significance, and relevance to the forging of an image of national identity. In the context of art there was a coincidence between the primitive qualities of folk art and the fashionable European style of abstract modernism. American critic and curator Holger Cahill (1887–1960) saw an opportunity to usurp European dominance of modern art and to appeal, at the same time, to nationalist sentiments in America by promoting the folk art idiom.

American critics' and collectors' interest in folk art continued into the 1940s, but there was a change in emphasis: the appeal now lay not so much in its value as an early American art form, but in its aesthetic qualities which appealed to modern sensibilities. These can be seen in the work of Horace Pippin [**57**], which exemplifies the characteristic flat shapes, use of space and simple colour palette. This simplicity resonated with the sophisticated, intentionally naïve style of contemporary African-American artists Jacob Lawrence and William H. Johnson [**68, 69, 70**], who worked in the fine art tradition.

Riding on the crest of folk art popularity, two African-American artists rapidly gained a high reputation. William Edmondson and Horace Pippin became better known than any African-American fine artist of the period, with their work being promoted as exemplifying modernist prototypes. Edmondson was the first African-American artist to have a solo exhibition at the Museum of Modern Art.

The fame of these artists was due entirely to the enthusiasm of critics and collectors. They themselves took no interest in studying modern trends, and did not value formal art training. Pippin successfully resisted Barnes's many invitations to view his collection. The interest of these artists was in their local community—as subject, and as audience. They had exactly the qualifications so sought after by Alain Locke: an art which drew upon folk culture and yet was aesthetically modern.

William Edmondson (1863–1951) spent most of his life in Nashville, Tennessee, his birthplace. At about age sixty, he began carving small gravestones from abandoned commercial limestone curbing. He carved tombstone ornaments for his neighbours—animals which he called 'critters' and 'varmints', and human figures, mostly biblical, as in *Eve* [**56**]. The light and shadows catching on the edge of his shallow reliefs create the effect of a line drawn upon the stone surface, suggesting a form just barely freed from its stone block.

Sidney Hirsch, a poet and fellow citizen, discovered Edmondson around the year 1935, and Hirsch's friend Louise Dahl-Wolfe, a pho-

55 Sargent Claude Johnson

Forever Free, 1935.

This sculpture is meticulously built up of polychromed wood covered with several coats of gesso and layers of fine linen, which were sanded between layers to create a highly polished and smooth surface.

tographer for *Harper's Bazaar* magazine, facilitated Edmondson's solo exhibition at the Museum of Modern Art in 1937. A year later Edmondson's sculptures were included in an exhibition in Paris at the Jeu de Paume: 'Three Centuries of Art in the United States'. Edmondson's appeal can undoubtedly be attributed to his work's coincidence in style with that of modernist sculptors, who, influenced by primitive, especially African, sculpture, chose to work as direct carvers (rather than having their models cast in metal or reproduced in stone by professional stonecutters).

After two years' employment (1939 and 1941) in the WPA Edmondson had his first exhibition in Nashville. Catapulted from stonecutter to renowned folk artist, Edmondson never veered from his customary way of working which he regarded as a sacred mission:

This here stone and all those out there in the yard come from God. It's the work in Jesus speaking His mind in my mind. I must be one of His disciples. These here is miracles I can do. Can't nobody do these but me. I can't help carving. I just does it. It's like when you're leaving here you're going home. Well, I know I'm going to carve. Jesus has planted the seed of carving in me.

Horace Pippin (1888–1946) was a native of Pennsylvania and lived there for most of his life. He fought and was wounded in World War I while serving in the renowned 369th Infantry Regiment. Despite the result-

56 William Edmondson
Eve, c.1932.

ing disability (immobility in his right arm) he taught himself to paint. After burning images into wood with a hot poker, he began oil painting in 1928. His first work was *The End of War: Starting Home* (1931), which took three years to complete. By supporting his disabled arm at the wrist with his left hand, he could work at an easel, and in this way painted African-American historical events, biblical themes, domestic interiors and landscapes on canvas.

The appeal of his naïve folk narratives grew between 1938 and 1948. Holger Cahill included Pippin in an exhibition, 'Masters of Popular Painting' at the Museum of Modern Art (1938). Cahill noted that these 'popular' artists 'set down not only what they see but what they know and feel'. *New Yorker* art critic Robert M. Coates, upon seeing the 'American Negro Art, 19th & 20th Centuries' exhibition at the Downtown Gallery (1941) wrote that Pippin was 'incontestably in the very front rank of modern primitive painters, here or abroad. Indeed Pippin's skill and resourcefulness have progressed to the point at which it is hardly proper to call him a primitive at all.'[7] Albert C. Barnes took an interest in him at around the same time, accepting Pippin as a stu-

57 Horace Pippin

John Brown Going to his Hanging, 1942.
Pippin recorded the scene as it had been described by his mother, who witnessed it. The painting is one of his few political narratives.

dent at his foundation to study his collection of Impressionist and post-Impressionist paintings (and possibly African art), hoping to inspire Pippin to greater artistic heights. Pippin was unmoved and soon left. Yet this did not deter Barnes from calling him the 'first important Negro painter to appear on the American scene'. Pippin exhibited his paintings at the African-American art organization, the Pyramid Club (established 1940) in 1943, and at Edith Halpert's Gallery in 1944. One painting, *John Brown Going to his Hanging* [57] won the Pennsylvania Academy of Fine Arts purchase prize when it was shown at the 138th Annual Exhibition.

John Brown Going to his Hanging shows that fateful day on 2 December 1859 when John Brown (1800–59), a white American abolitionist, considered a martyr to the anti-slavery cause, was executed in Charleston, West Virginia. The symmetrical composition, clearly delineated forms and details of dress and architecture, with overall simple flat colours and stark contrasts of light and dark shades, describe the scene straightforwardly. Pippin's popularity with critics, collectors, and curators resulted in his participating in several types of exhibition: American art surveys, Negro art shows, and, self-taught, folk art. As a result he became one of the better known American artists of the mid-twentieth century.

American Scene painting

American Scene painting, considered in the 1930s to be a 'sincere national art', represented American artists' attempts to create a native American style. There were Regionalists, typically in the Midwest, who painted rural genre, and those who painted urban genre. No one

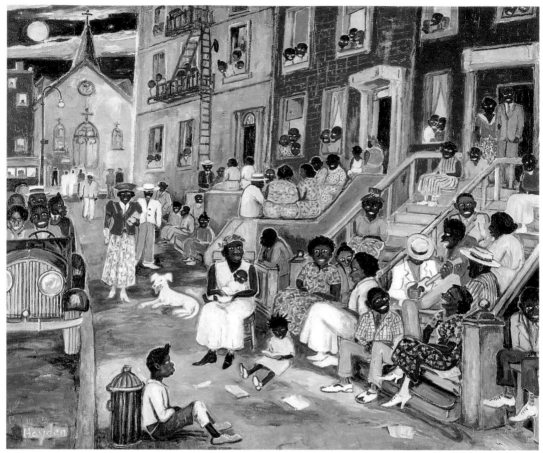

58 Palmer Hayden

Midsummer Night in Harlem,
1938.

particular style technique predominated and academic styles were borrowed from earlier European art movements, for example, sixteenth-century Italian Renaissance art, although with a preference for realism. Typically, those who painted rural scenes were considered nostalgic and politically reactionary because they turned their back on modernity, whereas those who painted urban scenes were considered politically liberal. Urban scenes were especially popular among those lured to the cities on the promise of economic success; such images reflected America's fascination with urban life, the emblem of twentieth-century modernism.

Two such artists were Palmer Hayden and Archibald J. Motley, who returned from Paris during the Great Depression (1929–39) to New York City and Chicago respectively. The popular interest in American subject-matter licensed African-American artists to portray black folk culture. As Alain Locke wrote in 1933:

Just as it has been a critical necessity to foster the development of a national character in the American art of our time, by the very same logic, it has been reasonable and necessary to promote and quicken the racial motive and inspiration of the hitherto isolated and disparaged Negro artist.

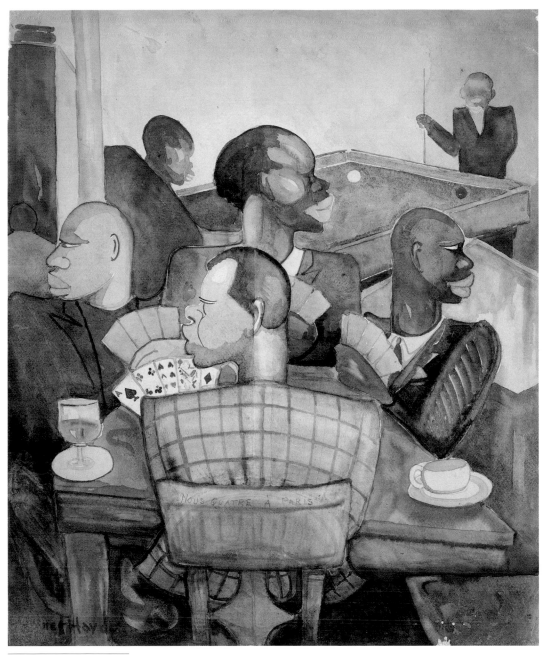

59 Palmer Hayden

Nous Quatre à Paris, 1935.
Following Hale A. Woodruff's
Card Players, Hayden pays
homage to Cézanne, who
painted the same subject,
and to his life in Paris, playing
cards with Woodruff and
Ernest Duprés.

Palmer Hayden painted many urban genre scenes including his most renowned work, *Midsummer Night in Harlem* [**58**]. Here, with his depiction of the brownstone town houses of Harlem, showing the lower- and middle-class residents out on the steps or in the street, an automobile and a church, he showed the African-American urban community that thrived as a city within a city. *Midsummer Night* is a modernist translation of a special event, midsummer night—24 June—which marks the feast of the birth of St John the Baptist and also the summer solstice, when supernatural beings were thought to roam and which involved pre-Christian solar ceremonies. The satirical content is also emphasized. The strong element of farce in William Shakespeare's comedy, *A Midsummer Night's Dream*, is expressed visually in the exaggerated expressions of the figures, who appear like stereotypes portrayed in films, advertisements, and comics. African-American art historian James Porter ridiculed the work in 1943, comparing it to 'one of those ludicrous billboards that once were plastered on public buildings to advertise the black face minstrels'. Hayden's response to critics like Porter was that he was painting an era, and that his works made a symbolic reference to comedy, tragedy, and pleasures of a black lifestyle. He considered himself, as did Alain Locke who praised Hayden's painting, a modernist who depicted modern society and for whom, as for European modernists and American folk painters, expressionism was more important than descriptive realism.

Between 1934 and 1940, while employed on WPA art projects, Hayden painted *Nous Quatre à Paris* (We Four in Paris) [**59**], probably a tribute to Hale Woodruff, who had also painted the Negro colony in Paris [**51**]. The painting mimics late nineteenth-century European modernism, and simultaneously is a tongue-in-cheek parody of the master of the New Negro artists, Aaron Douglas, whose illustrations for *The New Negro* [**45**] and *Opportunity* (1925, 1926) show the same human head in profile with full, lighter-coloured lips and elongated neck. Hayden also recalled with these figures his earlier tribute to African art, the Fang reliquary statue shown in *Fétiche et Fleurs* [**47**].

When Archibald J. Motley returned to the United States in 1930, he replaced his Parisian genre scenes with scenes of the African-American community in Chicago's Bronzeville. *Saturday Night* [**60**], an image of a raucous jazz club, is one example. The compressed objects and figures, with their flowing contours and the floor tilting almost parallel to the painting's surface, suggest the influence of European abstract modernism. The overall rhythmic patterns created by the figures, the contrasting light and dark tones with the dominant red hue, create a jazz-like syncopation and mood. Motley excelled in his pictorial record of African-American night-life. Amidst the crowded cabaret and streets, a figure disengaged from the surrounding

social activity conveys a sub-theme about social isolation. Motley painted an aspect of black life unnoticed by most, yet enjoyed by adventurous whites: a black society in the Jazz Age in America.

African-American murals

Murals were a very important part of the Federal Arts Project as they enabled ordinary citizens to see the best of American art, an art that reflected nationalist ideals and values. Murals could, according to George Biddle (1885–1973), show that 'these younger artists of America are conscious of the social revolution that our country and civilization are going through'. However, President Roosevelt needed some convincing after the débâcle surrounding Diego Rivera's murals at the Rockefeller Center. He did not want, as he put it, 'a lot of young enthusiasts painting Lenin's head on the Justice Building'.[8] In the end the mural project proved to be most effective in creating an epic national style that was realistic, unfussy and clearly narrative.

African-American artists appreciated the pedagogical value as well as popular appeal of mural painting. They looked, as did many American artists at the time, to the Mexican muralists for inspiration. African-American artists like Charles White (1918–79), Aaron Douglas, and Hale Woodruff used the Mexican muralists' strategy, but

60 Archibald J. Motley, Jr
Saturday Night, 1935.

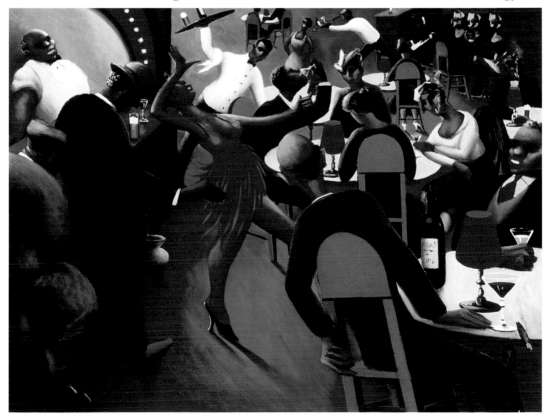

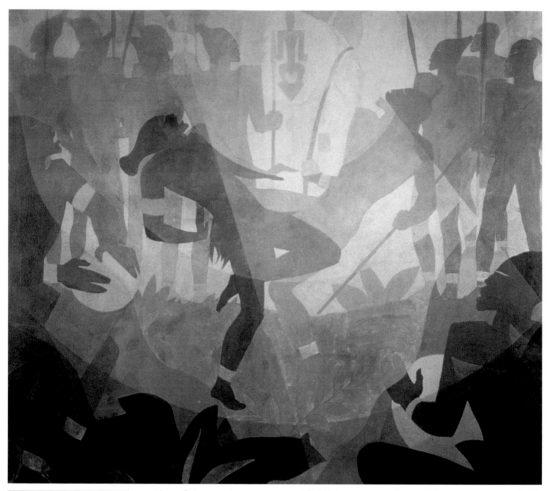

61 Aaron Douglas

Aspects of Negro Life: The Negro in an African Setting, 1934.

tailored it to the context of African-American life, to convey their social concerns to the public, especially the African-American public.

During the last phase of the Negro Renaissance, and sponsored by the FAP, Douglas completed *Aspects of Negro Life*, a group of four mural paintings, his most impressive response to Alain Locke's directive to use African art and African-American folk culture as an inspiration. It also reflected W. E. B. DuBois' conviction that any art of value must be morally responsible and instructive. In a 1926 issue of *Crisis*, DuBois had asserted, 'I do not care a damn for any art that is not used for propaganda. But I do care when propaganda is confined to one side while the other is stripped silent.'

Aspects of Negro Life was installed at the 135th Street branch of the New York Public Library. The historical narrative, on Africa and African descendants in the United States, is shown in two horizontal and two vertical compositional formats, featuring African ritual and ceremony, and African Americans, first in the South and finally in the

North. As in his earlier works, Douglas restricted his palette, ranging from light mauve-browns to dark blue-purples, interweaving his silhouetted figures of abstract geometrical design. More clearly than in any of his previous works, one senses what literary historian Houston Baker termed 'soundings', the performative aspects of African culture. Africa's musical progeny, jazz, is rendered in the colour tones, concentric circles, and the unfolding of figural groups; the viewer's eye transforms visual rhythms into sound.

Douglas studied African art in the collections of Albert C. Barnes and of Alain Locke, but though this gave him a greater appreciation of African art, it had little effect on his representation and depiction of Africa. In the first painting of the series, *The Negro in an African Setting* [**61**], Douglas employs the popular tropes of 'primitivism'—dancing figures, standing figures holding spears, drummers, and a highlighted fetish statue. The figures are painted in his elongated 'Egyptian style'. The only ethnographically accurate image is of the dancing woman, whose profiled hairstyle is that of the *Mangbetu Woman* whom Douglas portrayed for the cover of *Opportunity* magazine (May 1927).

In the last painting, *Song of the Towers* [**62**], the Statue of Liberty has replaced the African fetish; the saxophone player the dancer. The first and last paintings represent the quintessential symbols of African and African-American culture. However, *Song of the Towers* also carries a social realist message, a critical comment on the forward march of science and technology, which has had little effect in improving the economic and social lot of African Americans. The icons of American secular society modernism—industrialization and urbanism—are rep-

Mexican mural painting

Mexican epic murals featured scenes from history and folk legend, which were used as vehicles for protest at political and social injustices, and the plight of the working class. As Diego Rivera stated: 'We can establish it as a basic fact that the importance of an artist can be measured directly by the size of the multitudes whose aspirations and whose life he serves to condense and translate.'

Diego Rivera (1886–1957), José Clemente Orozco (1883–1949), and David Siqueiros (1896–1974) were known as 'Los Tres Grandes' (The Three Great Ones) and were employed to paint murals by the Mexican government. When American artist George Biddle (1885–1973) saw their murals in Mexico he became very enthusiastic about their value as 'a paradigm of socially-conscious wallpainting', and subsequently helped persuade President Roosevelt to devise a government scheme to similarly employ American artists. All three Mexican artists came to paint murals in the United States during the 1930s. This gave several African Americans the opportunity to observe them working and view their paintings before many of them travelled to Mexico in 1945. Rivera was particularly influential as he worked in Detroit, San Francisco, and New York City, where his murals at the Rockefeller Center and the New Workers' School, completed in 1933, provided excellent examples for African-American artists living in or visiting New York City.

62 Aaron Douglas

Aspects of Negro Life: Song of the Towers, 1934.

resented by skyscraper buildings, smokestacks, wheel cogs, belching smoke, the jazz musician, and the worker. The tilting perspective presses toward the viewer, virtually obliterating the sky and overshadowing the figures.

Through such compositional devices, Douglas reveals his socialist and labour union sympathies. Socialist organizations attracted many African Americans in the 1930s and 1940s because of their credo of social and economic equality, and anti-racism. Artists' organizations, such as the left-wing Artists' Union (est. 1934), functioned like any other labour union, fighting for occupational solidarity, better working conditions and economic benefits. Another, the American Artists' Congress, whose members included Douglas, strove to make a 'politically cogent artistic intervention' and were concerned with international and national political issues, such as the Popular Front Against

Fascism in 1935. Douglas also belonged to the Harlem Artists Guild (see p.147), an African-American alternative to the Artists' Union, whose members desired the visibility and economic opportunities which were denied to most of them.

Aaron Douglas wrote in his essay 'The Negro in American Culture' (1936):

Our chief concern has been to establish and maintain recognition of our essential humanity, in other words, complete social and political equality. This has been a difficult fight as we have been the constant object of attack by all manner of propaganda from nursery rhymes to false scientific racial theories. In this struggle the rest of the proletariat almost invariably has been arrayed

63 Charles Alston

Modern Medicine, 1937.

The compact compartmental and hierarchical grouping of figures, disregard for spatial perspective, and careful delineation of form show the influence of Mexican muralist, Diego Rivera, whose mural *Man at the Crossroads* Alston had observed at the Rockefeller Center (popularly known as Radio City) in 1933.

against us. Some of us understand why this is so. But the Negro artist, unlike the white artist, has never known the big house. He is essentially a product of the masses and can never take a position above or beyond their level. This simple fact is often overlooked by the Negro artist and almost always by those who in the past have offered what they sincerely considered to be help and friendship.[9]

This potential victimization and continued precarious survival is suggested in the image of a man on the verge of falling into grasping skeletal hands, also seen in an illustration entitled 'Charleston', which Douglas designed for Paul Morand's book *Black Magic* (1929). The image fits well with W. E. B. DuBois' opinion on the relationship between racism and working-class consciousness: 'modern imperialism and modern industrialism are one and the same system; root and branch of the same tree'.[10] The potential political power of labour was undermined by a white racism that divided the working class. The struggle of the workers to gain equality was part of the struggle for national liberation from the 'shadows' of colonialism. *Song of the Towers* also represented the outlook of black labour leader and radical socialist, A. Philip Randolph (1889–1979), who at the time was an advocate for the industrial worker of the world, and fought for interracial labour organizations.

Charles Alston (1907–77) became the first African-American supervisor of a division within the Federal Arts Project. He grew up in New York City where he met many of the Negro Renaissance writers and leaders, including Alain Locke, who shared with him his library and collection of African art. It was in his studio, which was also the Harlem Art Workshop, assisted by Beauford Delaney (see p.161–4), that in 1936 Alston completed his first major art commission: two mural paintings about healing for the Harlem Hospital. These murals gained Alston more recognition than any other work. *Magic and Medicine* and *Modern Medicine* [63] were installed at the Harlem Hospital after their exhibition at the Museum of Modern Art.

 Magic and Medicine illustrated the origins of medicine in Africa, with a monumental Fang (Central Africa) reliquary statue as the focus of the composition, surrounded by spiritual objects—drums, statuary—a herbalist and spiritually possessed people. In Africa, illness was considered a manifestation of spiritual imbalance (as it had been in Europe until comparatively recent times). *Modern Medicine* is about medicine in contemporary Western culture, with Hipprocrates, the Greek 'father of modern medicine', surrounded by scientific objects (a microscope, flasks, the operating theatre) and by surgeons, including Dr Louis Wright, the supervising physician at the hospital. *Modern Medicine* symbolized reason over faith, science opposed to spirituality.

 In collaboration with Hale A. Woodruff, Alston completed another

64 Hale A. Woodruff

Mutiny Aboard The Amistad, 1839, Panel 1, 1939.
Woodruff researched this notorious incident, and studied Nathaniel Jocelyn's painting of Cinqué, who, with other survivors, was repatriated to Sierra Leone.

major mural project for the Golden State Mutual Life Insurance Company in Los Angeles in 1949.

In 1936, while teaching at the Atlanta University complex, Hale A. Woodruff won a grant which enabled him to travel to Mexico City to assist Diego Rivera. He took the opportunity to observe and study the murals of Orozco and Siqueiros in Mexico City and Cuernavaca. Upon his return to the South in 1939, with moneys from the Federal Arts Project, Woodruff completed his first critically acclaimed three-part mural, *The Amistad Mutiny, 1839*. The historical narrative begins with *Mutiny Aboard The Amistad 1839* [**64**], and ends with the return of the Mende captives to their home in Sierra Leone (West Africa). The portrayal of events is based on archival research. In *Mutiny* Woodruff changed his style temporarily to conform to the popular realist style of the Mexican muralists, as can be seen in the sculptural effect of the carefully modelled forms, the clustering of figures, the pantomimic gestures and brilliant colours. Content and theme (heroism and fighting against injustice, and for personal freedom) are likewise typical of Mexican murals. W. E. B. DuBois praised the murals highly, and in 1946 Woodruff settled in New York City for good.

WPA workshops and community art centres

Under sponsorship of the WPA, art workshops and community art centres were established in several African-American urban communities, such as Chicago (Southside Community Art Center, 1940), Cleveland (Karamu House Artist Association, 1935), Detroit

(Heritage House) and Harlem (Harlem Art Workshop and the Harlem Community Art Center) to provide art instruction for young aspirants who could not afford formal art tuition, and employment (as teachers) for professionally trained artists. Art exhibitions were also held there. Art centres frequently provided the opportunity to learn about abstract modernism because several artist–teachers were practitioners of this style, which they learned in Europe or as students. This was especially true for the Harlem Community Art Center, which opened in 1937, and became a model for other WPA urban art centres. The first director, Augusta Savage, said 'I have created nothing really beautiful, really lasting. But if I can inspire these youngsters to develop the talent I know they possess, then my monument will be in their work.' One of those young artists was Robert Blackburn, who reminisced about being at the Center, aged 13:

I cannot tell you the impact of coming down to Augusta Savage's place and sitting in a room with Norman Lewis, Jake Lawrence and Spinky [Charles Alston]. [Vacla] Vytlacil, strong and so intense about what he was doing, would get down on his knees to explain to us about abstract art. Now remember at this time, we didn't have too much knowledge of what was going on in Europe.[11]

The Federal Arts Project provided, through the graphics division, an impetus for the development of printmaking as an important medium in American art. The government's support lead to the establishment of printmaking workshops across the country and to the mounting of several exhibitions at the Federal Art Gallery. These initiatives provided for African-American artists such as James Wells (1902–93),

Savage Studio of Arts and Craft opened in Harlem in 1932 at 163 West 143rd Street. It became the Harlem branch of the adult education project of SUNY (State University of New York). It operated with a grant from the Carnegie Corporation, which was administered through the New York Urban League, and ran scheduled classes in drawing, painting, clay and woodworking.

Harlem Art Workshop (1933–7), located at the 135th Street branch of the New York Public Library (now the Schomburg Center for Research on Black Culture), had the sponsorship of the Harlem Adult Education Committee. Augusta Savage, followed by Charles Alston, Henry W. Bannarn and James Lesesne Wells (1902–89), established the workshop for aspiring artists. First partly funded by the Carnegie Foundation, and later by the Works Progress Administration (1934–7) at 306 West 141st Street, it became an important meeting and exhibition place for artists, and gave its number to the 306 group.

Harlem Community Art Center (1937–42), eventually located on 125th Street and Lenox Avenue, became a model for other WPA art centres. Over 1500 students enrolled in day and evening classes in drawing, painting, sculpture, printmaking and design. The gifted children in Harlem were drawn to it as if by a magnet. The first director, Augusta Savage, was soon followed in 1939 by Gwendolyn Bennett (b. 1902). Teachers included Charles Alston, Aaron Douglas, Selma Burke (1900–95), Ernest Crichlow, Norman Lewis and William H. Johnson, as well as white artists from the Art Students League: Nathanial Derk, Vacla Vytlacil (1892–1984) and Riva Helfond (b. 1910).

Harlem Artists Guild (1935–41) was an independent artists' group whose founders—Augusta Savage, Elba Lightfoot, Charles Alston and bibliophile Arthur Schomburg—created a forum for artists to discuss and plan strategies to foster the visual arts in the community, and to focus generally on social, political activities and issues of concern to African-American artists. One major issue was the WPA's reluctance to engage African-American artists in projects and to appoint them to local WPA boards. The Guild became for African Americans an alternative forum to majority white artists' groups, such as the Artists' Union. In Chicago, there was the comparable Arts and Crafts Guild.

John Wilson (b. 1922), Robert Blackburn, and Dox Thrash, a chance to train or refine their techniques in lithography, serigraphy, and etching.

Robert Blackburn (b. 1920) had the skills of a mature artist by the age of 17, when he completed *People in a Boat* [**65**]. The men's physical isolation, and the barren land towards which they seem destined, allude to the social and political isolation of America before World War II, and is a metaphor for the 'land of opportunity' which offered no benefits for African Americans. After attending the Harlem Community Art Center, where he was introduced to printmaking, Blackburn eventually opened, in 1948, the Printmaking Workshop, on 17th Street (New York City), today one of the more important print studios in the United States.

Dox Thrash (1892–1965) was employed as head of the graphics division

at the Philadelphia WPA (1935–42), and while there invented the carborundum printmaking technique. Eventually settling in Philadelphia, he remained a part-time artist for the rest of his life, exhibiting at the African-American cultural centre, Pyramid Club (Philadelphia), and at the Harmon Foundation.

Defense Worker [**66**] was completed while Thrash was working for the WPA. An isolated figure looms over the horizon, creating a powerful image which became an American New Deal icon. The transformation of the populist image of the American industrial worker into a positive symbol of capitalism and democracy came about by association with the war effort. Orders for armaments boosted a previously weak United States economy. That this image was a black man alluded to the vision of a racially integrated workforce, equal opportunity among workers, and the achievement of economic and social change. Prior to 1940 African-American workers were normally excluded from industrial jobs, but now the urgent need for manpower persuaded whites to join blacks in the campaign for getting African Americans into factories. American publisher Henry Luce promoted images of the American Negro industrial worker in his magazines *Fortune* (1930) and *Life* (1936). A. Philip Randolph's proposed march on Washington (DC) in 1941 motivated Franklin D. Roosevelt to issue an executive order banning the exclusion of blacks from employment in defence plants. In the same year the NAACP conference theme was 'The Negro in National Defense', and their magazine, *Crisis* (August/November 1941), ran stories about training programmes for blacks in the defence industry. The campaign succeeded, and from the end of 1941 until 1945, the employment of African-American workers became commonplace in American industries.

Social realism

African-American artists, like many other Americans, were disillusioned with capitalism in the wake of the stock market crash in 1929. Art became a part of the intense ideological struggle, provoked by the crisis in United States capitalism, and by the possibility of a socialist future. Social realism caught on among artists and writers at that time, as it provided a means by which they could address their concerns regarding socio-political issues. Among the visual artists, images of the urban working class, labourers, and industry connoted economic exploitation, and social and racial inequality, and quickly became aligned with leftist politics. Publications for artists' groups, such as the American Artists' Congress's *Art Front*, gave African-American artists and critics a forum to express their views about art, race, and politics. Artists such as Aaron Douglas and Charles White (1918–79) wrote about racial oppression. White wrote that 'paint is the only weapon [that] I have with which to fight what I resent. If I could

write I would write about it. If I could talk I would talk about it. Since I paint, I must paint about it.'

Artists such as Alston, White, and Romare Bearden drew illustrations for newspapers that expressed their political sentiments more overtly than did their paintings. These often focused on oppression at home and abroad, racism in the South, and economic exploitation.[12] Lynchings of blacks was a subject of particular interest. These increased tenfold after World War I. The NAACP, as part of their campaign against this crime, organized an exhibition in 1935, 'An Art Commentary on Lynching' (Arthur V. Newton Gallery), at which seven African-American artists, including Woodruff, White and Barthé, showed their works alongside white American artists.

By 1939 works sponsored by the WPA were under attack by the press and United States Congress, who feared that artists would use their government-sponsored freedom to organize labour unions or produce communist propaganda (in the United States, there was little distinction between socialism and communism). Social realism's association with socialist ideas made it inappropriate after 1945. Eventually

66 Dox Thrash
Defense Worker, c.1942.

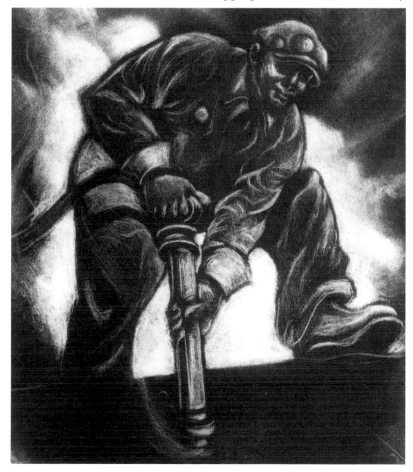

any realistic art connoted public art and a nationalist flag-waving, and the style lost credence to the oncoming international abstract style.

Abstract art and modernism in New York

While federally sponsored art projects promoted realism and American subjects in art, there were American artists who looked towards abstraction. An increasing number of American artists' groups, collectors, museums, and galleries were coming to prefer abstraction to the popular conservative artistic conventions.

One figure who played a part in creating a favourable reception for abstract art was the art critic and author Clement Greenberg (1909–94). In his essay 'Avant-Garde and Kitsch' (*Partisan Review*, 1939), Greenberg underscored the historical inevitability of abstraction in the search for the 'absolute' in art. Painting was *the* medium for abstraction. In his exploration of the relationship between individual aesthetic experience and its social and historical contexts, Greenberg concluded that the 'avant-garde' comprised the only culture currently alive, whose function it was to maintain cultural vitality and forward movement. He also identified a cultural dichotomy: avant-garde v. kitsch. 'Kitsch' he defined as a consequence of the industrial revolution: reproducible products which sold to the masses—commercial art and literature, films, magazines etc. These are cultural commodities. Avant-garde he defined as process and originality. Its products, select or singular, appeal to an educated cultural élite.

Greenberg continued into the late 1950s to argue for 'art for art's sake', a term coined in the nineteenth century to mean a personal art devoid of any social significance or function. Alain Locke, however, could not share this view: 'No art idiom, however universal, grows in a cultural vacuum; each, however great, always has some rootage and flavor of a particular soil and personality.' Locke's conviction that abstraction and cultural reference were inseparable confronts the idea upheld by critics like Greenberg that true avant-garde art transcends culture.

Abstract figurative painting

African-American artists who were attracted to abstraction stayed on a conservative course in the 1930s and early 1940s, a middle ground between abstraction and realism, never relinquishing the representational image. They simplified form, emphasizing colour and design and expressionism. Their modernist art styles, emulating early twentieth-century European art, were a prism through which they viewed African-American life.

Early in his career, Norman Lewis (1909–79) painted *Yellow Hat* [67] in

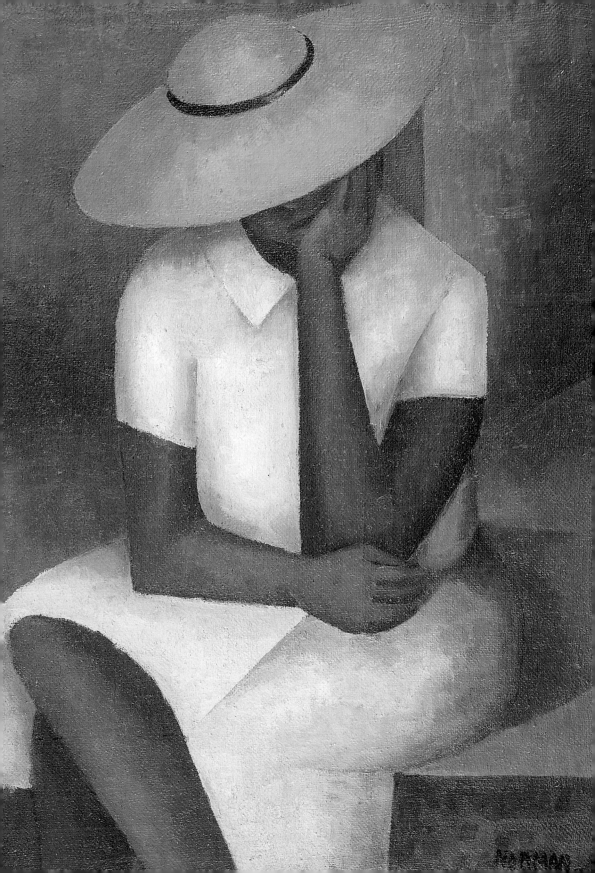

Abstract art describes artworks that have no recognizable subject. The synonyms for abstract include 'non-objective' and 'non-representational'. Abstract art, however, may be inspired by an actual object. The process of producing such art requires the artist to strip away all distracting surface manifestations of realism and focus on essential form and shape, hoping thereby to identify the fundamentals of visual experience. There are two general styles: organic, characterized by fantastic large curvilinear shapes; and geometric, using hard-edged and angular shapes.

Interest in abstract art in the USA was stimulated by the arrival in the 1930s of many European artists fleeing the rise of the Nazis in Germany. Exhibitions promoted the new style: 'Abstract Painting in America' (1936) at the Whitney Museum of American Art (founded 1931), 'American Sources of Modern Art' (1933) and 'African Negro Art' (1935) at the Museum of Modern Art, which explored the relationship between non-Western art and modern painting. Albert E. Gallatin's Gallery and Museum of Living Art opened at New York University in 1927, and the Solomon R. Guggenheim Foundation's Museum of Non-Objective Painting in New York in 1939.

American Abstract Artists (1936–66), a group of painters and sculptors, promoted abstract art often very similar in style to synthetic Cubism: a geometric Cubist-derived idiom of hard-edged forms, applying flat, strong colours. They rejected Expressionism and Surrealism. Their first president was Balcomb Greene (b. 1904), and they included American artists like A. E. Gallatin and Carl Holty (1900–73), and European artists like Piet Mondrian (1872–1944). Their peak years were between 1937 and 1942.

which an isolated female figure is fractured into planar shapes of colour. Lewis was a product of the New York WPA art centres, a student of the New Negro. He was aware of Locke's ideas about art and, like Woodruff, studied African art held in private and in public collections (e.g. the African sculpture exhibition at the Museum of Modern Art, 1935). Soon, though, he wanted to move away from what he saw as the 'limitations which come under the name "African Idiom", "Negro Idiom" or "Social Painting" [and towards] a whole new concept of myself as a painter'.

As a step in that direction he exhibited in shows organized by the American Abstract Artists, and became active in the 306 Group. The 306 Group and Studio, under the direction of Charles Alston and African-American sculptor Henry Bannarn (1910–65), had evolved from an insignificant informal art group to one that by 1940 represented the emerging African-American painters, printmakers, and sculptors. Number 306 West 141st Street became *the* meeting place for artists, writers, poets, and performing artists in New York City. The 306 Group exhibitions were attended by people from the Northeast, from Europe, from downtown and mid-town Manhattan, by whites and blacks. Their programmes fulfilled the objectives of the Harlem Artists Guild, some of whose members were active in 306: to identify, mentor and promote emerging African-American artists who represented the African-American community's criteria for black American art.

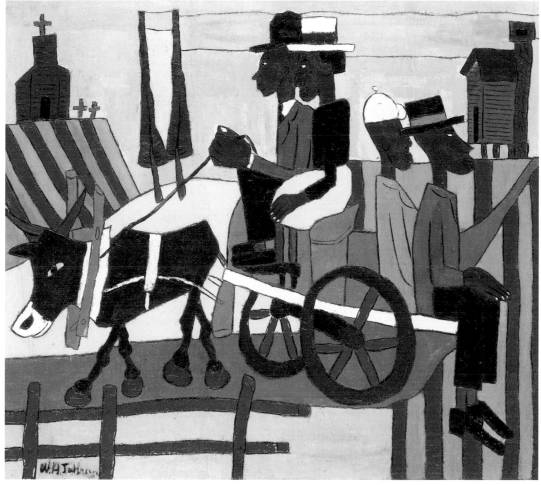

68 William H. Johnson
*Going to Church, c.*1940–1.

When William H. Johnson (1901–70) arrived in New York City in 1918, he quickly established his reputation as an abstract artist, partly through the support he received from the Harmon Foundation and Alain Locke. By 1926 he had left for Paris. In 1938 the threat of World War II forced him to return from Europe—by then he was in Denmark—to the United States. He re-established his connection with the African-American art community, first by teaching at the Harlem Community Art Center and then, although not a member, exhibiting with artists of the Harlem Artists Guild. Johnson at this time considered himself a 'primitive', meaning one who preferred simple forms and shapes, and had little concern for optical illusionism. With support from the WPA, Johnson was involved in several mural painting projects between 1939 and 1943, which undoubtedly helped him arrive at the pictorial clarity and narrative seen in *Going to Church* [**68**]. In the 1940s he set out to 'tell the story of the Negro as he has existed' in the rural South and urban North. Brilliant primary colours, simple shapes for figures and landscape create a rhythmic design that is very

similar to naïve painting. For the remaining years, Johnson never veered from the style, exhibiting in mostly Negro art exhibitions, and gaining critical accolades from both white and black art dealers and collectors. By 1946 he had severed his close ties to the Harmon Foundation, and returned to Denmark, taking all of his work with him. Shortly thereafter he was found destitute, living on the streets in Oslo, Norway. Mary Brady, director of the Harmon Foundation, on hearing of his plight, arranged for his return to the United States and the safekeeping of his works. Johnson never painted again and spent the remainder of his life in Central Islip State Hospital, New York.

One of the more promising students at the Harlem Art Workshop and Harlem Community Art Center was Jacob Lawrence (b. 1917). He studied Aaron Douglas's paintings, and Locke's ideas about art; he learned about the Mexican muralists, and about African art and history from Charles Alston and 'professor' Charles Seifert. Seifert lectured about black culture and history at his home, on 137th Street in Harlem, and took students to exhibitions of African art. Lawrence later recalled that Seifert wanted 'to get black artists and young people such as myself who were interested in art to select as our content black history. For me, and for a few others, Seyfert [*sic*] helped to give us something that we needed at the time.' With the encouragement and efforts of Augusta Savage, he was employed on a WPA project, and

69 Jacob Lawrence

Migration of the Negro, Panel 1: During the World War there was a Great Migration North by Southern Negroes, 1940–1.

Consisting of 60 panels in all, this narrative series is based on the experience of the artist's family during the Great Migration. Edith Halpert showed the entire series at her Downtown Gallery.

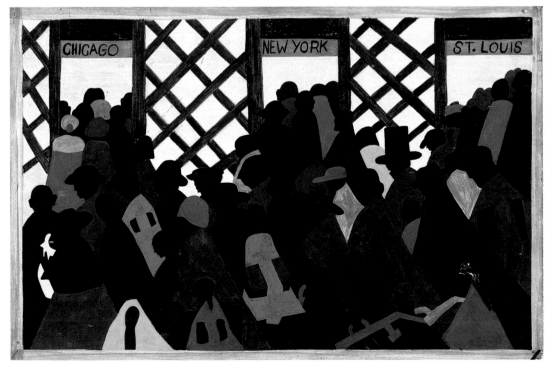

70 Jacob Lawrence

Migration of the Negro, Panel 50: Race Riots were very Numerous all over the North, 1940–1.

The explanation displayed with the caption read: 'Race riots were very numerous all over the North because of the antagonism that was caused between the Negro and white workers. Many of these riots occurred because the Negro was used as a strike-breaker in many of the Northern industries.'

won a scholarship from the progressive American Artists School (1936–8), an institution which had a history of hiring faculty members who were politically active in social issues, and whose purpose was to give students 'an understanding of modern society itself, its forces, tendencies, and conflict'. This, along with his experiences in Harlem, surely affected Lawrence's aesthetic outlook and what he chose to paint.

At the age of 23 Lawrence completed his best-known narrative painting series: *The Migration of the Negro* [**69, 70**]. Alain Locke showed photographs of several paintings to Edith Halpert, who

arranged for *Fortune* magazine to publish part of the series. During the same year she also arranged to have the entire series of 60 panels exhibited in her prestigious Downtown Gallery. It received widespread critical acclaim and eventually became the focus of a purchasing conflict between Alfred H. Barr, Jr, director of the Museum of Modern Art, and Duncan Phillips, founder of the Phillips Memorial Gallery. Finally Barr acquired the even-numbered and Phillips the odd-numbered ones.

The Migration of the Negro tells a story based on the Lawrence family's experiences during the Great Migration. Painted in the inimitable style which Lawrence called 'dynamic cubism', the pictorial narrative flows from left to right, like a written text. The reductive style is similar to that found in naïve and folk paintings, leading many critics to regard Lawrence as essentially self-taught, and to describe his work as 'truer' or 'purer' than that of other American fine artists. It was not coincidental that Edith Halpert showed Lawrence's work at the Downtown Gallery around the same time she showed Horace Pippin's paintings.

The historical narrative also recalls popular documentary photographs and films of the 1930s. Lawrence effectively captured an important historical moment, recording specific episodes without indulging in sentimentality. Each panel's caption, written by Lawrence, is a narrative about aspirations, economic success, and perseverance. The series appealed broadly to critics and viewers alike because it embodied American ideals about individual good fortune. The refrain 'the migrants kept coming' punctuates the story about blacks' triumph over adversity. As he recalled, 'if our story rings true for you today, then it must still strike a chord in our American experience'.

Lawrence wrote a few years later: 'My pictures express my life and experiences. I paint the things I know about and the things I have experienced. The things I have experienced extend into my national racial and class group. So I paint the American Negro working class.' He continued to paint series dealing with African-American history and generic topics, such as builders, or war.

Patronage and critical debate

From the 1920s and continuing into the 1930s and 1940s, some African-American artists assumed the mantle of art critic. They noted the failure of black artists to develop their own style and progress professionally, and raised the issue of quality. Inadvertently, their remarks reflected critically on the benevolent patronage of whites, whose support had encouraged a racial art irrespective of skill or training.

On numerous occasions artists were exhibited because they were 'colored'. Reflecting on this in later years Aaron Douglas remarked

that anyone seen in Harlem with brush and paint was pulled off the streets, touted as an artist and exhibited in Negro art shows. In 1934 Romare Bearden criticized many African-American artists' works as 'hackneyed and uninspired, and only mere rehashing from the work of any artist that might have influenced him'. Bearden believed that organizations like the Harmon Foundation were at fault by not imposing high critical standards in their exhibitions and instead encouraging a 'racial identity' and mediocrity in the visual arts (not unlike, by the way, that seen in much of American art in the 1930s). Negro art exhibitions suggested that most artists were conservative in choice of subjects and styles, focusing on realism and naturalism, genre and portraiture. Cultural historians Eugene Metcalf and Nathan Huggins have pointed out that the art of black Harlem was in many ways created for white consumption. The Harmon Foundation's exhibitions at the periphery of Harlem, and later in mid-town, outside the African-American community, suggested that this was so.

In the 1920s, '30s and early '40s mainstream critical evaluations of African-American art predictably focused on white-sponsored Negro art exhibitions because these shows had visibility and financial support, and were part of a developing art market network. An example of this support is the fellowships awarded by the Julius Rosenwald Foundation between 1917 and 1948. Part of the popularity and success of the exhibitions was simply because they promoted the cultural endeavours of African Americans as professional artists.

During the late 1930s and early 1940s few American museums showed African Americans in group exhibitions of American art; the Art Institute of Chicago, Newark Museum, Museum of Modern Art, and Whitney Museum of American Art were exceptions. Few white-owned galleries showed African-American art; one notable exception was the Downtown Gallery (founded 1926), originally located in Greenwich Village and after 1940 on 51st Street (mid-town), which specialized in modern European art and especially American art. Through her contact with Alain Locke, Halpert, the owner and director, learned about and helped sponsor African-American artists such as Hale Woodruff, William H. Johnson, and Jacob Lawrence. Together Locke and Halpert planned one of the more important group exhibitions of African-American art, 'American Negro Art: Nineteenth & Twentieth Centuries' (Downtown Gallery, 1941), which juxtaposed modern Negro art with black folk art. In 1939 Caresse Crosby's G Place Gallery (Washington, DC), with the sponsorship of the Harmon Foundation, organized 'Contemporary Negro Art', which was shown at the Baltimore Museum of Art; and in 1941 another white-owned gallery, McMillen Gallery (New York City) organized 'Contemporary Negro Art', which juxtaposed modern Negro art with African art.

As a result of these mainstream Negro art exhibitions, many African-American artists formed their own organizations, for example, the Harlem Artists Guild and Chicago's Art and Crafts Guild, and persuaded the WPA-funded art centres to hold Negro art exhibitions that represented the exhibitors' own views about modern art. Such shows, although they publicized the efforts and accomplishments of African-American artists, also segregated them from the mainstream art world. African-American art was in its own world: black colleges and universities, such as Howard, Hampton, and Fisk, provided training, and exhibitions. There was the nationally known annual Atlanta University exhibition (1942–70), established by Hale A. Woodruff, which showcased faculty, student, national, and international artists. The African-American press, including the *Chicago Defender*, *Baltimore Afro American*, and *Amsterdam News* (Harlem), consistently reviewed these Negro art exhibitions for the African-American community.

By the mid-1930s the views of art historian James Porter and philosopher–aesthetician Alain Locke had crystallized the main issue with regard to African-American art, one which has remained central. In 1936 Porter wrote in *Art Front* that Locke's essay in *Negro Art: Past and Present* (1936) represented

one of the greatest dangers to the Negro Artist to arise in recent years; . . he has yielded to the insistence of the white segregationists that there are inescapable internal differences between white and black.

Porter continued to express his disdain for a racial art in *Modern Negro Art* (1943). For him, the solution was not imitation of African Art. He criticized African-American intellectuals for extolling African Negro art as the 'art of the noble savage', and pointed out that their admonitions had not produced a coherent artistic programme.

A division became apparent among the intelligentsia regarding the value of African art and the need to cull from African-American folk tradition to arrive at authentic expression. Those of Porter's view felt that an artist should choose freely what and how to produce, and that the study of African art would only lead to superficial copying and interpretation of the primitive, similar to that of white artists. Those who favoured Locke felt that African art was the classical art for African Americans, to be studied in the way that whites studied antique Greco-Roman art. The issue was not cultural retention of Africa, Greece or Rome; the earlier art forms and aesthetics could none the less serve as rootstock for contemporary development. Ultimately, African-American artists wanted to show that they could compare with the best American artists. Some were trapped rather than nurtured by Africanist ideas; others successfully used them as a starting point. As the artist David C. Driskell aptly asked, was it 'better to be a

"Negro artist" and develop a racial art or to be an American artist who was a Negro'. Either way, it was necessary to challenge the status quo and establish an identity as a professional artist.

At the beginning of the 1940s, Locke held considerable clout in the mainstream and African-American art communities. He considered African-American artists as potentially significant for they provided an 'authentic flavor and native American touch' and he saw them as those who would realize a racial art which would have social value and aesthetic merit. Locke felt that 'sooner or later it will be generally recognised that these artists have made and are making a substantial and important contribution to our national art'. Few actually did. Unfortunately, the bombing of Pearl Harbor on 2 December 1941 brought the United States into World War II and interrupted the momentum of critical attention being given to African-American artists.

American culture post World War II

After World War II, the United States had world-power status and with it a front-line place in opposing the USSR. The Cold War flared into open conflict during the presidency of Harry S. Truman (1945–53), when the United States intervened to strengthen Korean resistance to the communist invasion of their country. America had enormously increased influence in Europe, where—under the terms of the Marshall Plan—$12 billion was dispensed in aid between 1948 and 1957. This too helped resist any increase in communist influence.

The United States economy boomed, commerce and industry were expanding at a rapid rate, and technological advances spurred space ex-

ploration. Veterans returning from the war were able to receive education through the GI Bill; the American dream now included tract housing and electrical gadgets.

Art and architecture increasingly lacked a specific national identity as communication between societies facilitated a sharing of ideas and philosophies about art and culture. Late modernism denoted international art. American culture, with American money, infiltrated the Western world and much that was new and exciting was American. The fascination with things American that had begun after World War I intensified.

By 1950 the avant-garde artists in New York City, popularly called the New York School, attracted the kind of attention previously given to artists in European cities, most recently Paris.

Folk art

African-American folk artists were largely ignored by mainstream art critics and collectors in the 1950s. In their private creative realm they recorded their world, both real and imaginary. Sometimes their imaginary world was infused with religious fervour. This was the case with James Hampton (1909–64), whose singular sculptural ensemble, *Throne of the Third Heaven of the Nations' Millennium General Assembly* [71] (found in a rented garage after his death) is an exotic celebration/forewarning of the Second Coming.

This visionary work was made out of 'found objects' and old furniture, covered in gold and silver foil, purple Kraft paper and other materials. At the top of the central throne are the words FEAR NOT. There are labels and wall plaques recording his visions, often in an undecipherable script of his own devising, and a book displaying excerpts from the Bible. The intention is to provide a grand text about the judgment of all nations called the General Assembly. Hampton was a janitor working for the United States federal government (General Services Administration) in Washington. He was devoted to his all-consuming vision and claimed that 'Where there is no vision the people perish.'

Painting: Expressionism and Surrealism

McCarthyism (named after senator Joseph R. McCarthy (1908–57), who achieved fame for making unsubstantiated accusations of communism against United States officials and prominent people), labour violence, and the spectre of the atomic bomb created an environment receptive to very subjective artistic expression: Expressionism and Surrealism, and eventually Abstract Expressionism. The 1940s and 1950s were a time when the artist painted for his or her own gratification and not for any greater social purpose. They did so in a realistic or semi-abstract figurative mode as a way of heightening pictor-

ial content and provoking subjective response by the viewer.

African-American artists showed in galleries in New York like M. Knoedler and Co., in the 1930s and in the early 1940s. In the late 1940s and the 1950s only the ACA Gallery represented black artists— two of whom, Charles White and Ernest Crichlow, painted in a realistic style. When Abstract Expressionism was the vanguard style in America in the mid-1940s, those African-American artists who adopted it fared no better as a result. By 1947, only four African-American abstract painters—Romare Bearden, Norman Lewis, Rose Piper (b. 1917), and Thelma Johnson Streat (b. 1912)—had had solo shows in New York. No black artist was a member of The Club, and only Norman Lewis and Hale A. Woodruff participated in activities at Studio 35. Only Michael Freilich's RoKo Gallery, with Beauford Delaney, Rose Piper, and Claude Clark (b. 1915), represented more than one black abstract artist at a time. Samuel Kootz in New York, and Caresse Crosby in Washington, DC represented Bearden; Marian Willard in New York represented Norman Lewis, and Bertha Schaefer in New York represented Hale A. Woodruff.

Some African-American artists were still interested in realistic imagery, particularly of the human figure and the city. The difference between past art and present for these artists lay in message and style. The optimism and belief in progressive and social justice associated with figurative art of the 1930s and early 1940s had evaporated, and the predominant mood in the late 1940s and the 1950s was an introspective one of pessimism and isolation. This is reflected in the paintings of Beauford Delaney, Eldzier Cortor, and Hughie Lee-Smith. One artist, Herbert Gentry, conveyed a sense of psychological instability as he moved towards an expressionistic abstraction.

Beauford Delaney (1901–79) was an Expressionist artist. He operated in both the white and black art worlds. In the 1930s he attended the Boykin School of Art, was an active member of the Harlem Artists Guild, and exhibited at African-American venues like the Harmon Foundation and the 135th Street branch of the New York Public Library, but also in mainstream spaces like the Whitney Studio Galleries. In the 1930s and 1940s, living on Greene Street among the artistic bohemians in Greenwich Village, he was featured in an article in *Life* (1938), and he befriended many of the artistic avant-garde, including author Henry Miller (1891–1980), whose essay in *The Air-Conditioned Nightmare* (1945) described Delaney's paintings of a few years earlier.

I remember some small canvases of street scenes. They were virulent, explosive paintings. They were all Greene Street through and through, only invested with color, mad with color; they were full of remembrances too, and solitudes. In the empty street from which, by the way, there seemed no egress,

a spirit of hunger swept with devastating force. It was a hunger born of re-membrance, the hunger of a man alone with his medium in the cold storage world of North America.

His professional career took off in the 1940s when he exhibited in the Pyramid Club (1947), and success continued in the 1950s, with a show at the RoKo Gallery (1950–53), and the 1960s, by which time he was living in France. By the mid-1940s he had perfected his inimitable style of using brilliant expressionistic colours to depict cityscapes and por-traits. Delaney was fascinated throughout the decade with urban street scenes, some of which, for example *Can Fire in the Park* [**72**], show denizens of the street adrift in an apathetic world. The huddled vibrat-ing figures, boldly outlined in black, are set against a tilting city square and park (typical of those found throughout New York City) and con-verging streets. The idiosyncratic choice of colours and use of *impasto*, i.e. thick ridges of paint, give a work which aptly expresses, in image and content, the Cold War era. This painting accords with the tech-nique of abstract expressionism which culture critic Clement Greenberg expounded in his article 'Towards a Newer Laocoön' in 1940. 'The picture plane itself grows shallower and shallower, flatten-ing out and pressing together the fictive planes of depth until they meet as one upon the real and material plane which is the actual surface of the canvas.'[13] However, it was not until a few years later that Delaney made the leap to true Abstract Expressionism—the elimination of imitating visual reality.

Delaney sailed on the *Île de France* for Europe in 1953. He settled first in Paris, and afterwards in Clamart, a suburb. In the mid-1950s he

72 Beauford Delaney
Can Fire in the Park, 1946.

took Expressionism a logical step further and abstracted his images, eventually painting non-representational works. From then on he continued to shift between expressionistic portraits and Abstract Expressionism, but never relinquishing the emotional aspect of brilliant and pure colour. Delaney eventually had a role like that of Henry Ossawa Tanner earlier in the century, as the doyen of expatriate black American artists.

With the rise of Hitler and Nazism in Germany, and impending war in Europe, many artists fled to the United States in the late 1930s

74 Hughie Lee-Smith
The Piper, 1953.
In the 1950s Lee-Smith often used children as a metaphor for an uncertain future. Other personal symbols included crumbling walls, balloons and fluttering ribbons, which made his surrealist work enigmatic and metaphysical, like the paintings of Giorgio de Chirico, whom he admired.

and afterwards. A cadre of writers and artists called Surrealists came to New York City. They and their American counterparts embraced the idea of the unconscious (Freud), and the primordial (Jung). This held a special appeal for African-American artists like Eldzier Cortor, Hughie Lee-Smith, and later Herbert Gentry.

Eldzier Cortor (b. 1916) established his career in Chicago, where he studied art and afterwards worked as part of the Illinois Federal Art Project, at the WPA Southside Community Art Center. Cortor is one of a few African-American artists who painted the female nude in the tradition of European Masters; according to him 'the black woman represents the black race, continuance of life'. In *Room No. 5* [**73**] the classic image of the nude reflected in a mirror is transformed into a modern subject. The voluptuous, soft female form is changed by its elongated form to a modern icon of African sculpture. Ideal beauty sits amidst urban decay, a decrepit tenement room whose walls, patched with pages from magazines, create a contradictory image that is surreal and sombre. Like Delaney, Cortor caught the attention of a novelist, Sinclair Lewis, who immortalized the artist in his novel, *Kingsblood Royal* (1947).

Hughie Lee-Smith (b. 1915) spent part of his adulthood in Detroit, and later moved to Cleveland, where he eventually taught art at Karamu House (in the 1930s) and worked in lithography for the Ohio WPA. By the 1950s, exhibiting regularly at the Detroit Artists' Market had established his reputation as a 'magic realist', or 'surrealist' who focused on urban decay. His characteristic style of the time, as in *The Piper* [**74**],

consisted of dark earthy tones, with one or a few figures positioned in front of a barren cityscape of architectural ruins, enveloped in a soft light. The mood thus created is of haunting loneliness and alienation.

Abstract Expressionism and African-American art

After the end of the World War II some galleries and museums, e.g. Betty Parsons, Samuel Kootz, and Marian Willard galleries, the Museum of Modern Art, and the Whitney Museum of American Art, began to show abstract art. Artists continued to establish their own spaces or 'schools' for exhibiting and critiquing art; for example, the school run by Hans Hofmann, a German expatriate, and Studio 35.

Clement Greenberg continued to dominate the critical literature of the avant-garde in America and promoted the first generation of Abstract Expressionists. The flat picture plane, devoid of imitation of visual reality was ideal; brushstrokes could be visible; colours should be pure. Art, like music, could be 'an abstract art, an art of pure form', and purely sensory. Because of his Marxist views, Greenberg saw the avant-garde as part of a historical process, and as art critic Barbara M. Reise termed it abstract art as 'a revolution against the established' narrative, i.e. realistic paintings. Abstraction provided a powerful expressiveness in contemporary painting.

The paintings of the African-American vanguard reflected a cautious embrace of Greenberg's ideas, but there was a reluctance to discard representation. Hale A. Woodruff, Charles Alston, Romare Bearden and Norman Lewis used the landscape and the figure as a platform for exploring abstraction. Ultimately art was about not only technique but universal meaning. As such art was that which could be appreciated and understood by anyone from any culture. Technique had parity with subject-matter. Of the four, Bearden, and especially Lewis, moved furthest towards Abstract Expressionism, relinquishing the figure and any signs of mimesis.

Primitivism

The early practitioners of Abstract Expressionism desired to challenge the notion that art needs to be in the service of literature, to illustrate an idea. John Graham (1881–1961), painter and theorist, who presented Jackson Pollock to the American public for the first time, was instrumental in establishing 'primitive' art as a source for Abstract Expressionism. The Surrealists, too, were attracted to the meaning and aesthetics of 'primitive' art. Graham's emphasis on the spiritual nature of primitive art should have provided an opportunity for black artists to embrace the new style—except 'primitive' most often meant North American Indian and not African art and culture. By the late 1930s, American artists were mining 'primitive' non-Western cultures which represented visual reality by symbolizing it through abstract motifs,

Surrealism (1924–45): a style in art primarily practised in Europe, but also in Latin America and the US. The term 'surréalisme' was coined by the French poet Guillaume Apollinaire (1880–1918) *c*. 1917. It was a style in literature before it came to be used in the visual arts.

Surrealism is manifested in painting in one of two styles: a highly realistic dream-like image or a lyrical and highly abstract image loosely drawn or painted, involving improvisation. In either format reality was introspective, psychological. The technique of free association pioneered by Sigmund Freud in psychoanalysis, which allowed the workings of the unconscious to emerge, was an important element of Surrealism. In the US Surrealism also drew on the analytical psychology of Carl G. Jung (1875–1961), who propounded the existence of the collective unconscious, i.e. shared by all human beings. This 'collective unconscious' is manifest in archetypal images, patterns and symbols. Surrealism thus posited an alternative aesthetic involving unpremeditated impulse and creative freedom.

European Surrealist artists included Joan Miró, André Masson (b. 1896), Max Ernst (1891–1976), Yves Tanguy (1900–55), who all arrived in New York from Nazi Germany. The Julien Levy Gallery (in 1932 and 1936), Peggy Guggenheim's Art of this Century Gallery (opened in 1942), and the Hartford Atheneum followed by the McMillen Gallery exhibited their work and assured their influence in American art. Between 1944 and 1946, they often exhibited in collaboration with Abstract Expressionists at the Betty Parsons Gallery. Surrealism was instrumental in the development of Abstract Expressionism.

Abstract Expressionism: a movement in painting that emerged in New York City in the mid-1940s. It was called the 'New York School' and attained prominence in the 1950s. It is marked by an attention to surface qualities of painting: paint viscosity, monumental canvases, and improvisation. Two European artists were influential: Arshile Gorky (1904–48), who painted abstract art of organic forms, and Hans Hofmann (1880–1966), who spilled and dripped clashing colours of different media (oil, casein, enamel) on to the canvas. Jackson Pollock (1912–56), Franz Kline (1910–62), and Willem de Kooning (b. 1904), soon represented a kind of painting style known as 'action painting' or Abstract Expressionism, which developed between 1948 and 1951. The Museum of Modern Art's exhibition 'Abstract Painting and Sculpture in America' (1951) formally marked its arrival on the American art scene. Abstract Expressionism is considered the first significantly American art movement quite independent from European styles and influences.

The Subjects of the Artist School (1948–9) was established by Robert Motherwell (1915–91), William Baziotes, Mark Rothko (1903–70) and David Hare (1917–91) at 35 East Eighth Street as a place for sessions about art open to the public. It was taken over by three professors from New York University, Robert Iglehart (b. 1912), Hale A. Woodruff, and Tony Smith (1912–80), who renamed it Studio 35 (1949–50) after its address. They held art classes for students. But it was seen as an important meeting place (Friday evenings) for Abstract Expressionist artists.

The Club (also called the Artists' Club) was formed by de Kooning, Kline, Jack Tworkov and others. The members met (1949–62) in a loft a few doors away from Studio 35 on 39 East Eighth Street. It was the only meeting place for advanced, i.e. Abstract Expressionist, artist and critic Harold Rosenberg.

pictographs. American and Meso-American Indian art joined African art as the 'primitive' paradigm, as proven by three exhibitions at the Museum of Modern Art: 'American Sources of Modern Art' (1933), 'African Negro Sculpture' (1935) and 'Indian Art of the United States' (1941). American Indian art was more 'American' and, for social and political reasons, a more comfortable source of folklore and myth than African art, which had become entangled in the history of race and racism in the United States.[14]

Primitive art appealed aesthetically because of its flat abstract shapes, simple colours and design, and intellectually because of its ability to transcend the politics of everyday life, the precariousness of civilization in the wake of the atomic bomb. As mainstream Abstract Expressionists Jackson Pollock and Adolph Gottlieb looked to pre-Columbian and American Indian art, African-American artists like Hale A. Woodruff and Charles Alston remained focused on African art. Woodruff stated that he looked upon African artists as 'my ancestors'. As Woodruff, Alston, Romare Bearden, and Norman Lewis developed their inimitable style, at the heart of their Abstract Expressionism the primacy of African art was acknowledged.

Early Abstract Expressionism: Bearden, Woodruff, and Alston

In the 1940s abstraction was usually linear, having a cubistic style. At the time true abstraction, that is, no subject-matter or any reference to real objects, was promoted by a small group of American abstract artists, most of whom belonged to the American Abstract Artists' organization. Few African-American artists participated. One notable exception was Norman Lewis who was invited to exhibit in 1949. Romare Bearden, Hale A. Woodruff, and Charles Alston refer to, in varying degrees, the style of early twentieth-century Cubism. Herbert Gentry, however, paints compositions reminiscent of synthetic Cubism, yet whose images are surrealistic while simultaneously using an expressionistic technique. His paintings link Surrealism with Abstraction Expressionism, creating remarkably individualistic paintings.

Romare Bearden (1911–88) was primarily a self-taught artist. Because his family had a reasonable income, Bearden was not eligible for WPA support, but he was active in the Harlem community, attending the Harlem Artists Guild, and participating in the 306 Group activities. He experimented with different art styles, first American Scene, and then, by the mid-1940s, the abstract figurative image, as in *He Is Arisen* [75]. This is from a series of watercolour and oil paintings entitled *The Passion of Christ*. It was exhibited in 1945 at the Kootz Gallery, which was foremost in representing abstract modern art at the time, and was the first of Bearden's works to be purchased by a museum—the

Museum of Modern Art. With its colour segments and bold black outlines, it has the appearance of stained glass. The line creates the movement and energizes the image by establishing tension between painting and drawing. American critics enthused over *The Passion of Christ*, referring to its 'spiritual integrity', and 'nobility of theme'. In a statement for the exhibition brochure, Bearden wrote that the life of Christ

is one of the greatest expressions of man's humanism. The concept supersedes reality and the usual conformist interpretations. The power of the Christ story, its universal recognition, make it unnecessary for me to dwell on its literary aspects. I am not akin to the purists who disclaim all subject-matter in art, however, I do not believe the delineation of subject should constitute an end in itself … my concern is with those universals that must be digested by the mind and cannot be merely seen by the eye.

By 1948 Bearden was among the most discussed modernists in America, and had exhibited in the prestigious Whitney Museum of American Art Annuals (1945–7, 1950). Not everyone shared the enthusiasm for his art. Abstraction was still considered 'foreign', so much so than an exhibition titled 'Advancing American Art' (1946–8) which included a painting by Bearden in the style of *He Is Arisen*, sponsored by the State Department (United States Information Service), was soon pulled from its European tour. Works like Bearden's were lampooned in the American press and popular magazines. Ironically, the same style of painting was considered by Europeans, particularly in Paris, to be passé; hence an exhibition put on by Samuel Kootz with USIS support in the Galérie Maeght (Paris, 1947)—'Introduction to Modern American Painting'—was lampooned by the French press. It consisted

75 Romare Bearden
He is Arisen, 1945.

76 Hale A. Woodruff
Central Park Rocks, 1947.

of works by Kootz's stable of artists: Bearden, Byron Browne (1907–61), William Baziotes (1912–63), Robert Motherwell (1915–91), Adolph Gottlieb (1903–74), and Carl Holty (1900–73). In the United States these artists were the most talked about and exhibited modernists; the New York press often referred to Baziotes, Browne and Bearden as 'the three B's'. The show was a great disappointment to Kootz. The French press ridiculed several artists, focusing on those whose abstract-figurative paintings recalled early Cubism, and describing Bearden's as 'nothing but a puzzle of screaming accents. A painter of this sort would be considered very mediocre in France.' The devastating critiques may have been partly a reaction to the United States government's aggressive promotion of abstract expressionism, and other American enterprises in post-war Europe.

In the Kootz exhibition catalogue was an essay (1947) by art critic Harold Rosenberg (1906–78) which focused on an American art that only some of Kootz's artists stood for. American art displayed, according to Rosenberg, rejection of the past, denial of the object; 'a tendency away from nature as a pictorial source and instead one turning inward'. The descriptive elements in the paintings of Holty, Bearden and Browne did not accord with Rosenberg's concept of introspective existentialism, which was gaining credence as the very essence of modern painting. Kootz closed his gallery in 1948, and a year later, reopened it, with Bearden, Browne, and Holty eliminated from the gallery's roster of artists. Bearden was a casualty for being too 'foreign' for popular tastes in the United States, and too conservative for the avant-garde in New York and Paris. Bearden ceased exhibiting and for a brief period 'just turned away from painting'.

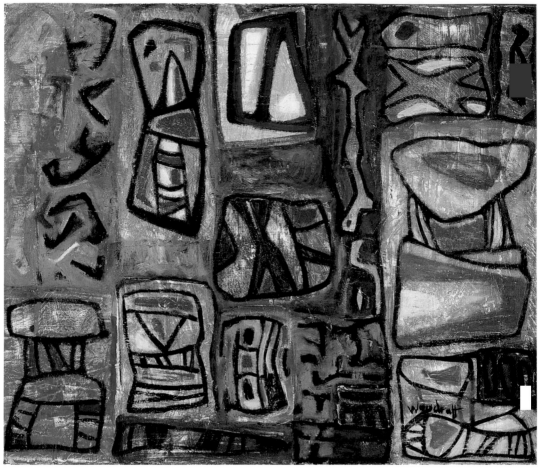

77 Hale A. Woodruff

Afro Emblems, 1950.
The horizontal and vertical compartments contain motifs copied from those on Akan (W. Africa) gold weights. The composition recalls ancient totems or stelae.

When Hale A. Woodruff moved permanently to New York City in 1946 and began teaching at New York University, he quickly returned to what he called his 'going modern' style of the early 1930s. Thus in *Central Park Rocks* [**76**] a traditional cityscape becomes a fragmented linear composition that cuts across free-flowing colours. Spatial perspective is discarded; form and space are reduced to linear shapes and opposing lines, which change a view of a park into a contrapuntal composition of colour and design.

In the late 1940s American abstract artists adopted symbols from non-literate cultures for their mythical meanings, a practice which earned them the moniker 'myth-makers'. Woodruff in *Afro Emblems* [**77**] used pictographs based on African art, including prehistoric rock and cave drawings. In other works Woodruff borrowed motifs found on meso-American temple monuments or used imaginary ones evocative of primitive culture, which he called 'doodles'.

Charles Alston would not completely relinquish the human figure. In *Untitled* [**78**], minimal shapes created in thick brushstrokes suggest the

human figure, with broad lines dissolving into two-dimensional painted areas of the canvas. His earlier interest in sculpture re-emerges both here and in *The Family* [**79**]. In the latter work, Alston proceeded as an Abstract Expressionist painter by first placing down areas of colour, and then as a representational painter using line to delineate the volumes and contours of the human figures, thereby creating a tension between two- and three-dimensional space, and between the non-objective and representational image.

Abstract Expressionism

Harold Rosenberg reiterated Greenberg's emphasis on formalism, i.e. style and technique. But he took it one step further. In one of his most important essays, 'The American Action Painters' (1952), he wrote that the canvas was an 'arena in which to act—rather than … a space in which to reproduce, redesign, analyse or "express" an object, actual or imagined. What was to go on the canvas was not a picture but an event.'[15] Painting was an encounter between the artist and his materials. It was what he called 'action painting', which aptly described a particular technique and style of Abstract Expressionism. Foremost was, as Rosenberg noted, 'its motive for extinguishing the object'. The pictorial field was larger than the field of vision; there was no one focal point. One always had the sense of looking at part of a large field of expressive colour and splashed paint. Abstract Expressionism (with cap-

78 Charles Alston
Untitled, 1950.

ital A and E) denoted 'action painting'. It was uniquely an American art form. The meaning of art became inseparable from a particular moment when the artist spontaneously laid down the pigment on the canvas. For Rosenberg, the act of painting was 'of the same metaphysical substance as the artist's experience', the existential self. This interpretation was influenced by the ideas of Jean-Paul Sartre, whose essay 'L'Existentialisme est un Humanisme' (Paris, 1946) claimed that 'there is no reality except in action', and encouraged the individual's exercise of free will. Thanks to Rosenberg, existentialism found its way into the symbolic interpretation of Abstract Expressionism. At the same time the use of improvisation in action painting represented freedom and individuality, attributes that were supposedly American.

In the 1950s and 1960s, Woodruff's paintings were Abstract Expressionist. They displayed an emphasis on technique—paint was heavily laid or scrubbed on to the surface of the canvas. Broad fields of colour, with the gesture of the brush very evident, subsumed the occasional eruption of abstract motifs or faint allusion to landscape or figure, as in *Blue Intrusion* (1958).

At the same time, Bearden was painting Abstract Expressionist paintings, and briefly exhibiting in the Michael Warren Gallery (1960), and the Warren and Cordier Gallery (1961). In *Blue is the Smoke of War, White the Bones of Men* [**80**] paint has been poured, splattered and dripped on a large (for Bearden) unprimed canvas, creating a

translucent poetic work partly influenced by his interest in Zen Buddhism. Not until 1964 was he to arrive at his most renowned and idiosyncratic style (see Chapter 4, pp.187–90).

Norman Lewis, after exploring figurative abstraction in the early and mid-1040s, moved quickly to Abstract Expressionism. Between 1946 and 1964 Marian Willard showed Lewis at her gallery, which was considered one of the most prestigious commercial venues for abstract expressionism in New York. Lewis was a frequent participant at Studio 35, and was also an invited exhibitor in a show organized by the Art Institute of Chicago to represent the United States in the Venice Biennale of 1956.

Lewis felt strongly that titles were important means to communicate the content of a non-representational image to the public. Thus the title *Harlem Courtyard* [81] guides the viewer to detect the urban streets of Harlem and the vertical tectonic designs of African sculpture. And in *Harlem Turns White* [82] we can perceive Lewis's restrained abstract expressionist style. This quietude can perhaps be elucidated by his response in an interview:

I'm a loner and paint out of a certain self-imposed remoteness. When I'm at work, I usually remove my state of mind from the Negro environment I live in. I paint what's inside, and like to think of it as a very personal, very individual environment. Being Negro, of course, is part of what I feel, but in expressing

81 Norman Lewis

Harlem Courtyard, 1954.
Criss-cross lines suggest a grid of streets; improvisatory use of a limited range of colours, with shifting tone values, suggest the rhythms of African-American jazz.

82 Norman Lewis

Harlem Turns White, 1955
We can sense the frenetic movements of human figures that seem to vaporize into a white haze. This creates an imaginary scene: the black community of Harlem transformed to reflect its earlier history as a white community.

all of what I am artistically, I often find myself in a visionary world, to which 125th Street would prove limited and less than universal by comparison.[16]

Abstraction provided an occasion for him to create a 'universal' art based on African art, and according to him, to strike a 'blow against stereotype'. Abstract expressionism could thus release an African-American artist from the burden of realism that seemed inextricably associated with the racial art of the 1920s and 1930s.

Among curators and gallery directors Lewis was considered to be in the mainstream of abstract expressionists, but collectors and some critics did not share this view. When his paintings appeared similar to those of Mark Toby (1890–1976) or Clyfford Still (1904–80) critics dismissed his work as not being original (a central criterion for modernism). Other critics, more sympathetic, remarked that the public was ready to accept African-American artists as abstract expressionists (i.e. as mainstream) when their paintings were included in group exhibitions on American art. His works did not sell, and Lewis remains an enigma.

The art historian Ann Gibson has suggested that critics and others failed to appreciate Lewis's art because, although abstract, it in fact revealed his racial self. Abstract Expressionism was typically thought to be non-representational, i.e. to have no pictorial subject. Yet on the

contrary, as Gibson pointed out, most abstract expressionist painting was representational. Artists, as she aptly noted, '*did* intend to refer to feelings, objects, events, relationships outside the canvas'.[17] It was just that these artists avoided an overt reference to literary or political content. The subject of the painting was the artist. Mark Rothko remarked that 'the artist does not paint for society's sake but for himself'. If one regarded the artist as an author, the artist as subject became clearer, for the subject was the one who acted or, more appropriately, the one who made the art. Gibson suggested that it was the 'blackness' of Lewis's self that eluded critics.

Second generation of Abstract Expressionists 1955–61

A second generation of abstract expressionist painters, for example Merton Simpson (b. 1928) and Richard Mayhew (b. 1934) emerged in New York City. These younger African-American artists met in Greenwich Village, participated in co-operative gallery exhibitions, including those at the Brata Gallery, travelled, and studied in Paris. One artist, Vincent Smith (see pp.195–7), vividly recalled those days of the Beat culture.

We were a strange group because people didn't know what to make of us. People were used to black musicians and performers, but the visual arts were sacred territory. Most people I came in contact with never knew a black painter nor had they hardly ever heard of one.

But we hung out and we hung in, in lofts and cold water flats. We used to sit in the Riviera Café, Pandora's Box and Rienzi's and have marathon sessions rapping about art, politics, literature, religion, esthetics and women. We'd also drop in at the Whitney Museum and the Hans Hoffman [*sic*] School, both of which used to be on 8th Street. The abstract painters used to hang out at night in The Cedar Bar, but we preferred the Five Spot Café as that's where they played jazz every night.

People thought we were crazy, man. We were young pioneers on the brink of new discoveries. We were going to be the movers and the shakers. We went through the hallowed halls of the museums, and we didn't see anything reflect the black experience or black contribution to American culture. We knew that we were going to be scorned and ridiculed. We also knew that our achievements were going to have to take knowledge and skill and scholarship and long years of dedication.

The art scene was in transition. There were the social expressionists and the up and coming abstract expressionists. We were influenced by every thing. The French painters, Picasso, Brancusi, Klee, the Dutch painters, the Flemish school, Zen Buddhism, the Mexican painters, the German expressionists, the Japanese woodcut and African sculpture. Within the styles and forms and techniques of these schools we painted and experimented and attempted to find our way.[18]

Herbert Gentry (b. 1919) received his fundamental art training in Harlem under the WPA between 1938 and 1939, and then at New York

University. By 1953 he was living in Paris. Gentry belonged to the disenchanted black Americans of the Beat generation who succumbed to the allure of Europe, especially Paris. He, like other male artists, used the GI Bill to finance his trip. In Paris Gentry found himself among other black American expatriate artists—Clifford Jackson (b. 1927), Sam Middleton (b. 1927), and Walter Williams (b. 1920), who never relocated to the United States. Gentry, however, has retained a footing in the States and today divides his time between Sweden and New York. After many years of formal study in Paris, Gentry fell in with Cobra (1948–51), a group of artists who, in attempting to revive expressionism, used intense colours and surrealist techniques, and explored Freudian psychoanalysis. In *Untitled Figures* [83] imaginative biomorphic shapes allude to humans and animals, frolicking in expressionistic colourfields. A Freudian interpretation would classify this painting as an example of André Breton's definition of Surrealism: 'thought dictated in the absence of all control exerted by reason'. Yet the sense of gestural brushstroke and overall flatness is abstract expressionist. *Untitled Figures* indicates the continuing popularity of the Surrealist phase of abstract expressionism which began in the 1940s, and which Gentry established as his signature style.

Edward Clark (b. 1926) studied at the School of the Art Institute of Chicago, then, around 1952, went to Paris which he referred to as 'the freest of cities and a true magnet for artists'. There he made the transition from the realism of his student days to structural colour abstractions, having his first solo exhibit in 1955 at Raymond Creuze's gallery near the Champs Elysées. Clark credited his breakthrough to abstraction to Russian-born painter Nicolas de Staël (1914–55), at that time one of the leading abstractionists in Paris: 'I've always liked Cézanne, you know, his way of flattening out space, the sky. Well, de Staël kind of simplified that. For me he was more emotional than the rest of them.' Clark stayed in Paris for five years, returning to New York City in 1956 and becoming a charter member of the Brata Gallery.

The second generation of abstract expressionists was very active in establishing artists' co-operatives during the mid- to late 1950s, all of them located on 10th Street. One of the most important was Brata. Clark participated in several group shows and had his first New York solo show at Brata, but resigned around one year later, possibly because he remained an 'action' painter, i.e. held a different artistic philosophy. Members like Al Held started out as 'gestural' painters, and ended up as hard-edge painters or painters of highly structured compositions.

By this time Clark had developed his abstract expressionist style and technique, 'action painting'. This involved applying paint to a very large unstretched canvas placed on the floor, a procedure which signified Abstract Expressionism. This technique and his interest in

luminosity of colour are demonstrated in *Wasted Landscape* [**84**], in which movement of his body is manifest in the splash and broad strokes of paint. Clark continued to explore the psychology of colour, different applications and viscosity of paint. By 1963, he was using a push-broom guided by tracks to increase the speed and breadth of strokes. He remains the last of the abstract expressionist vanguard, constantly travelling between New York City and Paris.

African Americans worked in various abstract expressionist styles in painting. Although they knew and were friends with white American artists who later became renowned, the African-American vanguard mostly lacked the extensive sustained exposure through exhibitions, patronage and critical reviews in the press. It was a competitive art market. Bearden and Lewis in the 1940s and 1950s respectively (at the Whitney Museum) are exceptions among African-American abstract expressionist artists; they received major critical recognition in the art and popular presses. The 1950s was an exciting time for American artists, but also a difficult time professionally, especially for the African-American artist. The co-operative art networks in Harlem had collapsed after World War II. Places to exhibit were virtually non-existent in the black community uptown. The market-life of galleries is generally brief, so obtaining gallery contracts became very competitive. Only a few mid-town galleries, like Kootz, Willard and Schaefer, which cornered the avant-garde art market, offered contracts to African-American artists. Furthermore, African-American artists lacked an advocate like Greenberg, who arranged gallery contacts which helped establish Baziotes, Motherwell, Rothko, and Still. There was no replacement for Alain Locke.

Henry Miller's comments about Beauford Delaney highlighted the difficulty of the situation:

When such an individual also happens to have a dark skin, when in a cosmopolitan city like New York only certain doors are open to him, the situation becomes even more complex. A poor white artist is a miserable sight, but a poor black artist is apt to be a ridiculous figure as well. And the better his work the more cold and indifferent the world becomes … but to aspire to greatness, to make pictures which not even intelligent white people can appreciate, that puts him in the category of fools and fanatics. That makes him just another 'crazy nigger'.[19]

Novelist Amiri I. Baraka recalled that in the 1950s

the nucleus of the New York African-American artistic community was small, informative, intense, but short-lived. Many contemporaries 'disappeared' by either relinquishing their professional careers as artists or relocating to live outside the United States. They were Ralph Elison's invisible men.

84 Edward Clark

Wasted Landscape, 1961.
The directions of the splattered paint reveal the various positions the artist stood over the canvas.

And he noted that a decade later, 'most of those blacks I met who were artists left this country, finally, never to return'.[20] Artists like Walter Williams (b. 1920), Clifford Jackson (b. 1927), Sam Middleton (b. 1927), and Beauford Delaney became permanent expatriates living in Europe.

African Americans lacked appreciable market value in an art community where art was increasingly considered a speculative investment because there was no substantial critical literature. By 1961, Abstract Expressionism was an economic and critical success. American artists who held on to realism were not considered avant-garde. Yet African Americans who too enthusiastically embraced abstraction, especially Abstract Expressionism, were often misconstrued as imitative. The spectre of a racial art idiom from the 1920s to the 1940s discouraged critics from moving beyond race in their assessment of African-

American abstraction. African-American artists strove to express the universal, but through the African-American experience. In retrospect, it is apparent that they showed that this newer art could conceptually and stylistically accommodate an African-American identity and be appreciated by those outside of the cultural or social experience. Eventually, the civil rights movement, begun in the late 1950s, made the association between Abstract Expressionism and existentialism untenable for the African-American artist. Of paramount importance was the representation of African-American life. As Hale A. Woodruff expressed it

Any black artist who claims that he is creating black art must begin with some black image. The black image can be the environment, it can be the problems that one faces, it can be the look on a man's face. It can be anything. It's got to have this kind of pinpointed point of departure. But if it's worth its while, it's also got to be universal in its broader impact and its presence.

Twentieth-Century America: The Evolution of a Black Aesthetic

4

Introduction

For the USA the 1960s brought social disruption and violence as a result of two issues in particular: the failure to make progress on the integration of black Americans as equal citizens and the waging of an unpopular war in Vietnam. The economic repercussions of the Vietnam War were high inflation and mounting unemployment entailing social problems during the 1970s and early 1980s.

Civil rights and black nationalism

I am invisible, understand, simply because people refuse to see me ... That invisibility ... occurs because of a peculiar disposition of the eyes of those with whom I come in contact. A matter of the construction of their *inner* eye, those eyes with which they look through their physical eyes upon reality. (Ralph Ellison, *The Invisible Man*, 1965)

That Ellison could write this in the 1960s is a comment on the lack of progress on civil rights issues. Landmark decisions taken in the 1950s by the United States Supreme Court, for instance, Brown v. Board of Education of Topeka, Kansas, which desegregated schools, were rescinded or undermined by state laws, leading to events which culminated in riots in major cities throughout the United States. As the elaborate structure of legalized southern segregation began to disintegrate, the system of black disenfranchisement in the South came under fierce attack. Much of the moral energy of the anti-segregation and voting rights drives came from black Americans themselves. They were often supported by white American liberals, whose wealth and media access proved invaluable in the fight for social justice, political equality, and economic opportunity.

By the late 1960s the tactics of non-violent, conciliatory organizations were seen to have been largely ineffective. This encouraged the

In the early twentieth century the struggle to gain equal rights for black people at work and in daily life, officially through the work of such organizations as the NAACP (1909–) and the Urban League, was spearheaded by such figures as W. E. B. DuBois (in the early years) and A. Philip Randolph (in mid-century). The desegregation of schools in the Supreme Court decision, Brown v. Board of Education of Topeka, Kansas, in 1954 marked a new era of civil rights movements. In 1955, the Rev. Dr Martin Luther King Jr led the Montgomery (Alabama) Bus Boycott, initiated by Rosa Parks's refusal to relinquish her seat to a white man; and in 1957 organized the Southern Christian Leadership Conference (SCLC), which was a network of non-violent activists drawn mainly from the black Church. Using the ethic of non-violent resistance advocated by Mohandas Gandhi in his campaign against British colonial rule in India, the SCLC, with the Congress of Racial Equality (CORE, founded in 1942), succeeded in convincing the United States Congress to pass the first Civil Rights Act since Reconstruction. A commission to monitor civil rights violations was created, and the Justice Department was authorized to guard black voting rights through litigation. There were 'sit-ins' at lunch counters, mostly by students, many of whom were members of the Student Nonviolent Coordinating Committee (SNCC, founded in 1960). Racial polarization began to worsen. In 1963 a coalition of African-American groups and their white allies sponsored a march on Washington, DC on 28 August to advance the civil rights bill then before Congress. Martin Luther King gave his historic 'I have a dream' speech. In 1964 the Civil Rights Bill was enacted, banning segregation in public accommodations, ending federal aid to segregated institutions, outlawing racial discrimination in employment, seeking to strengthen black voting rights, and extending the life of the United States Commission on Civil Rights. In 1965 approximately 25,000 black and white people walked from Selma to Montgomery, Alabama, to protest against continued racism. The black movements became more fragmented, yet the concept of black solidarity gained strength. The Watts Riots flared in Los Angeles in August 1965. Stokely Carmichael and Hubert H. 'Rap' Brown, leaders of SNCC, took a militant stance, promoting racial separatism, not integration. In 1966 the Black Panther Party for Self Defence, a militant organization for black youths, was established in the San Francisco Bay Area. Its founders were Huey P. Newton and Bobby Seale, whose ideas were influenced by Karl Marx and Malcolm X.

creation of militant organizations and a change of approach from one of consensus to one of conflict. The black nationalism of the 1920s and '30s, when Marcus Garvey called for black pride, black power, and pan-Africanism was rekindled, and was now fuelled by subsequent struggles of the 1940s and '50s for equality in the workplace and economic opportunity.

A lead in employing more aggressive tactics was taken by SNCC (Student Nonviolent Coordinating Committee) and CORE (Congress of Racial Equality). Influenced by Third World anti-colonialism, the ghetto riots of 1965–7, the rise of black nationalism under Malcolm X of the Nation of Islam, and by the Black Panther Party, these bodies challenged the pacifism and integrationist credo of

SCLC (Southern Christian Leadership Conference). What they wanted was separatism, or at least integration which accepted African Americans on their own terms.

This was a difficult time for Americans, whose earlier unshakeable confidence in their government and their self-image as a morally upright nation were called into question. Confidence yielded to uncertainty. Three months after the civil rights March on Washington, in November 1963, President John F. Kennedy was assassinated. The following year the Civil Rights Act was passed, and Martin Luther King Jr received the Nobel Peace Prize, yet in that same year James Chaney, Andrew Goodman, and Michael Schwerner, freedom workers for CORE, were murdered in Mississippi. In 1965 the African-American population was further devastated by the assassination of Malcolm X, leader of the Organization of Afro-American Unity, at the Audubon Ballroom in Harlem. A month later Martin Luther King held his historic march from Selma to Montgomery, Alabama.

Cultural crisis: Black artist or American artist?
Spiral artists' group 1963–6

In this climate of social and political turbulence a group of artists in New York City discussed ways in which they as artists could show their sympathies and support the civil rights movement, while sustaining their individual artistic identities. This discussion group of ten to sixteen artists met at Romare Bearden's studio in Greenwich Village and included Charles Alston, Bearden, Norman Lewis, Hale A. Woodruff, Reginald Gammon, Richard Mayhew, Ernest Crichlow, Felrath Hines, Alvin Hollingsworth, and Emma Amos, the only woman. Not since the Harlem Renaissance had such a group of artists been formed around a political, aesthetic, and social agenda. The group accepted Hale A. Woodruff's suggestion that they should name their group Spiral, 'as a symbol for the group … a particular kind of spiral, the Archimedean one; because, from a starting point, it moves outward embracing all directions, yet constantly forward'. Meetings continued at Bearden's Christopher Street studio, where the group explored their creative philosophies, their value and worth as visual artists, often using the opportunity to reflect on their own careers. The sharpest spur to action was the March on Washington in 1963. As they later claimed, they 'could not fail to be touched by the outrage of segregation, or fail to relate to the self-reliance, hope, and courage of those persons who were marching in the interest of man's dignity'. A decision was taken to hold an art exhibition in downtown Manhattan, in a rented space at 147 Christopher Steet. At first it was entitled 'Mississippi 1964' in homage to the three slain civil rights workers, but eventually the group decided on a less political, more racially generic title: 'Black and White'.

The 'Black and White' exhibition, 1965, gathered together black-and-white paintings and prints in a range of individual styles. The participants did not want to be labelled 'black artists', nor to have their work categorized as 'naively primitivist' or 'realist'. Yet each wished to identify and define their own relationship to their people's struggle and to explore the possibility of conveying cultural significance through their art. For example, in *Processional* (1965) Norman Lewis, in his accustomed Abstract Expressionist style, applied overlapping brushstrokes of white paint to a black ground, which, with a truncated border, created the effect of marching figures. Despite the original intention not to be overtly political, the black-and-white palette could not but symbolize race and imply the separation of white and black Americans.

Hence this work, and the exhibition in general, foreshadowed the issue-oriented art of the late 1960s.

Reginald Gammon's realism produced *Freedom Now* [**85**], a painting which copied a photograph of the March on Washington, by the African-American photographer, Moneta Sleet Jr (1926–96). In the new American avant-garde style of pop art Gammon borrowed a familiar media image of protest marchers, with its objective element of photojournalism, and translated it into a painterly monochromatic work which exists midway between reality and the artifice of the painted canvas. In common with pop art, *Freedom Now* lacked the personal introspection of Abstract Expressionism, but unlike pop art the work has a personal resonance, for Gammon's identity as a black man infuses the image with emotive content. The photographer's lens may seem to treat the subject in purely formalist terms, but as treated by Gammon the formal becomes personal.

[My work has developed] out of a response and need to redefine the image of man in the terms of the Negro experience I know best. I felt that the Negro was becoming too much of an abstraction, rather than the reality that art can give a subject. What I've attempted to do is establish a world through art in which the validity of my Negro experience could live and make its logic. (Romare Bearden, 1964)

Romare Bearden suggested to his fellow artists in Spiral the idea of a collective project, in which each artist could contribute to the work by using the collage technique. His colleagues' lack of enthusiasm did not deter him from pursuing the idea alone. In 1964 he completed several small photomontages, using clippings from popular publications, such as *Life*, *Ladies Home Journal*, and *Look*. At the suggestion of Reginald Gammon, he then enlarged his photomontages to 24 × 36 ins (61 × 91.4 cm) using a photostat process. Initially not enthusiastic about the results, Bearden put the sheets in a corner of his studio. His gallery agent, Arne Ekstrom, happened to notice them and declared, upon viewing them: 'That's your next show!'. Bearden's solo exhibition, entitled 'Projections', at the Cordier and Ekstrom Gallery in 1964, attracted so much critical praise that he had his first solo museum exhibition at the Corcoran Gallery of Art in 1965.

The figurative, quasi-abstract style of the *Projections*—a name which refers to the original and photocopied collages but also suggests the projection of personal on to documentary material—encompassed both photojournalism and pop art. They consisted of scenes of Pittsburgh (Pennsylvania) and Harlem, and, principally, of Charlotte (North Carolina), where Bearden spent his childhood. He effectively captured both contemporary urban black life and the quickly disappearing rural southern black life. The rural scenes of North Carolina

86 Romare Bearden

Prevalence of Ritual: Mysteries, 1964.
The pop-arty use of a commercial reproduction process combined with the mixing of imagery from historical sources (e.g. the paintings of Zurbaran) and contemporary advertising make *Mysteries* conceptually postmodern.

focus on daily and seasonal rituals, such as planting and sowing, picking cotton, baptisms in the river, night ceremonies when one hears 'down-home' blues or jazz, and family meals—as in *Prevalence of Ritual: Mysteries* [**86**]. As Bearden remarked: 'people started coming into my work, like opening a door'.

Quickly he developed a personal iconography of black culture and society. One symbol is the train, which he called a 'journeying thing':

I use the train as a symbol of the other civilization—the white civilization and its encroachment upon the lives of blacks. The train was always something that could take you away and could also bring you to where you were. And in the little towns it's the black people who live near the trains.

As a child visiting train stations on summer evenings with his paternal grandfather, Bearden would look forward to watching 'the goods trains go by, [which] interrupted the monotony of the hot day, and was an exciting sign of a different world'.

Bearden's technique was considered very radical at the time. He had taken the technology of popular media reproduction and made it a bona fide 'fine art' medium, breaching the division between commercial media and high art. Collages made from photographic magazine illustrations used the language of Dada and pop art, but the content,

personal and culturally specific, was grounded in the social realism of the 1930s and early '40s, and the underlying compositional design owed much to the abstract art of the '50s. In making photostat copies of his original collages he compromised the idea of 'original', which is such a prized feature of high art and modernism.

Bearden's modernist aesthetic is based upon black cultural sources: African art, African-American quilts, and jazz. The cuttings of paper, the reassembling of segments of photographic reproductions (water, grass, metal, wood, leaves, cloth, art—often African art) create fractured forms, simple shapes and an elaborate abstract design from which figures, landscapes, and the architecture of streets emerge. The technique creates an overall shallow pictorial space, yet gives a greater angularity and plasticity to form. The figures appear like African sculptures. There is a similar jazz-like rhythm created for the eye in the juxtaposition of different-sized figures in one spatial plane; the intervals created by the various rectangular segments; and the pauses or silences created by use of white paint or paper. Using improvisation, Bearden effectively translated the black musical impulse through the collage.

Bearden realized Alain Locke's goals for the 'New Negro' artist: African art as the formal foundation for his collages, and African-American folk culture—strip quilt and jazz—as the subject-matter and the basis for compositional design.

The heightened political atmosphere of the Civil Rights Movement and the use of mostly black-and-white photographs, which has a documentary effect, affected art critics' perception of Bearden's collages. Dore Ashton, in an essay for the exhibition brochure, 'Projections' (1964), interpreted the facial expressions in *Mysteries* as 'accusing' and 'disquieting'. She referred to most of the photomontages showing scenes filled with 'denizens exasperated and sullen'. As Bearden revealed:

A lot of people see pain and anguish and tragedy in my work. It's not that I want to back away from this, or to say that those things are not there. Naturally, I had strong feelings about the Civil Rights Movement, and about what was happening in the sixties. I have not created protest images. The world within the collage, if it is authentic, retains the right to speak for itself.

Through his art Bearden attempted not only to create an autobiography, and historical narrative about black life, but also to show the humanity of black people as in *Three Folk Musicians* [**87**]. Ralph Ellison summarized it this way:

Bearden's meaning is identical with his method. His combination of technique is in itself eloquent of the sharp breaks, leaps in consciousness, distortions, paradoxes, reversals, telescoping of time and surreal blending of styles, values, hopes and dreams which characterize much of Negro American history.[1]

87 Romare Bearden

Three Folk Musicians, 1967

Shortly after completing the *Projections*, Bearden continued his collage technique using snippets of his own work.

As his friend the artist Ernest Crichlow (b. 1914) remarked at the time, 'Romie, it looks like you've come home.'

Artists responded to the events of the turbulent 1960s with varying degrees of engagement, passion, or indifference. Mainstream artists who were political activists usually kept their art separate from their political convictions. For example, the Artists' and Writers' Protest in 1962 took out a letter-ad in the *New York Times* in favour of disarmament, and three years later denounced United States intervention in Vietnam and in the Dominican Republic. There were collaborative exhibitions, performances and 'happenings' which focused on political sentiments, either against government policies or for racial and class equities. However, African-American visual artists increasingly expressed their political sentiments in art; for them race and politics were inextricably linked, and the plight of black people in America was seen as being representative of the plight of people in the Third World.

Painting

African-American figurative artists used images or incidents from the civil rights movement to show their anger, and to pay homage to the victims of various incidents. The bombing of a church in Birmingham (Alabama), which killed three children, is depicted in *Birmingham Totem* (1964) by Charles White; the children who bravely endured verbal and physical abuse during the desegregation of schools appear in *Ordeal of Alice* (1963) by Jacob Lawrence.

The political activist and figurative painter, Benny Andrews (b. 1930)

established the Black Emergency Cultural Coalition (BECC) in 1969. Together with his co-chair, Cliff Joseph, he picketed the major art museums with other artists' groups, such as the predominantly white Art Workers' Coalition, to protest about the exclusion of racial and ethnic minorities from exhibitions and employment, and the under-representation of women. Andrews is best known for his distinctive collage paintings, which demonstrate a skilful manipulation of design, colour and texture. The dense, rich impasto pigments or flat opaque colours, the gathered and crinkled cloth, the schematic compositions, and the compressed space, are all combined with simple forms and the minimal background of the stark primed canvas. The placing of clearly delineated figures in the immediate spatial plane of the painting created expressionistic paintings, as in *Southern Pasture* (1963), which shows a mother standing protectively behind her child, in front of whom are barbed-wires—clearly referring to the desegregation of public schools in the South. But the timbre of Andrews' painting subtly changed, reflecting the social tensions in America.

The *Champion* [**88**] symbolizes survival, tenacity and cultural identity.

I wanted to show the strength of the black man, the ability to persevere in the face of overwhelming odds, and I have used the symbol of the prizefighter. I

Art styles and movements: Pop art and collage

Pop art was an art movement of the late 1950s and the 1960s mainly in Great Britain and the United States. The term, standing for 'popular art', first appeared in an essay, 'The Arts and Mass Media' (1958) by Lawrence Alloway, a British critic. Americans became aware of pop art when 'The New Realists' exhibition was held at the Sidney Janis Gallery, New York, in 1962.

Characterized by an interest in consumer objects and urban debris, pop art was indebted to Dada. With popular culture as its subject-matter, it celebrated post-war consumerism and mocked the notion of autonomous, disinterested, fine art, defined by aesthetic quality. In this it differed from Abstract Expressionism, but in common with that style it was characterized by spatial flatness, a feature of avant-garde painting generally.

The best known examples of pop art in America are paintings and prints of popular media images by Andy Warhol, scenes from comics by Roy Lichtenstein, and sculptures of food or utilitarian objects by Claes Oldenburg.

Collage denotes both a technique and type of art, but not a style. The term comes from the French verb *coller* ('to glue'). Thus it is the sticking of paper or other media to a two-dimensional surface. It can be used to blur the distinction between reality and illusion in art. Pablo Picasso produced the first 'high' art collage. After World War I, Dada and then the Surrealist artists used this technique extensively.

Collage is the most common form of appropriation, borrowing images from paintings and from the media, as exemplified in Romare Bearden's photomontages. Contemporary collage, unlike Dadaism, is not seen as representing an iconoclastic stance, but as being associated with mass cultural images.

Champion, 1968.

Strands of real rope focus our attention on the exhausted boxer, his battered face dramatically enhanced by the crunched cloth.

remember the fights of Joe Louis and how his strength carried us through so damn much, and today I think of the strength that Muhammad Ali has shown in his battles for his principles, so when I was working on the *Champion* I was trying to capture the essence of that thing, whatever it was, that the black man was and is able to muster in the face of so damn much adverse odds. Also, I cannot fail to relate my sense of indignation over the fate that has befallen the black man's *Thors*, and it is in this sense of indignation I tried to paint my heart out in the *Champion*. The epitome of the sad fate that has engulfed our *Thors* came to surface a few weeks ago when it was reported that an official at the Colorado Psychiatric Hospital said that former world champion Joe Louis, 56, had been admitted on a 'hold for treatment' order.[2]

Boxing, one of the few professional sport opportunities available for African Americans at the time, was seen as a means to escape poverty; boxers Jack Johnson (1878–1946), Joe Louis (1914–81), and Cassius Clay/Muhammad Ali (b. 1942) became black heroes.

Paintings such as the *Champion* did not receive much contemporary recognition. In the 1960s Andrews refused to let curators pigeon-hole him as a 'black artist', i.e. an artist only interested in African-American subject-matter and overt African designs. This limited his access to the mainstream market. When, after 1966, the tide changed

and black images from African-American artists became fashionable, Andrews was unable to profit from it fully, as curators would only consider his paintings of black people (not the ones he had done of whites) for African-American exhibitions. Besides, his figurative painting did not find critical and curatorial support, being too reminiscent of Social Realist paintings of the 1930s and 1940s.

Postmodernism has changed this. The collage-paintings of the 1960s and '70s have been interpreted afresh. In *The Collages of Benny Andrews* (1988) Donald Kuspit wrote 'collage implies scorn for conventional notions of art, and undermines the "rightness" of the picture'. Kuspit uses the anti-aesthetic significance of *bricolage* (a Surrealist approach) as a way of reading the racial text of the image, take over i.e. collage undermines convention just as blackness undermines whiteness. The rawness, rage and social estrangement coaxed out by Kuspit's metaphorical readings of Andrews' work accords with the current image of the artist as a black postmodern tragedian.[3]

The evolution of a modern black aesthetic

The year 1968 was a watershed, with headlines proclaiming war, political insurgency, and racial strife. Many black Americans, particularly the Black Panther Party, became increasingly aggressive in tactics and viewed themselves as balkanized communities under attack by the dominant white culture, quintessentially represented by the urban police. Student coalitions were formed to fight racism, segregation, and the Vietnam War. Their agitation was considered un-American and became aligned with extreme leftist politics. News of Martin Luther King's assassination in April set off a wave of inner-city riots that made the previous riots seem 'like tea parties'. Optimism was extinguished by anger, frustration, and hopelessness.

The intensity of political and social agitation inspired the images of African-American art, which became more abrasive, and challenged viewers to engage with the subject-matter of the works. Younger painters seemed more attuned to black nationalism and produced such images as Malcolm Bailey's *Separate but Equal* (1969/70), an image based on old drawings of slaves loaded in ships, and Dana Chandler's *Memorial to Fred Hampton* (1970), an image of a red door punctured by real bullet holes. Hampton, a leader in the Panther Party in Chicago, was slain by the Chicago police as he slept in bed. Others painted horrific images of lynchings from the 1940s and '50s, and of people slain in campus and city riots, or of militant activists armed with guns. Noah Purifoy created assemblages from charred remnants of the Watts riot, Los Angeles (1966). Sometimes the images achieved vivid realism through use of laser transfer photographs or silk-screens, recreating the gory news photos out of popular magazines from the first half of the century and from the 1960s.

Defining black art

Two terms, 'black show' and 'black art', became an important part of contemporary discussion and critical debate in the late 1960s and in the 1970s. The quality of black art and the existence of a black art aesthetic were debated in weekly editorials by white American art critic Hilton Kramer and by African-American artist Benny Andrews, and occasionally African-American critic Henri Ghent. Edmund B. Gaither attempted to clarify what 'black art' meant and to communicate the relevance of 'black art shows'. His seminal African-American art exhibition, 'Afro-American Artists, New York and Boston' (1970) was a watershed for the black art debates. In the catalogue introduction he wrote:

At its simplest, a 'black show' is an exhibition of work produced by artists whose skins are black. The term seldom connotes the presence of properties or qualities intrinsic in the work and therefore it does not act as an art historical definition. The 'black show' is a yoking together of a variety of works which are, for social and political reasons, presented under the labels 'black' or 'Afro-American'. Such a show is thus a response to pressures growing out of racial stresses in America. At the same time, 'black shows' attempt to introduce a body of material to a race-conscious public in order to force that public to recognize its existence and its quality. And like most socially motivated devices, the 'black show' has its strengths and weaknesses. The 'black show' as a serious exhibition is a twentieth-century invention. It began in the dual system which characterized American life early in the century, and it has continued because social and political factors still make black people a special group in the national population.

Gaither and others stressed the difference between these shows and those of the Harmon Foundation. The present works were considered to be of a much higher quality. Critical standards were applied in the selection and assessments because 'one no longer grabs everything possible for a "black show"'. Another difference was the introduction of African-American curators, who avoided the earlier mistakes made by the major art museums and galleries. African-American group exhibitions served a cultural and political purpose for the black community and for the professional art world, reviving the kind of relationship which had existed during the Negro Renaissance.

Black art or African-American art needed a critical language to describe and identify its meaning. Gaither and others revived Alain Locke's ideas with regard to a 'school of Negro art' based on the study of African art and Negro folk culture. This was intended to provide a basis for the 'rebirth of cultural and political nationalism among black people'. According to Gaither, artists who embraced national and international art styles and aesthetics should be identified as 'cosmopolitan artist(s)' and not as 'black' or 'Afro-American'. He also believed that only those who based their art on African culture and African-

American culture and history qualified as 'black'.

Gaither also identified two kinds of black art: first, the art—usually realist in style—which stemmed from a strong nationalistic base, and encompassed historical events, heroes, and ideas. It identified the 'enemy' using contemporary political and social events, and involved anticipating a better future after the 'struggle'.

The second kind he described as Neo-Africanism. This meant a modern interpretation of traditional African art and included an attempt 'to fathom its aesthetic, to get at its [spiritual and ritualistic] essence'. The formal composition and colourful palette of painted masks and house walls remained but applied instead to a flat white canvas. Gaither concluded that 'Neo-Africanists share with black artists proper a nationalist basis and, like black artists, they are associated with a syndrome of essentially nationalistic political views.'[4]

Painting

In the 1950s and '60s Vincent Smith (b. 1929) had chronicled contemporary African and African-American urban society and everyday life, his genre paintings depicting the bars, poolrooms, street-corners and small tenement rooms of the densely-populated neighbourhoods. Working in various media, moving fluently between monoprint, etching, and drawing, he interpreted the realm of black life, combining figurative with abstract.

After seeing a retrospective exhibition of Paul Cézanne at the Museum of Modern Art in 1952 and traditional African art displayed at the Brooklyn Museum, Smith recalled that:

I came away with the feeling that I had been in touch with something sacred. For a year afterward I haunted the libraries reading everything I could get my hands on about art, literature, philosophy, religion, existentialism—you name it, I touched on it somewhere.

But he added, 'I didn't see anything reflecting the black experience or black contribution to American culture.' So he read James Porter's *Modern Negro Art* (1943); sought out exhibitions about African-American artists in New York City, including Charles White at the ACA Gallery; focused on the works of Jacob Lawrence, the Mexican muralists of the 1930s, and German Expressionism. His bohemian existence in the 1950s (see p.176), meeting other African-American writers, musicians, and artists like Walter Williams and Sam Middleton, informed his creative vision.

During the 1960s and '70s civil rights protesters, activists and political prisoners all became a major part of his visual repertoire, as in *Negotiating Commission for Amnesty* [89]. The influence of Jacob Lawrence is seen in the simple colour schemes and shapes, and the schematic arrangement of figures in the composition, and the Cubist-

style faces with broad open mouths, recalling African masks.

For nearly forty years, Vincent Smith has portrayed a universal humanism in the context of modern black life and culture, expressing his beliefs on social justice.

The flag is the only truly subversive and revolutionary abstraction one can paint. (Faith Ringgold, 1973)

Since the late 1960s, Faith Ringgold (b. 1934), unconcerned about collectors and art critics, has used her art to voice her dissatisfaction with racism and gender inequality, and the absence of the black image and subject-matter in contemporary art. In 1971 she helped found a women's group, Where We At, in response to her exclusion from Spiral (which, except for Emma Amos, was an an all-male group) and her rejected proposal to exhibit at the Studio Museum in Harlem (the male dominance of the art world filtered into the black art world too). She deplored the minimal presence of women in all important American art exhibitions, particularly African-American art exhibitions. Perhaps Ringgold had a particularly difficult ride because her style made her work appear like naive painting, and later on her textile-art did not qualify as 'high' art.

Her series *American People* (1967) focused on racial conflict and discrimination. One of the series, *Riot* (1967), portrays two (one white, one black) children huddled together amidst the slaughtered victims, of men and women, of racial conflict. *The Flag Is Bleeding* (1967), showing a bleeding black man standing next to a white couple, denotes a rapidly disintegrating alliance between whites and blacks, and points to the 'front-line' position of the black male in the battle against economic and political colonialism.

The *Black Light* series (1967-9), which includes *Flag for the Moon: Die Nigger* [**90**], is even more pessimistic. This painting expresses Ringgold's concern with the issue of colour, and what the colour black has come to stand for. She conceived the idea after seeing American artist Ad Reinhardt's black minimalist paintings from which she soon realized the optical possibilities of black. Black is symbolically potent. In her flag black is a colour, absorbing and containing within it all colours, denoting presence. Consequently she has said, 'Black art must use its own color black to create its own light, since that color is the most immediate black truth'.[5]

The symbolic potency of the American flag was not lost on dissenting artists, who, despite restrictions about its use, deliberately reinterpreted the flag as a means of expressing their views on domestic and international policy. The white artist Jasper Johns had also painted the American flag, but his paintings were about painting and illusionism and were not politically subversive like Ringgold's. In *Flag for the Moon: Die Nigger* the irony is based upon the title's reference to *the*

90 Faith Ringgold

Flag for the Moon: Die Nigger, 1969.

The American flag is changed from red, white, and blue to colours which approximate the African-American flag: red, black, and green. With humour and militancy, Ringgold 'got rid of the white' and reversed the popular perception of black being a non-colour, denoting absence. By association, blacks are not invisible citizens.

major media, political and scientific event of the decade: the landing of Apollo 11 on the moon in July 1969, when Neil Armstrong planted an American flag and uttered the words 'That's one small step for man, one giant leap for mankind.' The media image of the American flag on the desolate surface of the moon became the key symbol of American democracy, progress, and a bright future in which anything was possible. Yet while, to increasing popular dismay, billions were being spent on space exploration, millions of people in the USA were living in poverty; infant mortality was amongst the highest in the Western world, and citizens endured heavy taxation as a result of the Vietnam War. The painting also refers to Black Panther Party leader, H. 'Rap' Brown, who embraced the term 'nigger' as an embodiment of black resistance against racism, and in his book *Die Nigger Die!* (1969) posited the central theme of radical ideology: what is a group's identity and who defines it? Ringgold, like many contemporary African-American artists, used the American flag as a symbol of America's historical mistreatment of black people.

In 1970 Ringgold was arrested, along with artists John Hendricks and Jean Toche, 'the Judson three', who participated in the 'People's Flag Show', a protest against repressive laws on the use of the American flag. The Judson church was the cradle for some of down-

town's (NYC) vanguard art movements, especially, 'happenings' and performance art.

I feel that my art relates to my total environment—my being a black, political, and social human being. Although I am involved with communicating with others, I believe that my art *itself* is really my statement. For me it has to be. (David Hammons, 1971)

David Hammons (b. 1943) moved to Los Angeles from Springfield, Illinois, in the early 1960s, expecting, like any new migrant, a better life and environment. While there he made a series of works called 'body

91 David Hammons
Injustice Case, 1970.
The X-ray effect conjures a variety of allusions—nuclear extermination, impermanence of life, archaeological documentation of burial mounds, invisibility—which can accommodate changes in where the art is seen and who is looking at the art.

prints', which overtly express his reaction to socio-political events of the time. An American flag borders his body print, *Injustice Case* [**91**]. As a preliminary step to printing, he lightly coats his body, his clothing, and even his hair with margarine. He first selects the fabrics carefully to enhance the textures of the image. He then presses his body against the illustration board, which is on the floor or on the wall:

When I lie down on the paper which is first placed on the floor, I have to carefully decide how to get up after I have made the impression that I want. Sometimes I lie there for perhaps three minutes or even longer just figuring out how I can get off the paper without smudging the image that I'm trying to print.

Then he sifts powdered pigments through a strainer to make a fine mist that completely covers the work. The colour is more intense on those areas which have absorbed the margarine, a softer haze covers the grease-free surfaces. Hammons always does the 'body print' first, then decides where the image of the flag will be.

 Injustice Case is both biography and a symbol of civil liberties abuses and political injustices: the image is a physical record of Hammons, like a fingerprint, and the subject of the painting is also the painting's subject. Phrased another way, the artist is the creator of the object and the object of meaning; artist and image coincide. The image also refers to the 1969 'Chicago Seven' conspiracy trial in which anti-war radicals Rennie Davis, David Dellinger, John Froines, Tom Hayden, Abbie Hoffman, Jerry Rubin and Lee Winer were accused of conspiring to cross state lines and otherwise incite people to disorderly conduct surrounding the 1968 Democratic National Convention in Chicago. In the opening stages, an eighth defendant, Bobby Seale (b. 1936), a Black Panther Party founder, refused to be represented by anyone other than Charles Garry, who could not appear in court for medical reasons. When Judge Hoffman insisted on proceeding without Garry, Seale began shouting obscenities and otherwise disrupting the court. The judge's response was to have him gagged and bound to a chair, on which he was carried daily into the courtroom until his case was severed from the others. William Kunstler, the defence attorney, recently recalled the case during an interview for the *Chicago Tribune*: 'When they bound and gagged Seale, of course, that skewered the whole trial. From that point I knew we had it. I saw the faces on the jury and I knew we couldn't lose that trial.'

Sculpture
Betye Saar (b. 1926) for a brief period made assemblages that expressed her intense feelings about racial stereotypes. Her works challenged the dominance of fine or 'high' art by using found objects and recycled materials, and also the dominance of painting by emphasizing symbolism

and allegory. She, too, used the American flag as a symbol, but she also invented racial and gender myths. *The Liberation of Aunt Jemima* [**92**] subverts the black mammy stereotype of the black American woman: a heavy, dark-skinned maternal figure, of smiling demeanour. This stereotype, started in the nineteenth century, was still popular culture's favourite representation of the African-American woman. She features in Hollywood films and is also used to market kitchenware and notably as the advertising and packaging image for Pillsbury's 'Aunt Jemima's Pancake Mix'. As in the *Ladies Home Journal* ads, Saar's Aunt Jemima is smiling, but her agenda is not servitude but liberation. The 'new' Aunt Jemima, set against a backdrop of repeated images of a

92 Betye Saar

The Liberation of Aunt Jemima, 1972.

The earlier images of Aunt Jemima were of a black-coloured woman with a full figure wearing a colourful head-tie. Towards the mid-twentieth century she became thinner, brown-coloured, wearing a less flamboyant head-tie, as shown in the wallpaper behind the standing figure. She does, however, retain her smile.

smiling black consumer, holds a rifle in one hand, and a broom and grenade in the other. To make the message still clearer, Saar inserts the black silhouette of a clenched fist, the Black Power symbol. Popular culture is where stereotype is created, sustained, and most unassailable. African-American artists in the 1960s and '70s confronted these insidious images by depicting them in their art but changing their attributes or surroundings. Consequently stereotype becomes a primary marker for racism. The viewer must then examine his or her own assumptions and simplistic categorization of people and cultures. But such tactics must be played out carefully because the use of these images risks perpetuating that which the artist wants to destroy.

In an early solo exhibition at the Berkeley Art Center in 1972, *Black Girl's Window*, the work with the same title [**93**] marks the beginning of Saar's autobiographical assemblages.

I knew it was autobiographical ... there's a black figure pressing its face against the glass, like a shadow. And two hands that represent my own fate. On the top are nine little boxes in rows of three marked by the crescent, the star and the sun. But look what's at the center, a skeleton. Death is in the center. Everything revolves around death. In the bottom is a tintype of a woman. It's no one I know, just something I found. But she's white. My mother's mother was white, Irish, and very beautiful. I have a photograph of her in a hat covered with roses. And there's the same mix on my father's side. I feel that duality, the black and the white.[6]

In *Black Girl's Window* the girl wants out of the box, and into the world. The window functions as a metaphor for entrapment, and also desires, a passage inside ourselves and outside ourselves; a way of travelling from one level of consciousness to another, like the physical looking into the spiritual. Saar's exploration of phrenology, palmistry, voodoo, shamanism, and later Botanicas show her interest in the occult, spiritualism and ritual. She sees making art as a ritual process.

Saar's next important phase in her art-making was the decision to use the box form. She was influenced in this by the American artist, Joseph Cornell, whose works she saw in Pasadena in 1968—'the first time I had ever seen art in a box'—and the Italian American Simon Rodia, whose monumental sculpture made from found objects, *Watts Towers* (1921–54) she visited while at her grandmother's house. She also wanted to expand on the assemblage technique in order to reflect on her penchant for collecting and accumulating 'stuff'. Scouring alleys, antique shops, yard sales, she collects for future works. Her box constructions are enigmatic; strongly reminiscent of spirit-power containers, fetishes, they are also memorials about family, a repository of memories: 'The boxes are coffins; they're all coffins. They contain relics from the past.' Her travels to Haiti, Mexico, and Africa, and Arnold Rubin's essay on power and display in African sculpture, all reinforced her spiritual and psychic personae and confirmed the ubiquitousness of people's beliefs in the spiritual power of used objects, the detritus of individual lives. By recycling she transforms found objects into works of art. These travels and the death of her Aunt Hattie resulted in a series of boxes made in her aunt's memory. Hattie's personal belongings—old letters, postcards, faded photos and, especially, handkerchiefs—are assembled to create an allegory about womanhood in *Record for Hattie* [94]. Saar's aesthetic of accumulated found objects, like the Surrealists' *bricolage*, is based on African art. But where Western modern artists used *bricolage* to express irony, anti-rationality, destructiveness, and a subversive aesthetic, Saar uses her objects to express the point of view of an African descendant, a child of the diaspora who uses the 'anti-aesthetic' to express a collective racial (as cultural) consensus, affirmation, and continuity: a reinforcement of social values.

Elizabeth Catlett (b. 1919) is best known for her highly charged political sculptures and prints made in 1968–70, although her art career by then had been going since the 1940s and '50s. For her, 'art is important only to the extent that it helps in the liberation of our people'. The pivotal position and gesture of *Homage to My Young Black Sisters* [**95**] animates an otherwise classical early-twentieth century modernist work, in which contours of the human anatomy interplay with shapes created by pierced openings in the wood. The polished surfaces amplify the sensuousness of the female form. This life-size figure is Catlett's most reproduced and talked about work; it stands for black nationalism and women's liberation, both of which were vociferous at the time of its creation. The women's movement, led mostly by white women, followed the strategy of black militants by adopting a personal or collective vision, a value orientation or at least a perception of shared female identity, and a recognition of themselves as 'the other'. Both repudiated coalitions: women excluded men and by 1967 black nationalists excluded whites, believing that the goal of self-determination was indisputable and that the radical approach was the only viable way to success.

The sculpture's message was unequivocal. Artist and educator Jeff

95 Elizabeth Catlett

Homage to My Young Black Sisters, 1968.
Catlett's staunchly standing figure has an upturned face, directing our gaze towards the right fist raised in a Black Power salute, which was the most widely understood image of protest against racial inequality. The treatment of the face suggests that the sculptor does not intend a nationally specific image. *Homage* is not just about African-American women, it is about black feminism worldwide. Her advocacy of women in all spheres of social and political endeavour was unusual at a time when men dominated black nationalist movements.

Donaldson, the founder of AfriCobra, understood it when he wrote a 'commentary' for Catlett's solo exhibition at the Studio Museum in Harlem (1971).

Some Black artists have committed their art to the Struggle for Survival/ Victory of Black and Third World peoples over their oppressors. Elizabeth Catlett has made that commitment. Black and Third World people need Elizabeth Catlett because her work speaks to these concerns, ever has and, hopefully, ever will. We need reflectors, interpretors [*sic*] and prophets who charge us with our divine mandate to regain our motherlands and our manhood and to punish those who persist in robbing us of them. Elizabeth Catlett offers visual praises to our potential. Wise and Brave Man of the Future will smile and praise her.

Catlett creates a form that infuses modernism with cultural and historical significance, simultaneously placing black women in these contemporary narratives. Artistically, it transcends a specific socio-political moment to create a powerful image of the black woman.

David Hammons remarked, when he saw one of Melvin Edwards's Minimalist sculptures, that this was the 'first abstract piece of art that I

saw that had a cultural value in it for black people; I didn't think you could make abstract art with a message'. He was referring to a 30-foot (10-metre) composition of chains and barbed wire suspended from the ceiling, called *Curtain for William and Peter*, shown at the Whitney Museum of American Art in 1970.

Edwards (b. 1937) began making his large-scale, free-standing stainless steel sculptures around 1965. His earlier work in painting is apparent in the burnished and wire-brushed light-reflecting surfaces of *Gate of Ogun* (1983) [**96**], which create the visual effect of brush-strokes. Geometric sculptural masses compose a system of weights and counterweights which momentarily balance, abut or precariously extend into or bisect space. Here, space is not merely a formal element but a location of experience, where the light-reflective surface qualities complement minimal, elegant forms and the silhouette of stainless steel. The post-and-lintel construction and the smaller cluster of forms create two glimmering gateways, carefully made to a scale which is humanly accessible in order to create a more personal and immediate spatial experience. Edwards described the sculpture as 'environmental because you can move through it'. The steel chain is a symbol of slavery and his metaphor for 'connections, chains of loves, cultural linkages'.

96 Melvin Edwards

Gate of Ogun, 1983.
Ogun is the deity of iron and war found among the Yoruba, Bini, and Fon people in West Africa, and in Cuba and Brazil. Ogun lives in the flames of the blacksmith's forge, on the battlefield, and is felt on the cutting edge of iron. Hence Ogun, through iron tools, is associated with cultivation of nature, with civilization. The curved lintel of Edwards's piece appears like a curved blade.

The portal is a symbol of transition representing the Middle Passage and spiritual transformation.

Edwards has also created assemblages of welded iron and industrial detritus entitled *Lynch Fragments*. They have been a major part of his output over three periods: the first, 1963–6, included the production of *Lynch Fragments: Afro Phoenix nos 1 and 2* [**97**]; the second was in 1973, and the third from 1978 to the present. When shown in a series the fragments create a visual rhythm and engage the viewer in a processional movement, evoking a sense of the ceremonial that would not be evident if they were seen individually mounted. *Lynch Fragments* invite psychological interpretation: unfolding ellipses and rigid projections evoke male and female sexuality, and invite Freudian interpretation or Jungian reflections on primeval universal patterns of destruction, aggression, and regeneration.

These sculptures are also about race, culture and autobiography. Edwards scripts with steel: 'As a modern artist, you work on the invention of an independent language, your own language of forms and symbols. Everybody else has to learn that language from you.' That language is a 'private conversation' clearly expressed in a visual African-American vernacular, especially in the *Lynch Fragments*. Like archaeological specimens, or cultural detritus, they are compressed and fragmented, spliced and fused into artefacts of a time, a place, a people, and the sojourn of a black male. It was urban racism in Los Angeles and New York City in the 1960s, the civil rights movement and black nationalism that motivated Edwards to make his first *Lynch Fragment*. His cultural memories are embedded in the sculptural form. Titles such as *Texas Tale*, *July 4*, *South African Passbook* or *Igun Hammer* provide clues about Edwards's life, family and African-American history,

which he learned through family stories. He came full circle after he learned that his mother's great-great grandfather was a blacksmith. His free-standing sculptures are also autobiographical, as in works titled *Conversations with My Father* (1974) or the *Rocker* series begun in 1970, which are monuments to his grandmother. In 1993 Edwards said, 'The *Lynch Fragments* have changed my life. They made this life of thirty years as a sculptor. They are the core to all the work. If anybody ever knows I lived, this is going to be why.' Looking at Melvin Edwards's sculptures, one can easily understand their persevering vitality; for ultimately he himself is the subject. The sculpture is merely a manifestation, a mirror of his existence, and simultaneously of an African-American ethos. Each work encapsulates a moment of his life mediated through modernism.

Sculpture is a religious affair. This makes for a very dense object rather than a lean one. Let's call it maximal art. I think our civilization is minimal enough without underlining it. Sculpture as a created object in space should enrich, not reflect, and should be beautiful. Beauty is its function. (Barbara Chase-Riboud, 1973)

Barbara Chase-Riboud (b. 1939), after studying art first at the Tyler School of Fine Art and later at Yale University, left permanently for Paris in 1961 and took a break from making sculptures for five years. In the 1970s her work was disparaged for not being 'black' and for avoiding any overtly polemical content. This, and her view that 'sculpture should be beautiful', often placed Chase-Riboud on the sidelines of black art debates.

She made wall and free-standing sculptures combining cast or hand-beaten bronze or silver, with fibres—wool or silk—to create a formal tension between the two-dimensional (contour) and the three-dimensional (volume). Such contrasts are seen as representing the interrelationship between male and female, hard and soft, naturalism and abstraction, opposites that are tense and complementary, one flowing into the other. Unlike the Minimalist artists, who emphasized only formalism, Chase-Riboud regarded sculpture as a reinterpretation of primitivist notions about magic and spirituality. She remarked,

My object[ive] in the wall hangings is to reinterpret the aesthetic function [of African and Oceanic masks] in abstract language, using non-anthropological materials: bronze and silk, bronze and wool, steel and synthetic, aluminum and synthetic. In the dancing masks of New Caledonia, the braiding and cording in the skirts attached to the masks serve the same purpose as my braided skirts do: to hide the armature (the person wearing the mask) and to dissociate [*sic*] the mask from the ground and its surroundings so that it is no longer simply a piece of sculpture, but a personage: an object of ritual and magic.[7]

In her first solo exhibition in New York, at the Bertha Schaefer Gallery in 1970, Chase-Riboud made four *Monument to Malcolm X* sculptures, each dedicated to the memory of Malcolm X. The overall spirituality which emanates from these wall-hangings makes them, by virtue of their title, votive works of art. Instantly her abstractions were transformed into political art which, at the time, given the definition of black art fostered by Gaither, seemed a contradiction. Chase-Riboud takes this Muslim leader out of the specificity of his time and place and heroicizes him as the person he became, a leader and champion for pan-Africanism and a universal brother/sisterhood. Her intent, she says, was that the sculpture should 'embody the idea of Malcolm rather than to make monuments to a dead man.' In *Monument to Malcolm X no. II* [98] the pliant braided wool reminds us of women's hairstyles, which, when seen against the harder surfaces of metal, convey gendered difference embodied in the idea of hard and soft. This reference to sexuality and gender and African spirituality humanizes the popular notion of political leaders as being remote and aloof.

In her second show, in New York in 1972, the silk and wool are more

98 Barbara Chase-Riboud
Monument to Malcolm X no. II, 1969.

99 Barbara Chase-Riboud
Confessions for Myself, 1972.

elaborately knotted, wrapped, braided and corded. *Confessions for Myself* [99] is entirely black, with the crinkled folded surfaces of bronze and the luxurious cascade of wool evoking a totemic figure wrapped in a cloak or a protective shield. The wool and silk allude to hairstyles found among African, African-American, and Afro-Caribbean women, some of whose styles have now become mainstream but which in the 1970s were construed as overtly political because of the unequivocal signal they gave of 'blackness'. Even today, the manipulation of hair and use of elaborate designs remain culturally specific. More than a self-portrait, the sculpture visibly represented the male and female nature in all humans. The elaborate manipulation of materials and black colours (the effect of the plaiting and dyeing is to create several shades of black) explores the personal significance of being black and female. In the 1970s, assertions of 'blackness' were political acts. 'Black is beautiful' was a familiar refrain. Chase-Riboud joins Saar and Ringgold in seeing colour symbolically and metaphorically. In art, the aesthetic and political are inseparable.

Art institutions and artists' groups
Mainstream art institutions

In the 1960s artists more than at any other time organized formally and informally into groups. The reasons for this were various: to learn about and from each other; to become involved in the civil rights movements in their respective cities; and to lobby for more exhibitions, and recognition by critics and art institutions. Their agenda was not dissimilar from the agenda of political activists such as Martin Luther King and the SCLC: integration into mainstream American society.

Artists sought integration into, yet recognition within, the mainstream American art world. They wanted their works shown in major art institutions and reviewed in the mainstream art journals and magazines and newspapers, and to have their works evaluated by African-American critics and art historians. In the early 1960s most African-American art exhibitions were mounted by historical black colleges in the South, or by African-American historical and cultural societies, usually in black neighbourhoods. One such exhibition of this decade was 'Art of the American Negro', organized in 1966, by Romare Bearden. This, the first large survey of African-American art, was held at Kenwood Reter's Furniture store on 125th Street, New York, and was sponsored by the Harlem Cultural Council.

From the late 1960s African-American art was increasingly directed not only to the black communities but to a national audience. But wider recognition did not come easily; success was hard won, often marred by misunderstandings and attended by controversy. Alongside attempts to win a place in mainstream museums and galleries there were moves to stand apart and maintain a separate Afro-American

artistic identity. This too helped establish African-American artists on the map.

At the same time there were indications that the call for equal rights was filtering into the mainstream art community. Art galleries and corporations were more inclined to sponsor local and travelling exhibitions. For example, in 1968 'New Voices: Fifteen Black Artists' was put on by the American Greetings Gallery in downtown New York City, and the Minneapolis Institute of Arts, assisted by the public relations firm Ruder & Finn, organized 'Thirty Contemporary Black Artists', an exhibition which toured nationally.

Mainstream museums, even though they had been acquiring works of individual artists for some time, were remiss in excluding African-American artists from important group exhibitions (Romare Bearden and Norman Lewis in the 1940s and '50s were exceptions), and no African-American artist (except for folk artists at the Museum of Modern Art in the 1930s) was given a solo museum exhibition. In 1968 the Museum of Modern Art, planning a memorial exhibition for Martin Luther King, had to be forced by protestors to include black art. Even then it was shown in a separate gallery, not integrated into the original exhibition design. In 1969 the 'Harlem on My Mind' exhibition at the Metropolitan Museum presented James Van Der Zee's photographs as documentary images, not as art, using them as a backdrop to the display of artefacts, letters, etc. In response to this Benny Andrews, Henri Ghent and John Sadler founded the all black artists' group, Black Emergency Cultural Coalition (BECC, 1969–71).

The BECC focused their efforts on the Whitney Museum of American Art, demanding a major exhibition of black art, a fund to buy more black art, at least five annual solo shows of black artists, more black artists in the prestigious Whitney Annuals, and consultation with black art experts.

Meanwhile Faith Ringgold and Tom Lloyd, among other artists, were agitating for a black wing at the Museum of Modern Art. In their letter to the director they wrote: 'We are waiting. We cannot wait very much longer, Mr Lowery.'

In 1968 art historian Henri Ghent organized 'Invisible Americans: Black Artists of the 30s' at the Studio Museum in Harlem. This was a response to the Whitney Museum's exhibition of art from the 1930s, which did not include a single African-American artist.

As a result of these efforts, African-American artists began to have solo exhibitions, albeit not always in the main galleries. Between 1969 and 1975 the Whitney Museum scheduled a few solo exhibitions in their 'projects' gallery, a small gallery on the first floor, showing the works of William T. Williams and Melvin Edwards. Robert Doty, curator, organized a major exhibition of contemporary African-American art entitled 'Contemporary Black American Art' in 1971,

which the BECC boycotted because the museum did not consult with the black art community or choose a black curator.

The BECC's action caused a division among their members. Some pulled out of the show, others resigned from the organization. Fifteen artists withrew from the Whitney show and participated in 'Rebuttal of Whitney Museum Exhibit' (1971) at the downtown African-American-owned gallery, Acts of Art Galleries (1969–74). This gallery also exhibited 'Where We At, Black Women Artists, 1971', whose members included Dinga McCannon, Faith Ringgold, and Kay Brown.

The BECC's activities and the rebuttal exhibitions may not have commanded total support from the African-American art community, but they did have the effect of galvanizing critics and art historians, mainstream and African-American, into considering aesthetic, economic and political questions. The debate about who defines and selects black art continued.

Meanwhile Romare Bearden and Richard Hunt had solo exhibitions at the Museum of Modern Art in 1971, and Alma Thomas had an exhibition at the Whitney in 1972, the first African-American woman ever to do so.

African Americans established their own art institutions, galleries and museums, sometimes in the mainstream art districts, sometimes in the black communities. Two important institutions were founded in the late 1960s: the Studio Museum in Harlem in New York City, and the Museum of the National Center of Afro-American Artists in Boston. The Studio Museum, the first contemporary fine art museum of African-American art, opened in 1968 with 'Electronic Refraction II', a solo exhibition of the sculptures of Tom Lloyd (1921–96). This was followed in 1969 by a group exhibition, 'X to the Fourth Power', showing works by William T. Williams, Sam Gilliam, Melvin Edwards, and also a white artist, Steve Kelsey.

Similar activities occurred in other American cities. Romare Bearden, Ernest Crichlow, and Norman Lewis established Cinque Gallery in New York City in 1969 (still active) to show emerging African-American artists. In the 1970s more white galleries showed African-American artists, and most had one or two in their 'stable'. In New York City there were more galleries owned and directed by African Americans: Weusi Nyumba Ya Sanaa, Acts of Art Galleries, Kenkeleba Gallery, and Just Above Midtown.

Black art aesthetics

In the late 1960s and the 1970s there were cultural movements in most major American cities which saw art as having a role in the political struggle for social equality and economic opportunity. The tone was considerably more militant than earlier. There was a call for a revolu-

tionary art. The dictum 'art for art's sake' was repudiated. Art should reflect cultural values and 'must expose the enemy, praise the people and support the revolution'. Literary critic Addison Gayle published an anthology, *The Black Aesthetics* (1971), which clearly delineated the agenda of this new black art movement. Gayle asserted that African-American arts should assist in the political revolution, and be honest in content, speaking to a black, not white audience. Gayle and subsequent African-American critics frequently cited W. E. B. DuBois' idea of 'double-consciousness', the sense of always looking at one's self through the eyes of others which must be overcome in order to arrive at true self-worth and an acknowledgment of African heritage.

Gayle's premise was that because African Americans had a 'unique experience and that art is a product of such cultural experiences … [a] unique art derived from a unique cultural experience mandates unique critical tools for evaluation'. He was one of those who championed a black aesthetic as a corrective: 'a means of helping black people out of the polluted mainstream of Americanism'.[8]

Black art and black power

'Black power', a slogan of the late 1960s and the 1970s, was predicated on the concepts of self-defence, self-definition, and self-determination, and sought autonomy not integration. Two nationally known advocates, Stokely Carmichael and Charles V. Hamilton, in *Black Power: The Politics of Liberation in America* (1967), expressed it this way:

Our basic need is to reclaim our history and our identity from what must be called cultural terrorism, from the depredation of self-justifying white guilt. We shall have to struggle for the right to create our own terms through which to define ourselves and our relationship to the society, and to have these terms recognized.

A central theme was the group's identity and who defines it. Artists' groups developed around this philosophy; they did not care to seek approbation from the mainstream art community or exhibitions at the art museums. Theatre, literature, music, along with the visual arts, were targeted for the expression of this newly found black pride and black cultural nationalism. Artists established themselves in their respective African-American communities, and were committed to bringing the arts to the black urban neighbourhoods. Their sentiments, as expressed by activist and writer Larry Neal, were not dissimilar from those of the Negro Renaissance.

In New York City, for example:

Uptown was looked upon by the nationalist impulse as the place to be. That's where the people were. That was an historical place. It was very important in some way to claim Harlem. The downtown group was essentially trying to move through the main currents of American avant-gardism. The Village had

always been a place that was relaxing for Afro-Americans, at least in the 1950s. There was a ready home down there, but there was a tension about whether that was relevant.[9]

Black artists' groups

In 1965 a group of artists who called themselves '20th-Century Creators' changed their name to Weusi (Swahili for 'people') and two years later established a gallery in Harlem called Nyumba Ya Sanaa (House of Art), which was operated exclusively by artists as an alternative to the mainstream exhibition spaces. The Weusi group did not see being part of the mainstream as relevant. Approximately eight artists formed the core of the group. One of these, Ademola Olugebefola, looking back on those times, has reflected, 'We were set on making things very African. Some of the work was very abstract. At that point in history, we felt that art needed to be involved in politics, because that was the need of our people at the time.' The most important goal was to establish communication between the artist and the African-American community.

The reclamation of African culture, called 'Africanity' or 'Afro-centricity' for political and cultural reasons, was motivated by a revival of pan-Africanism. As newly independent nations emerged in Africa, there grew up an interest in Swahili as a pan-African language, and hundreds of African Americans travelled to West and East Africa to see and experience the 'motherland' firsthand. Abstract art was embraced only if it conveyed a style or aesthetics that seemed African, by which was meant abstract motifs, brilliant colour, dense and rhythmic design compositions.

Ben Jones (b. 1941) was an important part of this development. His first exhibition, held in Harlem at the Weusi Gallery, included *Black Face and Arm Unit* [**100**], a classic representation of the renewed interest in African art culture. It consists of a series of wall reliefs made from plaster casts of Jones's face and arms. Each element has a distinctive pattern; seen together they create a rhythm of colour and abstract pattern. The brilliantly coloured decorations recall ritual body paintings, or body decorations seen during masquerades and carnivals in Africa and the Americas, which Jones had observed during his travels in West Africa, Brazil, and the Caribbean. The work was a self-portrait but it was also a model which combined abstraction (design and colour) with realism (casts of his body).

In July 1962 a couple of painters, Jeff Donaldson and Wadsworth Jarrell, discussed whether it would be possible to start a 'Negro' art movement based on a common aesthetic creed. They, along with Barbara Jones-Hogu and others, formed the Organization of Black

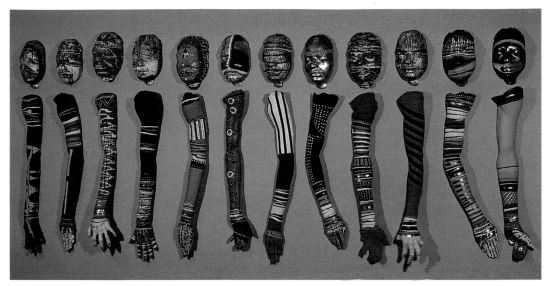

100 Ben Jones
Black Face and Arm Unit,
1971.

American Culture (OBAC) artists' workshop and, following Chicago muralist William Walker's lead, helped paint the *Wall of Respect* [**101**] (1967; additions 1969; destroyed 1971). For this project, which covered the exterior wall of a building on the Southside of Chicago, they collectively chose the theme of black heroes: musicians, writers, political leaders like Muhammad Ali, W. E. B. DuBois, Malcolm X, and Amiri Baraka. Highly controversial at the time, the *Wall of Respect* marked a revival of mural painting by African Americans which was to far outstrip, in numerical terms, the production of the 1930s and '40s. Some 1500 outdoor murals were created between 1967 and 1972 in major cities throughout the United States. In 1969 Walker and Eugene Eda supervised *Wall of Truth* (1969), a sister mural to the *Wall of Respect* and sited across the street.

Political and social turmoil in Memphis, Harlem, and Los Angeles encouraged five OBAC artists in 1968 to change their name to Coalition of Black Revolutionary Artists (Cobra). Not long afterwards, and having gained two new members, they renamed themselves African Commune of Bad Relevant Artists (AfriCobra), and solidified their agenda and philosophy of art.

AfriCobra initially operated outside traditional venues and avoided media of 'high' art; they were committed to making art understandable, relevant and accessible to ordinary people. Their anti-modernist stance directed them to make poster-prints. In these, representational images splinter into abstract designs in which exhortations about unity, respect and nationalism use art as a pedagogical and ideological tool. Paradoxically, on the eve of their leaving Chicago in 1970, they agreed to exhibit at the Studio Museum in Harlem (after first showing at Weusi Gallery), with a show of silk-screen prints of original works, titled 'Ten in Search of A Nation'. They exhibited again in 1971:

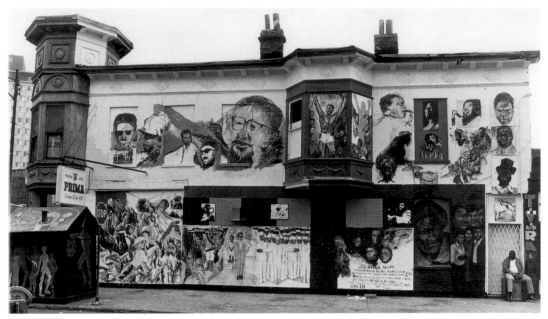

101 OBAC

Wall of Respect, 1967.

'Africobra II'. Founding member Jeff Donaldson summarized the group's ideology and aesthetic in polyrhymic prose in the 1971 exhibition pamphlet.

We strive for images inspired by African people/experience and images which African people can relate to directly without formal art training and/or experience. Art [is] for people and not for critics whose peopleness is questionable. We try to create images that appeal to the senses—not to the intellect. It is our hope that intelligent definition of the past, and perceptive identification in the present will project nationfull direction in the future … look for us there, because that's where we're at.

 Among our roots and branches we have selected these qualities to emphasize in our image making—a) **Symmetry** that is **free**, repetition with change, based on African music and African movement. (b) Images that mark the spot where the real and the overreal, the plus and the minus, the abstract and the concrete—the reet and the replete meet. c) **Color** color Color color that shines, color that is free of rules and regulations. Color that is expressively awesome. Superreal images for SUPERREAL people. Check out the image.

AfriCobra remains active and continues to focus on African-American imagery, vibrant colours, improvisation, and rhythmic design as can be seen in Jeff Donaldson's recent painting, *JamPactJelliTite (Jam Packed and Jelly Tight)* [**102**], in which the influence of jazz pervades the composition, including the depiction of a bifurcated jazz musician. Donaldson, and the other members, all continue their quest for 'a universal aesthetic adhered to by persons of African descent all over the world'.

Towards a new abstraction

In the early 1960s during the rise and fall of pop art, the interest in Abstract Expressionism continued. Several African-American painters, including Bill Hutson, Oliver Jackson, Mary Lovelace O'Neal, and Vivian Browne, embraced this older form of Abstract Expressionism. Several new art-critical categories in painting emerged: colour-field, hard-edge, and monochromatic (Minimalism). The visual effect was aloof and elusive in comparison with the bombastic expressionism of the previous decade. African-American artists followed these styles, on their own initiative or as a result of their formal art education at universities and art school, where many proponents of the new art taught—especially in or near New York City, still the international art capital.

Are you black enough?

Black American artists who embraced the new abstraction were caught in debates about culture, race and community. The cultural underpinning of Black Nationalism/Black Power forced artists to be accountable. How are you going to be part of the revolution? What are you doing to ensure that artistic enterprise reflects who you are as a 'black' American? (This was construed as different from a 'Negro' American, which connoted someone who adhered to the old integrationist philosophies of the 1950s, or accepted their social place in society, as

102 Jeff Donaldson
JamPactJelliTite, 1988.

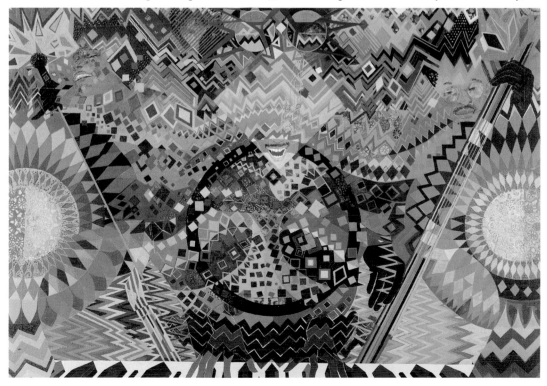

during the first half of the twentieth century.) The emphasis on 'black' did not allow for 'American' as a descendant of white European culture, at least not more than was due to African heritage.

In the minds of most Black Nationalist artists, abstraction was aligned with the mainstream (translate as 'white') art community. Abstraction was dismissed as 'art for art's sake' and unsuitable for the needs of black art, which needed to be accessible to all. Consequently, Sam Gilliam, William T. Williams, Alvin Loving, and Richard Hunt were not seen as 'black' except for the fact that they were African-Americans. Only abstract art which apparently emulated African design, or which was supported by a statement of intent referring to experiences in Africa or to the study of African art, was accepted under the rubric of 'black'. The works of Ben Jones or Jeff Donaldson, therefore, would be 'black art'. A dichotomy 'black' versus 'mainstream' art was established in the art-historical and critical literature, and especially in the art criticisms and editorials published in the *New York Times*. Elsa H. Fine's book, *The Afro-American Artists* (1973), provides a

Art styles

New abstraction: Two landmark exhibitions, 'Toward a New Abstraction', Jewish Museum (1963) and 'Post Painterly Abstraction', Los Angeles County Museum (1964) showed the continuing popularity of Abstract Expressionism, and represented attempts to uphold the dominance of painting over the growing popularity of mixed-media and representational art. The 'new' abstraction was a reaction against Abstract Expressionists' disregard for formal ordering and lack of technical restraint. The heroic spirit of Abstract Expressionism, the free flow of paint and gestural brushwork prevailed, but now controlled by a more objective and conceptual approach. The paintings of Helen Frankenthaler or Mark Rothko illustrate this more classical sense of restraint in technique and effect.

Colour-field painting: a painting style that flourished from the mid-1950s to the late 1960s in the US. Its proponents rejected illusionism of depth and gestural brushwork, applying colour in thin, translucent washes that often span the entire canvas as if depicting a detail of some larger field. The emphasis is on the flatness of painting.

The peak of colour-field painting came in the 1960s with the formation of the Washington Color School. This included Gene Davis (*c*. 1958) and Morris Louis, representatives of the second generation of Abstract Expressionists, who exploited the physical properties of oil and acrylic paints on canvas. They were professors at the American University (Washington, DC) and, along with Kenneth Noland (b. 1924), formed the core of this regional group identified by Clement Greenberg.

Hard-edge painting: a phenomenon of the late 1950s and the 1960s. It first appeared in 1958 in Los Angeles, and then in New York. Flat areas of colour are circumscribed within carefully delineated forms as part of a formal investigation of colour and design problems. Kenneth Noland and Frank Stella (b. 1936) made typically geometric, symmetrical paintings in a limited palette. These, with the early works of Ad Reinhardt, became the precursors of Minimalism. Some painters, for example Frank Stella, abandoned the traditional rectangle for a differently shaped canvas format.

Minimalism: characteristic of the late 1960s to the mid-1970s, primarily in the US. The term emerged in an article by the art critic Barbara Rose, 'ABC Art' (*Art in America*, October 1965), in which she referred to art pared down to the minimum. It denoted the process of reducing painting and sculpture to their essentials: surface, shape and a basic palette, often of only one colour. Representational imagery was abandoned. Painters Barnett Neuman, Ad Reinhardt, and sculptor David Smith are among the foremost representatives of this art movement pioneered in America and which gained international significance. Minimalism is more frequently associated with sculpture that does not show the artist's hand, is produced by industrial fabricators, and displays elemental geometric forms—'primary structures', known as such after an exhibition of the same title, organized by Kynaston McShine a black curator at the Jewish Museum, New York City. Most sculptures were installed in urban environments, most familiarly as public sculptures in front of corporate offices.

Neo-expressionism: an international art movement of the late 1970s to the mid-1980s. It was a reaction against conceptual art and modernist rejection of imagery. Typical of the style is gestural paint handling and allegory, using imagery from a variety of sources, including dreams, classical mythology and non-art sources, for instance, popular novels and newspaper ads. Works often have psychological or conceptual orientation.

Conceptual art: an international art movement of the mid-1960s and 1970s which was made popular by American artist Sol LeWitt in 1967. The idea rather than the object is paramount. Viewers see a document of an artist's thinking, usually a statement rather than a physical realization. The event itself is the art. It challenges our definition of art by insisting that only the leap of the imagination, not the execution, is art. Works are a by-product of the creative process and need only be documented in some way, usually by verbal, photographic or cinematic means.

Environmental art: sculpture that is less an object than a place viewers might enter in a gallery or natural landscape. This is an art that avoids the issues of sale and ownership by either being temporary or being represented by photographs and other documentation.

mirror of the times. Labels like 'mainstream' and 'black' were constantly thrown about in the print media. Black-produced art whose styles appeared no different from newer art styles of white American artists was considered 'mainstream'. Fine interjected another category, 'blackstream' art, which denoted 'those who derive their inspiration from the Black protest movement, the Black experience in America, or the motifs, symbols, and color of Africa yet work within an established tradition'. Fine made another distinction, which she called 'black art movement', to denote artists who aligned their aesthetic and intent with Black Nationalism and separatist politics. Those distinctions were not often shared by African-American art historians and critics; for them, 'blackstream' and 'black art movement' collapsed under the rubric 'black art'.

Recent critical reviews of the art of the 1960s and '70s have shown that elements of an African-American aesthetic can be found: in im-

provisational technique, or the African aesthetic in accumulation of materials, or use of textiles. Examining the following artists, we shall see them from the perspective of their times as 'mainstream' artists, but from more contemporary critical perspectives as 'black'. Alvin Loving, Sam Gilliam, and Barbara Chase-Riboud are now seen as straddling both aesthetic camps.

Painting

Creative art is for all time and is therefore independent of time. It is of all ages, of every land, and if by this we mean the creative spirit in man which produces a picture or a statue is common to the whole civilized world, independent of age, race and nationality, the statement may stand unchallenged. (Alma Thomas, 1970)

Alma Thomas (1891–1978) attained recognition as a professional artist in 1960, after she retired from teaching art in the Washington, DC, public schools. Shortly before then she enrolled at American University, where Jacob Kainen and Joe Summerford were teaching art that emphasized colour-field painting and colour theory. Initially a representational artist, Thomas quickly became an abstract painter interested in colour and compositional structure. Within twelve years she too was creating colour-field paintings similar to those of the New York School—painters identified with Abstract Expressionism and its offshoots, like colour-field painting. In 1972 she was the first African-American woman to have a solo exhibition at the Whitney Museum of American Art. Another solo show took place at the Corcoran Gallery of Art (Washington, DC). She was assured a place in American art.

Thomas had her first retrospective exhibition in 1966 at the invitation of art historian James Porter, director of the Gallery of Art at Howard University. This resulted in a series called *Earth Paintings*, of which *Wind and Crepe Myrtle Concerto* [103] is one. Her interest in nature, plants and flowers and landscapes provides the basis for this study of colour and light, one of the most Minimalist colour-field paintings ever produced by an African-American artist. African-American artist and friend, Delilah Pierce (1904–92), recalled that she and Alma often took long drives in the country, and Thomas would show a keen interest in the different effects of light and atmosphere. Nature is here reduced to staccato strokes of one to four colours. The spacing and repetition of colours create a visual rhythm: the formalized progressions of symphonies rather than the syncopation of jazz sensed in her slightly later paintings.

The effect is of a myopic view of a screen of flowers against a formalized garden landscape. And indeed the *Earth Paintings* series, a long-running project, with later works becoming more geometric, almost mosaic-like in effect, was inspired by wind and flowers. Seeing

103 Alma Thomas

Wind and Crepe Myrtle Concerto, 1973

Thomas was attracted to the writings of Johannes Itten, a Swiss artist, whose dictum 'colour is life' is sensed in this painting with its optical tensions and movement, created by modulating the pink colours and spacing them over the green-yellow background. In its atmospheric and luminous effects *Wind and Crepe Myrtle Concerto* is like her paintings of the mid-1960s.

this painting, one is reminded of novelist Alice Walker's book *In Search of Our Mother's Gardens* (1977): 'guided by my heritage of a love of beauty and a respect for strength in search of my Mother's garden I found my own'.

Sam Gilliam (b. 1933), after studying art at the University of Louisville (Kentucky), moved to Washington, DC, where he quickly changed from a figurative painting style to hard-edge and colour-field abstractions. In 1966, he first poured translucent paints on unprimed canvas, making stained paintings like those of Morris Louis and Kenneth Noland, two central artists of the Washington Color School. A year later, Gilliam began to fold his paintings, experimenting with the paint's viscosity. At the age of 35 he dramatically altered the installation format for painting. He discarded stretchers for mounting the canvas and instead hung it free-form, from the wall or ceiling. Popularly referred to as 'drape' paintings, they represented one method of making paintings project from the wall, an interest shared by several painters in the late 1960s and the 1970s. Gilliam's 'drape' paintings catapulted him into the American art mainstream.

For the next four years, Gilliam continued to experiment with the ways in which painting can make the spatial transition from wall to floor and/or ceiling, and during this time he continued to use stretched canvasses as well. His first full-scale exhibition was as part of 'Gilliam-Krebs-McGowen' (1969) at the Corcoran Gallery of Art, which at that

time was the museum for contemporary art in Washington, DC. Eight of his massive drape paintings were suspended in two galleries and the central atrium of the museum. The effect was dramatic and monumental, as can be imagined looking at *Carousel Form II* [**104**]. Each installation, in this exhibit and in others, is site-specific, simultaneously transforming architectural space and changing the perception of mass and surface of the work. As an example, *Carousel Form II* creates a tension between structure and order versus improvisation and disorder.

Shortly afterwards, Gilliam began using poles and thongs to extend the canvas or polypropylene, at times reaching a length of 30 feet (9 m). These drape paintings of the 1970s engage with space as environmental sculpture, yet, because of the medium, remain paintings. The weightiness of the canvas was immediately hailed as masterful. Some time during the 1970s, he also made small-scale paintings (8 feet/2.4 m), called 'cowls', which were hung vertically along the wall.

In 1971, Gilliam had his first outdoor painting installation at the Philadelphia Museum of Art. In *Seahorse*, two canvasses (60 × 90 feet/18 × 27 m) were hung along the building's exterior. With exhibitions at the Whitney Museum of American Art (1969), the Museum of Modern Art (1971), the 36th Venice Biennale (1973) and the Corcoran's '34th Biennial of Contemporary American Painting', (1975), Gilliam exemplified the mainstream artist.

Gilliam's success and type of art concerned many 'black art' proponents. In a period of political fervour about race and racism, Black Nationalism and black art, his paintings had no identifiable black aesthetic. That these reductive colour-field paintings were widely acclaimed by mainstream critics and curators placed Gilliam at the centre

104 Sam Gilliam
Carousel Form II, 1969.

of heated discussion about black art and mainstream art, and at the same time further problematized the issue about what constitutes black art.

Recently art critics have revised or corrected previous perceptions of Gilliam's drape paintings as being non-representational and lacking any indication of black culture. For instance, John Beardsley, who earlier saw the 'cowl' paintings as devoid of subject, later saw them as allusions to floral or figural forms. African-American art critic and artist Keith Morrison discovered (1980s) a subtler aesthetic of blackness in all of Gillam's drape paintings:

I feel that aspects of Gilliam's work relate to Africanness in ways that have been overlooked. I refer especially to those draped pieces that are evocative of the spectres of garments, of the dramatic gesture that fabric assumes as it becomes more characteristic of movement and personality than any form, human or otherwise, that might be contained beneath it.

Morrison approached these works from a pan-African perspective and by doing so placed them within the culture of the African diaspora:

When I first saw Gilliam's drapes, I was reminded of childhood in the most African parts of the West Indies ... [in a masquerade there was a] cloak with its glittering colors which seemed to dance on air, Gilliam's color, with its brilliance and many-faceted hues inescapably reminds one of the bright colors of African and Afro-American clothes and designs.[10]

Morrison also applied certain principles of the AfriCobra definition of 'black art' to Sam Gilliam's drape paintings:

Many African cultures relied especially heavily upon color to reveal aspects of spiritualness. There remains in Black people the capacity to find spiritualness in sheer bright color, as though they were fascinated with the potential of irrationality. Gilliam uses color in this way very well, because he understands color principles and he sees color not only as hue, but as substance, as material. Gilliam puts colors together not only according to their visual potential but also because of their physical structure. He has therefore expanded his vision of color to become at once a sensation and a material.

When William T. Williams (b. 1942) organized an exhibition of the works of Sam Gilliam, Melvin Edwards, Steve Kelsey and himself for the Studio Museum in Harlem ('X to the Fourth Power', 1969), he dared to represent black art as mainstream avant-garde and to break the mould of 'black art shows' by including one white American artist, Steve Kelsey. Williams believed the artist has to be outside of the community; the artist's 'function is to bring *to* the community the highest level of ideals and ideas'. He disagreed with those who felt that black artists should reflect upon the socio-economic plight of black Americans and try somehow with their art to provide solutions or

Elbert Jackson L. A. M. F. Part II, 1969.

Tension is created as each strip competes visually with others; yet each is loosely joined with the others in a whole. Individuality and collectivity may be under consideration. Williams was interested in pure formalism, i.e. reducing form to the most elemental shapes, geometric in nature and reminiscent of architecture. The science of colour also interested him.

socio-political comment. However, he felt that art in the community was laudable; consequently he started the artist-in-residence programme at the Studio Museum in Harlem and, for a brief period (1968–70), organized the Smokehouse painters (including Melvin Edwards) to paint abstract hard-edge murals on building exteriors in Harlem.

Williams became a major practitioner of hard-edge painting for about six years. *Elbert Jackson L. A. M. F. Part II* [105] is devoid of emotional content, exhibiting a cool reductive formalism, what David C. Driskell called a 'highly reasoned art, a symbol of the urban architectural scene'. It has a formal purity that emphasizes colour and the variations of pigments and surfaces under different lights. The sense of borders framing the central image or design is discarded. Instead, the alignment of shapes, repetitious use of pattern and diagonal lines convey the sense of looking at a portion of a larger schema of colour and line. Visual tension results.

Alvin D. Loving Jr (b. 1935) also embraced hard-edge painting. His early works were geometrically shaped canvasses, single or grouped:

cube, parallelogram, hexagon, or—in the work illustrated here—
Septehedron [**106**]. In these works the experience of painting was com-
plete in itself and not (as in Williams's paintings) the representation of
a segment of visual reality. Loving remarked that 'You didn't need sub-
ject matter—the paint itself was the subject matter.'

Soon after coming to New York City in 1968, Loving succeeded in
having a solo show at the Whitney Museum (1969), which he credits to
effective agitation on the part of artists' groups.

He was prolific, completing 120 works within two months, and
caught the approval of mainstream art critics and collectors. But he be-
came increasingly dissatisfied with his Minimalist hard-edge paint-
ings; they lacked, he felt, an expressive quality. In this state of
disenchantment and on the way to Detroit for a commission, Loving
stopped by the Whitney Museum and saw the exhibition 'Abstract
Design in American Quilts' (1971). It irrevocably changed him, stirring
up memories of his childhood and family, particularly his grand-
mother, a quilter: 'All of a sudden I understood these quilts and the
people who made them.'

At once he began to cut up 60 paintings into diamond shapes and
strips, learned how to use a sewing machine, stitched them together
and hung the work from the ceiling or wall. Painted fabric became
hand-dyed fabric pieces and, sewn together, looked like garments
made of African-American quilts. *Self-Portrait No. 23* [**107**] presents an
unexpected visual rhythm, reminiscent of bebop, jazz. The swathe of
hanging, hand dyed cloth strips, with stitches that criss-cross the sur-

106 Alvin D. Loving, Jr
Septehedron, 1970.

faces, and with space included as a part of the composition, represents a dramatic move away from the conventions of painting. Shocked, Loving's gallery cancelled his contract.

Robert L. Thompson (1937–66) experimented with bohemian life in Louisville, Kentucky, and then left for Provincetown, Massachusetts in the summer of 1958. He joined the 'new figuralist' painters, Jan Müller (1922–58), Lester Johnson (b. 1919), and Red Grooms, who are credited with introducing figures to abstraction to produce 'figurative expressionism'.

Almost a year later he arrived in New York City, where he had his first solo show. His interest in figurative expressionism was already apparent, with his schematic compositions including human figures set in brilliantly and intensely coloured landscapes. Thompson developed his personal symbols of sexuality and death from contemporary literature, music, and historical art masterpieces. He absorbed the visionary expressionist style of Jan Müller's works, German Expressionism, Paul Gauguin, and Abstract Expressionism. He wove figurative forms within flat, schematic and repetitious abstract designs, reducing each form to its simplest shape, and appropriated compositional elements and iconic motifs from masterpieces of Western art, some of which he observed during his trips to Europe (1961–3, 1966). *Blue Madonna* (1961) is based on early Sienese School Madonna altarpieces by Duccio, *Blue Caledonia Flight* (1963) upon Francisco Goya's *Los Caprichos* (1799). *Expulsion and Nativity* [**108**] incorporates figural

107 Alvin D. Loving, Jr

Self-Portrait No. 23, 1973. An alternative to unstretched canvas, Alvin D. Loving's fabric construction speaks of artisanship, 'women's art', African-American culture and personal history. The model for the quilts which had inspired Loving was West African narrow-strip weaving, and the compositions it creates.

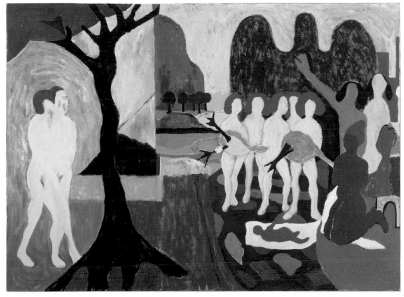

compositions from two Italian Renaissance painters. Religious symbolism becomes ominous allegory. Anxious moral and theological speculations on the nature and purpose of existence are strongly suggested in this and other paintings. Thompson's works can also be seen as tormented emotional portraits, revealing the demons of his own psyche. Yet such interpretations stress the elusive quality. Thompson is an enigmatic painter, who defies categorization.

Cultural critic Stanley Crouch has written of him:

The black identity in Thompson's world is part of a boiling gumbo. Heroes and demons, angels and villains, come from everywhere, and the victim reverses his role—usually in intimate situations—to become the monster or join the gargoyles. Adoration intertwines with cannibalism; love, narcissism, and dependency descend to a revolting and devouring gluttony. ...Thompson improvised the world he knew onto his canvases, creating a mulatto art rich with rowdy, seditious humor.[11]

In 1967 Raymond Saunders (b. 1934) considered his work was *not* 'black art'. Ensuing discussions about aesthetics and politics motivated him to publish a pamphlet titled *Black is a Color* (1967), in which he stressed individual expression:

some angry artists are using their arts as political tools, instead of vehicles of free expression, ...an artist who is always harping upon resistance, discrimination, opposition, besides being a drag, eventually plays right into the hands of the politicians he claims to despise—and is held there, unwittingly (and witlessly) reviving slavery in another form. For the artist this is aesthetic atrophy.

Certainly the american black artist is in a unique position to express certain aspects of the current american scene, both negative and positive, but if he restricts himself to these alone, he may risk becoming a mere cypher, a walking

protest, a politically prescribed stereotype, negating his own mystery, and allowing himself to be shuffled off into an arid overall mystique.

Racial hang-ups are extraneous to art. no artist can afford to let them obscure what runs through all art—the living root and the ever-growing aesthetic record of human spiritual and intellectual experience. can't we get clear of these degrading limitations, and recognize the wider reality of art, where color is the means and not the end?

Saunders established his professional career in the San Francisco Bay Area, California. Using his knowledge and love for visual illusionism, nineteenth-century landscapes and still-lifes, and Abstract Expressionism, he took a variety of images and textures from popular

109 Raymond Saunders
Marie's Bill, 1970.

culture and reassembled them as if anticipating that they would be re-examined, layer by layer, by an archaeologist. Mixed media paintings like *Marie's Bill* [**109**] are accumulations of fragmentary impressions, often tinged with whimsy or satire. Consequently Saunders's paintings function as a repository of memory; according to the artist, his 'objective is to convey what could be anybody's history, anybody's landscape or idea of consciousness'. The meaning of his paintings is deliberately elusive: fragments of images tease the viewer; threads of meaning keep his art from being dated. Saunders, by recreating graffiti on urban walls, disregards traditional ideas about 'good' or 'quality' art. The art of the city is an art of the street, and because his paintings appear like city walls, they represent the disasters of contemporary society: entrenched cultural, racial and political ghettoes.

Minnie Evans (1892–1987) was compelled to draw on Good Friday 1935; there was a spiritual admonition, her hand guided by an external force. Evans recounts the event: 'I had a dream, its voice spoke to me: "Why don't you draw or die?" "Is that it?," I said, "My, My."' For a brief period she made drawings, then stopped for about five years, and began making paintings (watercolours) in the early 1940s, eventually reaching artistic maturity in the 1960s. She was interested in unconventional images which developed from and reflected her visions. Her paintings are typically of gardens and omnipresent faces, usually women's, gazing unperturbed towards the viewer, painted in brilliant lush colours, as in *Untitled* [**110**]. A noticeable feminine presence pervades Evans's works, suggesting a sexuality, an eroticism in the allegorical and transformative forms of nature. Gardens become the place for personal mythology anchored in spiritual revelation, through dreaming. Jungian psychoanalytic theory provides a key to understanding her surreal images, her motifs and forms as representations of a personal and collective unconscious.

Modern and contemporary African-American folk artists are today's 'primitives'. For example, descriptions of Minnie Evans's work often claim that she had a 'child-like' vision and created images of 'primitive religious faith'. This suggests an assessment of her work as 'merely' idiosyncratic creative expression, not 'real art'—a commonly held view of folk art. In the 1980s, as cultural historian Eugene Metcalf recently noted, 'folk art fever [was used] as a dumping ground for unusual forms of expression that might challenge the artistic and social status quo'.[12] Many African-American artists have been misread in this way because their art is considered to differ from the standard, acceptable art of the mainstream and not because they meet the folk artist criteria: someone who is self-taught, unaware of other art, and who makes objects displaying a shared cultural life and community values.

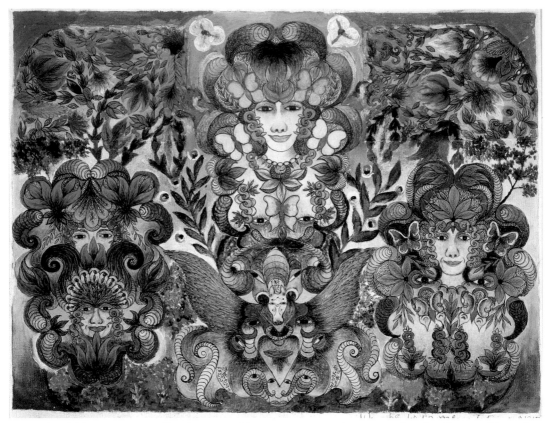

110 Minnie Evans

Untitled, 1945–67.

Nature is visionary; the compositional density and symmetry of foliage, flower, faces has been compared to the sacred diagrammatic Tantra paintings of Buddhism and Hinduism.

By the 1970s Evans was certainly aware of and influenced by other artworks, which she observed in the homes of collectors where she worked, and in museums. Yet her paintings remained full of visionary images of the kind encountered in folk art, covering the entire surface of the painting.

Late in her career, she was recognized by some art curators as an artist. The Whitney Museum of American Art held a solo exhibition of her work, the last of the 'projects' gallery exhibitions of black American artists in the summer of 1975.

The question 'folk artist or artist?' has been posed recently in assessing Minnie Evans and other 'folk' artists, and remains unresolved, because today distinctions between 'folk' and 'fine' are increasingly ignored, and her exhibition at the Whitney weighs in favour of her being considered an artist. Irrespective of categories of art, in Evans's paintings we find ourselves immersed within a beatific revelry that is hypnotic, seductive, and extraordinary.

Sculpture

African-American sculptors translated hard-edge, colour-field painting and minimalism into polychrome wood sculptures, as in Daniel LaRue Johnson's *Homage to René d'Harnoncourt* (1968), Frederick

Eversley's translucent geometric forms made from polymer resins or electric light sculptures in geometric shapes, diamonds, Xs as in Tom Lloyd's *Mousakoo* (1968). One African-American sculptor, Richard Hunt, exploits the dynamics of space and form, creating superb minimalist forms in iron and stainless steel.

Richard Hunt (b. 1935) studied at the School of the Art Institute of Chicago. In the Institute's exhibition, 'Sculpture of the 20th Century', he saw the linear welded iron sculptures of Julio Gonzalez, which turned him to sculpture. Hunt taught himself how to weld metal, and in 1955 exhibited in the Institute's 'Fifty-eighth Annnual Exhibition by Artists of Chicago and Vicinity', and two years later in 'Recent American Acquisitions' (1957) at the Museum of Modern Art, which purchased *Arachne* (1956). Hunt was the youngest African-American to exhibit there.

Hunt's works of the early 1960s complied with two mid-twentieth-century developments in sculpture: critical acceptance of 'junk' sculpture, and the craze for assemblage. He was interested in Surrealism's sculptural experiments, and reshaped what he called the 'metal garbage of the industrial age', such as car bumpers, into organic forms and extensions.

By the mid-1960s he had moved away from linear extensions and reliance on 'found' objects towards increasingly swelling forms, as in *The Chase* [111]. Abstract works derived from classical themes, such as the *Antique Study After Nike*, evolved into his characteristic style, which he termed 'hybrid-form'. 'In some works, it is my intention to develop the kind of forms nature might create, if only heat and steel were available to her.' Sculptures conceived in the most general terms are firmly grounded yet engage with surrounding spaces, giving an expressiveness to abstracted botanical–zoomorphic forms. In his series *Natural Forms* (1966–8), nature and artifice merge to create tectonic and organic forms, metal metamorphoses into sensuous and mobile configurations, natural or human. *Torso Hybrid* [112] recalls *Unique Forms of Continuity in Space* (1913) by the Italian Futurist sculptor, Umberto Boccioni, which in turn is based on classical Greco-Roman sculptures of Aphrodite or Venus. This reference to the history of sculptural idioms, while reinterpreting them in a way that reflects contemporary sensibilities, is modernist in its approach. Hunt wrote in 1966: 'Now sculpture can be its own subject, and its object can be to express itself, by allusion to its traditions, involvement with its new means, and interaction with its environment.' A year later he hints at a late modernist view in dismissing originality as a criterion for great art.

We should take advantage of the panoramic historical view our point in time allows [us] to see that no art or artist is all that different from any other. The

enlightened view will see the differences within the similarities. Furthermore, art does not succeed in time by being more personal, different, or even original than any other. It succeeds by remaining intact, and, while it may not look so different from other art of the period, or whatever else constitutes its environment, containing within its form ideas and associations, which can continue to stimulate people who view it.[13]

The postmodern condition 1980–93

In the past two decades, new theories and ideas about cultural production have emerged. Postmodernism, brainchild of French literary critics around the mid-1960s, has provided a new interpretive framework. The term suggests we are living in a period 'after' modernism. For America this period is generally understood to be from the end of the Cold War era, which was marked by its defeat in Vietnam in 1975. Modernism denotes cultures and societies associated with the industrial age and with colonialism (end of the nineteenth century up to *c.* 1965). Postmodernism is supposed to denote a more pluralist culture, a move from an industry-based to a computer-based economy. However, this idea is contested by some because colonialism is believed still to operate in many societies, meaning that we are not in a postmodern, but late modern period. Modern art of the previous 40 years, as defined by Clement Greenberg, who emphasized formalism (colour, space, etc.), abstract painting, and the idea of an avant-garde, was exhausted. Michael Fried (b. 1939)—a follower of Greenberg, also promoted a formally purist art in the 1960s and thereafter. Fried believed mixed-media art and artistic content were theatrical and not 'high' art. Both Fried and Greenberg viewed art as part of historical evolution, and not concurrent cultural developments. The privileging of the artist as the author of the work, and the view of art as reflecting the hegemony of Western civilization, became outmoded. But, after all is said,

111 Richard Hunt
The Chase, 1964.

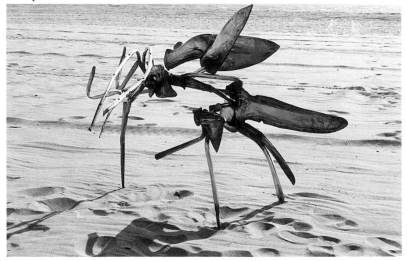

there is no single definition of postmodernism; its diverse theories and viewpoints constitute the postmodern perspective on culture and the arts.

Postmodernism has changed the way we understand art and how we define it. It is no longer the exclusive domain of art historians, curators and collectors. Now scholars from various disciplines, especially literary studies and including a new discipline called culture studies, are licensed to interpret the visual arts as cultural artefacts. Since the 1980s there have been more theories and critical studies published about art, including African-American art, than ever before.

Postmodernism is not about a new art form or movement, but new ways of thinking about and comprehending art production. It means a return to ways of interpreting art prior to the dominance of Greenberg's philosophies, i.e. prior to *c.* 1939. The meaning of art and its connection to social conditions often takes precedence over aesthetics and practice. In the 1980s content again became paramount. Figurative art, realism, narrative are no longer dismissed in art criticism and theory. Iconography and iconology, and the social history of art, all considered dated or conservative in the 1950s and 1960s, are again acceptable approaches to discussing contemporary art.

But postmodernism for some scholars is more than a return to 'the good old days'. It is more oppositional, questioning the power invested

in institutions, and the canonical traditions. For these scholars, such as Rosalind Krauss, postmodernism is about cultural politics. Their orientation falls into three broad categories. One questions the continuity and perseverance of Western culture, and instead focuses on analysis from the perspective of one's own particular social, historical, and political point of view (in other words not speaking *for* another). The second questions the idea of originality, which was central to modernism, and instead encourages appropriation, the practice of creating a new work by taking a pre-existing image from another context—art history, ads, media. Also the previously favoured dichotomies between avant-

Art styles and movements: Genre/performance

Postmodernism, a term used routinely by art critics in the late 1970s, is a collection of structuralist concepts associated with the analysis of opposite meanings and patterns formed by words and pictographs (signifiers). Postmodernism is also a collection of post-structuralist concepts which may mean a focus on difference, as in racial difference. A complex interrelation between object, art, and their meanings is conveyed. The artist becomes an author; the viewer becomes a reader of the artist's text. As in a novel, each reader can judge and interpret the text for him or herself. There is therefore no one primary meaning, but various meanings, each considered to be a valid interpretation. This form of appreciation reflects changes in the social and economic order in the West, encouraged by increased communication of the electronic age, globalization of economies, the 'americanization' of cultures, and computer technology. Despite whole economic and political infrastructures stressing homogeneity worldwide, people are reclaiming individual ethnicities and cultural legacies. These are a recognition of cultural pluralism.

There is no one art style. Postmodernism promotes popular culture, borrowing from other artists' compositions, that is 'appropriations', non-traditional media, non-Western forms and aesthetics, narrative, symbolism and metaphor. The old hierarchies of 'high' and 'low' art (folk or crafts), originality, and the portrayal of some greater truth is discarded. This, and the jettisoning of distinct theories based on disciplines like sociology, anthropology, and art, are considered the most distinctive elements of postmodernism. In the 1980s there was a heightened interest in 'referential' signs as a means to develop theories about history, originality and difference, an approach stimulated by the writings of Michel Foucault, Jean Baudrillard, Frederic Jameson, Rosalind Krauss and Edward Said.

Performance art is both high art and a form of popular culture, seen sometimes as an alternative to the work of art, and whose inspiration is derived from mass entertainment. Presented solo or as a collaborative, sometimes multi-media, performance, it was regularly seen in the late 1970s and during the 1980s in artists' spaces like Franklin Furnace and PS 122 in New York City. Performance art is never finite. It is always investigative, experimental, improvisational and metaphorical. Both ritual and narrative provide the format and the vehicle to convey meaning.

Performance art has been an integral part of the art scene since Allan Kaprow's 1959 'happenings' (environmental art work activated by performance and the viewers—popular in the early to mid-1960s), the Fluxus group, and dance events at Judson Church (NYC).

garde and kitsch, fine art and folk art, are considered irrelevant. The third category questions the assumption that modernism refers to a predominant culture, usually understood as Western, capitalist, white, middle-class, and male.

African-American artists used the three above-mentioned approaches, with particular attention to issues around the hegemony of Western culture. They exploit art's capacity to represent a set of ideas or an ideology about who they are. Art becomes a social and political text where the intellectual world is reduced to a series of referential signs, of competing narratives. Many African-American artists in the late 1980s and throughout the 1990s are interested in 'difference', and see art as a means to express their opposition to values and practices in Western culture which affect black peoples worldwide, those of the African diaspora. Some black American artists are also concerned about other 'people of colour' like the North American Indians, Asian Americans and Chicanos in the United States. Even though the new cultural theories of postmodernism are supposed to dismantle the privileging of a single viewpoint, and one from the dominant white culture, African-American artists believe that their work is misunderstood or understood in very simple terms. They frequently find that their race affects how their work is perceived (see comments by Martin Puryear, pp.250–2) which continued from the 1960s (see Benny Andrews, pp.191–3). There are artists, however, who continue to see art purely as an aesthetic and technical enterprise, but many are searching for ways to express their individual lives and genealogy of different cultures in order to enlarge the viewer's understanding of black people and what constitutes black art in the United States. The heated debates about 'black art' versus 'mainstream art' have dissipated.

Postmodernism encourages individuality, and African-American artists are revelling in it. It is not surprising, then, to see in the 1980s and 1990s that in order to ensure that the message is clear and unequivocal, artists are doing more video art (Adrian Piper, pp.247–9); room-installations to subvert the artificiality of the museum space (David Hammons's comments, p.263), performance art (Faith Ringgold, pp.242–5), and juxtaposing writing to the visual image (see Jean-Michel Basquiat, Howardena Pindell, Adrian Piper, Faith Ringgold, Lorna Simpson, and Pat Ward Williams, pp.238–66). Increasingly black American artists rely on a written narration and the associative power of words. Several artists draw upon African culture, as in the 1960s and 1970s, but in a more sophisticated and complex way because most have travelled and at least are well read in the area. This reliance on African culture, called Afrocentrism or Afrocentricity, imbues black art with non-Western symbolism and form (Alison Saar, Martha Jackson-Jarvis, and David Hammons, pp.253–7, 259–63).

Painting

Painting still dominated the artistic genres of the 1980s. Many African-American artists continued to paint in an Abstract Expressionist style; others in a expressive-figurative style. Several artists took on the style of 'Bad Painting' or Neo-Expressionism as a way of expressing their dissatisfaction with the high modernism of the East Coast which connotes pristine surfaces and carefully modelled forms. The emphasis was on content, not beauty or 'quality'. There were more mixed-media works, many breaking away from the traditional formats and installations (as, earlier, in works by Sam Gilliam), in which the distinction between painting and sculpture has become blurred. One of the most popular strategies used by painters in the 1980s was the appropriation of images from other artists' paintings (seen earlier in works by Robert Thompson). This 'borrowing' of other images, however, was more blatant than in the previous decades.

Robert Colescott (b. 1925), who began his career on the West Coast in the San Francisco Bay Area, turned the art community on its head when he painted *Eat dem Taters* (1975), parodying Vincent van Gogh's famous painting *The Potato Eaters* (*c*. 1855) and using it to comment satirically on race and class. From 1975 to 1980, with two exceptions in 1984, Colescott made what he calls 'subversive appropriations' of late nineteenth- and early twentieth-century masterpieces. He also used images from a wide range of sources: African art, advertising, cartoons. His paintings were satirical commentaries on race and discrimination and artistic hierarchies. *Les Demoiselles d'Alabama* (*des Nudas*) [113] duplicates Pablo Picasso's *Les Demoiselles d'Avignon* (1906–7). Picasso's figure with the blatant African mask-like face becomes the whitest figure in Colescott's painting. Colescott began appropriating the compositions of other artists made only 12 to 15 years earlier.

I think that the way I have appropriated paintings is subversive because my version puts into question the ownership of the idea. The fact that the original work can be redone questions its value. I think that if I make a painting that has such a strong quality of irony or 'sass,' if I push an idea so far that it's something that really sticks in people's minds, I've put a barrier between the viewer and the original work, because if people have seen my *Demoiselles*, they're going to think of mine [when they see Picasso's].

Quickly Colescott took on the grand tradition of history painting, the genre of eighteenth-century American and French artists like Benjamin West and Jacques-Louis David, who painted heroic historical episodes. Colescott draws upon the classical vocabulary of poses, gestures, and themes, using, like West and David, the large narrative format to convey a political message. But it is not necessarily a message we want to hear.

Some of my work talks about the meaning of history and points up a lack of objectivity in history or maybe the foolishness of even considering that capitalist, white American historians could in any way possibly be objective. The series of paintings called *Knowledge of the Past is the Key to the Future* is about that theme. I thought about what the teaching of history has meant, the holes that are in history, and how subjective history can be. The greatest lesson in history is that we don't learn from it.

In a series of large-scale canvasses, *Knowledge of the Past is the Key to the Future*, Colescott presents for our consideration the dilemma facing those who seek both access to American economic and political equality and the acknowledgment of the uniqueness of black American identity and heritage. In *Matthew Henson and the Quest for the North Pole* [**114**] Colescott corrects myth and revises American history to reflect the truth. Matthew A. Henson served for 17 years as navigator and chief assistant to Commander Robert E. Peary. On the 1909 expedition, when Peary fell ill, he pressed on and planted the American flag at the North Pole. Peary took full credit for the discovery. The drama of treachery, enslavement and betrayal is amplified by the metaphorical figures surrounding the 'portrait' heads of Peary and Henson. John the Baptist's head on Salome's platter is a metaphor for Peary's black

orderly, Henson. Colescott remarked that 'Racial identification has everything to do with politics and economics and where wealth and power are concentrated.' Henson lost his rightful place in history because of Peary's personal ambitions. The black and white couple represent the way in which the 'long continuing interdependence of the black and white races is generally overlooked in thinking about history or geography'.

Colescott's compositions have the fragmented appearance of collages, with seemingly disparate groups of distorted figures crowded together in a shallow pictorial space. His undulating brushstrokes of intense colour are Neo-Expressionist in idiom. His paintings are allegorical narratives: he sees painting not just as a pleasurable aesthetic enterprise but as a critical or pedagogical tool, a text which is discursive.

I think the artist's intent is what the painting is about. And what other people might think of it doesn't change that. What the artist intends *is* the meaning. I think that when someone's looking at one of my paintings, if they don't know who de Kooning is, or Captain Marvel, or Amos and Andy, or Jimmy Rushing, they're at a strong disadvantage in understanding the meaning, the irony and the aesthetics of it too ... [but my work] needs an environment of discussion and even controversy to bring out some of the meanings.

Art is a way to keep from getting damaged by the outside world. (David Hammons)

Jean-Michel Basquiat (1960–89) achieved artistic and critical acclaim in nine years. Born in New York, Basquiat was redefined as a postmodern 'primitive' partly because his parents were Haitian and Puerto Rican. Basquiat expressed his life within a multi-ethnic hip-hop culture, the culture of New York streets, with the sensibility of someone within the African diaspora. His artistic career began around 1977, with the spray-painting of witty philosophical poems on subway cars and walls, signing his name (tag) SAMO. He began painting on anything—boxes, doors, refrigerators—and 'hooked up' with graffiti artists in downtown New York City. He had his first solo show in Modena, Italy in 1981 and in the United States at Annina Nosei Gallery (New York City) in 1982. By the mid-1980s he belonged to a group of Neo-Expressionist artists who introduced a personal and subjective figurative imagery. Basquiat was a prolific painter. When he died he left an estimated 95 paintings and 900 works on paper.

Basquiat's mixed-media paintings went against the modernist aesthetic—quality, formal balance, purity in materials and technique. He took as his subjects art history, autobiography, black history, politics and popular culture. Within these are personal signs and symbols, words and phrases that initially seem nonsensical, yet together comprise a comment on contemporary urban cultures. The position of the

114 Robert Colescott

Matthew Henson and the Quest for the North Pole, 1986.

This painting, from the series *Knowledge of the Past is the Key to the Future*, represents what art curator Marcia Tucker, in 1978, termed 'bad painting'. She was referring to the artist's use of jagged and visible brushstrokes, strident unattractive colours and awkward figures. But these features had a deliberate purpose: to give expressionistic content to the work, to contemporize the artist's revisions of history, and prevent the viewer from becoming seduced by the technical skill of 'finished' painting.

black man worldwide was the dominant narrative of his paintings–constructions. Works completed between 1982 and 1985 are his most representative, for example, *Famous Moon King* [**115**]. The messy surfaces, a collage of found objects, paper, scrawled handwritten phrases, words and doodles, with abrupt minimal brushwork and strident colours, give a political sensibility to the work. Basquiat brought the streets to the pristine sanctums of art museums and galleries. Images of junk foods, cartoon characters, African-American historical figures like Marcus Garvey, Malcolm X, Joe Louis, and Langston Hughes, athletes, Hitler (called 'der Führer'), Spanish Conquistador Cortez, and Papa Doc Duvalier (Haiti's former president) mix with drawings copying the works of Manet, Rodin, Leonardo da Vinci, Picasso and Pollock, and illustrations from natural and medical science, history, literature, and comic books. Words were charged with meaning, revealing his concern about race, human rights, capitalism, environment. He clearly had an interest in African-American, African, Caribbean, Hispanic and pre-Columbian art, history, literature, politics.

Howardena Pindell (b. 1943) is committed to a discourse about discrimination and sexism, colonialism, and post-colonialism. She ad-

115 Jean-Michel Basquiat

Famous Moon King, 1984/85. Between the mid-1970s and mid-1980s graffiti moved from the streets into galleries and alternative exhibition spaces like Fashion Moda, New York. The *bricolage* of Basquiat's works represented metaphors, symbols and allegories of the black condition. As he said (*c.*1983): 'I'm not making paintings, I'm making tablets'.

dresses how Western societies have tried and still try to sustain their privileges as the paradigms of civilization, culture and intellectualism worldwide. After training in art at Yale, Pindell became politically committed in the 1960s and '70s, protesting against the Museum of Modern Art, and setting up a women's co-operative exhibition space in New York City—the AIR Gallery.

Her paintings of the 1970s were minimalist. Then came autobiographical works. In these Pindell focuses on the downside of her experience: abuse, racism, sexism, and class, but she also enlarges her pictorial text to include spiritualism, as well as her journeys toward self-discovery. Her video *Free, White and 21* (1980) marked the beginning of a paintings series titled *Autobiography*. Each painting has its own explanatory subtitle, which is key to understanding a particular subject. *Autobiography: AIR/CS560* (1988) is about international genocide, war, human rights violations; *Autobiography: Water/Ancestors/ Middle Passage/Family Ghosts* [**116**] depicts Pindell in silhouette, except that she has multiple arms like a Hindu deity. Centrally positioned, she literally commandeers the position of authority as the narrator of the written and visual text before us. The oval canvas displays family photos; photocopies of antebellum edicts governing slavery and the rights of slave-owners; a diagram of the hold of a slave ship; and printed texts which comprise an encyclopedia about genealogy, miscegenation, and African-American history. Strips of sewn canvas, which she calls weavings, allude to the narrow-strip weavings of West Africa, to women's handiwork, and, with the impasto of paint, create a corrugated surface that suggests physical and psychological wounds and healing. *Autobiography* is about power vested in racial and gender privilege.

Faith Ringgold moved away from her canvas paintings of the 1960s and began making soft sculptures and eventually her most distinctive work: story-quilts. She describes them as feminist art because they 'came out of being a woman, and the use of craft'. Influenced by cost considerations (quilts are less expensive to ship for exhibitions) and by her acquaintance with Tibetan *tankas* (sacred paintings on unframed fabric), Ringgold started making quilts featuring representational images, as in a canvas painting, framed by colourful decorative quilt borders. The borders were made by her mother, Wili Posey, from 1971 until her death in 1981. In 1977 Ringgold began writing her autobiography (*We Flew Over the Bridge: The Memoirs of Faith Ringgold*, 1995). She did not immediately find a publisher, so decided to write her stories on her quilts. For her the quilt, so intimately connected with women's lives, seemed the most effective vehicle for telling a woman's life story.

In 1982 she had her first solo exhibition at the Studio Museum. Preparing for this show, she experimented with different formats of

narration, the text sometimes taking precedence over the image. The narrators in all of her quilts are women. Consequently the merging of the heroine/narrator is a significant shift. Some are fictional, others biographical.

Ringgold tells her own story from a specifically female perspective in the language/voice of protagonist in *Change: Faith Ringgold's Over 100 lbs Weight Loss Performance Story Quilt* [**117**]. The theme deals with

116 Howardena Pindell
Autobiography: Water/Ancestors/Middle Passage/Family Ghosts, 1988.

the relationship of her independence to her sexuality. As Thalia Gouma-Peterson noted: 'The weight gain is part of that struggle and a response to the stress and pressures of conflicting demands and expectations. It becomes a protective shield in Ringgold's denial of her stereotyped image as a sex object (the Black temptress). Only after she has achieved her professional/artistic independence, in the 1980s, is she able to shed the shield.'[14]

Ringgold began doing performances associated with her artwork in 1973, sometimes before making the quilts. Performance art, which has developed substantially in the past two decades, provides a new context for creativity: conceptual in nature, the work is driven by the expression of ideas. It usually draws on the artists as source material and incorporates a range of media. Process, context and site are significant, as is the direct and unmediated interaction between the artist and the viewer.

One performance, *Change*, is an ongoing project. Thalia Gouma-Peterson provides a description:

During the performance Ringgold, dressed in a quilted jacket identical to the quilt, reenacts her 'Over 100 Pound Weight Loss' by reciting the text of the quilt. She emerges into the room dragging a big, black garbage bag (filled with two-litre plastic bottles of water) which looks like a human body and is equal in weight to the amount she lost, and which she is hardly able to move. At various point through the performance she returns to the bag and tries to move it, but to no avail. Both at the beginning and at the end, as Ringgold intones, 'I can do it. I can change, I can change. Now'. The audience is invited to join her in dance to the rhythms of 'Only the Strong Survive'. The finale is marked by the removal of the quilted jacket and Ringgold's emergence as she is now, as she has recreated herself as a Black activist, feminist, contemporary American artist whose art speaks with an authoritative female voice.

Combining this format with written narrative and images of women, Ringgold expands upon what it means to be a woman, and particularly an African-American woman. Men lose their central authoritative position.

Emma Amos (b. 1938), from Atlanta, spent some of her art training at the Central School of Art in London in the late 1950s, studying etching, painting, weaving and textile design. In 1960 she moved to New York where she was a weaver and textile designer for Dorothy Liebes for eight years. While studying for her master's degree at New York University, she met Hale A. Woodruff, a family acquaintance. She showed her prints to him and to members of Spiral, and was invited to become a member. Speaking about the significance of what she does, Amos has said: 'It's always been my contention that for me, a black woman artist, to walk into the studio is a political act.' In the 1980s she became involved with feminism, joining the Heresies Collective in 1984, and writing essays for their magazine, *Heresies*. Her paintings,

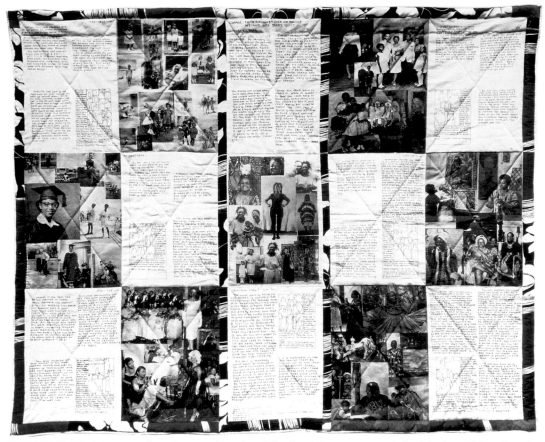

117 Faith Ringgold

Change: Faith Ringgold's Over 100 lbs Weight Loss Performance Story Quilt, 1986.

A pictorial transcription of her life over the past decade, which took Ringgold a year to complete, *Change* chronicles her struggle to be independent, from the 1930s onwards. In the text and photographic images we witness the progressive transformation from what she was expected to be to what she wanted to be and became.

therefore, reflect her life, feminism, race and the black middle class in the South.

As part of an exhibition called 'Changing the Subject' (1994) the mixed-media painting *Equals* [**118**] marks a step away from the personal autobiographical content of Amos's paintings of the previous decade. In this, as in other similar works by Amos, the viewer discovers a sequence of cultural, historical, and political references that ultimately centre upon race and gender. Certain features, such as unstretched canvas, West African cloth borders, and a human figure slipping or falling out of sight have been her artistic signatures since the 1980s. Now, as then, the background is abstract expressionist, with gestural notations of the brush and drips of paint, and the human figure is the pivotal subject. Always foreshortened and suspended in space, the falling figure is often, as here, Emma Amos herself. Another familiar technique is laser transfer photography, which allows her to exploit the tensions between photographic and painted illusion. Popular culture meets high art when mass-produced African cloth juxtaposes 'real' art—painting. The unstretched canvas with textile borders recalls quilts, again calling into question the division between fine art and craft.

118 Emma Amos
Equals, 1992.

The images and motifs provide symbolic and allegorical clues to the meaning of *Equals*. The falling figure is Amos, so the work is a psychological self-portrait that reveals her own phobias. Secondly, this image comments indirectly on the way that painting has historically displaced women as the authors of their own representation.[15] There is also an implied narrative about cultural boundaries and the displacement of African Americans. For example, the African fabrics represent the diaspora, the images of Malcolm X and the cut-fabric stars symbolize pan-Africanism, but with bits of stars snipped from the Confederate flag added. A figure adrift suggests an allegory of economic and social oppression; its tumbling conveys societal dislocation. The figure being Amos, the picture also conveys what it is like being black and a woman in that world. The title guides the viewer to an understanding of the visual text: 'Equals' connotes 'separate but …' or 'all men are created…'. As one looks upon the American flag, the irony of the gap between political ideology and social condition is strong. The

1930s photograph of a wagon in front of a shack directs our attention to her concerns about social and economic progress.

I look at that black man in his 70s, he would have been a slave; the separation from slavery and today reminds us it was not too long ago; and the young man if he is still alive would realize that this time equals that time [that the social and political conditions of blacks remain virtually unchanged]. What are the differences?

The question is clearly represented by the equals sign emblazoned on a pink (girls' colour) American flag that connects Amos to the photograph. *Equals*, like other similar paintings by Amos, represents shift and flux, spatially and temporally: a collapsing of history.

Adrian Piper (b. 1943) has used art over the last thirty years to literally write her autobiography while at the same time address her grave concerns about race and racism in the United States. A philosopher by training, she started her career in art working as an assistant to conceptual artist Sol LeWitt (b. 1928) in 1969. Her own conceptual artworks include *Talking to Myself: The Ongoing Autobiography of An Object* (1975), and, from the late 1970s, the series *Political Self-Portrait* (1978–80), in which a typescript narrative with headings: race, class and sex moves across a photograph of herself as a child. The script is a detailed analytical record of her own activities and surroundings, made to try to substantiate her own reality. Also in the 1970s, she gave a series of guerrilla street performances, often dressed as a black male, the purpose of which was to highlight opposing messages constructed in verbal and visual systems of language, pointing to the differences between appearances and reality, and black homophobia.

The *Vanilla Nightmare* series (1986–89) consists of drawings on pages from the *New York Times*. Articles about race, and racial strife, especially in South Africa, form a backdrop to nude figures, black and white, male and female, often in erotic and sensual, subjugated or confrontational poses that together compose a message about whites' phobias in respect of the black race and black America's understandings of those fears, manifested in apartheid and the history of miscegenation, and European colonialism. *Vanilla Nightmare no. 8* [**119**] is about language (written and visual) and meaning. The advertising text for a perfume, 'Eternity, a thousand and one journeys ... A mysterious encounter defying description, watch for the enchantress. Poison has arrived', highlighted against black figures, shows how important the visual aids are to our understanding of words, and how what we see affects our understanding of those images. In this work the black figures' blank eyes and fang-like teeth transform them into contemporary vampires or zombies and the white figure alters the meaning of words. Seduction has become ominous.

Video art

Video is a radical political art form, one which has developed rapidly in
the 1980s and continues to do so today. The heart of much of the video
art produced by women is a critique of the media representations of
women as the object of men's desires. In videos produced by artists who
are concerned about gender-roles, the role of the woman is reversed;
she is the subject. Women redefine representations and the image of

themselves and consequently empower themselves in relation to the media culture and culture in general. The fact that video art represents a private voice or vision means it is always in opposition to television, as a challenge to the status quo.

Video as a medium is accessible: tapes can be duplicated, and transported easily, making it possible to convey one message at multiple sites. In the United States (and other major industrial nations) virtually everyone can see the visual anywhere; no longer does the site of exhibition privilege certain people. A video can be shown in a small room, a classroom, in one's home, community centre, or the display window of a store or museum. *Cornered*, discussed below, has been displayed at the Museum of Contemporary Art, New York with screen and sound bringing the installation to people in the street. In this way video challenges not only the definition of what constitutes art but also where such art is seen. Mass media has infiltrated the hallowed spaces of the museum

Recently, Piper's interrogations of assumptions about race, gender and power have taken the form of room installations and video. Piper, more than any other African-American artist, exploits the video as an appropriate visual media. In *Cornered* [120] her image on the screen declares, 'I'm black. Now let's deal with this social fact and the fact of my stating it together.' Continuing in rhetorical style, she prompts the viewer to interrogate what it means to be 'black' rather than 'white' (Piper is very fair-coloured, often mistaken for white.) How does it affect her self-perception? It paints her into a corner where there isn't really very much room to manoeuvre linguistically or philosophically. She furthermore questions how the history of racism and miscegenation has affected our perception of ourselves and others. 'At what threshold do people perceive difference; where does physical or psychic space end and mine begin?' Piper asks the viewer to consider the substance of her propositions and polemics, written or spoken. She challenges us to engage in self-reflection about who we are, what we have become.

Because I believe we are all implicated in the problem of racism, my work addresses an audience that is diverse in ethnicity and gender. I am particularly interested in grappling with the 'who, me?' syndrome that infects the highly select and sophisticated audience that typically views my work. But the work functions differently depending on the composition of the audience. For a white viewer, it often has a didactic function. It communicates information and experiences that are new, or that challenge preconceptions about oneself and one's relation to blacks. For a black viewer, the work often has an affirmative or cathartic function: it expresses shared emotions or pride, rage, impatience, defiance, hope that remind us of the values and experiences we share in common. However, different individuals respond in different and unpredictable ways that cut across racial, ethnic, and gender boundaries.

Some people align themselves with the standpoint from which I offer the critique. Others identify themselves as the target of the critique. Yet others feel completely alienated by the whole enterprise. There is no way of telling in advance whether any particular individual is going to feel attacked by my work, or affirmed, or alienated by it. So people sometimes learn something about who they are by viewing my work. For me this is proof of success.[16]

Sculpture

In the 1970s and '80s more African Americans worked as sculptors than in the past. But no longer did artists have to respond to the assumptions set by a preceding style. They could self-consciously select or refer to art history and to the work of their contemporaries, and to one or several cultures. Forms and styles of their art elude categorization into simple 'isms'; no one medium dominates, as stainless steel and iron did for modern sculpture. Artists use a variety of media— rattan, woods, ceramics, glass. Their works incorporate the study of the classical art of Africa and refer to African-American cultural history.

Maren Hassinger's and Martin Puryear's sculptures are minimalist; Alison Saar's are figurative. Alison Saar, Houston Conwill and David Hammons often make sculptural environments in museums and galleries. Puryear, Hassinger, and Conwill are among those whose sculptural environments are often out-of-doors. Site-specific sculptures, introduced by the Minimalists, are dependent upon location, which is integral to form and meaning. The great number of sculptors prevents discussion of them all. Their distinction lies in the use of materials and assemblage, and the study of African and American cultures and improvisation.

Martin Puryear's (b. 1941) abstract minimalist sculptures represent a goal: 'I wanted purity and simplicity.' After completing his art degree Puryear travelled to Africa and Europe, where he independently studied various woodworking techniques: carpentry and sculpture in West

Africa (1964–6) and Sweden (1966–8).

Puryear's sculptures, free-standing or wall pieces, are a hybrid of his experiences abroad and at home. He acknowledges that 'the time in Sierra Leone and in Sweden have become the myth behind the work'. He produces monumental minimalist forms, geometric or organic. His manipulation of wood is extraordinary—compact forms, lattices, circular forms, or rings display his keen understanding of form, structure, and materials. At times forms extend into space; at other times they seem to fold inward or compress into simple masses. Works allude to human physicality or abodes: landscapes, animals or playthings, everyday objects and tools. In his more recent sculptures he fuses these allusions in one form. Meaning and significance are intentionally ambiguous.

I value the referential quality of work, the fact that it has the capacity to allude to things, but I don't want to have the work go back the other way, linking to some source from which I have carefully pruned the inessentials. I do not start with a particular thing and abstract from it. I have more a recombinant strategy. It's like combining from many sources into something that has clarity

121 Martin Puryear

Self, 1978.

It looks as though it might have been created by erosion, like a rock worn by sand and weather until the angles are all gone. *Self* is all curve except where it meets the floor at an abrupt angle. It is meant to be a visual notion of the self, rather than any particular self—the self as a secret entity, as a secret, hidden place. (Martin Puryear)

and unity. I like a flickering quality, when you can't say exactly what the reference is.

Puryear likes to emphasize the intrinsic quality of materials, as in the monolithic piece, *Self* [121]. This was completed in 1978, shortly before Puryear left the Washington, DC area, where he had lived for several years, for the East Coast. The suggestive anthropomorphic form alludes to male sexuality and for Puryear approaches iconic status as a representation. Its massive and heavy appearance suggests weight and solidity but this is an illusion. *Self* is actually built of thin layers of wood over a hollow core.

Puryear never imposes himself or his work on a site and visitors. His is a humanistic approach, inspired by the hope that the viewer will experience the site in a profound manner. *Bodark Arc* [122] is considered his most original and remarkable outdoor project so far. Situated in the grounds of an old farm, amidst fields, hedgerows, and ponds, it is demarcated by a semi-circular path carved from the grass, a low bridge over an existing pond, and a hedgerow of Osage orange trees. Beyond the path, the bridge, and the stand of trees, he added two objects to the site: a simple wooden gateway that stands near the point where the paths meet near the pond, and a cast of a small bronze chair which closely follows the form of a Liberian (West Africa) chief's chair.

Bodark Arc functions spatially in two ways: an aerial view gives a linear effect; the ground view gives a sequence of landscapes virtually free of manmade forms.

It seemed best to turn the whole thing inside out, and make the objectness of my work disappear. The site I landed on feels much more isolated than it really is; it's almost magical. It occurred to me that within its limited radius there was a whole range of the local ecology. I used a long arcing path to pull you through 180 degrees of very different landscape realms—a little swamp with cattails, a pond which you cross over on a narrow curving bridge, all beginning and ending in the arcade of tree branches beneath the hedgerow of Osage orange, or bodark trees, which is very secluded.[17]

About his work in general Puryear remarks that

there's a level that doesn't require knowledge, or immersion in, the aesthetic of a given time and place. I realize you can never totally escape this kind of thing, because art objects are linked to a given culture, but we can certainly experience a sensual pleasure in these objects.

He adamantly rejects a narrow interpretation of his work, especially in the context of race. However, art critics constantly revise their interpretation of his works, and thus reflect the social and cultural preoccupations of the times in which they write. During the early phase of his career, Puryear's works were looked at and critiqued as the work of an

122 Martin Puryear
Bodark Arc, 1982.
The title is a distortion of the French term *bois d'arc* (bow wood) which refers to the bows that North American Indians made from the wood of osage orange trees—seen here in the hedgerow. As a child Puryear used to make such bows, thus there is an autobiographical element in the project.

American artist of no matter what racial origin. Now writers want to discover the African-American ethos. Puryear reminisced of past times: 'And that was a wonderful honeymoon because the work didn't have to carry the incredible freight of race that it now is carrying, even though it's the same work. ... I prefer to respect my own complexity.'[18] It is this complexity which is the hallmark of a pluralist aesthetic.

Maren Hassinger (b. 1947) plays upon illusion and reality. By using metal wire ropes, which she discovered that she could weld, weave, and comfortably manipulate, Hassinger has recreated the natural world. Her outdoor site-specific installations, in which a series of bristling steel wire cables are regularly spaced apart, mimic the real landscape. Thus in *Weeds* [**123**], minimalist shimmering wires describe line as much as mass, and when inserted in the earth extend into space like a luxuriant field of algae swaying in ocean currents. Repetitious, rigid industrial forms create both artifice and a visual rhythm that is exuberant, what she terms 'kinetic'. The splayed edges of wire appear electrically charged, possessing a life of their own. Hassinger has reinstalled the same forms inside a gallery space, each time changing the physical boundaries, which in turn affect our perception of forms. 'I really feel that a lot of it has to do with not manipulating the material, but being "talked to" by the site. The site will tell me what I am supposed to do in terms of the vocabulary that I have with this particular material. That's how the pieces get made.' When Hassinger recaptured the essence of landscape in an urban space, she evoked a nostalgic response to the

123 Maren Hassinger
Weeds, 1986.

past, a pre-industrial age, as she also called our attention to disappearing farmlands (the agricultural roots of many black Americans), and the vulnerability of the natural environment in the presence of humankind.

Martha Jackson-Jarvis (b. 1952) has made a series of ceramic assemblages titled *Last Rites* (1992–3; a large scale installation, which are sculptures about cultural pluralism, gender, autobiography, and especially the natural environment. Far Eastern meditativeness intersects with African and Native American ritual in a room installation where seven coffin-shaped tables which she calls *Sarcophagi*, each supported by ornamental iron legs, are placed against the wall and upon floor reliefs of scattered ceramic fragments. The overall message pertains to health, nature, and the interrelationship between humankind and earth, as each piece is titled after a specific subject: plants, earth, air, water, healing, and blood. In *Sarcophagus IV: Water* [**124**] tesserae of glass, ceramic, stone, copper, slate, and pigmented cement create the effect of a sea bed upon which we see heaps of fish, mostly carp and fossilized marine invertebrates. Appearing as both feasting tables and altars, they evoke the allegory about ritual and sacrifice, time and death.

She further elaborated on her concern about ecology, health, and spirituality:

In the face of world issues about racism, sexism, ecological destruction, home

lessness, economic and spiritual deprivation, war and possible planetary anni-
hilation, contemporary artistic discourse has landed squarely on the spiritual
in art. Using many cultures as resources from which to cull images and sym-
bols, artists seek to evoke ancient knowledge and visions of man's primal
strengths and fears. It is imperative to empower symbols and rituals through
belief. Devoid of this potent human element of belief, symbols and ritual re-
main forever impotent lines and marks spent in useless and powerless decora-
tive frill and performance linked only to flamboyant and arrogant gestures.

Clay provides a means for Jackson-Jarvis to retrieve and sustain
memories about herself, and African-American culture, particularly
matriarchy. She remembered as a child observing her grandmother
taking broken plates and bits of pottery to the grave sites of relatives in

North Carolina, a practice of grave decoration originally brought over from West and Central Africa. Jackson-Jarvis's memories and technique, creating clay-*bricolage* pieces, ensure a legacy of African-American women as the purveyors of black cultural values. She also views improvization as spiritual (she often refers to the Chinese *I Ching*—Book of Changes—or West African divination), her process of making art as ritual, and her clay sculptures as conscious representions of the women in her family and the African diaspora.

Beginning in the 1980s, site-specific installations (also called art environments) became an increasingly popular process and art form among African-American artists. With installations an artist can extend the visual engagement to convey meanings and explore aesthetic ideas with the onlooker. The viewer is immersed within the work. Always recreated when the site changes, the work of art is never the same, always changing, which allows an artist to delete or incorporate new elements to reflect a historical moment, however transient, and artistic development. This impermanence, derived from the modernist philosophy of Dadaist and of African ritual art practices (the latter familiar to this generation of African-American artists, who study and travel to Africa), is essentially late modernist and postmodernist. Betye Saar's remarks about her installations resonate for the work of other artists.

The installation evolves as a ritual. A formula develops; the procedure of gathering materials/objects; altering them; placement and presentation. Installations are autobiographical as I am participating yet I am elsewhere.

In the sculptures of Alison Saar (b. 1956) spirituality and politics meet and reinforce each other. Saar's career as a sculptor was inspired first of all by her mother, Betye Saar, with whom she visited Simon Rodia's *Watts Tower*; by encouragement from her father, Richard Saar, a conservator who taught her about materials and techniques, and by her study of African, Latin American, and Caribbean art and religion. These influences, along with her formal studies in art history and studio art, have given her an inventive and multicultural approach to materials and image-making that produces works that appear unselfconscious, almost folk-like. Maturing in the 1980s, Saar made individual free-standing and wall-relief sculptures based on the extraordinary and ordinary denizens of the streets—the homeless, hustlers, social and cultural stereotypes, often societal discards found in Los Angeles, Mexico City, or New York City.

After leaving Los Angeles permanently for New York City, she embarked on room installations which focused on a particular theme. Invariably they revolved around the spiritualism of Africa and the African diaspora, shamans from the urban margins. In *Zombies, Totems, Rootmen, and Others* [125], Saar creates a ritual space filled with

125 Alison Saar

Zombies, Totems, Rootmen and Others, 1988.

The large female figure of Love Potion no. 9 replicates Kongo (Central Africa) fetishes.

125 Alison Saar

Zombies, Totems, Rootmen and Others, 1988.

The large female figure of Love Potion no. 9 replicates Kongo (Central Africa) fetishes.

126 Alison Saar

Dying Slave, 1989.

This figure copies the figure (of the same title) made by Michelangelo in 1534 for Pope Julius II's tomb.

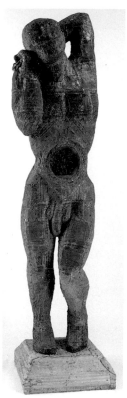

'power' objects and images—jujus, totems, gateways, wall altars, and figures; it is an environment of potions, belief, spiritual power and love and sexuality. In *Love Potion no. 9* the roughly hewn wood surface and ceiling-tin plated body of the large standing female figure, with rigidly awkward stance, allude to 'primitivist' formalism, an African or folk aesthetic of combining different materials with woodcarvings, which Western modernist artists defined as *bricolage*, an anti-aesthetic. The female reveals a wrapped nail-embedded object popularly called a fetish, in the cavity of her chest like an African power figure of the Kongo people (Central Africa). African-American folklore and belief about potions made from special roots to ensure success in gambling or love (ads for which are still seen in African-American newspapers) is reiterated in another figurative work, *Conkerin' John*, a male figure whose legs transform into gnarled roots. Both *Conkerin' John* and *Love Potion no. 9* not only refer to African culture, but also to African-American popular culture, especially to the blues and blues singers like 'High John the Conqueror' or 'Johnny the Conqueroo', and rhythm and blues song of the 1950s, e.g. 'Love Potion Number Nine'.

Black folk culture, the Americas, Africa, and Western art Saar considers rightfully hers to appropriate. In *Dying Slave* [**126**] African art and African-American folk art cloak the idealized human form copied from Michelangelo's *Dying Slave*. This Italian Renaissance masterpiece was based on Classical Greco-Roman sculpture, and stood for ideal beauty, whose sensuality is heightened by the smooth surfaces and languid contours. Saar has abruptly transformed a serene form into a tense one. The dying slave conveys anguish rather than a relinquishing to death sensed in Michelangelo's image. The mirror cavity directly copies the Kongo power figures—wood statuary in which the ab-

127 Houston Conwill

The New Cakewalk, 1988–9. The revised cosmogram, below (from 'The Cakewalk Humanifesto', 1989) shows three concentric circles. In it are five cities: New Orleans, Atlanta, Louisville, Memphis, and Tuscambia representing music, leadership, art, justice, and empowerment respectively. The ceiling scrim shows the same cities bisected by a horizontal line titled 'King' and a vertical one titled 'Malcolm'. The 'light books' at the back of the installation are made of 39 sandblasted glass blocks and 9 mirrors.

domen cavity contains a magical packet, making the figure spiritually powerful and providing protection for, or giving power to, the object's owner. The ceiling tin suggests scars, and ruptures of the skin, and the lack of detail carved on the face suggests racial invisibility or representation for a group of people. Saar's slave could be African, African-American, or Afro-Caribbean. The expressionism of the *Dying Slave* conveys a message often seen in Alison Saar's sculptures: we can transcend earthly matters despite physical and psychological scars caused by cultural disruption or societal displacement.

African and African-American culture are fundamental to the work of Houston Conwill (b. 1947). He focuses on the concepts of life, culture and community, and the need for a spiritual continuum to validate human experience. Conwill's brief tenure at a Catholic Benedictine monastery, from 1963 to 1966, deeply affected his outlook. He has merged the ritual and ceremony of Catholicism with that of Africa in *The New Cakewalk* [127]. 'Cakewalk' denotes slave dances performed for the amusement of slave masters, who awarded cakes to competing dancers. The choreography of the dance followed indigenous African rituals that survived in the Americas (see Ben Sullivan's description on p.00). This eighteenth-century dance, performed also by free blacks, parodied the genteel dances of Europeans and European Americans, and embodied blacks' mockery and subversion of whites' culture. Ironically, whites adopted the cakewalk and it became part of the repertory of minstrel shows (popular musicals performed in 'black face' by white and black Americans) in the nineteenth century. For Conwill the dance reflects 'its sacred roots as a ritual of jubilant release, yet also embodies the spirit of survival'.

The New Cakewalk consist of three elements: a ceiling scrim, a wall containing glass blocks, nine mirrors, and a glass 'dance' floor. The wall contains 48 niches which hold glass blocks called 'light books' on

128 David Hammons
Untitled, *Flight Fantasy*, and *Lady with Bones*, 1990.
'Those [hair pieces] were all about making sure that the black viewer had a reflection of himself in the work.' (David Hammons).

which are engraved quotations about the nature of laughter, mostly taken from the works of African-Americans authors, allowing Conwill to incorporate language into art. The ceiling scrim of the map of the United States marks the site and plan represented on the floor. Sacred places and modern African-American society are inseparable. New Orleans, Atlanta, Louisville and Memphis are the four 'cardinal' Southern cities, each located on a river, as auspicious cultural, historical, and biographical sites. Ritual is art in the form of a 'cosmogram' etched in the glass dance floor. The cosmogram reveals references to the circular labyrinth of Chartres Cathedral (France), ritual dance circles where in Africa such dances are performed counter-clockwise, the ritualistic ground drawings found in the South, Caribbean and Brazil, and the quartered circle of the Kongo (Central Africa) cosmogram. There are symbols and pictographs that further expand on an elaborate text, one transcendental, the other cerebral. Mapping a journey in time and space, it is a circle of life, birth to life to death and rebirth. Focusing on the ground as a stage for his art, Conwill is interested in 'the notion of ritual ground as a sort of process of empowering and re-empowering cultural memory and of coming to grips with a sense of one's heritage and one's self'. The entire installation is what he describes as a 'dwelling place for reflection: to dwell for me signifies the way we are on the earth'. He fuses the old world (Africa) with the new world (Americas): Africa and the diaspora. *The New Cakewalk* is a metaphysical treatise.

David Hammons continues to ignore the boundaries of what is or is not art. Approximately a year after his arrival in New York in 1974, he created another unique abstract work. After seeing a work of African sculpture with hair attached, Hammons decided to use hair as a medium. He believes hair has cultural and spiritual connotations, and he likes its texture, so for the next few years he collected hair discarded from barber shops, and made hair sculptures, and Plexiglas mixed-media works, such as the *Dreadlock* series (1976) and *Nap Tapestry* (1978).

 Untitled, Flight Fantasy, and *Lady with Bones* [128] are re-creations of previous installations including *Greasy Bags and Barbecue Bones* first shown in 1975 at Just Above Midtown Gallery. The materials are brown paper shopping bags, human hair, barbecue bones and grease, wire, and other 'found' objects. Hair, according to Hammons, is the essential sign of 'blackness'. Barbecue and greasy foods, closely aligned with black people, become cultural tokens. He sees this work having a particular meaning for African Americans, which may elude a white audience, because it is not relevant to white culture or may be easily dismissed because it confirms popular assumptions about black people. Hammons states it this way:

Old dirty bags, grease, bones, hair ... it's about us, it's about me ... it isn't neg-
ative ... we should look at these images and see how positive they are, how
strong, how powerful ... our hair is positive, it's powerful, look what it can do.
There's nothing negative about our images, it all depends on who is seeing it
and we've been depending on someone else's sight ... We need to look again
and decide.[19]

By using found objects, human detritus (hair) and animal bones,
Hammons interjects his opposition to what constitutes art and forces
us to re-examine assumptions about aesthetics and cultures. Creativity
is more directly conveyed, through manual manipulation of materials.
His formal process excludes use of sophisticated tools. His is an art not
reliant on money for its manufacture; recycled materials are not rare,
special or costly. It is not marketable. Hammons rejects conventional
forms and processes. The bags absorb grease the same way as an un-
primed canvas absorbs oil paints; Hammons's bags are paintings. Hair
on thin wires creates minimalist sculptures. His anti-mainstream art
stance is about who determines art and where it should be seen; he
claims for himself the right to determine for himself what is art and
what has meaning for black people. At the same time he strives to cir-
cumvent power accrued through ownership (of art).

Hammons is a consummate *bricolage* artist: his art is conceptually
sophisticated yet, aesthetically, disarmingly simple. He collects, recy-
cles discarded materials, the detritus of urban black communities, and
transforms them into aesthetic statements about black culture and
contemporary society. Hammons plays on words, uses irony and hu-
mour (he acknowledges the influence of Colescott's work) as a disguise
for works which hold a more serious meaning. For example, *Higher
Goals* (1986) at Cadman Plaza Park, Brooklyn, are telephone poles cov-
ered with bottle-caps, shaped and arranged like basketball hoops.
They constitute a metaphor of achievement, reminding the viewer of
one of the few means by which black males can achieve professional
and economic success.

Untitled (Night Train) [**129**], shown at Exit Art (New York City) in
1989, included piano tops, an electric blue painted train, actual train
tie-rods, wine bottles, coal, and a 'boom' box (portable cassette-tape
player playing jazz). The site-installation was an excellent example of
how Hammons exploits objects' ability to denote culture, and by impli-
cation represent economic and political narratives about American,
particularly urban, societies. *Night Train* pays homage to the African-
American communities that were always on 'the other side of the
tracks'. The train had the same meaning as it did for Romare Bearden,
between 1913 and 1945 taking thousands of African Americans north-
ward from the South. The installation is also a tribute to jazz and jazz
musicians. The painted blue train becomes the Blues Train, as it

129 David Hammons

Untitled (Night Train), 1989.
'Night Train' is a brand of
cheap wine, marketed to
the black communities.
An allusion is being made
to this aspect of life in these
communities, alongside the
references to jazz and to
African culture.

weaves its way through the gallery amid the piano tops erected like ste-
lae. The word 'train' denotes jazz saxophonist, John Coltrane, his com-
position 'Blue Train'; pop icon James Brown's song and performance,
which mimicked the train moving along the tracks, as he screamed out
'Night Train', and, finally, novelist Albert Murray's *Train Whistle
Guitar* (1974), titled after the train sounds imitated on the blues guitar.
There is a disturbing reference to social blight and economic exploita-
tion: the sculpture-wheels were made from empty bottles of 'Night
Train'. Finding these dark green bottles in the streets, Hammons, the
scavenger-artist, began in 1987 to use them in his art. He saw them, like
the hair, as special spiritual objects, for, as he recounted; 'there is a lot
of spirit caught up in these bottles, every one has had a black man's lips
on it'. He admits that his study of African art, and the writings of art
historian Robert Farris Thompson, who seeks evidences of the Africa
cultural practices in the Americas, have helped form the philosophical
underpinnings of this, and other, works. The overarching theme is
freedom and escape, for during the period of slavery the Underground
Railroad was often called the 'freedom train'.

Hammons excels in site-specific installations, preferring outdoor
sites (e.g. vacant lots) and public commissions but also exhibiting occa-

sionally in galleries and museums.

It's hard dealing with a white cube. I don't see the importance of interacting with it. To me its like playing Carnegie Hall or Lincoln Center. White walls are out of context. They don't give me any information. Its not the way my culture perceives the world. Its for mad people, you put in the hospital.

Art should be accessible on the street, so that it 'becomes just one of the objects that's in the path of your everyday existence'. Ultimately, Hammons wants to make sure the black viewer has a reflection of him/herself in the work.

Photography

For most of the twentieth century photography has been considered a medium that threatens the integrity of painting. In the process of making photography 'art', art photographers and critics strove to sustain the medium's special qualities against the rapidly increasing production of snaps and the easy availability of photographs in non-artistic media, such as magazines and newspapers. Art photographers were concerned about how they could retain originality, the aesthetic of flatness and significant form as a modern art medium.

As a reaction against the pure formalism of photography fostered during the first half of the twentieth century, advocates of postmodern theory revived the photographic image as having a wealth of symbols about culture and society; and a strong narrative component. Also, they called into question the objectivity of photojournalism. In the 1970s and 1980s more photographers began to use techniques once labelled trick photography (solarization, manipulation of both negative and print, re-photography, etc.) to expand photographic images and subjects and effects to include dreams and visions; to exploit the illusions of photography.

Pat Ward Williams (b. 1948) appropriates photographs from mass media and popular magazines and combines them with 'found' objects. Dissatisfied with the limitations of a solitary photograph, Williams began using multiple images, often inserted in a discarded window-frame, thereby creating a visual polyptych, multiple views, capturing space and time. With a written narrative text, she provided a personal response to the image, focusing on history, race, memory and family. In around the 1970s, when Williams saw photographer Roy DeCarava's *Sweet Flypaper of Life* (1949) photographs, she decided on photography as her medium, and when she became aware of Diego Rivera's works, she discovered that 'art can be a powerful weapon in the larger struggle against oppression'. Both influences led her to realize that the political could be infused in art photography; and that by combining photographs with written text, her work func-

tions both as art and document.

Within four years Williams produced one of the most scathing political photographic images of the 1980s, entitled *Accused/Blowtorch/Padlock* [**130**]. It is a response to the many, exact renderings of African Americans that have depicted them as exotic, violent, or victimized. She found that the exotic/violent/victimized myth was viewed as the real depiction of African Americans, and anything outside that form was considered false. Williams takes a *Life* magazine photograph with the caption 'Accused in 1937 of murdering a white Mississippi man, this black man was tortured with a blowtorch and then lynched', which shows a man chained and padlocked to a tree, alone in a setting of grass and bushes. The image, taken from a book titled *The Best of Life Magazine*, is mounted in the first pane of a weathered window-frame and a detail is seen in subsequent panels, as if the viewer had a zoom-lens camera. The title is stencilled across the entire set of images. Handwritten sentences mark the photographer's presence, providing a narrative on black tarpaper which surrounds the image. The tone is of anguish and anger: 'There's something going on here. I didn't see it at first ... Can you be BLACK and look at this without fear? WHO took this photograph?' The narrative ends with 'Oh God, somebody do something.' But each time the work is exhibited she changes the text slightly.

Being interviewed in 1990, Williams identified a type of photographic genre called the 'trophy photograph' (reminiscent of hunting or war photographs). Such 'honorific' journalistic images of lynched black men, often showing a crowd or party of witnesses, were frequently seen in popular magazines and newspapers during the first half of the century.

I think that very often we look at a photograph like this and it is meant to stand for all the lynchings that have happened over the history of black people in this country. And we don't really look at these photographs any more, we don't really critically think about what this photograph means, or when it was taken, or who it is of.

The written text of *Accused/Blowtorch/Padlock* reflects Williams's reaction to the realization that the man is not yet dead—at least not yet lynched:

The writing on the wall is immediate. I didn't even know what the text was going to be until I was confronted with this black space on the gallery wall ... [and] that *Life* magazine, unwittingly, we hope unwittingly, published it, which more or less distributed this terroristic threat even more; ... who was this person who took this photograph ... these are things that I really want people to think about when they look at this photograph, instead of just consuming it, and saying, 'Well, this is racial violence, oh, isn't that too bad.'[20]

There's SOMETHING going on here. I didn't understand it right away. I just saw that he looked so HELPLESS. He didn't look tortured, he didn't look lynched. WHAT is that? How long has he been LOCKED to that tree? Can you be black and look at this without fear? Life mag. WHO took this picture? Couldn't he just as easily let the man go? Did he take his camera home and bring back a BLOWTORCH? And where do you torture someone with a Blowtorch BURN off an ear. Melt an eye a screaming mouth Oh God WHO took this picture. HOW can this photograph EXIST? somebody Life answers — Page 141 — no credit do something

published this photo. Could Hitler show pics of the Holocaust to keep the JEWS in line?

130 Pat Ward Williams

Accused/Blowtorch/Padlock, 1986.

I used a combination of dominant and subordinate pictures. I force the viewer to look at what is really going on by dissecting the important body of information and by directing with text what the viewer should notice: the tied hands (accused), the scarred back (blowtorch), and the lock, chain and tree (padlock). (Pat Ward Williams)

Williams continues her critiques about public media and its role as censor and author of the 'truth' as in later installation, *Move* (1988). She also makes three-dimensional memorials, photo-sculptures, as in *Thirty-Two Hours in a Box and Still Counting* (1987), which recreated the actual scale of the box in which Henry 'Box' Brown escaped from slavery by travelling in it for more than 32 hours.

Williams takes a critical approach to both viewing imagery and making imagery. Photography is more than form; it is about meaning.

Lorna Simpson (b. 1960), the first African-American woman to have a solo show at the Museum of Modern Art, began her career as a photo-journalist. Quickly she moved to photography as an artistic enterprise, exploring as a result of her earlier career the power of image and words: how one informs or misinforms the other. A word or words on labels juxtapose one or several photographs of an individual, usually a woman, each with her (or his) back facing the viewer. Simpson prevents us from doing the obvious: intuiting the meaning of the subject based on appearances, and seeing the face which permits us to scrutinize and classify based on our individual experiences. On such occasions, the viewer then assumes a very subjective understanding of the photographed person. Simpson reverses the expected sitter's position and inflects on presumptions about the object of the viewer's gaze. Clothes, often a simple cloth garment, act like a shield, further preventing us from quickly synthesizing visible 'signs' from the human photographed subject.

The inadequacies of the visual and written language as tools for

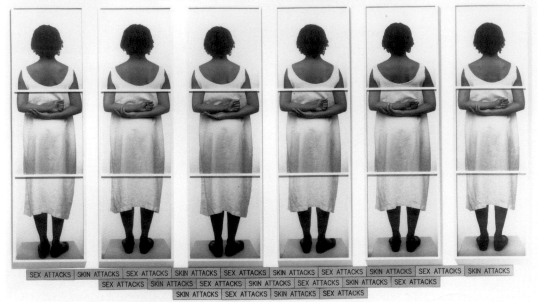

GUARDED CONDITIONS

SEX ATTACKS | SKIN ATTACKS | SEX ATTACKS | SKIN ATTACKS | SEX ATTACKS | SKIN ATTACKS | SEX ATTACKS | SKIN ATTACKS | SEX ATTACKS | SKIN ATTACKS
SEX ATTACKS | SKIN ATTACKS | SEX ATTACKS | SKIN ATTACKS | SEX ATTACKS | SKIN ATTACKS | SEX ATTACKS
SKIN ATTACKS | SEX ATTACKS | SKIN ATTACKS | SEX ATTACKS

131 Lorna Simpson
Guarded Conditions, 1989.

acquiring knowledge are evident in *Guarded Conditions* [**131**]. She explores photography's social function and political implications: how racial and sexual identity is shaped. *Guarded Conditions* is about power, the power of the gaze in the act of looking, the position of the onlooker and the cultural implications of that role and position. In light of recent feminist theory about power and sexuality, such placement of women as the object of the male gaze is construed as sexual commodification, possession and control, and, if that female is black, about colonialism. Simpson leaves the reconstruction of meaning to the viewer; leaves the viewer responsible to tease out the relationships between artist, him or herself (viewer) and the subject photographed.

Christian Walker (b. 1954) photographs the human body in intimate spaces. *Miscegenation* series [**132**] consists of 15 sepia-tone, formal photographs. Individual photographs frame close-up shots of white and black human nude bodies. Collectively they create a splintered collage of images which allow the viewer to interject his or her narrative instead of trying to understand the artist's story. Neither narrative is resolved. Individually each image evokes a landscape, the rich tonality and surface, created by dry pigments rubbed into the surface and finally varnished, enhances the sensuousness of the image. The images belie a tension suggested in the elements of the human body: hands, bent knees. As a group, the figures whose genders are not always identifiable compose a metaphor of complicit alliance, lovemaking, or illicit alliances, about miscegenation. Age-old issues about race, gender and

sexuality are camouflaged in the visual trappings of art, the monochromatic tonality and texture of the forms.

Dawoud Bey (b. 1953) represents a generation of African-American photographers who photograph the vulnerable but tough urban youth whose fashion and bodies reflect their personal power and spaces. Bey photographs portraits of young African-American, Latino/Hispanic and, recently, Asian-American men, many belonging to marginalized youth culture, yet who at the same time are the sources for popular culture's trends and mark 'hip-ness'. We see a youth convey his or her individuality while defiantly and proudly expressing group identity.

After seeing the Metropolitan Museum exhibition 'Harlem on My Mind', which, as he said, 'contradicted everything I had been taught to believe Harlem was', Bey embarked on a career as a photographer. 'It is important, if a photograph is to succeed', he stated, 'that it cease to be merely a record of a person, place or thing. It must transcend that. To be a photographer one must be in love with life.' In *Brian and Paul* [133] Bey created a diptych using Polaroid's large (20 × 24 in; 51 × 61 cm), camera that produces a 22 × 30 in (56 × 76 cm) image. Familiar with the Polaroid camera which he began using around 1988, he easily transposed his skills to this larger camera in 1991. These latest urban portraits are formalized in the tradition of studio photography but devoid of the props which provide clues for our understanding of the person. Partly as a result of the process, which can take up to four hours, a rapport between photographer and sitter is established, an intimacy immediately apparent in the image. As a result, the viewer sees them as Bey came to know them through his photographic lens. He asks that we see them on their own terms: 'My interest in young people has to do with the fact that they are the arbiters of style in the community; their appearance speaks most strongly of how a community of people defines themselves at a particular historical moment.'

Yet by using such a large-size format, Bey gives his subjects heroic proportions, and they acquire an importance analogous to that conferred in the past by history paintings. In *Brian and Paul* the black and white sitters are as clearly differentiated as their seated positions. On the right Paul coolly appraises the viewer, while Brian contemplates something unseen. These two gazes split the composition. Thus our ability to understand their personality or their relationship with us or with each other is complicated by their positions to each other and towards us. There is an energy, and a suggestion of impending movement that makes this diptych disquieting, and visually riveting.

Conclusion

Modernism positioned painting as the dominant medium, and one which strove for aesthetic purity without reference to culture, repre-

sentation, or symbolism. Art achieves formalist purity as part of a historical process. Critics and art historians, in determining what is or isn't art, invariably cite the modernist coda, especially regarding African-American art, that art should be 'above' race and, by association, politics. In the 1960s, the art by African Americans was accepted as 'art' when its styles and techniques accorded with the aesthetics of modernism. One of the odd facets of the controversy about 'black art' and 'mainstream art' is that it reactivated what was previously considered a dead issue—conflict over purely abstract as opposed to representational art. The representational image was invariably associated with social realism of the 1930s and early 1940s, and African-American artists who considered themselves social artists, that is artists concerned with meanings that referred to who they were politically and culturally, were not considered to be making 'good' art. This issue fuelled the heated exchanges printed in the *New York Times* in 1970 and 1971 between Hilton Kramer, an art critic who understood social art as social realism, and who in 1974 wrote 'painting is no longer expected to traffic in narrative themes', and Edmund Barry Gaither (art historian) and Benny Andrews (artist), who understood social art as that made by an artist committed to figuration yet who is not monolithically a social realist. Gaither in particular 'saw cultural decay when art is segregated into the category of non-essential objects existing only for esthetic or monetary purposes'. The 'high' art of Kramer was based on the ideas of Clement Greenberg and later of Michael Fried on modern art.

Throughout the 1940s, and especially in the '50s and '60s, a great many African-American artists were making representational art that emphasized narrative content, often using figurative images. Some (e.g. Bob Thompson) were appropriating canonical art forms; others (such as Romare Bearden) were using popular media images. None the less, the majority of African-American artists, especially those who fell into the 'black art' camp, were not considered avant-garde or on the 'cutting edge' of modern art. Ironically, when critics and mainstream artists focused their attention again on representation, symbolism, and connotation—called forms of referentiality in the 1970s and '80s—African-American art gained a foothold in the art world.

Postmodernism has benefited the careers of African-American artists, leading to more professional black artists than before, and increasing their critical recognition. In a special effort to be inclusive, white art critics and scholars have studied black American art as never before. Consequently, artists' monographs, thematic black art publications, essays and reviews in cultural journals like *Third Text*, and art magazines like *Artforum* and *Artnews*, and popular magazines like *Time*, *Essence*, and *Elle* have increased the marketability of contemporary black American art. Beginning in the 1980s, there has been a considerable increase in the number of solo exhibitions and mixed-cultural

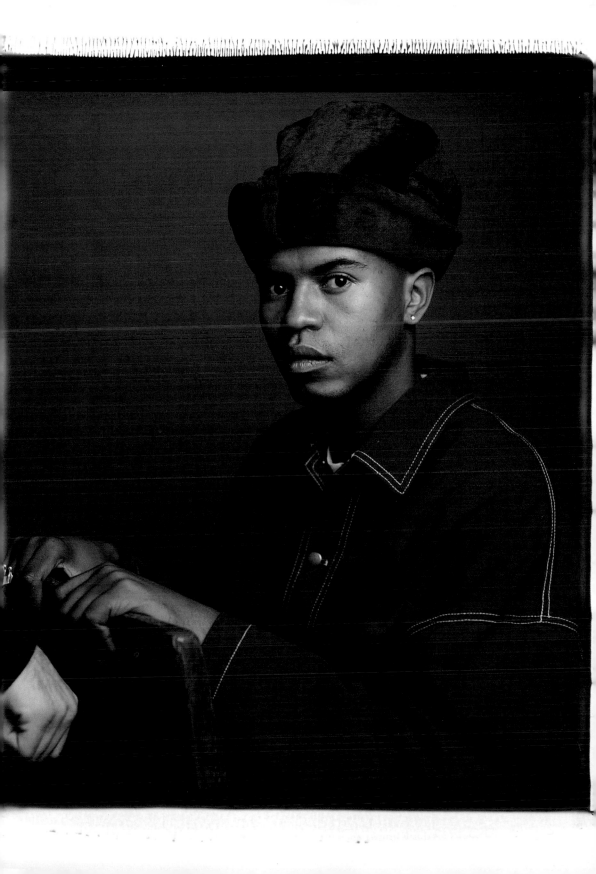

representations in group exhibitions, initiated by alternative museums and exhibition spaces and soon followed by mainstream galleries and museums. These efforts have brought African-American artists to the attention of collectors and the general public.

Art institutions have also played a role in fostering artists' careers. There are more African-American curators, many of whom received their first training at black institutions like the Studio Museum in Harlem and have moved on to mainstream museums. African-American museums and galleries like Kenkeleba, the California Afro-American Museum, the DuSable Museum, Anacostia Museum, and countless commercial art galleries, have been instrumental in indentifying and promoting aspiring artists who have since been main-streamed into the art world. Mainstream art museums and galleries reflect the new scholarship that calls for cultural pluralism in the arts, as attested by, for example, the past few Whitney Museum Biennials. That there is no one art style privileged over another (although there are vogue art styles) fosters a kind of curatorial and critical fluidity that eludes categorization. In other words, critical accountability has been diminished.

Various forms of art previously considered to be 'low', such as quilts, ceramics, and popular culture have entered the domain of 'art' history and criticism. African-American artists have empowered themselves by speaking for themselves. Contrary to the popular image of the artists who assert that the art speaks for itself, African-American artists have proved otherwise. Now, more than ever, they want their voices heard, their statements recorded or documented—often through the medium of their art. Theirs is an intervenient strategy that co-opts the authoritative voice of the art critic and art historian. The previously overt racial imagery and content of art has become subtle, and many of the younger generation of African-American artists, living in the global age, see cultural, social and political connections with other peoples of the African diaspora, and people of colour every-where. Africanity, also called Afrocentricity, denotes a reclamation of African culture which has become very popular among the younger generation of African-American artists who are well read in African art and culture, have travelled and lived in Africa, and, in some in-stances, intentionally sustain fragments of African cultural practice that they have observed among their older relatives. Africa is no longer seen as bright colours and geometric masks and elongated figures, as it was from the 1920s to the 1970s. Postmodernist artists have pried opened African-American cultural identities in ways that yield myriad perspectives about race, class and gender. The monolithic 'black' of the 1960s and '70s has served its political function as a pan-African tool, engendering and reflecting the optimism and confidence of that pe-riod. But 'black' of the 1980s and '90s is not an identity but identi*ties*, a

closer approximation to the real world, in which cultural survival in-
volves not only acclaiming difference but also recognizing differences
within it.

Notes

Chapter 1. Colonial America and the Young Republic 1700–1820

1. Gary B. Nash, *Red, White, and Black: The Peoples of Early America* (Englewood, NJ, 1974), 163–4.
2. D. W. Meinig, *The Shaping of America: A Geographical Perspective on 500 Years of History*, 2 vols (New Haven, CT, 1986), i. 188–9.
3. Georgia Writers' Project, *Drums and Shadows* (Athens, GA, 1940), 180.
4. Frederick Law Olmsted, *Journey in the Seaboard Slave States in the Years 1853–1854* (New York, 1856; reprinted New York, 1968), 633. Some scholars believe the mansion was built by Louis' son, Jean-Baptiste Louis (d. 1838).
5. Harold Edwin Dickson (ed.), 'Observations on American Art: Selections from the Writings of John Neal (1793–1876)', *Pennsylvania State College Bulletin*, 37 (5 February 1943), 42, cited in Lynda Roscoe Hartigan, *Sharing Traditions: Five Black Artists in Nineteenth-Century America* (Washington, DC, 1985), 39.

Chapter 2. Nineteenth-Century America, The Civil War and Reconstruction

1. Georgia Writers' Project, *Drums and Shadows* (Athens, GA, 1940), 179.
2. John Vlach, *The Afro-American Tradition in Decorative Arts* (Cleveland, OH, 1978), 82.
3. Ernest Ingersoll, 'Notes and Queries: Decoration of Negro Graves', *Journal of American Folklore*, 5 (1892), 68–9.
4. H. Carrington Bolton, 'Decoration of Graves of Negroes in South Carolina', *Journal of American Folklore*, 4 (1891), 214.
5. *Gleason's Pictorial* (April 1854), 208. Cited in *The Black photographer: An American View* (Chicago, 1985).
6. Angelina E. Grimké, *Appeal to the Christian Women of the South* (New York, 1836), 32–3. Cited in Jean Fagan Yellin, *Women and Sisters: The Anti-Slavery Feminists in American Culture* (New York, 1989), 3.

7. *The Art Journal* (1 March 1866), 93. Cited in Norman E. Pendergraft, 'Robert S. Duncanson: A British-American Connection', in *Duncanson: A British-American Connection* (Durham, NC, 1984), 13.
8. Kenkeleba House, *Edward Mitchell Bannister* (New York, 1992), 33–4.
9. Kirsten Buick, 'The Ideal Works of Edmonia Lewis', *American Art*, 9/2 (1995), 7–8.
10. Henry Ossawa Tanner, 'An Artist's Autobiography', *The Advance* (20 March 1913), 2012–14. Cited in Dewey F. Mosby, *Across Continents and Cultures: The Art and Life of Henry Ossawa Tanner* (Kansas City, 1995), 44.
11. Henry H. Mitchell, *Black Preaching* (Philadelphia, 1970), 70–2.
12. Alain Locke (ed.), *The New Negro* (New York, 1925; reissued New York, 1968), 265–6.

Chapter 3. Twentieth-Century America and Modern Art 1900–60

1. W. E. B. DuBois, *The Souls of Black Folk* (Chicago, 1903), 17.
2. Eugene W. Metcalf, 'Black Art, Folk Art, and Social Control', *Winterthur Portfolio*, 18/4 (1983), 275.
3. Brendon Gill, 'On Astor Row', *The New Yorker* (2 November 1992), 52.
4. Archibald J. Motley, Jr, 'The Negro in Art', private collection of Archie Motley. Jontyle T. Robinson and Wendy Greenhouse, *The Art of Archibald J. Motley, Jr* (Chicago, 1991), 15.
5. 'Albert Murry: An Interview with Hale A. Woodruff', in *Hale A. Woodruff: 50 Years of His Art* (New York, 1979), 77–8.
6. *Sargent Johnson: Retrospective* (Oakland, CA, 1971), 17–18.
7. Judith Stein, *I Tell My Heart: The Art of Horace Pippin* (Philadelphia, 1993), 29–30.
8. Barbara Rose, *American Painting: The Twentieth Century* (New York, 1986), 42.
9. Aaron Douglas, 'The Negro in American Culture'. Cited in Matthew Baigell and Julia Wilson (eds), *Artists Against War and Fascism:*

Papers of the First American Artists' Congress (New Brunswick, NJ, 1986), 83.

10. W. E. B. DuBois, 'The Negro Mind Reaches Out', in Alain Locke (ed.), *The New Negro* (New York, 1968), 386, 406–8.

11. 'Harlem Artists Guild and the Harlem Community Art Center', in Leo Hamalian and James V. Hatch (eds), *Artist and Influence 1987* (New York, 1987), 42.

12. Charles White made drawings for commercial papers like the *Daily Worker, Freedom*, and the *New Masses*, the journal for the John Reed Club of New York, a writers' organization with a socialist agenda. Romare Bearden and Charles Alston drew political images, editorial drawings, for the African-American press. Bearden drew editorial 'cartoons' for the *Baltimore Afro-American* between 1931 to 1935 which focused on racism, labour and totalitarianism.

13. Clement Greenberg, 'Towards a Newer Laocoön', *Partisan Review*, 7/4 (1940), 296–310.

14. Kirk Varnedoe, 'Abstract Expressionism', in William Rubin (ed.), *'Primitivism' in 20th Century Art* (New York, 1984), ii. 624.

15. Harold Rosenberg, 'The American Action Painters', *Art News*, 51 (December 1952), 22.

16. Lewis interviewed by Charles Wendal Childs. Cited in Romare Bearden and Harry Henderson, *A History of African-American Artists* (New York, 1993), 324.

17. Ann Gibson, 'Recasting the Canon: Norman Lewis and Jackson Pollock', *Artforum*, 30 (1992), 66–72.

18. Vincent Smith, 'The Painter Looks Back', *National Scene*, Supplement, 11/10 (1980), 12.

19. Henry Miller, *The Amazing and Invariable Beauford Delaney* (New York, 1941; reissued 1978), 4.

20. Imamu Amiri Baraka, *The Autobiography of Leroi Jones/Amiri Baraka* (New York, 1984), 127.

Chapter 4. Twentieth-Century America: The Evolution of a Black Aesthetic

1. Ralph Ellison, 'Introduction' to *Romare Bearden: Paintings and Projections* (Albany, NY, 1968).

2. Benny Andrews, 'On Understanding Black Art', *New York Times* (21 June 1970), 22.

3. Donald Kuspit, 'The Collages of Benny Andrews', in *The Collages of Benny Andrews* (New York, 1988), 12–19.

4. The full text of Edmund Barry Gaither's introduction (p.4) is as follows:
Black art is a didactic art form arising from a strong nationalistic base and characterized by its commitment to a) use the past and its heroes to inspire heroic and revolutionary ideals, b) use recent political and social events to teach recognition, control and extermination of the 'enemy' and c) to project the future which the nation can anticipate after the struggle is won. In his visual language the black artist is basically a realist. Black art is a social art and it must be communicative. … Neo-Africanists do not attempt to copy or translate African art, they attempt to fathom its aesthetic, to get at its essence. The ideas thus extracted from African art are used to create art forms reminiscent of African art but at the same time peculiarly modern. Such works may seem superficially based on the shaped-canvas idea, but they are in fact resonant with deeper meaning. The viewer of Neo-African work will be struck by the African qualities of the work which account for its consistency as a group. Neo-Africanists share with black artists proper a nationalist basis and, like black artists, they are associated with a syndrome of essentially nationalistic political views.

5. The full quote:
Black art must use its own color black to create its own light, since that color is the most immediate black truth. Generally, black art must not depend on light or light contrasts in order to express its blackness, neither in principle or fact. All 'black' artists are aware of this blackness I speak of, and with more black, black art to attest to it, white artists will also know what blackness and black truth is about.
Lucy R. Lippard, 'Beyond the Pale: Ringgold's Black Light Series', in *Faith Ringgold: Twenty Years in Painting, Sculpture, and Performance (1963–1983)* (New York, 1974), 22.

6. *Betye Saar* (Los Angeles, 1984), 11.

7. Françoise Nora-Cachin, 'Dialogue: Another Country', in *Chase-Riboud* (Paris, 1973).

8. Addison Gayle Jr (ed.), 'Introduction' to *The Black Aesthetic* (New York, 1971), xxiii–xxiv.

9. Larry Neal, 'The Social Background of the Black Arts Movement', *The Black Scholar*, 18/1 (1987), 14.

10. Keith Morrison, 'The Emerging Importance of Black Art in America', *The New Art Examiner*, 7/9 (1980), 4. The full text is as follows:
When I first saw Gilliam's drapes, I was reminded of childhood in the most African parts of the West Indies, where one was traumatized by the cat-like macabre gesture of the witchdoctor, who made no sound. You never actually saw him. He was always

somehow hidden beneath a cloak, many times larger than life. You saw only the giant spectre of the cloak with its glittering colors which seemed to dance on air, though you were also never sure you saw it move. Gilliam's color, with its brilliance and many-faceted hues inescapably reminds one of the bright colors of African and Afro-American clothes and designs.

11. Stanley Crouch, *Notes of a Hanging Judge* (New York, 1990), 186–7.

12. Eugene Metcalf, 'Black Art, Folk Art, and Social Control', *Winterthur Portfolio*, 18/4 (1983), 287.

13. 'Statements by Richard Hunt', in *The Sculpture of Richard Hunt* (New York, 1971), 15.

14. Thalia Gouma-Peterson, 'Faith Ringgold's Narrative Quilts', *Arts Magazine*, 61/5 (January 1987), 69.

15. John Roberts, *Postmodernism, Politics and Art* (Manchester, 1990), 4.

16. Adrian Piper, quoted in *Adrian Piper and Carl Pope* (Indianapolis, 1992), 6.

17. Neal Benezra, *Martin Puryear* (New York, 1991), 39.

18. Alan G. Artner, 'On Form and Function: The Finely Sculpted Thoughts of Martin Puryear', *Chicago Tribune* (3 November 1991), section 13, 12.

19. Linda Goode-Bryant and Marcia Phillips, *Contextures* (New York, 1978), cited in Leslie King-Hammond and Lowery Sims, *Art as a Verb* (Baltimore, 1988), 2.

20. Jeanne Dunning (ed.), *Affirmative Actions: Recognizing a Cross-Cultural Practice in Contemporary Art* (Chicago, 1990), 45.

List of Illustrations

The publisher would like to thank the following individuals and institutions who have kindly given permission to reproduce the illustrations listed below.

1. African House, c.1798–1800, and Metoyer Mansion, c.1830, Melrose Plantation. Photos © Richard K. Dozier.
2. Pieced quilt, late 18th century. The Valentine Museum, Richmond, VA.
3. Slave drum, c.1645. H. 45.7 cm. Museum of Mankind. Copyright The British Museum, London.
4. Wrought-iron figure, Alexandria, VA, late 18th century. H. 27.9 cm. Collection of Adele Ernest, Stony Point, New York. Smithsonian Institution, Washington, DC.
5. Colonoware jug, Combahee River, Bluff Plantation, Colleton County, SC, 1670–1825. Low-fired, handbuilt earthenware. H. 26 × D. 25.5 cm. Courtesy of the South Carolina Institute of Archaeology and Anthropology, University of South Carolina, Columbia.
6. Thomas Gross Jr: Chest on chest, 1805–10. Mahogany, poplar, pine. 208.2 × 109.8 × 56.2 cm. Philadelphia Museum of Art, Gift of Mrs Leslie Legum.
7. Peter Bentzon: Footed cup, c.1820. Silver. H. 17.1 cm. Philadelphia Museum of Art, Purchased with the Thomas Skelton Harrison Fund and partial gift of Wynard Wilkinson/photo Graydon Wood.
8. Scipio Moorhead: *Portrait of Phillis Wheatley* from her *Poems on Various Subjects, Religous and Moral* (London and Boston, 1773). Engraving. Library of Congress, Washington, DC.
9. Joshua Johnston: *Westwood Children*, c.1807. Oil on canvas. 104.5 × 117 cm. © Board of Trustees, National Gallery of Art, Washington, DC. Gift of Edgar William and Bernice Chrysler Garbisch.
10. Joshua Johnston: *Portrait of a Gentleman*, 1805–10. Oil on canvas. 71.1 × 55.9 cm.

Reproduced by permission of the American Museum in Britain, Bath ©.
11. Jean-Louis Dolliole: Creole cottage, Pauger Street, New Orleans, 1820. Photograph.
12. Facades (and a cross-section) of shotgun houses, New Orleans, mid-19th century. Facades: photo © Richard K. Dozier; Cross-section: from John Michael Vlach, 'Shotgun Houses', *Natural History* 86 (1977).
13. Tahro: Slave house, Edgefield District, SC, c.1890. Front and side views from *American Anthropologist* X (1908). By permission of the Syndics of Cambridge University Library.
14. Peter Lee (attrib.): Cellarette, John Collin's Rodney Plantation, Marengo County, AL, c.1850. Photo courtesy of The Marengo County Historical Society, Inc., Demopolis, AL.
15. Thomas Day: Secretary, c.1840. Center for African American Decorative Arts, Atlanta, GA.
16. Dutreuil Barjon: Sleigh bed, c.1835. Mahogany. 190.5 × 76.2 cm. Center for African American Decorative Arts, Atlanta, GA.
17. Anon.: Clockwork Figure, St John Parish, LA, c.1833. Cast lead. On loan to the Louisiana State Museum, New Orleans.
18. Henry Gudgell: Walking-stick with figural relief, Livingston County, MO, c.1863. Wood. H. 92.7 cm. Yale University Art Gallery, Director's Fund, New Haven, CT.
19. Dave the Potter: Storage Jar ('Great and Noble Jar'), 13 May 1859. Stoneware, ash glaze. H. 65.4 cm, circumference 206.4 cm. Courtesy of the Charleston Museum, Charleston, SC.
20. Anon.: Afro-Carolinian face vessel, Edgefield District, SC, c.1860. Stoneware, kaolin, ash glaze. H. 13.3 cm. Museum of American History (Division of Social History), Smithsonian Institution, Washington, DC.
21. Aunt Ellen and Aunt Margaret: Silk quilt, Logan county, KY, 1837–50. 224 × 221.2 cm.

The Metropolitan Museum of Art, Gift of Roger Morton and Dr Paul C. Morton, 1962.

22. Harriet Powers: Bible quilt, 1886. Pieced and appliquéd. 187.3 × 224.8 cm. Museum of American History (Division of Social History), Smithsonian Institution, Washington, DC.

23. Harriet Powers: Bible quilt, *c.*1898. Pieced, appliquéd, and printed cotton embroidered with plain and metallic yarns. 175 × 267 cm. Courtesy Museum of Fine Arts, Boston, MA. Bequest of Maxim Karolik.

24. Anon.: *James P. Ball's Great Daguerrean Gallery of the West, c.*1854. Engraving. Cincinnati Historical Society (B-87-290).

25. Robert S. Duncanson: *Uncle Tom and Little Eva*, 1853. Oil on canvas. 69.2 × 97.2 cm. Photograph © 1997 The Detroit Institute of Arts, Gift of Mrs Jefferson Butler and Miss Grace Conover.

26. William Hackwood: *Am I not a Man and a Brother?*, 1787. Black on yellow jasper. Diameter 3.3 cm. By Courtesy of the Trustees of the Wedgwood Museum, Barlaston, Stoke-on-Trent, England.

27. Patrick H. Reason: *Am I not a Man and a Brother?, c.*1839. Engraving. 5.2 × 4 cm. Collection of the Moorland-Spingarn Center, Howard University, Washington, DC.

28. Patrick H. Reason: *Portrait of Henry Bibb*, 1848. Copper engraving. Photographs and Prints Division, The Schomburg Center for Research in Black Culture, The New York Public Library, Astor, Lenox and Tilden Foundations.

29. Jules Lion: *View of Chartres Street, New Orleans*, 1842. Lithograph. Louisiana State Museum, New Orleans.

30. Robert S. Duncanson: Landscape Murals (1850–2) in the entrance hall of Nicholas Longworth's Belmont Mansion. Oil on plaster. 276.2 × 222.9 cm. The Taft Museum, Cincinnati, OH. Bequest of Charles Phelps and Anna Sinton Taft.

31. Robert S. Duncanson: *Blue Hole, Flood Waters, Little Miami River*, 1851. Oil on canvas. 74.3 × 107.3 cm. Cincinnati Art Museum, Gift of Norbert Heerman and Arthur Helbig (acc. no. 1926.18)/photo Ron Forth, 1977.

32. Robert S. Duncanson: *Land of the Lotus Eaters*, 1861. Oil on canvas. 134 × 225 cm. Collection of His Majesty, the King of Sweden © The Royal Collections/photo Alexis Daflos.

33. Grafton Tyler Brown: *Grand Canyon of the Yellowstone from Hayden Point*, 1891. Oil on canvas. 70 × 40.6 cm. Collection of the Oakland Museum of California, Oakland Museum Founders' Fund.

34. Edward Mitchell Bannister: *Newspaper Boy*, 1869. Oil on canvas. 76.5 × 63.5 cm. National Museum of American Art, Washington, DC/Art Resource, New York.

35. Edward Mitchell Bannister: *Approaching Storm*, 1886. Oil on canvas. 102.2 × 152.4 cm. National Museum of American Art, Washington, DC/Art Resource, New York.

36. Edward Mitchell Bannister: *Haygatherers*, *c.*1893. Oil on canvas. 45.7 × 61 cm. Reproduced by kind permission of Dr Nicholas P. Bruno/photo Roger King Gallery of Fine Art, Newport, RI.

37. Eugene Warburg: *Portrait of Young John Mason*, 1855. Marble. H. 58.4 cm. The Virginia Historical Society, Richmond, VA.

38. Edmonia Lewis: *Forever Free*, 1867. Marble. 102.9 × 27.9 × 43.2 cm. The Howard University Gallery of Art, Washington, DC.

39. Edmonia Lewis: *Death of Cleopatra*, 1876. Marble. 160 × 79.4 × 116.8 cm. National Museum of American Art, Washington, DC/Art Resource, New York.

40. Henry Ossawa Tanner: *Banjo Lesson*, 1893. Oil on canvas. 124.5 × 90.2 cm. Hampton University Museum, Hampton, VA.

41. Henry Ossawa Tanner: *Resurrection of Lazarus*, 1896. Oil on canvas. 95 × 121.5 cm. Musée d'Orsay, Paris © Photo RMN-Arnaudet.

42. Henry Ossawa Tanner: *Annunciation*, 1898. Oil on canvas. 144.8 × 181.6 cm. Philadelphia Museum of Art. The W. P. Wilstach Collection.

43. Meta Warrick Fuller: *Ethiopia Awakening*, 1914. Plaster. 170.2 × 40.6 × 50.1 cm. Art and Artifacts Division, The Schomburg Center for Research in Black Culture, The New York Public Library, Astor, Lenox and Tilden Foundations.

44. James Van Der Zee: *Couple with a Cadillac*, 1932. Photograph © by Donna Van Der Zee.

45. Aaron Douglas; *Rebirth*, 1927, from *The New Negro* (© Charles Boni, New York, 1925), ed. Alain Locke. Reprinted with the permission of Scribner, an imprint of Simon & Schuster.

46. Aaron Douglas: *Crucifixion*, 1927. Oil on board. 121.9 × 91.4 cm. Private Collection.

47. Palmer Hayden: *Fétiche et Fleurs*, 1926. Oil on canvas. 58.4 × 71.1 cm. The Museum of African American Art, Los Angeles, CA. Courtesy the Estate of Miriam Hayden.

48. Archibald J. Motley, Jr: *Mending Socks*, 1924. Oil on canvas. 111.4 × 101.6 cm. Ackland Art Museum, The University of North Carolina at Chapel Hill, Burton Everett Collection. Courtesy Archie Motley.

49. Archibald J. Motley, Jr: *The Octoroon Girl*,

1925. Oil on canvas. 101.6 × 76.2 cm. Courtesy Caroll Greene and Archie Motley.

50. Archibald J. Motley, Jr: *The Old Snuff Dipper*, 1928. Oil on canvas. 56.5 × 41.6 cm. Dusable Museum of African American History, Chicago, IL. Courtesy Archie Motley.

51. Hale A. Woodruff: *The Card Players*, 1930. Oil on canvas. 91.4 × 106.7 cm. Photo courtesy of the National Archives of American Art, Washington, DC.

52. Augusta Savage: *Gamin*, 1930. Bronze. 40.6 × 46.4 × 15.2 cm. Art and Artifacts Division, The Schomburg Center for Research in Black Culture, The New York Public Library, Astor, Lenox and Tilden Foundations.

53. Augusta Savage: *The Harp*, 1939. Plaster with black paint finish. Photograph by Carl van Vechten. Courtesy of the Beinecke Rare Book and Manuscript Library, Yale University, and Joseph Soloman, Executor of the Estate of Carl van Vechten.

54. Richmond Barthé: *Fera Benga*, 1935. Bronze. H. 49.5 cm. Gift of Mr and Mrs Charles W. Engelhard. The Newark Museum, New Jersey/Art Resource, New York.

55. Sargent Claude Johnson: *Forever Free*, 1935. Lacquered cloth over polychromed wood. 91.5 × 29.2 × 24.2 cm. San Francisco Museum of Modern Art. Gift of Mrs E. D. Lederman.

56 William Edmondson: *Eve, c.1932* Limestone. 81.3 × 29.8 × 17.1 cm. Gift of Mrs Alfred Starr Collection. Cheekwood Museum of Art, Nashville, TN.

57. Horace Pippin: *John Brown Going to his Hanging*, 1942. Oil on canvas. 61.3 × 76.8 cm. Courtesy of the Museum of American Art of the Pennsylvania Academy of the Fine Arts, Philadelphia, John Lambert Fund (acc. no. 1943.11).

58. Palmer Hayden: *Midsummer Night in Harlem*, 1938. Oil on canvas. Museum of African American Art, Los Angeles, CA. Courtesy the Estate of Miriam Hayden.

59. Palmer Hayden: *Nous Quatre à Paris*, 1935. Watercolour on paper. 55.6 × 45.7 cm. The Metropolitan Museum of Art. Purchase Joseph A. Hazen Foundation, Inc. Gift, 1975 (acc. no. 1975.125). Courtesy the Estate of Miriam Hayden.

60. Archibald J. Motley, Jr: *Saturday Night*, 1935. Oil on canvas. 81.3 × 101.6 cm. The Howard University Gallery of Art, Washington, DC. Courtesy Archie Motley.

61. Aaron Douglas: *Aspects of Negro Life: The Negro in an African Setting*, 1934. Oil on canvas. 182.9 × 199.4 cm. Art and Artifacts

Division, Schomburg Center for Research in Black Culture, The New York Public Library, Astor, Lenox and Tilden Foundations.

62. Aaron Douglas: *Aspects of Negro Life: Song of the Towers*, 1934. Oil on canvas. 274.3 × 274.3 cm. Art and Arifacts Division, The Schomburg Center for Research in Black Culture, New York Public Library, Astor, Lenox and Tilden Foundations.

63. Charles Alston: *Modern Medicine*, 1937. Oil on canvas. 518.2 × 182.9 cm. The Harlem Hospital Center, New York (Linnette Webb, Snr VP & Executive Director)/photography Michael Armstrong, Robert Grier, Sherlock Robinson. Courtesy the Estate of Charles Alston.

64. Hale A. Woodruff: *Mutiny Aboard The Amistad, 1839*, Panel 1, 1939. 180.3 × 304.8 cm section of *The Amistad Murals* at Talladega College, Slavery Library, Talladega, AL. Courtesy of the Estate of Hale A. Woodruff (Kenkeleba Gallery, New York).

65. Robert Blackburn: *People in a Boat*, 1939. Lithograph. 238.5 × 50.6 cm. From the Collection of Dave and Reba Williams. Courtesy the artist.

66. Dox Thrash: *Defense Worker*, before 1943. Carborundum print. 19.3 × 16.3 cm. Gift of the Works Progress Administration. The Print and Picture Collection, The Free Library of Philadelphia/photo Will Brown.

67. Norman Lewis: *Yellow Hat*, 1936. Oil on burlap. 92.7 × 66 cm. Courtesy the Estates of Norman W. Lewis and Reginald F. Lewis.

68. William H. Johnson: *Going to Church*, c.1940–1. Oil on burlap. 96.8 × 115.6 cm. National Museum of American Art, Washington, DC/Art Resource, New York.

69. Jacob Lawrence: *Migration of the Negro*, Panel 1: *During the World War there was a Great Migration North by Southern Negroes*, 1940–1. Tempera on masonite. 30.5 × 45.7 cm. The Phillips Collection, Washington, DC. Courtesy the Artist.

70. Jacob Lawrence: *Migration of the Negro*, Panel 50: *Race Riots were very Numerous all over the North*, 1940–1. Tempera on gesso on composition board. 45.7 × 30.5 cm. The Museum of Modern Art, New York. Gift of Mrs David M. Levy/photo © 1998 The Museum of Modern Art, New York. Courtesy the Artist.

71. James Hampton: *Throne of the Third Heaven of the Nations' Millennium General Assembly*, c.1950–64. Mixed media. 274.3 × 975.4 cm. National Museum of American Art, Washington, DC/Art Resource, New York.

72. Beauford Delaney: *Can Fire in the Park*, 1946. Oil on canvas. 61 × 76.2 cm. National

Museum of American Art, Washington, DC/ Art Resource, New York.

73. Eldzier Cortor: *Room No.5*, 1948. Oil on board. 94 × 68.6 cm. Private Collection. Courtesy the artist.

74. Hughie Lee-Smtih: *The Piper*, 1953. Oil on conposition board. 55.9 × 89.5 cm. Photograph © 1998 The Detroit Institute of Art, Gift of Mr and Mrs Stanley J. Winkelman © Hughie Lee-Smith/VAGA, New York/DACS, London, 1998.

75. Romare Bearden: *He is Arisen*, 1945. Black and coloured ink on paper. 66 × 49.2 cm. The Museum of Modern Art, New York. Advisory Committee Fund/photo © 1998 The Museum of Modern Art, New York/ Romare Bearden/ VAGA, New York/DACS, London, 1998.

76. Hale A. Woodruff: *Central Park Rocks*, 1947. Watercolour. 33 × 51.4 cm. The Harmon and Harriet Kelley Collection of African-American Art/photo courtesy Indianapolis Museum of Art. Courtesy Estate of Hale A. Woodruff.

77. Hale A. Woodruff: *Afro Emblems*, 1950. Oil on linen. 45.7 × 55.9 cm. National Museum of American Art, Washington, DC/Art Resource, New York © National Museum of American Art, Washington, DC. Courtesy Estate of Hale A. Woodruff.

78. Charles Alston: *Untitled*, 1950. Oil on canvas. 127 × 91.4 cm. Metropolitan Museum of Art, New York, NY. Arthur H. Hearn Fund, 1951. Courtesy Estate of Charles Alston.

79. Charles Alston: *The Family*, 1955. Oil on canvas. 122.6 × 90.8 cm. Collection of Whitney Museum of American Art, purchase, with funds from the Artists and Students Assistance Fund/photo © 1998 Whitney Museum of American Art. Courtesy Estate of Charles Alston.

80. Romare Bearden: *Blue is the Smoke of War, White the Bones of Men*, c.1960. Acrylic on canvas. 168.3 × 132.1 cm. Collection of Harry Henderson, Croton-on-Hudson, NY/photo Manu Sassoonian. © Romare Bearden/ VAGA, New York/DACS, London, 1998.

81. Norman Lewis: *Harlem Courtyard*, 1954. Oil on canvas. 152.4 × 101.6 cm. Collection of Eric Robertson/photo Goldfeder\Kahan Framing Group, Ltd, New York. Courtesy the Estate of Norman W. Lewis.

82. Norman Lewis: *Harlem Turns White*, 1955. Oil on canvas, 127 × 162.6 cm. Private Collection. Courtesy the Estate of Norman W. Lewis and the Michael Rosenfeld Gallery, New York.

83. Herbert Gentry: *Untitled Figures*, 1958. Oil on canvas. 198.1 × 172.7 cm. Courtesy the artist

and G. R. N'Namdi Gallery, Chicago, IL/ photo Becket Logan.

84. Edward Clark: *Wasted Landscape*, 1961. Oil on canvas. 195.6 × 200.7 cm. Courtesy the artist and G. R. N'Namdi Gallery, Chicago, IL/photo Becket Logan.

85. Reginald Gammon: *Freedom Now*, 1965. Acrylic on board. 101.6 × 76.2 cm. Courtesy the artist.

86. Romare Bearden: *Prevalence of Ritual: Mysteries*, 1964. Collage, polymer paint and pencil on board. 28.6 × 36.2 cm. Courtesy Museum of Fine Arts, Boston. Ellen Kelleran Gardner Fund. © Romare Bearden/ VAGA, New York/DACS, London, 1998.

87. Romare Bearden: *Three Folk Musicians*, 1967. Oil and collage on canvas. 127.3 × 152.4 cm. Private Collection. Courtesy Sheldon Ross Gallery, Birmingham, MI. © Romare Bearden/VAGA, New York/ DACS, London, 1998.

88. Benny Andrews: *Champion*, 1968. Oil and collage on canvas. 127 × 127 cm. Collection of Peter Blum. Courtesy the artist.

89. Vincent Smith: *Negotiating Commission for Amnesty*, 1972. Oil, sand, and collage on canvas. 152.4 × 121.9 cm. Bayly Art Museum of the University of Virginia, Charlottesville/ photo Rusty Smith. Courtesy the artist.

90. Faith Ringgold: *Flag for the Moon: Die Nigger*, 1969. Oil on canvas. 91.4 × 127 cm. Copyright © Faith Ringgold Inc. Courtesy the artist.

91. David Hammons: *Injustice Case*, 1970. Mixed media body print. 160 × 102.9 cm. Los Angeles County Museum of Art, museum purchase with M. A. Acquisitions Fund. Courtesy the artist (Jack Tilton Gallery, New York).

92. Betye Saar: *The Liberation of Aunt Jemima*, 1972. Mixed media. 29.9 × 20.3 × 7 cm. University of California, Berkeley Art Museum. Purchased with the aid of funds from the National Endowment for the Arts (selected by the Committee for the Acquisition of African-American art)/photo Benjamin Blackwell. Courtesy the artist.

93. Betye Saar: *Black Girl's Window*, 1969. Mixed media assemblage. 90.8 × 45.7 × 3.8 cm. Courtesy the artist/photo Grey Crawford.

94. Betye Saar: *Record for Hattie*, 1974. Mixed media. 5.1 × 35.6 × 34.3 cm. Courtesy the artist.

95. Elizabeth Catlett: *Homage to My Young Black Sisters*, 1968. Cedar. H. 175.3 cm. Collection of Andrew Owens, New York/ Photo Lloyd Yearwood, New York. © Estate of E. Catlett/VAGA, New York/DACS, London, 1998.

96. Melvin Edwards: *Gate of Ogun*, 1983.

Stainless steel (2 parts). 243.8 × 365.8 × 121.9 cm (installed). Collection of Neuberger Museum of Art, Purchase College, State University of New York, museum purchase with funds provided by Vera List and the Roy R. and Marie S. Neuberger Foundation. Courtesy the artist and CDS Gallery, New York/photo Morris Lane.

97. Melvin Edwards: *Lynch Fragments: Afro Phoenix nos 1 and 2*, 1963/64. Welded steel. No. 1: 31.8 × 24.1 × 10.2 cm. The Estate of Theresa Lackritz, Chicago. Courtesy the artist and Richard Gray Gallery, Chicago/photo Morris Lane. No. 2: 35.6 × 22.9 × 12.1 cm. Collection of Jayne Cortez, New York. Courtesy the artist and CDS Gallery, New York/photo Morris Lane.

98. Barbara Chase-Riboud: *Monument to Malcolm X no. II*, 1969. Bronze and wool. 182.9 × 101.6 cm. Courtesy the artist (Betty Parsons Gallery, New York)/photo Manu Sassoonian.

99. Barbara Chase-Riboud: *Confessions for Myself*, 1972. Bronze and wool. 304.8 × 101.6 × 30.5 cm. University of California, Berkeley Art Museum. Purchased with funds from the H. W. Anderson Charitable Foundation (selected by the Committee for the Acquisition of African-American Art)/photo Benjamin Blackwell. Courtesy the artist.

100. Ben Jones: *Black Face and Arm Unit*, 1971. Painted plaster. 12 life-size plaster casts. New Jersey State Museum, Collection Purchase FA 1984.92a-x. Courtesy the artist.

101. OBAC: *Wall of Respect*, 1967. Courtesy of Ken Barboza Associates/photo Robert Sengstacke.

102. Jeff Donaldson: *JamPactJelliTite*, 1988. Mixed media on linen canvas. 91.4 × 127 cm. Courtesy the artist.

103. Alma Thomas: *Wind and Crepe Myrtle Concerto*, 1973. Acrylic on canvas. 88.9 × 132.1 cm. National Museum of American Art, Washington, DC/Art Resource, New York.

104. Sam Gilliam: *Carousel Form II*, 1969. Acrylic on canvas. 304.8 × 2286 cm. Courtesy the artist.

105. William T. Williams: *Elbert Jackson L. A. M. F. Part II*, 1969. Synthetic polymer and metallic paint on canvas. 279 × 292.6 cm. Museum of Modern Art, New York, Gift of Carter Burden, Mr and Mrs John R. Jakobson, and purchase/photo © 1997 The Museum of Modern Art, New York. Courtesy the artist.

106. Alvin D. Loving, Jr: *Septehedron*, 1970. Synthetic polymer on canvas. 224.2 × 261 cm. Collection of Whitney Museum of American Art. Gift of William Zierler Inc. in honour of John I. H. Baur/photo © 1997 Whitney Museum of American Art. Courtesy the artist

(Christiane Neinaber Contemporary Art, New York).

107. Alvin D. Loving: *Self-Portrait No. 23*, 1973. Dyed canvas. 315 × 363.2 cm. Courtesy the artist and Christiane Nienaber Contemporary Art, New York.

108. Robert L. Thompson: *Expulsion and Nativity*, 1964. Oil on canvas. 160 × 219.7 cm. Private Collection, Dallas, TX. Estate of Robert L. Thompson.

109. Raymond Saunders: *Marie's Bill*, 1970. Mixed media on canvas. 215.9 × 210.8 cm. Courtesy the artist and Stephen Wirtz Gallery, San Francisco.

110. Minnie Evans: *Untitled*, 1945–67. Graphite, oil, wax crayon, and collage on canvas board. 53.3 × 67.3 cm. Collection of Dorothea M. Silverman/photo courtesy Luise Ross Gallery, New York.

111. Richard Hunt: *The Chase*, 1964. Welded steel. 114.3 × 172.7 × 139.7 cm. Courtesy the artist.

112. Richard Hunt: *Torso Hybrid* (from the series 'Hybrid Forms', 1967–88). Welded chrome steel. 91.4 × 61 × 66 cm. Courtesy the artists, and Dorsky Gallery , New York.

113. Robert Colescott: *Les Demoiselles d'Alabama (des Nudas)*, 1985. Acrylic on canvas. 238.8 × 228.6 cm. Greenville County Museum of Art, Greenville, SC, museum purchase. Courtesy the artist (Phyllis Kind Gallery, New York and Chicago).

114. Robert Colescott: *Matthew Henson and the Quest for the North Pole*, 1986. Acrylic on canvas. 228.6 × 289.6 cm. Courtesy the artist and Phyllis Kind Gallery, New York and Chicago/photo Keith Fitzgerald.

115. Jean-Michel Basquiat: *Famous Moon King*, 1984/85. Oil and acrylic on canvas. 180 × 261 cm. Courtesy Galerie Bruno Bischofberger, Zurich © ADAGP, Paris and DACS, London, 1998

116. Howardena Pindell: *Autobiography: Water/Ancestors/Middle Passage/Family Ghosts*, 1988. Acrylic, tempera, cattle markers, oil stick, paper, polymer-photo transfer, and vinyl tape on sewn canvas. 299.7 × 180.3 cm. Wadsworth Atheneum, Hartford, CT. The Ella Gallup Sumner and Mary Catlin Sumner Collection Fund. Courtesy the artist.

117. Faith Ringgold: *Change: Faith Ringgold's Over 100 lbs Weight Loss Performance Story Quilt*, 1986. Photo-etching on silk and cotton, printed and pieced fabric. 144.8 × 177.8 cm. Copyright © Faith Ringgold Inc. Private Collection. Courtesy the artist.

118. Emma Amos: *Equals*, 1992. Acrylic on linen canvas, laser transfer photograph by G. Shivery, c.1937, African fabric/Confederate

flag collage, African fabric borders. 193 × 208.3 cm. Emma Amos © 1992.

119. Adrian Piper: *Vanilla Nightmares no. 8*, 1986. Charcoal on newspaper. 35.6 × 55.9 cm. Collection Richard Sandor. Reproduced by kind permission of the artist.

120. Adrian Piper: *Cornered*, 1988. Video installation with birth certificate, videotape, monitor, table, ten chairs. Dimensions variable. Collection of the Museum of Contemporary Art, Chicago, Bernice and Kenneth Newberger Fund 90.4/photo Joe Ziolkowski, © MCA, Chicago.

121. Martin Puryear: *Self*, 1978. Painted red cedar and mahogany. 175.3 × 121.9 × 63.5 cm. Joslyn Art Museum, Omaha, NE. Courtesy the artist.

122. Martin Puryear: *Bodark Arc*, 1982. Nathan Manilow Sculpture Park at Governors State University, University Park, IL/photo Richard Burd. Courtesy the artist.

123. Maren Hassinger: *Weeds*, 1986. Wire rope, site installation. 1.22 × 22.9 × 15.2 m. Collection of the artist/photo Mary Margaret Hansen, Houston, TX.

124. Martha Jackson-Jarvis: *Sarcophagus IV: Water*, from the series 'Last Rites', 1992–3. Clay, glass, pigmented cement, and wood. 121.9 × 76.2 × 182.9 cm. Courtesy of the artist/photo Becket Logan.

125. Alison Saar: *Zombies, Totems, Rootmen, and Others*, 1988. Mixed media installation. 120 × 192 × 264 cm. Queens Museum of Art, New York. Courtesy the artist.

126. Alison Saar: *Dying Slave*, 1989. Wood, tin, nails, plexiglass. 205.7 × 48.3 × 48.3 cm. Courtesy the artist.

127. Houston Conwill: *The New Cakewalk*, installation, 1988–9. *Dance floor:* sandblasted, tempered, and laminated glass, 20 parts (sixteen, 2.5 × 91.4 × 91.4; four, 2.5 × 91.4 × 34.3 cm); '*Light Books*': 39 sandblasted glass blocks (each 20.3 × 20.3 × 7.6 cm) and 9 mirrors (each 25.4 × 25.4 cm); *Ceiling scrim:* silkscreen and ink marker on muslin, on metal frame 457.2 × 365.8 cm. Collection of the High Museum of Art, Atlanta, GA. Purchase with funds from the 20th-century Art Acquisition Fund, a grant from the Lenora and Alfred Glancy Foundation, and by exchange, 1989.7. Diagram for 'cosmogram' on dance floor, and of the ceiling scrim. Courtesy the artist.

128. David Hammons: *Untitled*, 1981; *Flight Fantasy*, 1983. Records, hair, plaster. 11.8 × 165.1 × 25.4 cm; and *Lady With Bones*, 1983 (recreation 1990). Shopping bags, grease, rib bones (on wall). Courtesy the artist and Jack Tilton Gallery, New York/photo Dawoud Bey.

129. David Hammons: *Untitled (Night Train)*, 1989. Installation at Exit Art, New York. Coal, piano lids, model train and tracks, boombox, glass bottles. Courtesy the artist and Jack Tilton Gallery, New York/photo Lary Lamé.

130. Pat Ward Williams: *Accused/Blowtorch/Padlock*, 1986. Wood, tar paper, gelatin silver prints, film positive, paper, pastel, and metal. 151.1 × 271.8 × 11.4 cm. Collection of Whitney Museum of American Art. Purchase with funds from the Audrey and Syndey Irmas Charitable Foundation, 93–46. Courtesy the artist.

131. Lorna Simpson: *Guarded Conditions*, 1989. 18 colour polaroid prints, 21 engraved plastic plaques, plastic letters. 231.1 × 332.7 cm. Collection Museum of Contemporary Art, San Diego, museum purchase, Contemporary Collectors Fund (acc. no. 90.12.1–28). Courtesy the artist (Sean Kelly Gallery, New York).

132. Christian Walker: *Miscegenation*, 1985–8. Silver gelatin print. 40.6 × 50.8 cm. Courtesy the artist and Jackson Fine Arts, Atlanta, GA.

133. Dawoud Bey: *Brian and Paul*, 1993. Polaroid on paper. 74.9 × 110.5 cm. Collection Walker Art Center, Minneapolis, Justin Smith Purchase Fund, 1994.

The publisher and author apologize for any errors or omissions in the above list. If contacted they will be pleased to rectify these at the earliest opportunity.

Bibliographic Essay

Since the publication of Samella Lewis, *Art: African American* (Los Angeles, 1978), there has been a twelve year hiatus in the publishing of art history surveys about African-American art from the eighteenth to the twentieth century. Lewis's text has been reissued as *African American Art and Artists* (Los Angeles, 1990), and has been updated to include more contemporary artists. More recently writer Harry Henderson and the artist Romare Bearden have co-authored *A History of African-American Artists from 1792 to the Present* (New York, 1993), which focuses on selected artists, and is not a survey of styles and art movements. Richard J. Powell, *Black Art and Culture in the Twentieth Century* (London, 1997), takes a thematic approach to writing about African-American art and artists, and other artists effected by the African diaspora. Recently published American art history survey texts, unlike earlier ones, include the works of African-American artists. Many focus on contemporary American art such as Barbara Rose, *American Painting: The Twentieth Century* (Lausanne, 1969; rev. edn, New York, 1986), or Sam Hunter and John Jacobus, *American Art of the Twentieth Century: Painting, Sculpture, and Architecture* (New York, 1993). Wayne Craven in *American Art: History and Culture* (New York, 1994), breaks with tradition by including African-American artists, starting in the nineteenth century with Joshua Johnston, and ending in the 1960s with painter Romare Bearden, and folk artist James Hampton. Craven groups twentieth-century artists into a separate category by race, or what he perceives to be a distinctive style, and unfortunately does not integrate them into mainstream American art movements or styles. That black art may veer from the now considered acceptable and standard definitions, chronologies, and characterizations of American art, may possibly provide an explanation for this and for other books which display an intellectual or canonical segregation of African-American artists. Another reason, possibly, is not understanding the culture or societal context in which the art is produced. There is a segment of American culture and society—African descendants in North America—which has neither been given the kind of art historical and critical examination it deserves, nor an exploration of its forms and styles merely for the visual pleasure they can provide.

Anyone newly introduced to African-American art must divide their attention between three types of sources: American art history, African-American cultural history, and African-American art. The latter consists of art history surveys and artists monographs, particularly exhibition catalogues. Catalogues are not advertized widely and tend to go out-of-print quickly, consequently information about black American art is not always accessible. Established publishing houses are to be praised for the fact that catalogues are now being distributed through them. Generally, I have listed publications in this essay in similar groups under the categories of cultural history, American art, or African-American art.

The citation of sources in this bibliographic essay follows the organization of the chapters, and includes subheadings, although not every section is discussed as some works will be relevant to more than one section, or because there is no readily available publication. I am aware of the lack of accessible material and wherever possible I have identified sources which can be found in most large university libraries, or are still available for purchase. Consequently archives, special collections, and dissertations are not listed here. Attention has been given to sources that provide basic information, as well as more specialized texts centred around a particular period or scholarly concern. It will become apparent to readers that information about art after the 1960s must be gleaned from numerous artists monographs

and a few anthologies. Formerly students of American art, after reading an introductory survey text, had to move directly to an artist's monograph in order to learn more about the period and artist. There was no intermediate level text in American art prior to *c.*1970. Although this remains the predominant situation in the field of African-American art, we now have Rose, *American Painting* which attempts to bridge the gap.

Any student needs a good reference text such as a bio-bibliography and an encyclopaedia. There is one excellent bio-bibliography on African-American art, Lynn Igoe, *250 Years of Afro-American Art: An Annotated Bibliography* (New York, 1981), which also has information about published reproductions of works of art. Unfortunately it is now out-of-print, but it is well-worth trying to find a second-hand copy. The six volume *Encyclopedia of African-American Culture and History* (New York, 1996), edited by Jack Salzman, David Lionel Smith, and Cornel West, includes excellent entries on individual artists as well as cultural movements like pan-africanism. *Afro-American Folk Culture*, 2 vols (Philadelphia, 1978), edited by John F. Szwed and Roger D. Abrahams, is an annotated bibliography grouped according to regions in the Americas and the West Indies. Volume 1 on North America is invaluable for anyone interested in material culture.

For the novice unfamiliar with certain terms and art movements there are several references. A recent, easy-to-use publication, now available in paperback, is Robert Atkins *ArtSpoke: A Guide to Modern Ideas, Movements, and Buzzwords, 1848–1944* (New York, 1993), and the subsequent book by the same author *Artspeak: A Guide to Contemporary Ideas, Movements, and Buzzwords* (New York, 1990), which begins with the post-World War II period.

Chapter 1. Colonial America and the Young Republic 1700–1820
Introduction
Several American art survey texts like Milton Brown, *American Art* (New York, 1979), John Wilmerding, *American Art* (Baltimore, 1976), and Craven, *American Art History*, will provide basic information. There are only two African-American art history texts: James Porter, *Modern Negro Art* (New York, 1943; repr. 1969; rev. edn, Washington, DC, 1992), and David C. Driskell, *Two Centuries of Black American Art* (New York, 1976), which briefly refers to the colonial arts following Porter's lead in

showing that slaves were artists and artisans, and includes more illustrations. There are numerous texts on early American history, but only a few of the more recent ones include the African and African-American experience. However, there are standard African-American histories like John Hope Franklin, *From Slavery to Freedom: A History of African Americans* (New York, 1947; rev. edn, New York, 1994), first subtitled, *A History of American Negroes*, and Lerome Bennett, *Before the Mayflower: A History of Black America* (Baltimore, 1966; repr. and rev. edn, New York, 1984), first subtitled *A History of the Negro in America, 1619–1964*. Michael L. Conniff and Thomas J. Davies, *Africans in the Americas: A History of the Black Diaspora* (New York, 1994) is a useful introductory text that summarizes and highlights topics like slavery and the law or acculturation within broad chronologies, and has a useful timeline and bibliographic essay. For university students there is D. W. Meinig, *The Shaping of America: A Geographical Perspective on 500 years of History* (New Haven, 1986), a multi-volume project expected to be completed in the year 2000. Vol. 1: *Atlantic America, 1492–1800*, is a very useful resource for maps and provides a succinct geographical history. For a multicultural perspective on American colonial history there is Gary Nash, *Red, White and Black: The Peoples of Early America* (Englewood Cliffs, NJ, 1974; 2nd edn, 1982). This history takes a different approach to early American history by discussing the cultures of North American Indians and Africans and the effect upon their lives of contact with each other and with Europeans. This and Nash's book, *Struggle and Survival in Colonial America* (Berkeley, 1981) enlivens the usual pedantic history of the American colonial period with anecdotes revealing a personal side of this predominantly British enterprise. Alden T. Vaugh, *Roots of American Racism: Essays on the Colonial Experience* (New York, 1995), gives an economic history of slavery and the experiences of free blacks. A few texts focus on a particular region such as Peter Wood, *Black Majority: Negroes in Colonial South Carolina from 1670 through the Stono Rebellion* (New York, 1974).

The presence of cultural traits which could be traced to Africa, called Africanism, was first given scholarly treatment by cultural anthropologist Melville Herskovits in *Myth of the Negro Past* (New York, 1941; repr. Boston, 1990). His assertion that there were no Africanisms in the visual arts was disproved by art historian Robert Farris Thompson in his

article 'African Influence on the Art of the United States' in Armstead L. Robinson, Craig Foster, and Donald H. Ogilvie (eds), *Black Studies in the University* (New Haven, 1969). This ground-breaking essay has been reprinted in William Ferris (ed.), *Afro-American Folk Art and Crafts* (Jackson, MS, 1983). Thompson looked at art styles and forms, such as pottery, quilts and woodcarvings, and grave decorations and showed varying degrees of African retentions in the art forms and designs. Subsequent publications have expanded upon the concept of Africanisms to include interpretive practices. However most cited examples date from the nineteenth century as in John Holloway (ed.), *Africanisms in American Culture* (Bloomington, 1990), and John Vlach, *The Afro-American Tradition in Decorative Arts* (Cleveland, OH, 1978). There is an abbreviated version of the latter: John Vlach, *By The Work of Their Hands* (Charlottesville, 1991). A useful anthology on cultural history for someone familiar with the literature on Africanisms is *Global Dimensions of the African Diaspora* edited by Joseph E. Harris (Washington, DC, 1993). Particularly pertinent are George Shepperson's essay 'African Diaspora: Concept and Context', and Lawrence W. Levine, 'African Culture and Slavery in the United States' which is about settlements and the transformation of the African into the African American. Further documentation on the retention of African culture in North America can be found in histories like Sterling Stuckey, *Going Through the Storm: The Influence of African American Art in History* (New York, 1994) in which one chapter, 'The Skies of Consciousness: African Dance at Pinkster in New York, 1750–1840' documents an African masquerade through the records of first-hand witnesses.

Plantations

Historical archaeology has revealed much about African culture and the development of African-American culture in the seventeenth and eighteenth century. The discipline was developed in North America, and focuses on the fifteenth through the twentieth centuries, and draws on two or three separate types of data: archaeological deposits, documents, and oral history. Its focus on African Americans began in earnest in the 1970s. It includes the study of plantation life, the analysis of communities of free blacks in both northern and southern, rural and urban contexts, and the excavations of important cemetery sites.

The largest body of information within the subfield derives from analysis of the plantations. Research has demonstrated the essential and pervasive role of slaves, and more importantly provided information about the lives of slaves, especially documenting the presence of African culture: ceremonies, house plans, and folk art. Most archaeological documentation and reports are published in specialist journals. There are, however, a few anthologies which explain basic terminology and concepts used in archaeology, and cultural anthropology: Theresa Singleton (ed.), *The Archaeology of Slavery and Plantation Life* (Orlando, 1985), which includes a section on the diaspora, a useful bibliography and is well illustrated (which most historical anthropology publications are not); Charles Fairbanks, *Florida Archaeology* (New York, 1980), whose excavations in 1968, 1969, and 1972, fuelled the academic debate on the material living conditions of the Old South slaves that dominated the historiography of slavery during the 1970s; John Solomon Otto, *Cannon's Point Plantation, 1794–1860: Living Conditions and Status Patterns in the Old South* (Orlando, 1984) which gives a good chronology of historical archaeology about slave life in its first chapter, and Leland Ferguson, *Uncommon Ground: Archaeology and Early African America, 1650–1800* (Washington, DC, 1992) which provides a very good introduction to African-American archaeology, and the status of research in the South.

John M. Vlach's essay on slaves' vernacular architecture on plantations in the *Encyclopedia* usefully summarizes style, materials, and plans. Two publications are essential to understanding plantations as architectural and industrial enterprises. One is John M. Vlach, *Back of the Big House: The Architecture of Plantation Slavery* (Chapel Hill, 1993). Vlach selected over 200 photographs and drawings from the historic American Buildings Survey archive (established in 1933) at the Library of Congress. Images of slave dwellings and the structures built and used by slaves, the service buildings, as well as the planters' houses, are complemented by an excellent and thorough introductory text which includes testimonies of former slaves taken from the Federal Writers Project collections of the 1930s and 1940s. The other is Singleton, *The Archaeology of Slavery*. The essays cover topics like settlements, class, and artefacts by examining sites in the United States and Caribbean, and the introduction gives readers basic

information about terminology, and methodology.

The revival of African culture on the plantation

One essay in Singleton's book is of particular interest: Thomas R. Wheaton and Patrick H. Garrow, 'Acculturation and the Archaeological Record in the Carolina Lowcountry' which is about the Curribboo and Yaughan plantations. For a thorough cultural and social history of plantation life there is Wood, *Black Majority*; and Mechal Sobel, *The World They Made Together* (Princeton, 1987) which shows the complex interrelationships between the whites and blacks, the slave-holder and slaves, the house and field slaves in eighteenth century Virginia; it masterfully demonstrates pervasive acculturation in America.

A Planter's House

Information about the Metoyer family is taken from Gary Mills, *The Forgotten People: Cane River's Creoles of Color* (Baton Rouge, 1977); and about French Creole plantations from W. Darrell Overdyke, *Louisiana Plantation Homes* (New York, 1965). A good cultural history is Gwendolyn Midlo Hall, *Africans in Colonial Louisiana: The Development of Afro-Creole Culture in the Eighteenth Century* (Baton Rouge, 1992). It marks a milestone in tracing Africans, their origins, artisan skills, folkways and the impact on the lower Mississippi Valley region which was always inferred but never as thoroughly researched as in this book.

Plantation Slave Artists and Craftsmen

After reading Porter, *Modern Negro Art*, Vlach, *By The Work of Their Hands*, and Driskell, *Two Centuries*, a more in-depth discussion of slave artisans can be found in Vlach, *The Afro-American Tradition*, and James E. Newton and Ronald L. Lewis (eds), *The Other Slaves: Mechanics, Artisans, and Craftsmen* (Boston, MA, 1978), which is an anthology about colonial industries and the artisan in the South. Newton's own essay is specifically about artisanship, training, and types of work. Sidney Kaplan, *Black Presence in the Era of the American Revolution 1770–1800* (Greenwich, CT, 1973), provides some documentation of artisans by referring to archival materials like runaway and newspaper advertisements, and plantation inventories and letters, many of which are reproduced in this book. For reproductions of actual objects, and for folk art and architecture, there is

Vlach, *The Afro-American Tradition*, and Ferguson, *Uncommon Ground*. The focus of these two texts is on handmade pots, plantation architecture and settlements on the coastal southeast, and African folkways and cultural practices. For the specialist there are also data tables.

Urban Slave Artists and Craftsmen

A difficult to find but very important booklet is *Negro Ironworkers of Louisiana, 1718–1900*, (Gretna, LA, 1972) by Marcus Christian. This is the most thorough study of African-American blacksmiths. Information about the decorative arts is equally sparse. Most are found in specialized journals such as *Arts and Antique Magazine*, and museum bulletins, like *A Selection of Works by African American Artists in the Philadelphia Museum of Art*, 19/382–83 (1995), which provided most of the information about silversmith Peter Bentzon and cabinetmaker Thomas Gross, Jr. Steven Jones, 'A Keen Sense of the Artistic: African American Material Culture in the Nineteenth Century' in *International Review of African American Art*, 12/2 (Baltimore, 1995), 4–29, gives information about late-eighteenth-century artisans such as Scipio Moorhead and Moses Williams of Philadelphia. The brief information on Philadelphia potters and pottery industries, was taken from Sarah Turnbaugh (ed.), *Domestic Pottery of the Northeastern United States, 1625–1850* (New York, 1985). Phillis Wheatley is thoroughly discussed in Kaplan, *Black Presence*, and Joshua Johnston in Carolyn J. Weekley's catalogue *Joshua Johnston: Freeman and Early American Portrait Painter* (Williamsburg and Baltimore, 1987). The latter is the most thorough and well illustrated art history, and a virtual catalogue raisonné of the artist. It also has a supplemental catalogue of works by other artists including those by members of the Peale family. Recently Craven, *American Art* and John Vlach, *Plain Painters: Making Sense of American Folk Art* (Washington, DC, 1988), have controversially discussed Johnston as a folk artist instead of a fine artist.

Chapter 2: Nineteenth Century America: the Civil War and Reconstruction
Introduction

A good introduction to the history of the period is Meinig, *The Shaping of America*, vol. 2, *Continental America, 1800–1867*. There are several good texts on the antebellum period, slavery, and about free blacks including Richard Wade, *Slavery in the Cities, The South,*

1820–1860 (New York, 1964); Ira Berlin, *Slaves without Masters: The Free Negro in the Antebellum South* (New York, 1974); and James Oliver Horton, *Free People of Color: Inside the African American Community* (Washington, DC, 1993). Much of the information about abolitionism is based on Horton's book.

Several publications focus on a particular region or city, and on free blacks: John W. Blassingame, *Black New Orleans 1860–1973* (Chicago, 1973); Wendell Phillips Dabney, *Cincinnati's Colored Citizens* (Cincinnati, 1926); Douglas Henry Daniels, *Pioneer Urbanites: A Social and Cultural History of Black San Francisco* (Berkeley, CA, 1990); John Hope Franklin, *The Free Negro in North Carolina, 1790–1860* (New York, 1943); James Oliver Horton and Lois E. Horton, *Black Bostonians: Family Life and Community Struggle in the Antebellum North* (New York, 1979); George Nash, *Class and Society in Early America, Forging Freedom: The Formation of Philadelphia's Black Community, 1720–1840* (Cambridge, MA, 1988), and James M. Wright, *The Free Negro in Maryland, 1634–1860* (New York, 1921).

Most studies of slavery focus on plantation society. More modern scholarship has moved away from generalizations to specifics like the status of artisans, as in John Blassingame, *The Slave Community: Plantation Life in the Antebellum South* (New York, 1972), and Eugene D. Genovese, *Roll, Jordon, Roll* (New York, 1974). Recently histories about slave women have been published that explain how their gender and experience shaped slavery in the antebellum period. The now standard text, Elizabeth Fox-Genovese, *Within the Plantation Household: Black and White Women of the Old South* (Chapel Hill, 1988), has been complemented by Jean Fagan Yellin, *Women and Sisters: The Antislavery Feminists in American Culture* (New Haven, 1989), and an anthology, Patricia Morton (ed.), *Discovering the Women in Slavery: Emancipating Perspectives on the American Past* (Athens, GA, 1996). Edward D. C. Campbell, Jr (ed.), *Before Freedom Came: African-American Life in the Antebellum South* (Richmond, VA, 1991) provides a summary of history, archaeology, and cultural anthropology of African-American life. It focuses particularly on the social life and customs of slaves, and includes several excellent illustrations of architecture, and decorative arts. Lawrence W. Levine, *Black Culture and Black Consciousness: Afro-American Folk Thought from Slavery to Freedom* (New York, 1977) focuses on the orally transmitted culture of African Americans in an attempt to counterbalance popular assumptions that black history was one of degradation and impotence. Levine examines concepts of the sacred world, the meaning of slave tales, sacred and secular songs and music, and heroes.

For the voice of the slave, there are several publications including one sixteen-volume publication, *The American Slave: A Composite Autobiography* (Westport, CT, 1972–3), edited by George Rawick, which provides the slaves' narratives about American society and culture, including comments on the activities of slave artisans. John Blassingame (ed.), *Slave Testimony: Two Centuries of Letters, Speeches, Interviews and Autobiographies* (Baton Rouge, 1976), is the first attempt to present in one volume several different kinds of primary sources. This allows the reader to compare one type with another, and to determine the reliability of each and to analyze the complex black response to bondage. In addition there are several reprinted slave narratives, either from a single voice such as Lydia Maria Child (ed.), *Incidents in the Life of a Slave Girl Written by Herself/ by Harriet A. Jacobs* (Boston, 1861) which has been newly edited with an introduction by Jean Fagan Yellin (Cambridge, MA, 1987), and *Narrative of the Life and Adventures of Henry Bibb, an American Slave* (New York, 1850; repr. 1969); or from several voices as in Arna Bontemps (ed.), *Great Slave Narratives* (Boston, 1969), and Henry L. Gates (ed.), *The Classic Slave Narratives* (New York, 1987). As part of the Work Projects Administration, employees of the Georgia Writers' Project interviewed and recorded former slaves in the 1930s. This was published as *Drums and Shadows* (Athens, GA, 1940), and documented folk culture of coastal Georgia and South Carolina, often recorded in the vernacular, and includes an appendix on West African culture patterns (taken from published cultural anthropology), to show possible parallels between these and African-American culture.

For a continuing overview of the slave artisan there is Newton and Lewis (eds), *The Other Slaves*. A pioneering publication about the relationship between African and African-American arts and crafts by Judith Wragg Chase, *Afro-American Art and Craft* (New York, 1971) gives a succinct survey of West African art and crafts; an overview of urban and plantation artisans, and finally African-American art from the nineteenth century to *c.*1969, including fibre arts and jewellery.

Chase, a former curator of the Old Slave Mart Museum in Charleston, South Carolina, discusses the connections between African and African-American art by looking at basketry, pipes, architecture, tools, and woodcarvings. An article by her, 'American Heritage From Antebellum Black Craftsmen', *Southern Folklore Quarterly*, 42 (1978), 135–58, updates her research providing substantial evidence based on archives and interviews with plantation descendants. Again for the fine artist, Driskell, *Two Centuries*, and Porter, *Modern Negro Art*, are useful.

Architecture, the Decorative Arts, and Folk Art

Vlach, *The Afro-American Tradition* is the first substantive survey with numerous illustrations of folk art from the nineteenth to the twentieth century: basketry, musical instruments, woodcarving, quilting, pottery, boat-building, blacksmithing, architecture, and graveyard decorations. Ferris, *Afro-American Folk Art*, along with Vlach, *By the Work of their Hands* provide basic information for students, covering a variety of folk art genres: pottery, blacksmithing, musical instruments, and sculpture. Ferris's anthology is a more thorough study of individual artists within the genres of quilts and musical instruments, and has a very useful annotated bibliography which includes films.

The literature about urban and rural architecture concentrates on the rural South. Both John Vlach's essay on Vernacular Architecture, and Richard Dozier's on African American Architecture in the *Encyclopedia* cover basic concepts and plans of slave architecture, and an overview of key personalities and institutions, respectively. For a more detailed study of African influences on black folk architecture and decorative elements, there is Steven Jones, 'The African American Tradition in Vernacular Architecture', in Singleton, *The Archaeology of Slavery*, which incorporates Jones's own research in Africa, and makes formal comparisons with structures in North America and Africa, proposing some remarkable similarities based on architectural designs among West African and southern American structures. He includes a brief discussion about cabinetmaker Thomas Day who made various architectural ornaments as well as furniture. All these essays include a helpful bibliography for the novice. If the *Encyclopedia* is not readily available then try Driskell, *Two Centuries* and Vlach, *By the Work*

of their Hands.

Information about slave builders and houses are found dispersed among cultural histories like Charles Joyner, *Down By the Riverside: A South Carolina Slave Community* (Urbana, IL, 1984), and slave narratives edited by John Blassingame. There is scant information about urban architecture. One exception is New Orleans which has received more study regarding black architects and builders than any other antebellum city. Christian, *Negro Ironworkers* has information about the decorative iron grillwork found on New Orleans buildings. Vlach, *The Afro-American Tradition* is particularly valuable in the discussion about shotgun houses. Roulhac Toledano, Sally Kittredge Evans, Mary Louise Christovich, *New Orleans Architecture*, vol. 4: *The Creole Faubourgs* (Gretna, LA, 1974) is the only architectural survey about the free people of color in the then suburb, Faubourg Marigny, east of New Orleans proper. This book contains a history of the people, the district, and a visual catalogue of house plans, elevations, and photographs of remaining structures built for and by this special class of free blacks.

Information about artisans cabinet-makers, woodcarvers, and metalsmiths is woefully inadequate. A few museum catalogues such as *Thomas Day, Cabinetmaker* (Raleigh, NC, 1975), or an occasional journal article provide the only information about cabinetmakers. Vol. 12 of *The International Review of African American Art* edited by art historian Juanita Holland, gives the most recent research on antebellum and later nineteenth-century decorative arts and architecture (and fine arts), including my own essay 'Antebellum Cabinetmakers in New Orleans'. Examples of slave-made furniture are illustrated in texts like Porter, *Modern Negro Art*, and Campbell, *Before Freedom Came*, but not documented.

Recent, monographs on pottery and quilts have considerably augmented the earlier survey texts. Cinda K. Baldwin, *Great & Noble Jar: Traditional Stoneware of South Carolina* (Athens, GA, 1993) is the first in-depth study of American stoneware from South Carolina and survey of black (slave and free) potters in the Edgefield District. Unlike previously published essays, this book contextualizes black production within the broader history of South Carolina stoneware production, covering the early nineteenth century until the first half of the twentieth century. It also provides an excellent examination of

techniques and forms, and pottery industries. The face vessels have garnered considerable attention in the past ten years, including Vlach, *The Afro American Tradition* which still has the best illustrated documentation of vessels in South Carolina and Georgia, and elsewhere; and Thompson, 'African Influence'. Robert Farris Thompson, co-authored with Joseph Cornet, *The Four Moments of the Sun* (Washington, DC, 1981), in which Thompson's 'The Structure of Recollection: The Kongo New World Visual Tradition' argues convincingly that there are strong connections between Kongo and American cultures. Unfortunately it is out-of-print, but worth the search because it contains a substantial discussion of Kongo cultural traditions in the Americas, particularly in the United States, not found elsewhere. Using style, linguistics, archives, and fieldwork, Thompson spans both continents and covers a variety of genres including the visual arts, and specifically the Afro-Carolinian vessels. Folklorist, Michael D. Hall in his essay, 'Brother's Keeper: Some Research on American Face Vessels and Some Conjecture on the Cultural Witness of Folk Potters in the New World', in M. D. Hall, *The Stereoscopic View* (Ann Arbor, MI, 1988), 195–223, however, takes strong exception to scholars who see Africanisms in these vessels; and asserts that as folk art face and anthropomorphic vessels are signs of the temperance movement.

Quilts have become very popular in the past seven years as evidenced by four publications, two of which focus on the nineteenth century. Gladys-Marie Fry, *Stitched From the Soul: Slave Quilts from Antebellum South* (New York, 1990), is well-illustrated, and includes samples of all types of quilting techniques, quilter's lives, and photographs of slaves and loom houses. Fry emphasizes the element of African culture in black quiltmaking. Cuesta Benberry, *Always There: The African-American Presence in American Quilts* (Louisville, KY, 1992) covers slave and free black quilters in the antebellum and post-Civil-War periods, the genre of Bible quilts, and twentieth-century quilters, and questions the assumptions that distinctive designed quilts are slave-owned or that black quilts always show African design elements. Together they comprise a significant documentation of African-American quilters, particularly women. Marie Jeanne Adams, 'The Harriet Powers Pictorial Quilts', in Ferris (ed.), *Afro-American Folk Art* provides the

descriptions taken from an article by Gladys-Marie Fry who printed the description of the quilts scenes as they were given by Harriet Powers, which Adams analyzes as a sacred text. Maude Wahlman, *Signs and Symbols: African Images in African American Quilts* (New York, 1993) uses her expertise in African art to provide a particular perspective in her analysis of African-American quilts, a few of which date to the nineteenth century, but most to the twentieth century, identifying Africanisms in quilt designs in her book. The numerous colour plates of African textiles and African American quilts alone make this a valuable art historical resource.

Fine Arts: Painting, Sculpture and Graphic Arts

Barbara Novak, *American Painting in the Nineteenth Century: Realism, Idealism, and the American Experience* (1969; New York, 1974) focuses on particular artists in order to determine the 'American' character of American painting, and to provide an intermediary text for the student of American art who must otherwise go directly from survey to a monograph to find a more thorough consideration of a major art figure. A contemporary yet sophisticated interpretation and expansion about what iconography and iconology denotes is found in David C. Miller (ed.), *American Iconology: New Approaches to Nineteenth-Century Art and Literature* (New Haven, 1993).

For general texts on photography there are Robert M. Doty, *Photography in America* (New York, 1974), and Beaumont Newhall, *The Daguerreotype in America* (New York, 1976), both of which are useful for comparisons with the art of African-American photographers.

Porter, *Modern Negro Art*, Driskell, *Two Centuries*, and *Hidden Heritage: Afro-American Art, 1800–1950* (San Francisco, CA, 1985), and Bearden and Henderson, *A History of the African-American Artist*, provide an in-depth study and biography of major fine artists, with extensive endnotes. Another introductory text is Guy McElroy, Richard J. Powell, and Sharon F. Patton, *African-American Artists 1880–1987: Selections from the Evans-Tibbs Collection* (Seattle, 1989).

Information about exhibition spaces and the viewing public is buried in either artists' monographs or specializes texts about a particular medium or art form. Joy Kasson, *Marble Queens and Captives: Women in Nineteenth Century American Sculpture* (New Haven, CT, 1990) gives a very good summary

of the types of public and private viewing spaces before the rise of museums later in the century. The first monograph on James Presley Ball is Deborah Willis (ed.), *J. P. Ball, Daguerrean and Studio Photographer* (New York, 1993) which includes an annotated bibliography, a brief introduction, and photographs from museum and private collections, and most importantly a reproduction of the exhibition pamphlet for Ball's panorama. Information about Ball's African-American photography peers can be found in Deborah Willis-Thomas, *Black Photographers, 1840–1940* (New York, 1985), which is the first illustrated bio-bibliography on African-American photographers, and an invaluable source for any student of American photography.

Recently there have been several publications which address the nature of abolitionist patronage of black artists, especially by women and African-Americans. Joseph D. Ketner, *The Emergence of the African American Artist: Robert S. Duncanson 1821–1872* (Columbia, MO, 1993) who devotes one chapter to the topic and includes other African-American artists besides Duncanson; Juanita M. Holland, 'Reaching Through the Veil: African-American Artist Edward Mitchell Bannister', in *Edward Mitchell Bannister* (New York, 1992), is an exhibition catalogue which includes discussion of the pivotal role of black abolitionists; and Hal S. Chase, 'Abolitionist Patronage of Afro-American Art, 1833–1872', in *Duncanson: A British-American Connection* (Durham, NC, 1984). Patricia A. Turner, *Ceramic Uncles & Celluloid Mammies* (New York, 1994) contains material about the popularity of Uncle Tom; and Jan Nederveen Pieterse, *White on Black: Images of Africa and Blacks in Western Popular Culture* (New Haven, 1992) reprinted from the 1990 edition by Koninklijk Institut voor de Tropen, Amsterdam, provides a thorough analysis of slavery and abolitionism and its representations, both in Europe and the Caribbean.

For a discussion about the role of abolitionist patrons during the Victorian Age, it is essential to read Kasson, *Marble Queens*, and Shirley Samuels (ed.), *The Culture of Sentiment* (New York, 1992). The latter shows the relationship between sentimentalism and the women's anti-slavery movement.

The graphic arts, considered less prestigious than painting and sculpture in the nineteenth century, were a popular media, along with photography for the mass culture.

Also the medium was exploited by abolitionists to promote their cause. Only recently have scholars looked at its significance as a profession among African-American artists. Three issues of the *International Review of African American Art*, 12 provide the best information about African-American engravers and lithographers. Essays by Lizzetta LeFalle-Collins, 'Grafton Tyler Brown: Selling the Promise of the West', 12/1; Steven Jones, 'A Keen Sense of the Artistic: African American Material Culture in the Nineteenth Century', 12/2; and Patricia Brady, 'A Mixed Palette: Free Artists of Color of Antebellum New Orleans', 12/3. They cover the work of Grafton Tyler Brown, Patrick Reason, and Jules Lion respectively. Earlier publications in the 1970s also examined these artists and provided additional information for this book: Robert McDonald, John R. Kemp, and Edward F. Hass (eds), *Louisiana's Black Heritage* (New Orleans, LA, 1979), on Jules Lion as well as plantation artisans in that state; and Driskell, *Two Centuries*, on Patrick Reason, John James Audubon, and Jules Hudson.

Landscape painting has been a very popular subject of study in American art. Newer publications are using contemporary art theories as a method for interpreting landscape painting as a representation of culture and society, and the artists' particular milieu. These publications are for those who are familiar with the major artists and styles such as Barbara Novak, *Nature and Culture: American Landscape and Painting 1825–1875* (New York, 1980) which looks at landscape painting between 1850 and 1860; Angela Miller, *The Empire of the Eye: Landscape Representation and American Cultural Politics, 1825–1875* (New York, 1993), and Albert Boime, *Magisterial Gaze: Manifest Destiny and the American Landscape Painting, c.1830–1865* (Washington, DC, 1991). All three authors reflect contemporary scholarship by using art and literary theory as well as traditional methodology, iconology, and social history to understand landscape painting as representations of American culture and politics.

The first survey specifically on nineteenth century African-American artists was James Porter, *Ten Afro-American Artists of the Nineteenth Century* (Washington, DC, 1967). This was followed by a modest exhibition catalogue, *Selections of Nineteenth-Century Afro-American Art* (New York, 1976) by Regina Perry, which had short biographical entries for

Joshua Johnston, Julian Hudson, Jules Lion, Eugene Warburg, David B. Bowser, Robert S. Duncanson, Edward M. Bannister, Henry O. Tanner, as well as some folk artists including Harriet Powers. A well researched exhibition catalogue which has become a standard text is Lynda R. Hartigan, *Sharing Traditions: Five Black Artists in Nineteenth-Century America* (Washington, DC, 1985), which covers the art and careers of Johnston, Duncanson, Bannister, Lewis, and Tanner.

Robert S. Duncanson and Henry Ossawa Tanner have received more scholarly attention than Edward M. Bannister and Edmonia Lewis. There is Guy McElroy, *Robert S. Duncanson: A Centennial Exhibition* (Cincinnati, 1972); Norman Prendergraft, *Duncanson: A British-American Connection* (Durham, NC, 1984), and Ketner, *Robert S. Duncanson 1821–1872*. Ketner's book includes a catalogue raisonné, in addition to a chapter on African-American artists and abolitionist patronage of the nineteenth century. David Lubin, *Picturing A Nation: Art and Social Change in Nineteenth Century America* (New Haven, 1994) analyzes Duncanson's landscapes using postmodern theory to reveal a complex iconology. Much of the discussion revolves around the psychological effects of race, popularized as the myth of the 'tragic mulatto', and how this accounts for certain subjects in Duncanson's paintings. Lubin admittedly gives a speculative reading of only a few of Duncanson's paintings, but provides an example of contemporary methodology which reveals that there is no one absolute meaning to a work of art. Holland's essay 'Reaching Through the Veil', is the first substantial examination of Edward Mitchell Bannister, and looks at his political activism. It is well illustrated, showing previously unreproduced works, mostly in colour, with an artist chronology, and an interesting interpretation of his marine paintings by Corrine Jennings.

There are several survey texts on nineteenth century neocolassical sculpture in America including William H. Gerdts, *American Neoclassical Sculpture: The Marble Resurrection* (New York, 1973) and a few focusing on female neoclassical sculptors such as Carol Ockman, *Nineteenth-Century American Woman Neoclassical Sculptors* (Poughkeepsie, NY, 1972), Charlotte S. Rubinstein, *American Women Sculptors* (Boston, MA, 1990). A more thorough examination of the image of women, sentimentalism, and women artists and patronage is Kasson, *Marble Queens*. All are

well illustrated. An anthology for the specialists is Samuels (ed.), *The Culture of Sentiment*. This collection of essays uses feminist theory and cultural studies as a means of examining how the female body functions as a metaphor for class and race. Albert Boime, *The Art of Exclusion: Representing Blacks in the Nineteenth Century* (Washington, DC, 1990) provides a backdrop to understand how the depiction of blacks by African Americans differs from the norm as seen in popular culture and the fine arts. There are two publications about female abolitionists, which provide insights into the works of Edmonia Lewis: Yellin, *Women and Sisters*, and Jean Fagan Yellin and John C. Horne (eds), *The Abolitionist Sisterhood: Women's Political Culture in Antebellum America* (Ithaca, NY, 1994).

Within the last two years two articles and one essay on Edmonia Lewis have appeared. Kirsten P. Buick, 'The Ideal Works of Edmonia Lewis', *American Art*, 9/2 (1995), 5–19; Marilyn Richardson, 'Edmonia Lewis' *The Death of Cleopatra*: Myth and Identity', *International Review of African American Art*, 12/2 (1995), 36–52; and Judith Wilson 'Hagar's Daughters: Social History, Cultural Heritage, and Afro-American Women's Art' in *Bearing Witness: Contemporary Works by African American Women Artists* (New York, 1996). Buick's use of feminist theory provides a convincing analysis of Lewis's images of African-American women and North American Indians. These three authors explore symbolism and allegory in ways that show Lewis's works to be more complex than previously assumed.

Genre and biblical painting have always been secondary in importance to landscape painting and portraiture in American art from the nineteenth century. This is reflected in the available literature. One important source which includes discussion of biblical subjects favoured by many American artists is Lois Marie Fink, *American Art at the Nineteenth-Century Paris Salons* (Washington, DC, and New York, 1990). It is an excellent introduction to types of artistic subjects like biblical paintings, and a useful resource for identifying American artists exhibiting in the prestigious salons. For genre painting there are several books notably Patricia Hills, *The Painter's America: Rural and Urban Life, 1810–1910* (New York, 1974), and Elizabeth Johns, *American Genre Painting: The Politics of Everyday Life* (New Haven, 1992). Johns selected works made during the peak of genre

painting production (1830–61) to show how the ideology of 'everyday subjects' represented American character in the antebellum period; one which reinforced feelings of racial and gender superiority.

There are now two significant publications about Henry Ossawa Tanner, who produced many of the best representations of biblical subjects in his paintings. One is a virtual catalogue raisonné, *Henry Ossawa Tanner* (New York, 1991), by Dewey F. Mosby, Darrell Sewell, and Rae Alexander; the other a more succinct survey, Dewey Mosby, *Across Continents and Cultures: The Art and Life of Henny Ossawa Tanner* (Kansas City, 1995). Both publications were preceded by Marcia M. Mathews, *Henry Ossawa Tanner, American Artist* (Chicago, 1969) which was part of the Negro American biography series edited by historian John Hope Franklin, and was the first such book on the artist, sparsely illustrated in black-and-white. There is only one monograph about an African-American landscape painter who excelled in floral still-lifes, Helen K. Fusscas (ed.), *Charles Ethan Porter* (Marlborough, CT, 1988), an artist who lived in Hartford, Connecticut from *c*.1847 until 1923.

Chapter 3: Twentieth-Century America and Modern Art 1900–60
Introduction
For information about civil rights and the growing nationalism within the African-American community refer to any general African-American history text. There is a considerable literature on W. E. B. DuBois, whose *The Souls of Black Folk* (Chicago, 1903; repr., New York, 1990), contains his concept of 'double-consciousness' that scholars subsequently used as a basis for analyzing black intellectual thought and culture and race in the United States.

The Beaux-Arts tradition can be found in any American art history text, such as Craven, *American Art*. Published information about Meta Warrick Fuller is scattered. There is the Studio Museum Harlem, *Harlem Renaissance: Art of Black America* (New York, 1987); Rubinstein, *American Women Sculptors*; and a recent essay by Wilson 'Hagar's Daughters'.

A good introduction to modern art in America is Barbara Rose, *Readings in American Art Since 1900* (1968; rev. edn, New York, 1975), a compilation of the artists' own writings and those of contemporary critics which complements the organization of her *American Art Since 1900: A Critical History*

(1967; rev. and expanded edn, New York, 1975). A more comprehensive survey text is Hunter and Jacobus, *American Art*. Another very good introduction can be found in Rose, *American Painting*. Other good basic American art history publications are Craven, *American Art*; Milton W. Brown, *American Painting: From the Armory Show to the Depression* (Princeton, NJ, 1955); William Agee, *The 1930s: Painting and Sculpture in America* (New York, 1968). A very good introduction to art and popular culture, urbanism, and American artists at the turn of the century in the Northeast, is Rebecca Zurier, *Metropolitan Live: The Ashcan Artists and Their New York* (New York, 1995).

Publications on African-American art include Porter, *Modern Negro Art*, Driskell, *Two Centuries*, and Elsa Honig Fine, *The Afro-American Artist* (New York, 1973) which is now out-of-print. Fine's book is the only one which provides an overview of mainstream modern American art and European art with which readers will invariably make comparisons to black artists. The goal is apparently to show the sophistication of the artists illustrated in this book, and generally to help those readers with little knowledge about modern western art.

African American Culture, the New Negro and Art in the 1920s
There are two general art history publications: Richard J. Powell, *The Blues Aesthetic: Black Culture and Modernism* (Washington, DC, 1989), which highlights the effect of black culture on the development of modernism; and the Studio Museum Harlem, *Explorations in the City of Light: African-American Artists in Paris, 1945–1965* (New York, 1996).

The New Negro Movement and the Negro Renaissance
Foremost among the history texts on the New Negro Movement is Nathan Huggins, *The Harlem Renaissance* (New York, 1971), which provides the best study of visual arts contextualized within the social and cultural history of the period. He is especially attentive to Alain Locke's concept of the ancestral arts, and the development of a Negro 'school' of art, which Huggins concludes was a failure. Another very good introductory work is an anthology, David Levering Lewis (ed.), *The Portable Harlem Renaissance Reader* (New York, 1994) which has reprinted hard-to-find essays, short fiction, excerpts from novels, speeches and reminiscences by visual artists, writers, and philosophers, including some

unpublished material such as Aaron Douglas's recounting the painting of his murals at Fisk University. Lewis's introduction and preface before each essay helps the reader understand the Negro Renaissance from the viewpoint of those who participated in it. Lewis also wrote a more extensive book, *When Harlem Was in Vogue* (New York, 1981). For a journalistic account filled with quoted recollections of the participants, there is Jervis Anderson, *This Was Harlem: A Cultural Portrait, 1900–1950* (New York, 1981), which recaptures the vibrancy of Harlem during the renaissance.

The art historians are beginning to match the efforts of historians studying the period of the 1920s and 1930s. Again, Porter, *Modern Negro Art*; Driskell, *Two Centuries*; Fine, *The Afro-American Artist*; and McElroy, Powell, and Patton, *African-American Artists*, are useful. The only substantial survey of the period is the Studio Museum in Harlem, *Harlem Renaissance*, which contains essays by a historian, and several by art historians.

Deborah Willis-Thomas's research has been the foundation for the history of African-American photography. Here earlier published bibliography, *Black Photographers 1840–1940*, was followed by *Black Photographers 1940–1988* (New York, 1989). She also wrote a good introductory essay about black photographers during the 1920s and '30s in Gary Reynolds and Beryl J. Wright (eds), *Against the Odds: African American Artists and the Harmon Foundation* (Newark, 1989). The feminist perspective is provided by Jeanne Moutoussamy-Ashe, *Viewfinders: Black Women Photographers* (New York, 1993). A very good introduction to James Van Der Zee, written by Deborah Willis-Ryan (Willis-Thomas), is in the Studio Museum of Harlem, *Harlem Renaissance*. Prior to that there was Reginald McGhee, *The World of James Van Der Zee: A Visual Record of Black Americans* (New York, 1969) which was published in response to a renewed interest in the photographer after the Metropolitan Museum's 'Harlem On My Mind' Exhibition in 1969. This exhibition catalogue, Allon Schoener (ed.), *Harlem On My Mind* (1969; repr. New York, 1995) reproduces many of Van Der Zee's photographs displayed in the exhibition. The first survey of Van Der Zee's work in twenty years, and heavily illustrated including his late portraits in the early 1980s, and a biographical essay is Deborah Willis-Braithwaite, *Van Der Zee, Photographer 1886–1983* (New York, 1993). Finally there is a good book for students and non-specialists, Jim Haskins, *James Van Der Zee: The Picture Takin' Man* (Trenton, NJ, 1991).

Any student of the New Negro artists and the philosophy of Alain Locke must begin with *The New Negro: An Interpretation*, edited by Alain Locke (New York, 1925; repr. New York, 1969). It includes reproductions of the original illustrations of African art, and the drawings of Aaron Douglas. The pivotal essays, 'The Legacy of the Ancestral Arts', and 'The New Negro', provide the conceptual and philosophical basis for the cultural vanguard. Other essays by W. E. B. DuBois, and Albert C. Barnes reflect the different agendas held by white and black Americans for the New Negro artist. For the more advanced student interested in the role Africa played in the ideology of the African-American Renaissance should read Sidney F. Lemelle and Robin D. G. Kelley (eds), *Imagining Home: Class, Culture, and Nationalism in the African Diaspora* (New York, 1994), with particular attention to Charlotte Ogren's essay 'What is Africa to Me?'. A critical voice echoing Nathan Huggins reservations about the merits of the Negro Renaissance is Eugene W. Metcalf, 'Black Art, Folk Art, and Social Control', *Winterthur Portfolio*, 18/4 (1983), 271–88. Metcalf discusses the cultural exploitation of African Americans by whites in their pursuit of modernism.

This 'New Negro' art was first evident in the graphic arts. Within the past ten years there have been individual monographs on major New Negro artists including Amy Helene Kirschke, *Aaron Douglas: Art, Race, & The Harlem Renaissance* (Jackson, MS, 1995); Allan M. Gordon, *Echoes of Our Past: The Narrative Artistry of Palmer C. Hayden* (Los Angeles, 1988); and, Jontyle Robinson, and Wendy Greenhouse, *The Art of Archibald J. Motley, Jr* (Chicago, 1992).

State Funding and the Rise of African-American Art

A few intermediary level texts which focus on the cultural politics of President Roosevelt's New Deal, and Federal Arts programmes are: Francis Frascina, Jonathan Harris, and Charles Harrison (eds.), *Modernism in Dispute: Art Since the Forties* (New Haven, 1993); and Erika Doss, *Benton, Pollock, and the Politics of Modernism: From Regionalism to Abstract Expressionism* (Chicago, 1991). Doss chronicles the change in art patronage and taste from the 1930s to the 1950s, by focusing on Thomas Hart Benton, the premier American Scene painter, and his student

Jackson Pollock, the most significant representative of Abstract Expressionism.

One publication stands out for information about the legacy of the New Negro Movement: Reynolds and Wright, *Against The Odds*. It gives the first serious study of the Harmon Foundation, the major philanthropic organization which was so important in the 1920s and 1930s, and explains how it was instrumental in developing artists' careers and promoting the ideals of Locke after the decline of the Negro renaissance. There are essays on American history, the history of the Foundation, the association of William H. Johnson with the Foundation, photography, art criticism, and the Foundation exhibitions, and an exhibition checklist for 33 artists who were selected most frequently to exhibit with illustrations representative of their works, and an exhibition record. This publication aside from Bearden and Henderson, *A History of the African-American Artists*, is the only source for information and visual examples of such artists as Augusta Savage, Richmond Barthé, Lois M. Jones, and William H. Johnson. Another catalogue edited by William E. Taylor and Harriet G. Warkel, is *A Shared Heritage: Art by Four African Americans* (Bloomington, IN, 1996). This covers the lives and art of four artists whose training and early careers began in Indiana: William E. Scott (1884–1964), John W. Hardrick (1891–1968), Hale A. Woodruff, and William Majors (1930–1982).

Information about Négritude and the figurative sculptor is very scarce and may be found in individual art catalogues, for example, Deirdre Bibby, *Augusta Savage* (New York, 1989), and *Sargent Johnson: Retrospective* (Oakland, 1971); and Reynolds and Wright, *Against the Odds*.

The literature on folk art is rich. John M. Vlach and Simon J. Bronner (eds), *Folk Art and Art Worlds* (Ann Arbor, 1986), part of a series edited by Simon J. Bronner on American material culture and folklife, is an anthology of eleven essays exploring the changing face of folk art in different contexts or folk art 'worlds', using an interdisciplinary approach. Jane Livingston and John Beardsley, *Black Folk Art in America 1930–1980* (Jackson, MS, 1982), an exhibition catalogue has become a familiar text on black folk art partly because it is well illustrated, though its arguments on the analysis of what constitutes 'folk' are occasionally flawed. An earlier publication edited by Herbert W. Hemphill, Jr, *Folk Sculpture, USA* (New York, 1976) includes an essay by Michael Kan, 'American Folk

Sculpture: Some considerations of its Ethnic Heritage'. Kan shows several African-American genres from the nineteenth and twentieth centuries, many examples never before (nor since) illustrated such as voodoo figures found in New Orleans (*c*.1930).

There are now three exhibition monographs on William Edmondson: Edmund L. Fuller, *Visions In Stone* (Pittsburgh, 1973); Georganne Fletcher (ed.), *William Edmondson: A Retrospective* (Memphis, 1981); and *Miracles: The Sculptures of William Edmondson* (Philadelphia, 1994). There is one recent monograph on Horace Pippin, Judith Stein (ed.), *I Tell My Heart: The Art of Horace Pippin* (New York, 1993). Selden Rodman published the first such publication on Pippin, called *Horace Pippin: A Negro Painter in America* (New York, 1947; repr., New York, 1972).

Other than Taylor and Warkel, *A Shared Heritage* which has essays on the murals of William E. Scott and Hale A. Woodruff, and a few publications on individual artists, like Charles Alston, Jon Biggers (b. 1924), Hale A. Woodruff, and Charles White (1918–79), there has been no publication specifically about African-American muralists and their indebtedness to the Mexican muralists during the 1930s and '40s, until now. Lizetta LeFalle Collins and Shifra M. Goldman, *The Spirit of Resistance: The African-American and Mexican Muralists* (New York, 1996), is a bi-lingual (Spanish-English) catalogue with illustrations of African-American and Mexican murals. It also covers the 'second wave' of black muralists in the US and the image of the black in Mexican murals during the 1960s.

There is no single publication on the WPA art centres. Other than general African-American art books and Reynolds and Wright, *Against the Odds*, there is James Hatch and Camille Billops, *Artist and Influence 1987*, Vol. 5, *The Visual Arts* (New York, 1987). which publishes an interview with artists who were students at the Harlem Community Art Center, and who recalled activities in the Harlem Artists Guild. Catalogues about WPA and African-American printmakers are too few and difficult to find. However, one recent catalogue provides a good overview and is well illustrated: *Alone In a Crowd, Prints of the 1930s 1940s by African-American Artists* (2nd rev. end, New York, 1993), which is based on the collection of Reba and Dave Williams. Information about Dox Thrash's carborandum prints and his life can be found in this catalogue and in the museum bulletin,

A Selection of Works by African American Artists in the Philadelphia Museum of Art, 19/382–3 (1995).

Aside from survey texts on African-American art, only artists' monographs provide substantial information about the abstract figurative painters of the 1940s: *Norman Lewis: From the Harlem Renaissance to Abstraction* (New York, 1989); Richard Powell, *Homecoming: The Art and Life of William H. Johnson* (New York, 1991); Ellen Harkins Wheat, *Jacob Lawrence, American Painter* (Seattle, 1986). Another book, Elizabeth Hutton Turner, *Jacob Lawrence, The Migration Series* (Washington, DC, 1993) reproduces each panel in colour, providing a rare opportunity to see an entire series. It also includes a thorough history about the Downtown Gallery owner and director Edith G. Halpert and her role in the promotion of modern African-American art of the 1940s.

For a brief discussion about patronage and the critical debates revolving around modern black American art see Driskell, *Two Centuries*, Keith Morrison, *Art in Washington and Its Afro-American Presence: 1940–1970* (Washington, DC, 1985), and Porter, *Modern Negro Art*.

Post-war American Culture

Readers are again advised to start with any number of art histories: Hunter and Jacobus, *American Art*, and topical or thematic survey texts including Rose, *American Painting*, Irving Sandler, *The Triumph of American Painting: A History of Abstract Expressionism* (New York, 1970); Irving Sandler, *The New York School: The Painters and Sculptors of the Fifties* (New York, 1978); Maurice Berger, *Beat Culture and the New America, 1950–1965* (New York and Paris, 1995); Francis Frascina and Charles Harris (eds), *Art In Modern Culture* (New York, 1992); and Frascina, Harris, and Harrison (eds), *Modernism in Dispute*. The latter is one of a series of four books in association with the Open University, London, which focuses on art and cultural politics from the mid-nineteenth century to the end of the twentieth century. These and the following book are for the advanced reader already familiar with the standard arguments about modernist art. Charles Harrison and Paul Wood (eds), *Art in Theory 1900–1990: An Anthology of Changing Ideas* (Oxford, 1992) is an excellent anthology of edited essays by art critics, artists, and theorists in Europe and the United States. The introduction guides and contextualizes the different sections, which

provide the most comprehensive collection of writings on modern art, most of which are difficult to access. This paperback edition is of immense value to student, teacher, and scholar alike.

It is very difficult to obtain published information specifically on African-American artists and modernism of 1940s and 1950s. The literature mostly ignores this most experimental and aesthetically fertile period in American art. Journalist Cedric Dover's, *American Negro Art* (Greenwich, CT, 1960), is an eclectic book which concentrates on the mid-twentieth century, but includes eighteenth and nineteenth century fine art and crafts, and topics like the mulatto artist and academic art training. The reproductions of art not found elsewhere make this out-of-print publication worth noting. *Since the Harlem Renaissance: 50 Years of Afro-American Art* (Lewisburg, PA, 1985); Reginia Perry, *Free Within Ourselves* (Washington, DC, 1992), which reproduces black art from the permanent collection of the National Museum of American Art; Driskell, *Two Centuries*; and McElroy, Powell, and Patton, *African-American Artists*, together with Dover's book provide a sampling of visual images from the late 1940s and the 1950s with brief introductory essays. Elton C. Fax, *17 Black Artists* (New York, 1971) is a compilation of artists' autobiographies, including Elizabeth Catlett, Charles White, Eldzier Cortor, Roy De Carava, Romare Bearden, John Wilson and the younger generation of artists like Faith Ringgold, which provide some information about the 1950s.

A few other books are: Powell, *The Blues Aesthetic*, which examines different media and the aesthetic of the blues as the single most important African-American contribution to American art; Morrison, *Art in Washington*, which shows the role Alain Locke, James Porter, James Herring, and Alonzo Aden had in the promotion of mid-century modernism in the nation's capital; and the Studio Museum in Harlem, *Explorations in the City of Light*, which reveals a now familiar history about the relationship between African-American and Parisian artists. This last publication focuses on seven artists, a few of whom have not been studied before, such as Harold Cousins (1917–92) and Larry Potter (1925–66), and summarizes the intellectual life of whites and blacks in Paris during the 1920s and 1930s. Therefore, it will probably become a popular and basic text for the period.

Within the past ten years there has been a

proliferation of publications on American folk art which include African-American folk artists. Titles include: Vlach and Bronner, *Folk Art and Art Worlds*, part of a series edited by Simon J. Bronner on American material culture and folklife, which is an anthology of eleven essays exploring the changing face of folk art in different contexts or folk art 'worlds', using an interdisciplinary approach. Livingston and Beardsley, *Black Folk Art* has become a standard text on black folk art despite its occasional flawed arguments which seem contradictory in the analysis of the concept of folk, especially in modern and contemporary times. It began as an exhibition catalogue for the Corcoran Gallery of Art, and the Center for the Study of Southern Culture at the University of Mississippi, and has numerous illustrations with individual biographies and analysis of the artists' art. Other books are Chuck and Jan Rosenak, *Museum of American Folk Art: Encyclopedia of Twentieth-Century American Folk Art and Artists* (New York, 1990); Alice Rae Yelen, *Passionate Visions of the American South: Self-Taught Artists from 1940 to the Present* (New Orleans, 1993); Frank Maresca and Roger Ricco, *American Self-Taught: Paintings and Drawings by Outsider Artists* (New York, 1993). There are also monographs on black folk artists: I. Amiri Baraka, Thomas McEvilley, Paul Arnett, and William Arnett, *Thornton Dial: Image of the Tiger* (New York, 1993); Frank Maresca and Roger Ricco, *Bill Traylor: His Art, His Life* (New York, 1991); James L. Wilson, *Clementine Hunter, American folk Artist* (Gretna, LA, 1990); Norma J. Roberts (ed.), *Elijah Pierce, Woodcarver* (Seattle, 1992); and Charles Lovell (ed.), *Minnie Evans: Artist* (Greenville, 1993).

Information about Expressionism and Surrealism can be found in *Exploration of the City of Light*, and individual exhibition catalogues, *Beauford Delaney: A Retrospective* (New York, 1978), and *Hughie Lee-Smith: Retrospective Exhibition* (Trenton, NJ, 1989). So far there is no catalogue on Elzier Cortor.

The literature is very good in covering abstract expressionism in American art. Aside from the standard publications on twentieth century American art there are those which focus on Abstract Expressionism. Serge Guilbaut, *How New York Stole the Idea of Modern Art: Abstract Expressionism, Freedom, and the Cold War* (Chicago, 1983); *Reframing Abstract Expressionism: Subjectivity and Painting in the 1940s* by Michael Leja (New Haven, 1993), and *The Turning Point: The*

Abstract Expressionists and the Transformation of American Art by April Kingsley (New York, 1992). For a very good discussion and excellent visual resource about primitivism and modernism, there is the ground-breaking and controversial, William Rubin (ed.), *'Primitivism' in 20th Century Art* (New York, 1984), a two-volume exhibition catalogue. The second volume has an essay by Kirk Varnedoe, 'Abstract Expressionism', which closely examines the social and political motives for mainstream American artists' shift to North American Indian art as the preferred primitive source rather than African art.

Only one publication examines African-American artists and Abstract Expressionism. Ann Gibson, Steve Cannon, Frank Bowlin, and Thomas McEvilley, *The Search for Freedom: African American Abstract painting 1945–1975* (New York, 1991), is a well illustrated book which grapples for the first time with Abstract Expressionism and the lack of critical recognition of black artists in the late 1940s, '50s, and early '60s. Ann Gibson wrote the main historical overview which refers to 35 African-American artists whose works have never before been reproduced. In *A Shared Heritage*, an essay by Corinne Jennings about Hale A. Woodruff, and another by Harriet G. Warkel about William Majors, augment the slim documentation about black Abstract Expressionists. Researchers and general readers must ferret out information from hard-to-find exhibition pamphlets and catalogues on individual artists, for example, *Charles Alston: Artist and Teacher* (New York, 1990); *Norman Lewis: From the Harlem Renaissance to Abstraction* (New York, 1989), and Lowery S. Sims, *Romare Bearden: Origins and Progressions* (Detroit, 1986).

Chapter 4: Twentieth Century America: The Evolution of a Black Aesthetic
Introduction
Hunter and Jacobus, *American Art*; Corrine Robins, *The Pluralist Era: American Art, 1968–1981* (New York, 1984); Irving Sandler, *American Art of the 1960s* (New York, 1988), provide the broad coverage highlighting key philosophical and cultural issues. Several publications focus on art and politics including Nina C. Sundell, *The Turning Point: Art and Politics in Nineteen Sixty-Eight* (Cleveland, OH, 1988); Jeanne Siegel, *Artwords: Discourse on the 60s and 70s* (Ann Arbor, MI, 1985), which includes interviews with Romare Bearden, Alvin Hollingsworth, and William Majors; and Lucy R. Lippard, *Get the Message?*

A Decade of Art for Social Change (New York, 1984), which is about feminism and leftist politics.

For a feminist perspective, there is Lucy R. Lippard, *From the Center: Feminist Essays and Women's Art* (New York, 1976), and Randy Rosen and Catherine C. Brawer, *Making Their Mark: Women Artists Move into the Mainstream, 1970–1985* (New York, 1989). Arna Alexander Bontemps (ed.), *Forever Free: Art by African-American Women 1862–1980* (Alexandria, VA, 1980) was the first survey specifically about black women artists.

Other than Fine, *The Afro-American Artist*, and Lewis, *African American Art and Artists* (Berkeley, CA, 1990) there are only two publications specifically about African-American art, culture, and history in the 1960s: Mary Schmidt Campbell, *Tradition and Conflict: Images of a Turbulent Decade 1963–1973* (New York, 1985), which gives national perspective and has an excellent history of the period; and *19 Sixties: A Cultural Awakening Re-Evaluated, 1965–1975* (Los Angeles, 1975) which gives a regional perspective, focusing on California.

For additional information about Spiral and Romare Bearden there is an essay on the artists' group by Floyd Coleman in *A Shared Heritage*. Several monographs currently available have been published about Romare Bearden: Myron Schwartzman, *Romare Bearden: His Life and Art* (New York, 1990); Sharon F. Patton, *Memory and Metaphor: The Art of Romare Bearden, 1940–1987* (New York, 1991); and Gail Gelburd and Thelma Golden, *Romare Bearden in Black-and-White: Photomontage Projections, 1964* (New York, 1997).

There are a few publications which focus on the question of a black aesthetic. Addison Gayle Jr (ed.), *The Black Aesthetic* (Garden City, NY, 1971) lays out the basic premise for developing a black aesthetic in his introduction. Fine, *The Afro-American Artist*, is a survey art history text whose strengths are in its coverage of the art and politics of the 1970s. Two historically important exhibition catalogues which together define the moment of the black art debates are: Robert Doty, *Contemporary Black Artists in America* (New York, 1971) for the show at the Whitney Museum of American Art, and Edmund Barry Gaither, *Afro-American Artists, New York and Boston* (Boston, 1970).

Towards a New Abstraction

Information about 'black art' and 'mainstream'

artists is available in exhibition catalogues or small press publications which are not easily found or soon out-of-print. For example: Samella Lewis, *The Art of Elizabeth Catlett* (Los Angeles, 1984); Lucinda H. Gedeon (ed.), *Melvin Edwards Sculptor: A Thirty Year Retrospective 1963–1993* (Seattle, 1993); Studio Museum in Harlem, *Faith Ringgold: Twenty Years of Painting, Sculpture, and Performance (1963–1983)* (New York, 1983), and *The Collages of Benny Andrews* (New York, 1988); Merry A. Foresta, *A Life in Art: Alma Thomas, 1891–1978* (Washington, DC, 1981); Elizabeth Shepherd, *Secrets, Dialogues, Revelations: The Art of Betye and Alison Saar* (Los Angeles, 1990). Occasionally essays from such publications are reprinted in an anthology, e.g. Lowery S. Sims, 'Race Riots, Cocktail Parties, Black Panther, Moon Shots, and Feminists', in Norma Broude and Mary D. Garrard (eds), *The Expanding Discourse Feminism and Art History* (New York, 1992). Beryl Wright, *The Appropriate Object* (Buffalo, NY, 1989), features essays and interviews with several established artists like Richard Hunt, Oliver Jackson, Alvin Loving, Betye Saar, and Raymond Saunders. Another catalogue, David C. Driskell, *Contemporary Visual Expressions* (Washington, DC, 1987) similarly focuses on selected artists including Sam Gilliam and William T. Williams.

Minnie Evans has received quite a bit of attention since her death: Mitchell Kahan, *Heavenly Visions: The Art of Minnie Evans* (Raleigh, NC, 1986), and Lovell (ed.), *Minnie Evans*.

The Postmodern Condition 1980-93

It is difficult to find a basic introductory text on postmodernism. However, there is one which summarizes the theory, the academy, and different artistic genres including performance and popular culture: Steven Connor, *Postmodernist Culture: An Introduction to Theories of the Contemporary* (Oxford, 1989). Fortunately there are an increasing number of anthologies which reprint hard-to-find articles or new essays which allow the reader to compare different theories and ways of considering cultural politics. For the advanced student there is Francis Frascina and Jonathan Harris (eds.), *Art in Modern Culture: An Anthology of Critical Texts* (New York, 1992), and a series of publications by the New Museum of Contemporary Art, New York: Brian Wallis (ed.), *Art After Modernism: Rethinking Representation* (Boston, 1984), which has a

good introductory discussion about postmodernism by Hal Foster, and photography by Abigail Solomon-Godeau; Russell Ferguson, William Olander, Marcia Tucker, and Karen Fiss (eds), *Discourses: Conversations in Postmodern Art and Culture* (Cambridge, MA, 1990); and Russell Ferguson, Martha Gever, Trinh T. Minh-ha, and Cornel West (eds), *Out There: Marginalization and Contemporary Culture* (Cambridge, MA, 1990). Hal Foster has edited several anthologies of critical essays that focus on racial, sexual, and cultural difference: *Discussions in Contemporary Culture* (Port Townsend, WA, 1987); and *The anti-Aesthetic: Essays on Postmodern Culture* (Port Townsend, WA, 1983), which includes Craig Owens' essay on feminists and postmodernism which many artists of colour lambasted as they were not included in this discussion about feminism. For a discussion of *bricolage* as a modernist representation of primitivism refer to Hal Foster, *Recodings, Art, Spectacle, Cultural Politics* (Port Townsend, WA, 1985).

The New Museum of Contemporary Art, the Museum of Contemporary Hispanic Art, and the Studio Museum in Harlem, *The Decade Show: New Frameworks of Identity in the 1980s* (New York, 1989), and Lucy R. Lippard, *Mixed Blessings: New Art in a Multicultural America* (New York, 1990), discuss the cross-cultural processes in the art of Latino-, Native-, African- and Asian-Americans, including many of the artists cited in this survey. Both are well illustrated and have extensive bibliographies; and in *The Decade Show* there is a resource guide for performance art videos. Information may be found in individual exhibition catalogues; fortunately some of these have been published by major presses. For example, there is Richard Marshall (ed.), *Jean-Michel Basquiat* (New York, 1993); Neal Benezra, *Martin Puryear* (New York, 1991); Steven Cannon, Kellie Jones, and Tom Finkelpearl, *David Hammons: Rousing the Rubble* (Cambridge, MA , 1991); the Walker Art Center, *Dawoud Bey Portraits 1975–1995* (Minneapolis, 1995); and most recently, Adrian Piper, *Out of Order, Out of Sight*, 2 vols (Cambridge, MA, 1996).

Examples of site-specific installation are in Leslie King-Hammond and Lowery S. Sims, *Art As A Verb* (Baltimore, MD, 1988) which, unfortunately, is not readily available; but there are certain exhibition catalogues or books like *Places With A Past* (New York, 1991) which document the site-specific art

commissioned for Charleston's (South Carolina) Spoleto Festival, including those by Houston Conwill, David Hammons, Joyce Scott, and Lorna Simpson.

There is currently only one text that is specifically about African-American art and postmodernism: David C. Driskell (ed.), *African American Visual Aesthetics: A Postmodernist View* (Washington, DC, 1995). This anthology includes essays that look at the diaspora and cultural pluralism, black women and postmodern theory, selected artists and black art in the 1980s.

A concern about art institutions and their role in establishing who represents postmodern art is in Maurice Berger (ed.), *How Art Becomes History: Essays on Art, Society, and Culture in Post-New Deal America* (New York, 1992). This reprints his essays on museums and racism, and an interview with African-American artists, art historians and a museum director about race and the mainstream art community in the 1980s.

Gender and sexuality, and popular culture are two favoured topics for the postmodernist scholar. Useful essays on cultural politics and feminism for the more advanced student including Rozsika Parker and Griselda Pollack (eds.), *Reframing Feminism: Art and the Women's Movement, 1970–85* (London, 1987), and Arlene Raven, Cassandra Langer, and Joanna Frueh (eds), *Feminist Art Criticism* (Ann Arbor, 1988; repr., New York, 1991). The latter has an essay on performance and African-American women artists by Lowery S. Sims which makes this book an essential text.

One publication focuses on theory and black women: Stanlie M. Ames and Abena P. A. Busia (eds), *Theorizing Black Feminisms: The Visionary Pragmatism of Black Women* (London and New York, 1993). In it is an essay by Frieda High W. Tesfagiorgis who explores the ways theory can be a useful tool for analyzing art by black women and invents a new paradigm called 'afrofemcentrism'. This is best understood by first reading Patricia Hill Collins, *Black Feminist Thought* (New York, 1990). A fundamental essay about race, femaleness, and power is by Adrian Piper, 'The Triple Negation of Colored Women Artists', that first appeared in an exhibition catalogue, Lowery S. Sims (ed.), *Next Generation: Southern Black Aesthetics* (Winston-Salem, NC, 1990), and is reprinted in the newly published anthology of Piper's writings, *Out of Order, Out of Sight*.

Recently there have been three anthologies on black women artists published: Leslie

King-Hammond, *Gumbo Ya Ya: Anthology of Contemporary African-American Women Artists* (New York, 1995); Robert Henkes, *The Art of Black American Women: Works of Twenty Four Artists of the Twentieth Century* (Jefferson, NC, 1993); and *Bearing Witness: Contemporary Works by African American Women Artists* (New York, 1996). The first two publications function more like an encyclopaedia—biography, artists' statements, and formal anaylsis of each artist's representative works. *Bearing Witness* follows a similar format, except there are insightful essays which reflect the progress made in the scholarship about black women's art. All three books are well illustrated, and within the span of four years have made up for a major omission in African-American art history.

Thelma Golden (ed.), *Representations of Masculinity in Contemporary American Art* (New York, 1994), contains several essays and reprinted articles on art, film, music, and urban culture, by cultural historians and critics of black culture, many themselves African American. Gina Dent (ed.), *Black Popular Culture* (Seattle, 1992) is an anthology of essays by artists, critics, art historians and cultural studies scholars, examining race, gender, and sexuality and a variety of media and art practice. Kobena Mercer, *Welcome to the Jungle: New Positions in Black Cultural Studies* (New York, 1994), discusses for example, black hair and style politics. and the issues of black art and its representations, using psychoanalysis and postcolonial theory.

Discussions about the aesthetics of the African diaspora can be found in a few catalogues: Henry J. Drewal and David C. Driskell, *Introspectives: Contemporary Art by Africans and Brazilians of African Descent* (Los Angeles, 1989); Wyatt MacGaffey and Michael D. Harris, *Astonishments & Power: Kongo Minkisi and the Art of Renee Stout* (Washington, DC, 1993), and Alvia Wardlaw (ed.), *Black Art, Ancestral Legacy: The African Impulse in African American Art* (New York, 1989). This book surveys the connections between African and African-American art and Caribbean art, both folk and fine art.

	Pre-1700	1700	1720	1740	1760
Artistic achievements, movements, and exhibitions	● 1640s Slave-made drum on plantation, Virginia ● 1670 Earliest dated earthenware, Virginia and South Carolina	● 1700–50 Peak production of colonoware		● Blacks establish skill as blacksmiths	● 1770–1820s Portraiture becomes popular in US ● 1773 Scipio Moorhead draws a portrait of the American colonies' first black poet Phillis Wheatley – Slave-made wrought-iron figure, Virginia
Cultural and political history	● 1619 African slaves arrive in Jamestown, Virginia ● 1688 The Society of Friends (Quakers) begin to agitate for the abolition of slavery		● 1727 Benjamin Franklin organizes the *Junto*, Philadelphia, a benevolent society which opposed slavery ● 1739 Stono Rebellion, near Charlestown, South Carolina	● 1740 French Huguenots establish Curriboo and Yaughan plantations, South Carolina	● 1773 Phillis Wheatley's *Poems on Various Subjects* published, England ● 1775–83 War of Independence ● 1776 Declaration of Independence

1780

● 1780s–1830s African Americans dominate artisanship in South

1800

● 1790s–1800s African House built Natchitoches, Louisiana

● 1796 Joshua Johnston advertises in Baltimore as a portrait painter

● 1803 Moses Williams, a successful 'profile cutter', Peale Museum, Philadelphia, earns his freedom

● 1808 Philadelphia is the centre of furniture production in the Northeast

● 1810–25 Lithography introduced to America

1820

● 1820s–60s Shotgun house and creole cottage become popular architectural styles in New Orleans

● 1820–70 Start of popularity of landscape painting

● 1833 Robert Douglass, Jr lithograph of William Lloyd Garrison, earliest known surviving print by an African American
– African-American cabinet-makers succeed professionally
– Julian Hudson (active 1831–44) is earliest documented professional painter in South

1840

● 1840s–60s James Presley Ball operates 'Ball's Great Daguerrean Gallery of the West', Cincinnati

● 1842 Jules Lion introduces the danguerreotype, New Orleans

● 1850–80 Slaves and free blacks make Edgefield District, South Carolina, a major site for alkaline glazed stoneware

● 1852 Robert Duncanson completes murals for Nicholas Longworth's Belmont Mansion, Cincinnati

● 1855 James Presley Ball completes photo-panorama 'Ball's Splendid Mammoth Pictorial Tour of the United States'

● 1780s Free blacks establish mutual benefit societies in Northeast

● 1783 Great Britain formally recognizes a new sovereignty, the United States of America

● 1787 US Constitution recognizes and protects slavery
– Josiah Wedgwood executes porcelain abolitionist medallions which he sends to Benjamin Franklin in Philadelphia

● 1789 George Washington elected first US president

● 1791–1804 Slave revolts in St Domingue force free blacks to migrate to New Orleans and Charleston

● 1796 Fugitive Slave Bill is enacted

● 1803 Louisiana Purchase

● 1804 Haiti achieves independence from France

● 1808 Europe makes slave trade illegal
– US outlaws importation of slaves

● 1812 War with Great Britain

● 1816 White legislators in the US House of Representatives organize The American Colonization Society to encourage blacks to return to Africa

● 1827 First black newspaper, *Freedom's Journal* published

● 1828 Jacksonian Era and Manifest Destiny

● 1831 William Lloyd Garrison and Isaac Knapp Publish the *Liberator*, Boston

● 1833 American Anti-Slavery Society established, Philadelphia

● 1846 Mexican–American War

● 1847 AME Church publishes *Christian Herald*
– Frederick Douglass's *North Star* published
– Frederick Douglass elected president of New England Anti-Slavery Society

● 1849 Harriet Tubman, fugitive slave, becomes active agent in the Underground Railroad

● 1852 Harriet Beecher Stowe's *Uncle Tom's Cabin* published

● 1855 William Cooper Nell's *Colored Patriots of the American Revolution* published

● 1857 Dredd Scott decision by Supreme Court declares African Americans are not US citizens

● 1858 Last slave ship to North America, *The Wanderer*, runs aground on Jekyll Island, Georgia

● 1859 White abolitionist John Brown leads raid on federal armory, Harpers Ferry, Virginia, to secure munitions for large-scale revolt
– Harriet E. Wilson's *Our Nig* published, first novel by an African-American woman

 1860 **1880** **1900**

Artistic achievements, movements, and exhibitions

● 1862 Colonel Thomas Davies opens his pottery works which operate for 3 years and where face-vessels are made by slaves
● 1865 Robert Duncanson is acclaimed by European royalty, and by white and black abolitionists in US and Europe
● 1866 Edmonia Lewis becomes one of American women artists in Rome whom writer Henry James called the 'white marmorean flock'
– Robert S. Duncanson exhibits 'Lotus Eaters' in London

● 1870–79 Metropolitan Museum, Philadelphia Museum of Art, National Academy of Design, New York, and Art Institute of Chicago open
● 1873 Edmonia Lewis travels from Rome to California, making her one of the first American sculptors to exhibit in California
● 1876 Edward Mitchell Bannister's *Under the Oaks* wins Bronze medal for painting, at the United States Centennnial Exposition, Philadelphia
– Edmonia Lewis's *Death of Cleopatra* causes a sensation at the Exposition

● 1880 Edward Mitchell Bannister with several white artists charters the Providence (Rhode Island) Art Club
● 1886 Harriet Powers's Bible quilt shown at Cotton Fair, Athens, Georgia

● 1890 National Association of Women Painters and Sculptors founded
● 1893 Henry Ossawa Tanner speaks at 'The Negro in American Art' lecture, Congress of Africa Symposium, World's Columbian Exposition, Chicago
● 1897 Henry Ossawa Tanner exhibits *The Resurrection of Lazarus* at the Paris Salon

● 1909 William E Scott's mural, *Commerce*, completed, Lane Technical High School, Chicago
● 1911 Photo-grapher Addison Scurlock establishes studio Washington, DC
● 1913 The International Exhibition of Modern Art, 69th Regiment Armory New York, opens
● 1914 Meta Warwick Fuller first sculptor to introduce African subject-matter in African-American art

Cultural and political history

● 1861–65 The United States Civil War
● 1863 President Abraham Lincoln signs the Emancipation Proclamation
– William Wells Brown's *The Black Man: His Antecedents, His Genius, and His Achievements* published, Boston
– Colonel Robert Gould Shaw leads the black 54th Massachusetts Regiment out of Boston
● 1865 Recon-struction period
– Ratification of 13th Amendment to constitution abolishes slavery
– Freedman's Bureau established

● 1876 US celebrates centennial of the Declaration of Independence

● 1880 George Eastman perfects hand-held Kodak box camera
● 1881 Booker T. Washington (US educator, and former slave) organizes Tuskegee National and Industrial Institute
● 1887 William J. Simmons, *Men of Mark: Eminent, Progressive, and Rising* published Philadelphia

● 1890s Socio-cultural publications on southern blacks by Frederick Douglass, Booker T. Washington, W. E. B. DuBois
● 1895 National Association of Colored Women established
● 1896 US Supreme Court decision Plessy v Ferguson establishes 'separate but equal' law, and legitimizes Jim Crow laws
● 1898 Spanish-American War
– US annexes Hawaii

● 1903 DuBois's *The Souls of Black Folk* published
● 1909 National Association for the Advancement of Colored People (NAACP) founded by whites and blacks
– Explorers Robert Peary and Matthew Henson become first Americans to reach the North Pole
● 1910 NAACP *Crisis* magazine published
● 1911 National Urban League founded
● 1913–45 Great Migration
● 1914–20s 'Harlem Radicals' founded, a group of avant-garde African-Americans

1920

1930

● 1915–27 Cornelius M. Battey, photographer, sets up photography department, Tuskegee Institute

● 1916 James Van Der Zee opens studio in Harlem (1916–66)

● 1917 The Arts and Letters Society of Chicago exhibit the works of four African-American artists including Archibald Motley

● 1921 135th Street branch of New York Public Library exhibits nearly 200 works of African-American art

– James Herring's Art Department, Howard University started

● 1922 Meta Warrick Fuller exhibits *Ethiopia Awakening*, New York State Centennial Fair

– Henry Ossawa Tanner awarded France's Legion of Honour

– Albert C. Barnes's Foundation established, Merion, Pennsylvania

● 1923 Chicago Art League established by artist Charles Clarence Dawson through education department of Wabash YMCA

● 1924 Gertrude Vanderbilt Whitney opens Whitney Studio Club

● 1926 Harmon Foundation starts annual juried exhibitions for African-American artists

– Palmer Hayden wins Harmon Foundation first Gold award for *Fétiche et Fleurs*

– Edith G. Halpert opens Downtown Gallery

● 1927 Henry Ossawa Tanner elected full member of the National Academy of Design, and exhibits at Grand Central Art Galleries, New York, first African-American artist to have a solo exhibit in New York

– Aaron Douglas illustrates James Weldon Johson's *God's Trombones*

– 'The Negro in Art Week', Art Institute of Chicago, sponsored by Chicago Women's Club, opens

● 1928 Archibald Motley is first African-American artist since Tanner to have a solo exhibition in New York

● 1929 Museum of Modern Art (MOMA), New York, opens

● 1930 The Boykin School of Art, Greenwich Village, opens as meeting place for artists and intellectuals

● 1931 Whitney Museum of American Art opens

– Fragments of unglazed low-fired earthenware found by archaeologists, Colonial Williamsburg, Virginia

– Alain Locke writes 'The African Legacy and the Negro Artist' for Harmon Foundation exhibition catalogue

● 1917 US enters World War I

– Chandler Owen and A. Philip Randolph edit and publish *The Messenger*, a radical socialist publication

● 1917–35 New Negro movement

● 1918–25 UNIA established, Harlem

● 1919 W. E. B. DuBois organizes fist Pan-African Congress in Paris

– Chicago Riot known as Red Summer occurs

– The 369th Infantry (Black Americans) returns from France to a parade of 1 million in New York

– Women given the right to vote

● 1920 Marcus Garvey holds United Negro Improvement Association's first Annual Convention, New York

● 1921 Langston Hughes's 'The Negro Speaks of Rivers' published

– An anti-lynching bill is introduced in Congress that will make lynching a violation of federal law

● 1922 The Negro Colony flourishes in Paris

– UNIA, NAACP. and YMCA march in support of Dyer's anti-lynching bill

– James Weldon Johnson's *The Book of American Negro Poetry* published

– Urban League's *Opportunity* published

● 1925 William A. Harmon's Harmon Foundation established

– Alain Locke edits 'Harlem Mecca of the New Negro', a special edition of *Survey Graphic*

● 1926 Carl Van Vechten's *Nigger Heaven* published

– W. Thurman, L. Hughes, Zora Neale Hurston, R. B. Nugent edit and publish *Fire!* an avant-garde artistic magazine (only one issue printed)

● 1927 Marcus Garvey deported from the US

● 1929 US Stock Market crashes marking the Great Depression

● 1930s Charles Seifert's Ethiopian School of Research History established, later becomes Charles C. Seifert Library

● 1930 W. D. Ford founds the Black Muslims organization

– Négritude movement by French-speaking West Africans and West Indians begins in Paris

● 1932 John Reed Clubs, politically left cultural institutions, open in a dozen cities

1930

Artistic achievements, movements, and exhibitions	– Aaron Douglas's murals at Fisk University and Bennett College completed – Edith Halpert opens American Folk Art Gallery – Jose C. Orozco's mural completed New School for Social Research ● 1932 'American Folk Art: The Art of the Common Man in America 1750–1900', MOMA – Savage Studio of Arts and Crafts opens ● 1933 Harlem Art Workshop, 135th Street, New York Public Library, opens – Richmond Barthé exhibits in the Whitney Museum Annual	● 1934 Aaron Douglas's mural *Aspects of Negro Life* completed – Augusta Savage becomes first black member elected to the National Association of Women Painters and Sculptors – Artists' Union established ● 1935 Artists and models exhibition at YWCA, 138th Street, sponsored by New York Urban League, showcases 30 black artists – Harmon Foundation holds its last African-American art exhibition at the Delphi Studios	– Harlem Artists Guild established, with Aaron Douglas as the first president – NAACP sponsors an exhibit about lynching, New York – In Midwest, WPA sponsored Karamu House of Artists, Cleveland, opens – The Chicago Arts and Crafts Guild established – 'African Negro Sculpture', MOMA, opens – American Artists' Congress (1936–43) established	● 1936 Gallery curator Alonzo Aden organizes an exhibition of works by 38 African-American artists, Hall of Negro Life, Texas Centennial, Dallas – Charles Alston's Harlem Hospital murals completed – Locke's *Negro Art: Past and Present* published – Abstract Artists established, New York (to 1966) ● 1937 William Edmondson has solo exhibition, MOMA, New York – Augusta Savage becomes first director of Harlem community Art Center	– Richmond Barthé commissioned by WPA to make two 8 x 40 feet bas-reliefs for the Harlem Housing Project – Augusta Savage commissioned by World's Fair Corporation to make The Harp ● 1938 Horace Pippin exhibits at MOMA ● 1939 Hale A. Woodruff's epic mural *The Amistad* completed, Tallageda College – 'Contemporary Negro Art', Baltimore Museum of Art – Dox Thrash invents the carborundum printing technique
Cultural and political history	● 1933 Franklin Delano Roosevelt elected President, begins New Deal Administration – Diego Rivera's murals, Rockefeller Center completed, then whitewashed the same year because of the image of Lenin	● 1935 Holger Cahill, former curator at MOMA, appointed director of the Works Progress Administration – Elijah Muhammed becomes leader of Nation of Islam – The National Council of Negro Women founded, New York – Riot erupts in Harlem	● 1936 Henry Luce starts weekly photo-news magazine, *Life* – Jesse Owens wins the Gold Medal at Summer Olympics, Munich	● 1937 A. Philip Randolph succeeds in getting the Brotherhood of Sleeping Car Porters full membership of the American Federation of Labor – Zora Neal Hurston's *Their Eyes Were Watching God* published, the first exploration of the inner life of the black woman	● 1939 World War II begins in Europe – Clement Greenberg writes 'Avant-garde and Kitsch' for *Partisan Review*

● 1940 WPA-sponsored Southside Community Art Center, Chicago, opens
– 306 Group and Studio becomes an important place for artists and writers
– 'Art of the American Negro, 1851–1940' opens at The American Negro Exposition, Chicago
● 1941 'American Negro Art: 19th and 20th Centuries' and Jacob Lawrence 'Migrations of the Negro', Downtown Gallery
– 'Contemporary Negro Art', McMillen Gallery

● 1942 Hale A. Woodruff establishes the Atlanta University Exhibitions
– The National Gallery, Washington DC opens
● 1943 James Porter's *Modern Negro Art* published
– Charles White's mural *The Contribution of the Negro to Democracy in America*, Hampton University, Virginia, completed
● 1944 'New Names in American Art', Baltimore Museum.

● 1945–47 Romare Bearden exhibits in the Whitney Museum Art Annual
– Norman Lewis joins the Willard Gallery
● 1946 US State Department exhibition 'Advancing American Art', tours in Europe
● 1948 State Department pulls 'Advancing American Art' and auctions works (including those by Romare Bearden and Jacob Lawrence) through the War Assets Office
– Robert Blackburn establishes the Printmaking Workshop, New York

● 1949 Charles Alston and Hale Woodruff complete murals on a building designed by African-American architect Paul Williams for Golden State Mutual Life Insurance Co. Los Angeles
– Studio 35 opens on 8th Street

● 1950 Abstract Expressionism (also called 'New York School') makes US the art capital, and marks the first American art form
● 1951 Hale A. Woodruff's mural *The Art of the Negro*, Atlanta University, completed
– James Hampton starts assemblage *Throne of the Third Heaven*

● 1955 Norman Lewis exhibits in prestigious Pittsburgh International Exhibition, Carnegie Institute
– Richard Hunt is the youngest African American ever to exhibit in major American Museum, MOMA
● 1959 National Conference of Artists is founded, Atlanta University
– Elizabeth Catlett first woman professor to head sculpture department, National School of Fine Arts, Mexico

● 1941 US enters World War II after Japan bombs Pearl Harbor
– A. Philip Randolph's actions cause the integration of employees at defence plants nationwide

● 1942 CORE founded
– Richard Wright's *Native Son* published
● 1943 Detroit has worst race riot of the interwar period

● 1944 Gunnar Myrdal's American Dilemma: *The Negro Problem and American Democracy* published

● 1945 United Nations Charter is ratified
– Cold War era begins

● 1950 US engages in the Korean War under President Harry S. Truman
– Ku-Klux-Klan is revived in response to civil rights
● 1952 President General Dwight D. Eisenhower ushers in a period of heightened anti-Communist sentiment in America, known as McCarthyism
● 1954 Supreme Court decision, Brown v Topeka Board of Education, makes segregated public schools unconstitutional
– War in Southeast Asia
● 1955 Rosa Parks refuses to relinquish her seat to a white man, which initiates

the Alabama Bus boycott led by Martin Luther King, Jr
● 1956 British West African colony, the Gold Coast, becomes independent Ghana, and marks beginning of post-Colonial era in Africa
● 1957 Martin Luther King, Jr organizes SCLC
– Civil Rights Act passed
● 1959 Black students attend previously all-white public schools, Little Rock, Arkansas, the watershed for desegregation of public schools in the South

1960

Artistic achievements, movements, and exhibitions

● 1963 The artists' group, Spiral, and a photographers' collective, Kamoinge, New York, established
● 1965 Spiral holds exhibition 'Black and White' Christopher Street Gallery
– Black Arts Movement
– Artists group, Weusi, begins in Harlem
● 1966 First World Festival of Negro Arts, Dakar, Senegal
– 'Art of the American Negro' sponsored by Harlem Cultural Council and organized by Romare Bearden

● 1967 'The Negro in American Art', Frederick S. Wight Gallery, UCLA, opens
– Romare Bearden and Caroll Green Jr co-curate 'The Evolution of Afro-American Artists: 1800–1950', College of the City University of New York sponsored by the Urban League
– Organization of Black American Culture paints *Walls of Respect*

– The Harmon Foundation closes, giving over 1100 works to the Smithsonian Institution, Washington, DC, many of which are later distributed to historical black colleges
– The Studio Museum, Harlem, and Anacostia Museum of Culture and History, Washington DC, established
– Artists' group Weusi, opens Nyumba Ya Sanaa gallery, Harlem

● 1968 OBAC becomes Cobra and shortly thereafter Africobra in Chicago
– Museum of the National Center for Afro-American Art, Boston, established
– Two travelling exhibits help promote contemporary black art: 'New Voices' by American Greeting Gallery, New York; '30 Contemporary Artists' by Public relations firm Ruder & Finn
– 'Invisible Americans: Black Arts of the 30s', Studio Museum

– Artists William T. Williams, Guy Ciarcia, Billy Rose, and Melvin T. Edwards, form Smokehouse and paint murals in Harlem
● 1969 Benny Andrews and Cliff Joseph found BECC
– 'Harlem on My Mind', Metropolitan Museum
– 'New Black Art', Brooklyn Museum
– Cinque and ACA Galleries open

Cultural and political history

● 1960 John F. Kennedy elected President
● 1961 US supplies support troops to South Vietnam
● 1963 March on Washington, DC
– W. E. B. DuBois dies in Accra, Ghana
– *Black Scholar* journal established
– Four black girls killed in 16th Street Baptist Church bombing, Birmingham, Alabama
– President J. F. Kennedy assassinated, Dallas, Texas

● 1964 A. Philip Randolph awarded Presidential Medal of Freedom
– Malcolm X leaves the Nation of Islam to establish OAAU
– War in Vietnam escalates
– Martin Luther King, Jr awarded Noble Peace Prize
– Three CORE workers, Chaney, Goodwin, and Schwerner are found murdered in Mississippi
● 1965 Malcolm X assassinated, Audobon Ballroom, Harlem
– Civil Rights march from Selma to Montogomery, Alabama

– Riots erupt in cities, beginning with Watts, Los Angeles
– Ralph Ellison writes *The Invisible Man*
– President Lyndon B. Johnson signs Voting Rights Bill
● 1966 Stokely Carmichael launches Black Power Movement
– Black Panther Party founded, Oakland, California
– National Organization of Women founded
● 1967 Black Power Conference, Newark, New Jersey
– H. 'Rap' Brown new chair of SNCC

– Muhammed Ali convicted for refusing to serve in Vietnam and has his heavy-weight title taken away
– Third World Press founded
● 1968 Martin Luther King, Jr assassinated, Memphis
– US track athletes John Carlos and Tommie Smith raise clenched fists in support of Black Power, Summer Olympic Games, Mexico City
– Black Cutural Nationalism established by Mulana (formerly Ron) Karenga, and begins campaign to make Kwanzaa a black holiday celebration

– I. Amiri Baraka's The Black Arts Repertory Theater School founded
– Several black presses, like Third World Press and Broadside Press, focus on new cultural nationalism
– Manned space exploration begins with Apollo 8
● 1969 Fred Hampton and Mark Clark, Black Panther party leaders, are killed in early morning raid by Chicago Police
– *African Arts* magazine founded
– Apollo 11 exploration successfully lands men on the moon
– Chicago Seven Trial

● 1970s and 1980s Graphic workshops among black artists proliferate e.g. Workshop Inc., (DC) by Lou Stovall, and Brandywine Graphic Workshop (Philadelphia) by Allan Edmunds, Jr
– 'Afro-American Artists, New York and Boston' opens at the Museum of the National Center for Afro-American Art, Boston
– Samella Lewis's *Black Art International Quarterly* published

● 1971 Where We At, Black Women Artists, New York, founded
– Whitney Museum of Art organizes 'Contemporary Black American Art'
– 'Rebuttal to the Whitney', Acts of Art Gallery
– Whitney Museum schedules solo exhibits of black art
– Romare Bearden and Richard Hunt have solo exhibitions at MOMA, a first for African-American artists

● 1972 Alma Thomas has solo exhibition, Whitney Museum of American Art, first black woman artist to do so
– Sam Gilliam exhibits in the 36th Venice Biennale
– Joseph Crawford establishes the Black Photographer's Annual

● 1974 Just Above midtown Gallery opens
● 1975 Edmonia Lewis's *Death of Cleopatra*, lost for nearly 60 years, is rediscovered at a contractor's equipment yard, Forest Park, Illinois

● 1976 David C. Driskell organizes 'Two Centuries of Black American Art', Los Angeles County Museum of Art
– The Museum of African American Art, Los Angeles, and the Afro-American Historical and Cultural Museum, Philadelphia, established
● 1977 Al Diaz and Jean-Michel begin collaboration on SAMO

● 1978 'The Afro-American Tradition in Decorative Arts', Cleveland Museum
– Excavations at Kingsmill plantation prove that colonoware was made by slaves
● 1979 California African American Museum of Culture and History, Los Angeles, opens
– Martin Puryear begins a series of public art projects

● 1970 The 'Peoples Flag Show' which included Faith Ringgold results in The Judson Three case
– Breakdancing and dancers called 'B-Boys' emerge in South Bronx
– American universities establish African-American or Black Studies programmes

● 1971 Congressional Black Caucus is established
– US Supreme Court overturns Muhammed Ali's draft evasion conviction

● 1972 Shirley Chrisolm announces candidacy for the Democratic Party's nomination for president
– The rappin' emcee and emergence of the rap music genre
● 1973 US Supreme Court decision on Roe v Wade legalizes abortion
– National Black Feminist Organization founded

● 1974 Richard M. Nixon resigns from office, the first president to do so
● 1975 United Nations Conference, Mexico City, theme is 'The Year of the Woman'

● 1977 Alex Haley's 'Roots' airs on national television, and is a major commercial success
– FESTAC '77, The Second World Black and African Festival of Art, Lagos, Nigeria
– TransAfrica, the African-American lobby for Africa and the Caribbean, established

● 1978 Louis A. Farrakhan forms a new Nation of Islam
– Faye Wattleton becomes president of Planned Parenthood
● 1979 Fifty-three American diplomats taken hostage, United States Embassy, Tehran

1980

Artistic achievements, movements, and exhibitions

● 1980 Galleries selling African-American art nationally, and artists' solo exhibits and retrospectives more than double, continuing into the 1990s
– Video art becomes an important art medium for African-American artists
– 'Afro-American Abstraction', organized by April Kingsley, PS1, Long Island
●1981 Lorna Simpson becomes first African-American woman to have solo exhibit at MOMA
– Performance art becomes popular among black women artists

● 1982 'Forever Free: Art by African-American Women, 1862–1980', the first large survey of its kind
– 'Black Folk Art in America 1930–80', Corcoran Gallery of Art, Washington DC
– Jean-Michel Basquiat is youngest artist in Documenta 7, Kassel, Germany
● 1983 The National Conference of Arists has first international meeting, Dakar, Senegal
– Jacob Lawrence elected to the Academy of Arts and Letters

● 1984 'Primitivism in 20th-century Art, Affinity of the Tribal and the Modern', MOMA, opens
– 'Since the Harlem Renaissance: 50 Years of Afro-American Art', Bucknell University
– 'East-West Contemporary American Art', California Afro-American Museum, Los Angeles

● 1985 The Guerilla Girls, an anonymous women artists' collective, make public appearances wearing gorilla masks to campaign against racism and sexism
– PESTS, an African-American women artists' collective, focuses on the exclusion of women of colour and employs similar tactics as the Guerilla Girls
– Earth-art and site-specific installations occur more frequently

– 'Sharing Traditions, five Black Artists in the Nineteenth Century', National Museum of American Art, and 'Tradition and Conflict: Images of a Turbulent Decade, 1963–73, Studio Museum, Harlem
● 1986 The Museum of African-American Life and Culture, Dallas, becomes important repository of black folk art
● 1987 Romare Bearden receives the Presidential Medal of Honor
– National Museum of Women in the Arts, Washington, DC, opens

Cultural and political history

● 1980 Rhodesia becomes independent nation Zimbabwe
– US invades Grenada
– Afrocentrism concept emerges in black studies
● 1981 Fifty-two American hostages released from Iran
– Sandra Day O'Connor confirmed as first woman on the US Supreme Court
– The Center for Disease Control alerts nation to Acquired Immune Deficiency Syndrome (AIDS)
– The Equal Rights Amendment expires

● 1982 Alice Walker writes *The Color Purple*
– The black granite Vietnam Veterans Memorial by Maya Lin is dedicated in Washington, DC listing 58, 208 names
● 1983 President Reagan signs bill declaring a national holiday commemorating Marthin Luther King Jr

● 1984 Jesse Jackson declares candidacy for the 1984 Democratic Presidential nomination, and establishes the Rainbow Coalition
– Geraldine Ferraro is first woman to be nominated for Vice-President of the Republican Party
– NBC airs BBC footage of the devastating drought in Ethiopia
– Bishop Desmond Tutu wins Nobel Peace Prize

● 1985 Philadelphia police bomb the headquarters of radical acitivist group MOVE, causing the entire city block to be destroyed and making 300 people homeless
● 1986 Iran-Contra scandal erupts
– US officials estimate 350,000 homeless nationwide
– Three African Americans attacked at Howard Beach, Queens; Michael Griffith is killed
– Comprehensive Anti-Apartheid Act enacted as a result of Randall Robinson's efforts

– NASA space shuttle *Challenger* explodes
– Bill and Camille Cosby give major gifts to historical black colleges
● 1987 Dow Jones stock averages drop 508 points, the largest since 1914
– AIDS takes toll on the black and Hispanic communities
– African American Reginald L. Lewis, CEO of TLC Group, makes largest leveraged purchase of a non-American company, Beatrice International Foods

1990

● 1988 The first national Black Arts Festival is held, Atlanta, which alternates yearly with the Black Theater Festival – 'Art As a Verb, the Evolving Continuum', first major installation, performance and video art exhibition of 13 African-American artists, Maryland Institute, College of Art

● 1989 '19 Sixties: A Cultural Awakening Re-evaluated, 1965–1975', California Afro-American Museum – After 9 years of public debate Richard Serra's *Tilted Arc* is removed from Federal Plaza, New York – Martin Puryear represents the United States at São Paulo Bienal also awarded John D. and Catherine T. MacArthur Foundation Fellowship – Five noteworthy shows: 'Introspectives; Contemporary Art by Americans and Brazilians of African Descent', California Afro-American Museum; 'Tradition and Transformations: Contemporary Afro-American Sculpture', Bronx Museum; 'The Blues Aesthetic: Black Culture and Modernism', Washington Project for the Arts; 'Black Art: Ancestral Legacy', Dallas Museum of Art; and 'Against The Odds: African-American Artists and the Harmon Foundation' Newark Museum

● 1990 'The Decade Show: Frameworks of Identity in the 1980s', Museum of Contemporary Hispanic Art – New Museum of Contemporary Art and Studio Museum, Harlem form first multi-cultural museum collaboration of the decade – Lorna Simpson is first African-American woman chosen to exhibit in Venice Biennale
● 1991 'The Search for Freedom, African American Abstract painting, 1945–1975', Kenkeleba Gallery, New York

– An important site-specific installation exhibition 'Places with a Past', part of the Spoleto Festival USA, Charleston, South Carolina, includes four black artists
● 1992 Printmaker Robert Blackburn and sculptor John Scott receive the James McArthur Fellowship – 'Dream Singers, Story Tellers: An African-American Presence', New Jersey State museum, first large-scale show exploring relation-ship between fine and folk art – 'Free Within Ourselves', National Museum of American Art

● 1994 Thelma Golden organizes 'Black Male, Representations of Masculinity in Contemporary American Art', Whitney Museum of American Art

● 1988 Pan Am flight explodes over Lockerbie, Scotland in terrorist attack – Maxie C. Robinson, founder of the Association of Black Journalists, and first black TV network anchor, dies of AIDS

● 1989 Gulf War – The Berlin Wall, Germany, is torn down – Exxon Valdez oil tanker hits a reef off the coast of Alaska spilling 11 million gallons of oil and ruining 1100 miles of coastline – US invades Panama to oust General Noriega – Ron Brown is national chairman of the Democratic Party

– Controversy erupts in US Congress over the photos of Robert Mapplethorpe and Andres Serrano, which jeopardizes federal fundings of the arts through NEA

● 1990 Nelson Mandela released from prison after 27 years, and the 30-year ban on African National Congress is lifted – Rising concern about black-on-black crimes and killings nationally
● 1991 Mikhail Gorbachev's 'Glasnost' policy heralds the demise of communism as the official national ideology – African-American tennis champion Arthur Ashe dies of AIDS – Pearl Primus, choreographer and dancer, is awarded the National Medal of Arts

– Senate Judiciary Committee charges of sexual harassment by Anita Hill against US Supreme Court nominee Clarence Thomas
● 1992 William J. Clinton appoints several African Americans as cabinet members, the first US president to do so
● 1993 Author Toni Morrison awarded the Nobel Prize for Literature – Bombing of World Trade Center, New York, by terrorists

● 1994 Nelson Mandela becomes president of the Republic of South Africa – Affirmative Action is challenged by state and federal legislatures as inequitable and unconstitutional – US turns back refugees from Haiti – National Center for Afro-American Women established – Surgeon-General, African American M. Joycelyn Jones Elders, forced to resign because of views about sex education and drugs – Movement under way to reform Welfare Bill

Index

Oxford History of Art

Titles in the Oxford History of Art series are up-to-date, fully illustrated introductions to a wide variety of subjects written by leading experts in their field. They will appear regularly, building into an interlocking and comprehensive series.

Western Art

Archaic and Classical Greek Art
Robin Osborne
Hellenistic and Early Roman Art
John Henderson & Mary Beard
Imperial Roma and christian Triumph
Jaś Elsner
Early Medieval Art
Lawrence Nees
Late Medieval Art
Veronica Sekules
Art and Society in Italy 1350–1500
Evelyn Welch
Art and Society in Early Modern Europe 1500–1750
Nigel Llewellyn
Art in Europe 1700–1830
Matthew Craske
Nineteenth-Century Art
Modern Art: Capitalism and Representation 1851–1929
Richard Brettell
Art in the West 1920–1949
Modernism and its Discontents: Art in Western Europe & the USA since 1945
David Hopkins

Western Architecture

Greek Architecture
David Small
Roman Architecture
Janet Delaine
Early Medieval Architecture
Roger Stalley
Late Medieval Architecture
Francis Woodman
European Architecture 1400–1600
Christy Anderson
European Architecture 1600–1750
Hilary Ballon
European Architecture 1750–1890
Barry Bergdoll
Modern Architecture 1890–1968
Alan Colquhoun
Contemporary Architecture
Anthony Vidler
Architecture in the United States
Dell Upton

World Art

Ancient Aegean Art
Donald Preziosi & Louise Hitchcock
Classical African Art
Contemporary African Art
African-American Art
Sharon Patton
Nineteenth-Century American Art
Barbara Groseclose

Twentieth-Century American Art
Erika Doss
Australian Art
Andrew Sayers
Byzantine Art
Robin Cormack
Art in China
Craig Clunas
East European Art
Jeremy Howard
Ancient Egyptian Art
Marianne Eaton-Krauss
Indian Art
Partha Mitter
Islamic Art
Irene Bierman
The Arts in Japanese Society
Karen Brock
Melanesian Art
Michael O'Hanlon
Latin American Art
Mesoamerican Art
Cecelia Klein
Native North American Art
Janet Berlo & Ruth Phillips
Polynesian and Micronesian Art
Adrienne Kaeppler
South-East Asian Art
John Guy

Western Design

Twentieth-Century Design
Jonathan M. Woodham
Design in the USA
Jeffrey Meikle

Western Sculpture

Sculpture 1900–1945
Penelope Curtis
Sculpture Since 1945
Andrew Causey

Photography

The Photograph
Graham Clarke

Special Volumes

Art and Film
Art and Landscape
Malcolm Andrews
Art and the New Technology
Art and Science
Art and Sexuality
The Art of Art History: A Critical Anthology
Donald Preziosi (ed.)
Portraiture
Women in Art